OUVREGAMEBOOK

© 2005 Assouline Publishing
601 West 26th Street, 18th floor
New York, NY 10001, USA
Tel.: 212 989-6810 Fax: 212 647-0005
www.assouline.com

Translated from the French by Linda Jarosiewicz and Frank Coffee

Color Separation: Gravor (Switzerland)
Printed by Toppan Printing (China)

ISBN: 2 84323 733 5

PASCAL BONAFOUX / DAVID ROSENBERG

LOUVREGAMEBOOK
PLAY WITH THE LARGEST MUSEUM IN THE WORLD

ASSOULINE

"One should go to the Louvre through nature and return to nature through the Louvre."

PAUL CÉZANNE

How to use this book

 Game

 Observation

 Question

 Answer

 Monarchs

 Architects

 Painters

 Sculptors

Content

Artists' words
Who said what?

Pablo Picasso

Henri Matisse

Alberto Giacometti

Paul Cézanne

Georges Braque

Andy Warhol

André Malraux

Auguste Renoir

Marcel Duchamp

Marc Chagall

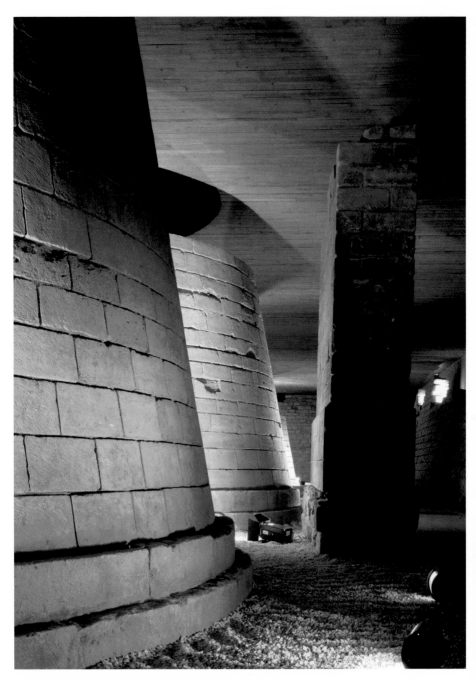

View of the moat in the crypt of the Cour Carrée:
vestiges of the medieval château built under Philip Augustus, end of the 12th century.

The Louvre: An Enigmatic Name

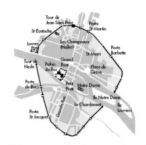

Paris takes its name from a tribe of Gauls called the Parisii (a Celtic word that refers to a river vessel). The tribe was defeated in 52 B.C. by Roman troops led by Labienus, one of Caesar's lieutenants.

Le Châtelet takes its name from a fortified castle, or "châtelet," built in 1130 by Louis VI, who was called Louis le Gros (the fat).

The Garden of the Tuileries takes its name from an ancient tile maker. The sandy banks of the Seine—in French, *bords sablonneux*—gave Sablons its name. One of the most fashionable districts in Paris today has kept the name of the swampy marsh—the French *marais*—on which it was built. But nothing is really known about the origin of the name of the Louvre. Toponymy (the study of the names of places) has been and remains unable to discover its origins. Should we think of the Latin words *lupara* or *lupera* (a place overrun with wolves) or the word *luperia*, which refers to a kennel dedicated to a wolf hunt? Or does it come from the word *lowar*, of Saxon origin, which means fortress? Is it a changed spelling of the word *rouvre* meaning oak tree? We have only conjectures and hypotheses. All we know is that at the start of the

twelfth century, the Louvre referred to a piece of land to the west of Paris. In 1186, the name was mentioned for the first time during the founding of a hospital named Saint-Thomas-du-Louvre. It was on this site that King Philip Augustus gave the order to build a real fortress. The history of the Louvre starts with this construction.

In 1983, when work was being done on the Grand Louvre (Great Louvre), excavations uncovered the keep built during the reign of Philip Augustus and the foundations of adjoining buildings built during the reign of Charles V. A visitors' path now leads to these entirely restored remains. This imposing configuration, 23 feet of which is buried below ground, is in the exact location of the Cour Carrée (square courtyard). The origin of the courtyard's name is no mystery: it is simply a perfect square measuring nearly 400 feet on each side.

Who was the first person to consider making a museum out of the Louvre?

13

The "First" Louvre

The "first" Louvre was a fortress built by King Philip Augustus. Successor to the Capetians, Philip acceded to the throne in 1180. A crusader and sworn enemy of the English, he was a pious and ambitious monarch who aspired to increase the size of his kingdom as well as his powers.

Paris, the capital of this kingdom, was then a small town with the Île de la Cité at its heart. It harbored the royal palace and the Notre-Dame cathedral, the chancel and transept of which were finished in 1200. The town's merchants were gathered around the town hall. On the left bank, the dark, sloping alleyways led to the first universities in Paris. All around were fields and countryside crossed by a few rare roads and paths.

Fear of invasion by Vikings coming up the Seine gave way to wariness of Paris's English neighbors, effectively installed in Normandy and the Vexin. Richard the Lion Heart, the king of England, was the suzerain, brother-in-law, and rival of Philip Augustus all rolled into one. In 1190, according to a chronicler, while getting ready to leave for the Holy Land with Richard, Philip Augustus ordered "the burghers of Paris to surround the city of Paris, that he loved so much, with a perfect wall equipped with towers and doors."

The wall went around the city. There was a parapet, crenellations, and fortified doors. In order to reinforce the west flank of this arrangement, the king built the Louvre fortress with his own money.

The oldest documents on this subject are a report from 1202 that gives an account of expenses "for the ironwork on the château's windows and the wine distributed to the burghers," and some royal letters dating from 1204 in which mention is made of an allowance given to the monks of Saint-Denis de la Chartre for the land for the Louvre.

The fortress was made up of a rectangular enceinte with ten towers: Tour de la Fauconnerie, du Milieu, de

Lafont de Saint-Yenne, a writer and art lover (1688–1771).

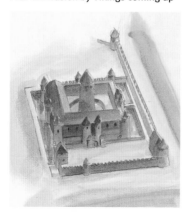

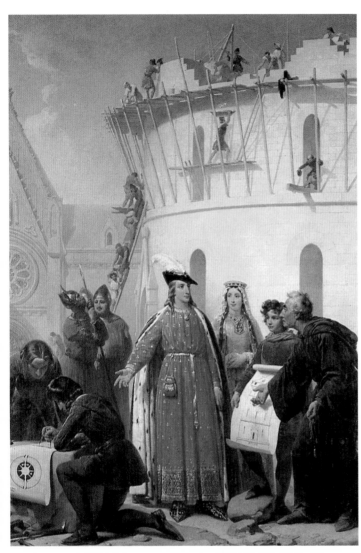

JEAN-BAPTISTE MAUZAISSE, *Philip Augustus Builds the Large Tower of the Louvre,* circa 1200, 1784–1841. Oil on canvas, 1.08 x 1.34 cm. Private collection.

Opposite page: Rebuilding of the donjon of the Louvre, situated at the western end of the Paris walls, by Philip Augustus.

la Taillerie, etc. At the center stood the Grosse Tour, which rose to a height of more than a 100 feet. It was surrounded by moats filled with water from the Seine that could only be crossed by a stone bridge and a drawbridge. The building was austere, with no decoration and few openings. In it, crossbows and various other weapons were made. There were also dungeons, the first known occupant of which was a certain Ferrand, count of Flanders, who spent ten years chained there. Even then, the Louvre was used to store the royal treasures: jewels, furniture, tapestries, and rich fabrics from the Orient.

The Louvre at the Time of Charles V

♛ CHARLES V (1338–1380), REIGNS FROM 1364 TO 1380
 Å RAYMOND DU TEMPLE

Charles V became king on April 8, 1364, following the death of John II, "The Good." Scion of the Capetian dynasty (from the name of the founder of the line, Hugh Capet), he ruled during a period marked by the Hundred Years' War, which pitted France against England; bloody Parisian insurrections, and peasant revolts called Jacqueries. He was the first sovereign after Philip Augustus to undertake major work at the Louvre.

During his reign, the Bastille and the fortress at Vincennes were built, as well as a larger protective wall surrounding the city that would permit the Louvre to be transformed into a palace and laid out like a beautiful mansion. Charles entrusted the work to Raymond du Temple, chief architect and project manager of the Louvre, whose name belongs to history.

Many of the rooms had mullioned windows; curtained walls, many covered in earthwork, had also been erected. There were towers wherever one looked, turrets riddled with perforations, bell turrets, pinnacles, weathercocks, and gargoyles.

To the north of the château, one would find gardens, as well as a small zoo and a handball court (an early version of tennis). The Grande Vis, a spectacular spiral staircase, ascended a round tower a bit more than sixteen feet in diameter. The royal apartments included a bedroom, a stateroom, a chapel, and an "estuve" (a primitive bathroom). The palace has many sculptures by Jean de Saint-Romain and Jean de Liège. The apartment walls were covered in fabrics woven with silver and gold, in tooled leather, or in tapestries. The ceilings and beams were painted. And one of the small rooms of the château was decorated with birds, deer, and hunting scenes. The king heard mass in a

A Romantic vision of the medieval castle. Engraving. Paris, musée Carnavalet.

Opposite page: *Festive Banquet Given by Charles V of France for Charles IV and His Son Wenceslas IV of Luxembourg in the Great Hall of the Palais-Royal in 1378*, 15th-century illustration from *Les Grandes Chroniques de France*. Paris, Bibliothèque nationale.

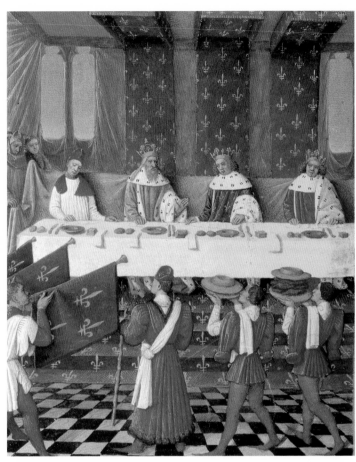

small chapel with statues of the prophets, which was equipped with a "back warmer."

Charles V owned numerous French translations of celebrated texts (theology, philosophy, history, the natural sciences, astronomy, and astrology), including an unprecedented collection of illuminated manuscripts. These priceless works, among them the famous Catalan atlas and the Chronicles of France, were housed in the so-called Falconry Tower, which was later rechristened the Library Tower. During his reign, the Louvre was filled with such precious objects as reliquaries and crucifixes encrusted with pearls and precious stones, chalices, holy pictures adorned with cameos, crystal ewers, alabaster pots, enamels, and silver vessels.

Which emperor was received at the Louvre in 1377 by Charles V?

The Louvre at the Time of Francis I

👑 FRANCIS I (1494–1547), REIGNS FROM 1515 TO 1547
⚔ PIERRE LESCOT

Crowned at Reims on January 25, 1515, Francis I embodied the spirit of the French Renaissance, daughter of the Italian Renaissance. Blois, Chambord, Fontainebleau, the Louvre: his reign was distinguished, among other things, by the renovation and construction of châteaux whose architecture was inspired by what he discovered during his military campaigns and captivity in Italy. A protector of the arts, he collected statues, paintings, and works of art. He loved to surround himself with humanists, poets, artists, and famous architects: Ronsard, Du Bellay, Le Rosso, Le Primatice, Benvenuto Cellini, and especially Leonardo da Vinci. On February 26, 1527, Francis I paid a certain Jean aux Bœufs the sum of 2,500 pounds to raze the Grosse Tour, the symbol of a medieval Louvre that, in his eyes, had become too run down and dilapidated. Within four months, it was knocked down. Its moat was filled and its courtyard paved. Along the Seine, a quay was built in place of an ancient towpath.

On March 15 of the same year, the king informed the merchants' provosts and the aldermen of his "good city of Paris" of his intention to make the Louvre his residence. To contribute to the financing of the work, he extended for six years the assistance that his predecessor, Louis XII, obtained by charging a tax on fish to city residents. A new fortified entrance was built near the Tour de Bois (Wooden Tower), and

Charles IV, son of John of Luxemburg, King of Bohemia.

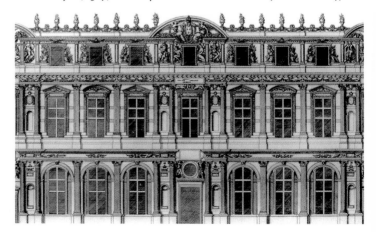

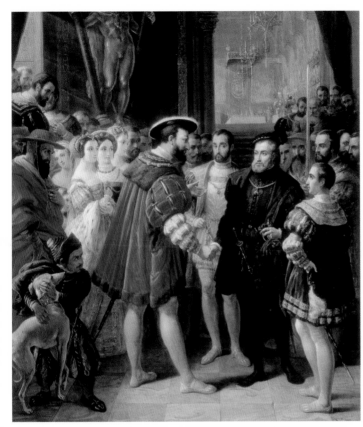

ALEXANDRE-MARIE COLIN, *Charles V Received at the Louvre Palace by Francis I*, 19th century. Oil on canvas. Châteaux de Versailles et de Trianon.

Opposite page: ANDROUET DU CERCEAU, *The Facade of Pierre Lescot*, in *Les plus excellents bâtiments de France (The Great Buildings of France)*, Engraving. Paris, Bibliothèque nationale.

the old fortifications were restored. Charles V's terraces were transformed into apartments.

In 1540, Francis I received his greatest rival in Europe, Charles Quint, emperor of the Holy Roman Empire—who had held him prisoner after the defeat in Pavia in 1525. The Louvre had to become a sumptuous theater for ballets, jousts, and tourneys. Sauval, a contemporary, tells us "(...) nothing was to be forgotten or spared in order to receive and regale the emperor magnificently."

Hangings, painted windows, golden weather vanes, and an imposing sculpture of Vulcan holding a torch adorn the courtyard of the "old" Louvre; for the time being, the old architecture of Charles V had to be hidden behind the decorum of pageantry.

The major work would only start a few years later. On August 2, 1546, Francis I wrote to his architect, his "dear and well-loved Pierre Lescot, Seigneur of Clagny" to inform him that he had decided "to build and construct, on our property the Louvre" a large and new palace. The work had just begun when, barely a year later, the king died on March 31, 1554.

1. CLAUDE PERRAULT (1613–1688), by Gérard Edelinck, 17th century. Engraving, 23 x 16.30 cm. Chateaux de Versailles et de Trianon. - **2. FÉLIX DUBAN** (1797–1879), by Domenica Monvoisin, 1873. Oil on canvas, miniature, 11.10 x 8.50 cm. - **3. CHARLES PERCIER** (1764–1838), by Robert Lefèvre, 1807. Oil on canvas, 86 x 54 cm. Châteaux de Versailles et de Trianon. - **4. JACQUES LEMERCIER** (circa 1585–1654), by Jean Morin, 17th century. Print, 30,70 x 25 cm. Châteaux de Versailles et de Trianon.

Answer

The Louvre's Architects Who is who?

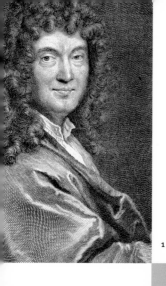

1

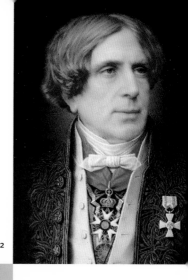

2

FÉLIX DUBAN

•

CLAUDE PERRAULT

•

JACQUES LEMERCIER

•

CHARLES PERCIER

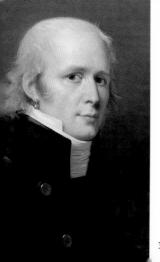

3

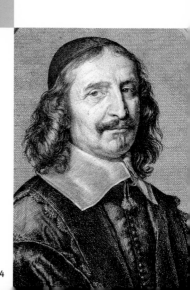

4

The Louvre at the Time of Henry II

♛ HENRY II (1519–1559), REIGNS FROM 1547 TO 1559
𝍌 PIERRE LESCOT
𝍍 JEAN GOUJON

The son of Francis I and Claude of France. Henry II was born in 1519. He acceded to the throne in 1547. Although Philibert Delorme was appointed superintendent of the royal buildings in this year, the architect Pierre Lescot remained solely responsible for restoring the Louvre. The construction of the "new" Louvre had truly started. The buildings to the south of Charles V's fortress were razed. The first building he completed had two floors and an attic, a third floor with a height exactly half that of the first ones. He broke up the monotony of the facade, punctuated by columns and pilasters, with three avant-corps, one at each end, and a larger one in the middle. Although Italian architecture, Lescot's

CINETON, *Staircase of Henry II at the Louvre,* 1853. Print, in *Description historique et graphique du Louvre et des Tuileries,* by Le Comte de Clarc.

Opposite page:
SAINT-ÈVRE GILLOT, *Mary Stuart Delivers a Funeral Oration in Latin, Which She Wrote Herself, in the Hall of the Caryatids of the Louvre in 1556,* 19th century. Oil on canvas, 176 x 134 cm. Châteaux de Versailles et de Trianon.

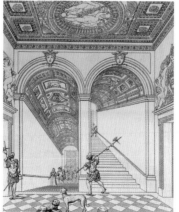

model, suggested to him a terraced roof, he decided to raise a gambrel roof with two slopes. A new staircase was built at the northern extremity of the first wing. Its sculpted arch, which can still be admired today, was devoted to the theme of the hunt. It was marked with the letter *H* and an ambiguous shape as much reminiscent of the letter *C*, initial of Catherine de' Medici, Henry II's legitimate wife, as the crescent of Diane de Poitiers, whom the king loved passionately. Pierre Lescot called on Jean Goujon and other sculptors, such as the Lheureux brothers, Lefort, Hardin, Ponce, and Cramoy, to decorate the facades with mythological and allegorical figures symbolizing science, fame, war, and peace. In 1556, the architect built the Pavillon du Roi near the Seine. To mark the corners of this austere facade, of which only the pediment is decorated with trophies, he chose vermiculated bosses (projecting stones with sinuous grooved streaks), which would become one of the characteristic features of the Louvre's architecture. The roofing he used to cover this pavilion rose to a height that for two centuries would determine the height of all this

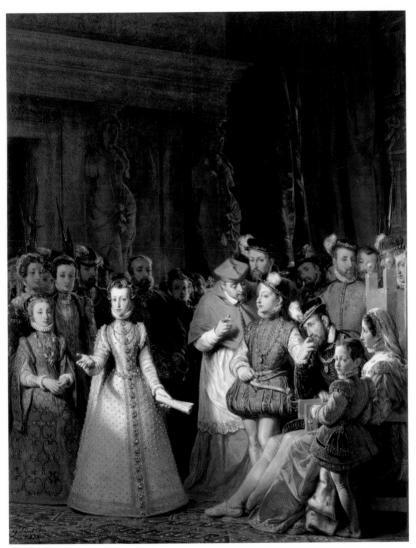

palace's pavilions. The Louvre was the setting for lavish celebrations and grand tournaments. On the occasion of one of these tournaments, the king nearly lost face in a fight with one of his vassals. Furious, he demanded a second confrontation. Catherine de' Medici implored the king to stop, but he would not listen. During the second bout, his adversary's lance penetrated the visor of his helmet. At the Hôtel des Tournelles, the doctor Ambroise Paré was powerless to prevent the king's death ten days later on July 10, 1559. Catherine de' Medici left the Louvre soon after with the young Francis II.

The Louvre at the Time of Charles I

👑 CHARLES IX (1550–1574), REIGNS FROM 1560 TO 1574
🏛 PIERRE LESCOT
🏛 ÉTIENNE CARMOY, MARTIN LEFORT, THE BROTHERS LHEUREUX

In 1560, Charles IX, the second son of Henry II and Catherine de' Medici, acceded to the throne. Barely 10 years old, he succeeded his brother Francis II who had only reigned for a few months. His mother thus maintained the exercise of power. She could no longer bear living in the Hôtel des Tournelles, where Henry II had died in 1559. So she decided to have it sold and demolished. In 1564, she bought several pieces of land outside the ramparts of Paris, not far from the Porte Neuve, in a place called the Tuileries. Philibert de l'Orme, the architect she appointed, wrote that he "built a palace following the layouts, measurements, and commandments of the queen." Catherine de' Medici also wanted to have a gallery join the Tuileries to the Louvre along the banks of the Seine. On March 9, 1565, the young Charles IX signed an order for this work to be executed "today rather than tomorrow." In 1566, the first stones of the Louvre's Petite Galerie and the gallery that was to join the two palaces were laid. But these projects would not be completed. In 1572, Catherine abandoned construction of her palace, although it was well advanced. Framed by two wings topped by terraces, the central pavilion contained a spectacular elliptical staircase. The decor mixed banded Ionic pilasters and columns, bossed arcades, inlaid marble, and golden bronze.

At the Louvre, Pierre Lescot supervised work in the south wing

Of having killed the Protestants with his crossbow from the windows of his room at the Louvre.

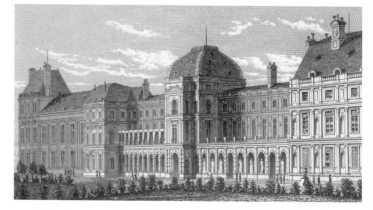

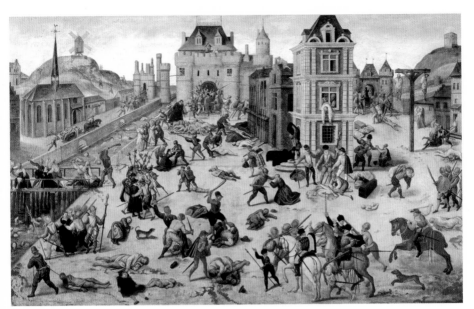

of the building, where, between 1562 and 1565, the Lheureux brothers, Martin Lefort, and Étienne Carmoy sculpted figures of children, birds, festoons, and floral and allegorical ornaments. Despite all the upheavals, Lescot remained the main director of the building. Appointed by Henry II, his duties were confirmed by Francis II, Charles IX, and Henry III.

The Arsenal was no longer at the Louvre; it was henceforth installed on the Quai des Célestins. The palace became the place for a succession of lavish celebrations and bloody intrigues.

After the failed assassination attempt on Coligny, a high-ranking Protestant dignitary, Catherine and her other son Henry pushed the young king to eliminate all the Protestant leaders. On August 23,

1572, the bells of Saint-Germain l'Auxerrois gave the signal for the start of the Saint-Bartholomew's Massacre. It was said that the courtyards of the Louvre were piled high with corpses, and the king himself was accused of personally taking part in the carnage. The ailing young king died at the age of 23, bequeathing to posterity a motto that ill described his reign: "Justice and charity."

FRANÇOIS DUBOIS, *The St. Bartholomew's Massacre,* 1572. Oil on canvas. Lausanne, Musée des Beaux-Arts.

Opposite page: AUGUSTUS PUGIN, *The Tuileries in 1564.* Steel-plate engraving. Berlin, Archiv für Kunst & Geschichte (Art and History Archive).

The Louvre in Time
Find the chronological order

Answer

5. 1739: The Louvre under Louis XV. - 1. 1867: The Louvre under Napoleon III.
2. 1622: The Louvre under Louis XIII. - 3. 1663: The Louvre under Louis XIV.
4. BEFORE 1362: The Louvre of Philip Augustus. - 6. 1380: The Louvre of Charles V.

After F. Hoffbauer, wood engravings, 1885, Berlin, Archiv für Kunst & Geschichte.

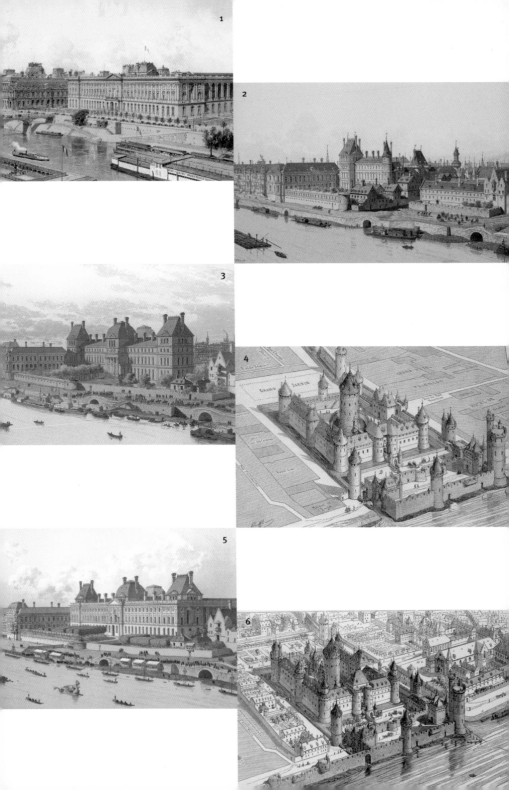

The Grand Design of Henry IV

♛ HENRY IV (1553–1610), REIGNS FROM 1589 TO 1610
𝔄 LOUIS MÉTEZEAU AND JACQUES II ANDROUET DU CERCEAU
🏛 PIERRE BIARD, THE BROTHERS LHEUREUX

In May of 1589, Henry III was stabbed by the monk and conspirator Jacques Clement. On his deathbed, he left his kingdom to his younger brother, Henry IV, who had come to see him: "If God takes me, I leave my crown to you as my legitimate successor." Following a long period of political and religious intrigue, Henry IV returned to Paris and took up residence at the Louvre on March 22, 1594. It had been twenty years since he had set foot in this palace where, in 1572, as the king of Navarre, he had married Marguerite of Valois.

On November 17, 1594, Henry IV signed the letters patent confirming his wish to continue "the improvements to the Louvre according to the designs and plans already made."

His grand design was to tie the Louvre to the Tuileries Palace. Throughout his reign, the palace was an ongoing construction project. His initials, *HDB,* for Henri de Bourbon, began to appear next to those of Charles IX, *H* and *K,* who had thus indicated the buildings put up by the Valois kings.

The great palace that Henry IV envisioned would be not just the symbol of his authority but a repository for the royal collections that would attract both artists and artisans.

The city ceded the land of the old close on the banks of the Seine. Sully was put in charge of the finances. In 1595, work was ready to begin. The Tuileries Palace and the south wing of the Louvre had to be completed, the height of the small gallery increased, and the buildings joined together. Louis Métezeau and Jacques II Androuet du Cerceau were in charge of construction. The layout of the Tuileries gardens was entrusted to Claude Mollet. Barthélémy Prieur did the bas-reliefs of the garden arcades, and Biard designed the western facade of the Petite Galerie. The courtyard was surrounded with arcades and windows surmounted by both round and triangular pediments. The facade facing the Seine was given pilasters and small windows. The eastern side of the gallery has a frieze attributed to the Lheureux brothers, which features putti and symbols of power: scepters, crowns, the scale of justice, a cornucopia...

Henry looked after every stage of the work himself. In 1607, he wrote to

ÉTIENNE-BARTHÉLEMY GARNIER,
Henry IV Has Galleries Built in the Louvre,
circa 1819. Oil on canvas, 145 x 117 cm.
Châteaux de Versailes et de Trianon.

What sort of animal did the son of Henry IV sometimes let loose in the Grande Galerie?

?

29

The Grand Design of Henry IV

Cardinal de Joyeuse: "You will find a large gallery here at Paris, stretching nearly to the completed Tuileries." And in 1608, the poet Malherbe (1555–1628) wrote in a letter: "If you come to Paris two years hence, you will not recognize it. The wing at the end of the gallery is almost completed."

The poet was referring to the pavilion of Flora, although the building has borne that name only since 1669; the name was taken from a memorable ballet celebrating the Greek goddess, which was performed during the reign of Louis XIV. The crouching Flora laughing at the children around her on the pavilion's facade is an 1861 copy by the architect Lefuel of the destroyed original by Carpeaux. It was a splendid time of sumptuous festivities at the Louvre, but the king was constantly targeted for assassination. Attempts were made on his life in 1589, 1593, 1594, and 1597. On May 14, 1610, he went to the Arsenal to meet Sully. As he entered the rue de la Ferronnerie, he was stabbed by Ravaillac. His death put an abrupt end to construction, and his grand design remains incomplete.

The court gathered to greet the remains of the monarch, which were laid out on a golden pall. An effigy of the king was put in a coffin and placed in the Hall of the Caryatids for public viewing. Mathieu Jacquet carved the face in wax. A bonnet and crown were placed on the head, and the body was clothed in a red satin doublet and a purple velvet cape with fleurs de lis and lined in ermine. For eleven days, the crowds filed by to pay their last respects.

He made a sport of racing a camel there.

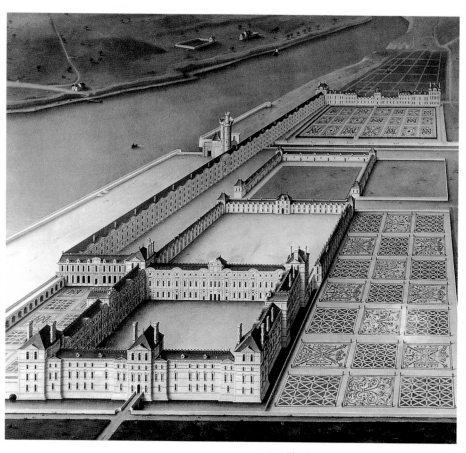

The Great Project for the Louvre, circa 1600
(re-painted in the 19th century). Musée de Fontainebleau.
Henry IV's project to join the Louvre and Tuileries palaces,
as painted on the walls of the château de Fontainebleau.
Only the Grande Galerie (at left, along the Seine)
was finished before the king died.

Opposite page:
LAFFORGUE, *Restoration of the South Facade*
of the Louvre Under Henry IV.
Print, circa 1680. Paris, Bibliothèque nationale.

Detail
Guess the artwork

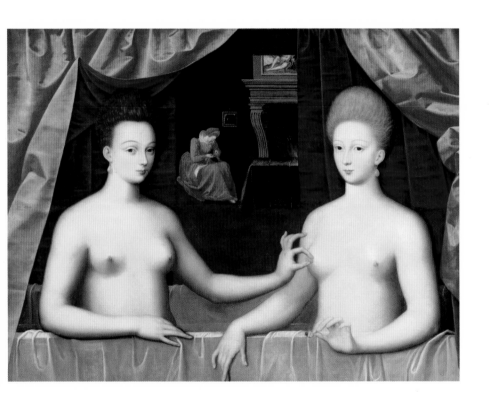

The Louvre at the Time of Louis XII

♛ LOUIS XIII (1601–1643), REIGNS FROM 1610 TO 1643
⚔ JACQUES LEMERCIER
🏛 PHILIPPE DE BUYSTER, GILLES GUÉRIN, JACQUES SARAZIN
⬤ NICOLAS POUSSIN (DECORATION PROJECTS)

Louis XIII, son of Henry IV and Maria de' Medici, was crowned king at Reims in 1614. Maria de' Medici acted as regent for the child, whose father had died when he was just nine years old. In 1617, Louis XIII had Concini, his mother's adviser, assassinated, and then dismissed her. The Cardinal de Richelieu then became his closest and most faithful adviser. In 1624, the king, who had observed "the discomfort of our lodgings in our Château du Louvre," wanted his turn at transforming the palace. He entrusted the work to Jacques Lemercier, one of the best-known architects of the time. From the time of the Regency, only the garden had been laid out along the Seine. When the heavy work resumed, the north wing of the medieval château, the library tower, and Charles V's Grand Vis were razed. In July, the king laid the first stone of the pavilion that was then referred to as the "middle" or "large" pavilion of the Louvre. Lemercier chose to keep the unity of the Louvre's complex of buildings. To the north, beyond the central pavilion, he reproduced the facade designed by Pierre Lescot. He made no changes to the height of the floors or the attic of the central pavilion. So as not to break the rhythm of the arcades that punctuated the facade on the ground floor, he opened three of these arcades into the pavilion. To crown the pavilion, he designed a remarkable pediment that supported four groups of caryatids. On the first triangular pediment, two spread-eagled figures embraced. A second curved pediment unfurled behind them, tangential to a third triangular pediment that spread across the entire width of the pavilion's facade. The whole was crowned by a square dome, flanked by two chimneys. The dimensions Lemercier used for this pavilion would continue to be a model for all the other architects up to the nineteenth century. It was during this century that the central window of the attic was replaced by a clock. The pavilion was named the Pavillon de l'Horloge (Clock Pavilion), then the Pavillon Sully. Although nineteenth-century France was becoming industrialized, it was still an agricultural country. It chose to pay homage to Maximilien de Béthune: baron of Rosny, duke of Sully, and minister of finance to Henri IV, who stated that "plowing and

Opposite page:
ÉDOUARD DENIS BALDUS, The Louvre, The Pavillon de l'Horloge, 19th century. Photograph. Paris, musée d'Orsay.

36

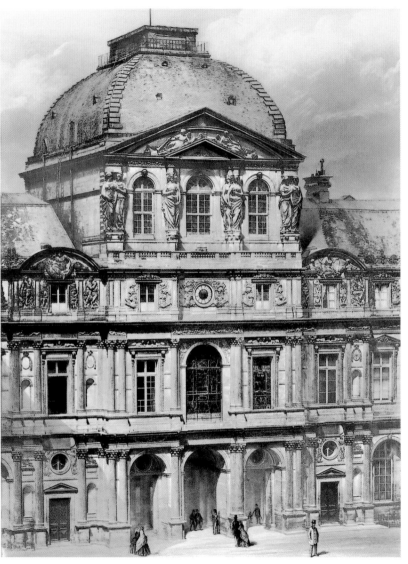

pasturing are the two teats of France." Louis XIII also built, in the words of a contemporary, "the inconsequential palace of Versailles, which a simple country squire would not want to call his own." At the time, no one could imagine the future of this "inconsequential palace" that Louis XIV would make the seat of his absolute power. The Louvre remained the stage for the magnificent ceremonies with which power adorned itself—for example, the sumptuous celebrations on the occasion of the betrothal of the king's sister Henriette-Marie to the king of

The Louvre at the Time of Louis XIII

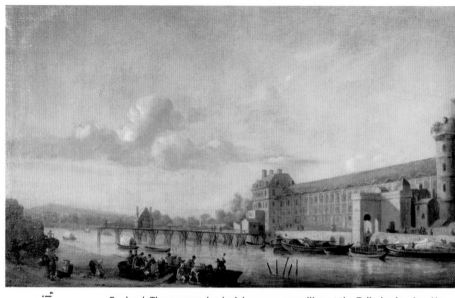

England. There were also lavish ballets. Decoration of the palace was entrusted to artists, some of whom had worked and spent time in Italy. Introduced to the Baroque style while staying in Rome, Jacques Sarazin supervised the sculpted decorations of the palace from 1639 to 1642. Breaking with the style of their predecessors, Philippe de Buyster and Gilles Guérin sculpted dynamic and graceful classical caryatids and figures. During the same period, Sublet des Noyers, superintendent of the buildings, planned to decorate the first floor of this gallery; the project was given to the painter Nicolas Poussin. On his return from Rome, where he had gone seventeen years earlier, Poussin was lodged in a

pavilion at the Tuileries in 1641. He quickly became disenchanted. He wrote to one of his Roman sponsors to tell him of his fear of becoming a "bungler like all the others here." In November 1642, Poussin returned to Rome, leaving the ceiling of the Grande Galerie unfinished. In 1639, Monnaies et Médailles (the commission that struck coins and medals) was installed at the Louvre, one year before the Imprimerie Royale (Royal Printer). Louis XIII was faithful to the choices made by his father, Henry IV, who, from 1608, had allowed a "number of the best workers and most satisfactory masters" to move their workshops into the ground floor of the Grande Galerie. When Théophraste Renaudot

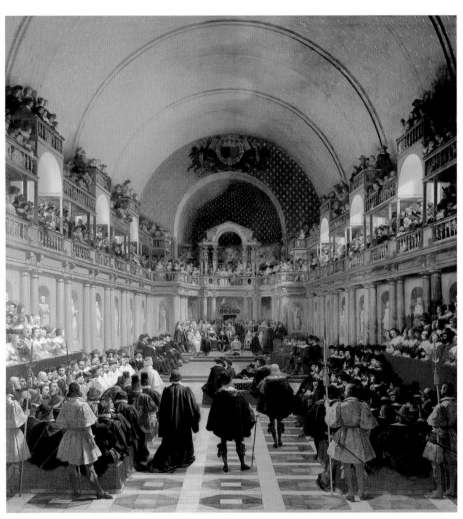

created *La Gazette de France,*
inventing the printing press, the
Cardinal de Richelieu, aware of what
could happen to his power, let him
move into the Louvre—better to have
the printing press near at hand. And
the king himself sometimes practiced
his talents as a writer and had his
articles published anonymously.

JEAN ALAUX (THE ROMAN), *Meeting of the États Généraux Called
by Louis XIII in a Room of the Petit-Bourbon Palace, at
the Louvre, October 27, 1614,* 1841. Oil on canvas, 400 x 370 cm.
Châteaux de Versailles et de Trianon.

Opposite page:
REINER NOOMS (ZEEMAN), *View of the Seine With
the South Facade of the Grande Galerie of the Louvre,* 1650.
Oil on canvas, 26 x 41 cm.

THE LOUVRE NEWS

NEWS IN BRIEF & TIDBITS

1527: Francis I moves "Recognizing that our castle the Louvre is a more commodious and suitable palace in which to lodge ourselves, (…) we have decided to have this castle repaired and set in order."

Le Petit Journal

• **1595: Scandal** On February 12, Madam organized a ballet danced by nine young girls. Several people from the court who had taken up the Protestant cause were shocked. Monsieur de l'Estoile made this comment: "Madam created a magnificent ballet at the Louvre, where nothing had

been forgotten, except, possibly, God, who does not mix in such companies so full of luxury and dissolution."

• **1540: Intrigues au Louvre.** Emperor Charles Quint has just left Paris. During the emperor's stay, many in the entourage of King Francis I encouraged him to take advantage of the moment to

avenge himself on this monarch who had kept him imprisoned for nearly a year in Spain. On his arrival at the Louvre, Charles Quint learned from the king himself that the duchess d'Etampes was among those who wanted the king to avenge himself, and decided to use cunning to make her change

her mind. Taking a valuable ring from his finger just as he was about to sit down at table, he let it drop while he was near the duchess. She hurried to pick it up and give it back to the emperor, who said to her: "No, Madam, I

cannot reclaim it from such beautiful hands; I beg you keep it for love of me."

MYSTÈRES & LITTÉRATURE

P R O P H E T I E S
D E
M. NOSTADAM VS.

• 1559: Nostradamus's Prediction

In 1555, the *Centuries* of Nostradamus made their appearance. In it, we read this quatrain:

The young lion shall overcome the old,
On the field of battle in a single combat,
In a cage of gold he shall pierce his eyes,
Two wounds from one, then shall he die a cruel death.

Four years later, on June 30, 1559, King Henry II was mortally wounded during a tournament organized at the Louvre in honor of the marriage of his sister Marguerite to the duke of Savoy and the marriage of his daughter Elizabeth to King Philip II of Spain. During the king's third confrontation with Gabriel de Montgomery, his opponent's lance penetrated the king's visor. He died from this injury on July 10, 1559, after ten days of atrocious suffering. His last words were:

"May my people persist and remain in the faith."

• 1560: Open Letter From the Poet to the Architect

In the *Second Livre de Poèmes (Second Book of Poems)* recently published by the poet Pierre de Ronsard, is this *Discours à P. L'Escot (Speech to P. L'Escot)*, seigneur de Clagny, architect of the Louvre. It is probably the first time the Louvre is mentioned in a poem. The last verses are reminiscent of words spoken by Henry II and the consequences they had:

❝ I was reminded one day that this Prince at table
Speaking of your virtue as being most admirable
Said that by yourself you had learned,
And won the prize for which you yearned,
As had done Ronsard, who Poetry
Despite all his past had made his fantasy.
And that you had engraved up high
On the Louvre, a Goddess, who would never require
The wind with swollen cheek at the trumpet's hole,
And showed her to the King, saying that she was made
Expressly to represent the force of my verse
That like the wind would bear his name to the Universe. ❞

The Louvre at the Time of Louis XIV

♛ LOUIS XIV (1638–1715), REIGNS FROM 1643 TO 1715
⌂ JACQUES LEMERCIER, LOUIS LE VAU, FRANÇOIS D'ORBAY, CLAUDE PERRAULT
🏛 FRANÇOIS GIRARDON, ÉTIENNE LE HONGRE, MATHIEU LESPAGNANDELLE,
GASPARD AND BALTHAZAR MARSY, THOMAS REGNAUDIN
🎨 EUSTACHE LE SUEUR, CHARLES LE BRUN, GIOVANNI FRANCO ROMANELLI

Louis XIV was the son of Louis XIII and Anne of Austria. He was born at Saint-Germain-en-Laye on September 5, 1638. Following the death of Louis XIII in May of 1643, the queen left the Louvre with her son and moved into the Palais Royal, the former home of Cardinal Richelieu. Mazarin, the uncle of the future Sun King, became the child's tutor and the most influential minister of the Regency. In 1649, threatened by the Fronde—a group of rebellious nobles—the queen and the young Louis had to leave Paris quickly. Thirteen years later, on October 21, 1652, the king returned to Paris and took up residence at the Louvre.

Mazarin, who was also living at the Louvre, soon persuaded the king to undertake several improvements. From 1653 to 1654, Jacques Lemercier directed the work on the south wing of the palace and created the winter quarters for the queen mother. All that remains today of these sumptuous apartments, decorated by Eustache Le Sueur and Charles Le Brun, are a few paintings and some sketches. Lemercier replaced Louis Le Vau in 1654. He designed the Salon of the Dome (today called the Apollo Rotunda) and the Grand Cabinet (the present-day Jewel Room). The wing containing the king's apartments was under construction from 1654 to 1656. Guérin painted the ceilings of the king's apartments. Le Brun and Le Sueur worked on them as well. Le Sueur painted *The Triumph of the French Monarchy,* a work of which only a preparatory design survives today. From 1655 to 1659, Giovan Franco Romanelli, a painter of Roman origins, worked on the ceilings of Anne of Austria's summer apartments. A large cosmogonic fresco using both natural and mythological symbols was unveiled in the Hall of the Seasons. In

PIERRE DELABARRE,
Ewer with a balustraded foot, circa 1630. Hard stone, enamel on gold relief, rubies, sardonyx, 27.50 cm.

Opposite page:
HYACINTHE RIGAUD,
Louis XIV, 1701. Oil on canvas, 277 x 194 cm.

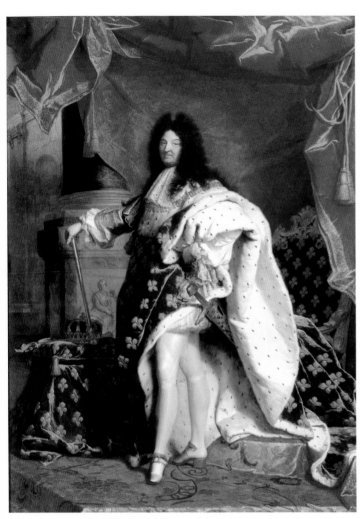

the Salon de la Paix, the decorations depict the abundance of nature. The paintings in the Grand Cabinet enlist Roman history to glorify moral values. A playhouse was built in the Tuileries, as well as a "machine room." An ordinance dated October 31, 1660, announces: "The king, following the advice of his prime minister, Cardinal Mazarin, has resolved to add as many buildings to his Louvre Palace as there are in the Tuileries Palace in order to join them according to the magnificent designs formerly made by his royal predecessors." The works were meant to show the world that Louis XIV, at the age of 22, was the rightful heir to his Bourbon ancestors, from Henry IV who conceived the grand design of tying the Louvre to the Tuileries, to Louis XIII, who had begun the north wing of the Square Court.

The Louvre at the Time of Louis XIV

SÉBASTIEN LECLERC THE ELDER, *Display of the Machines That Were Used to Lift the Two Large Stones to the Top of the Pediment of the Main Entrance of the Louvre,* 17th century. Print. Châteaux de Versailles et de Trianon.

In 1667, in the Salon Carré.

In 1662, for the Festival of the Carrousel, celebrating the birth of the Dauphin, Louis XIV chose a heraldic device: *Nec pluribus impar* (Without equal among men). And the sun became his emblem. One year later, the Small Gallery was reduced to ashes by a fire. The new gallery built by Le Vau and decorated by Le Brun became the Apollo Gallery, named for the god who drives the chariot of the sun. In 1663, the pediment of the Court of the Sphinx was completed. The following year, Le Nôtre began to lay out the Tuileries gardens. The central pavilion was redesigned, and the pavilion of Marsan was erected. Several decorative painters did stuccos according to the king's tastes: the brothers Gaspard and Balthazar Marsy, François Girardon, and Thomas Regnaudin. The workrooms of the Savonnerie made the tapestries. The eastern wing of the Louvre, facing the city and the last side of the Square Court (which was yet to be built), had to reflect the glory of the Sun King. The size of the court had quadrupled. The

architect Le Vau, who had drawn the plans of the grand design, saw the first works interrupted in 1664. Colbert, the superintendent of buildings, conferred in France with Le Vau, Mansart, and Marot, and in Italy with Candiani, Rainaldi, Pierre de Cortone, and Bernini. In 1665, the pope's architect, Bernini, was welcomed to Paris with all the honors. His plan had won, causing resentment and bitterness among prominent French architects. The king himself laid the cornerstone. But once Bernini had returned to Rome, construction came to a halt. Colbert then formed a council made up of Le Vau, d'Orbay, Le Brun, and the brothers Perrault. Claude Perrault's colonnade was erected in 1669, and in 1672 the pediment was put in place. Up until 1671, 500,000 francs had been allocated for construction projects each year, but in 1673 those funds only amounted to 12,000 francs. And year after year, they were further reduced. The construction project of Versailles could not be eclipsed by any other, and so that of the Louvre was abandoned. In 1678 Louis XIV moved to Versailles. According to an ambassador, if he left Paris "it was because he preferred to live where he would be most secure." The Louvre would never again be a royal residence. When Louis XVI was forced to return to Paris during the revolution, he moved into the Tuileries.

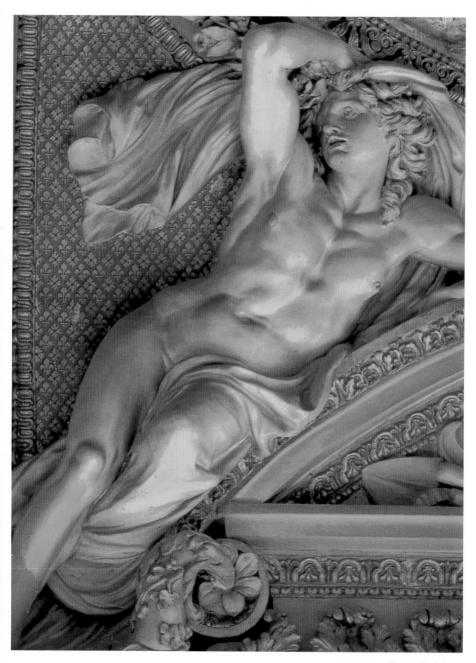

The Apollo Gallery.

Royal Objects
To whom do they belong?

Answer

1. **MARIE LECZINSKA**: Henri-Nicolas Cousinet, *dressing case of Marie Leczinska*, given by the king on the birth of the Dauphin, 1729–1730. Gilded silver, jewels, hard-paste porcelain, 13 x 2.40 cm. - **2. CHARLES IX**: Pierre Redon, *helmet of Charles IX*, circa 1572. Enamel on gold relief. - **3. LOUIS XV**: Augustin Duflos and Claude Rondé, *crown of Louis XV*, Paris, 1722. Golden silver, imitation stones and pearls, 24 x 22 cm. Former Abbey of Saint-Denis. - **4. MARIE ANTOINETTE**: François Rémond and Adam Weisweiler, *desk of Marie Antoinette*, for the sitting room of the château of Saint-Cloud, 1784. Steel, bronze, oak, ebony, lacquer, sycamore, 73.70 x 81.20 x 45.20 cm.

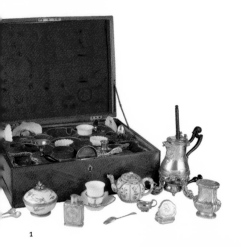

1

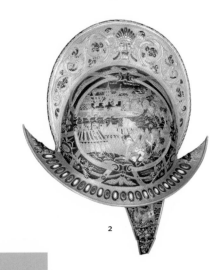

2

CHARLES IX

•

LOUIS XV

•

MARIE ANTOINETTE

•

MARIE LECZINSKA

3

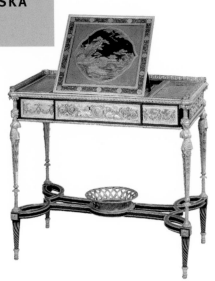

4

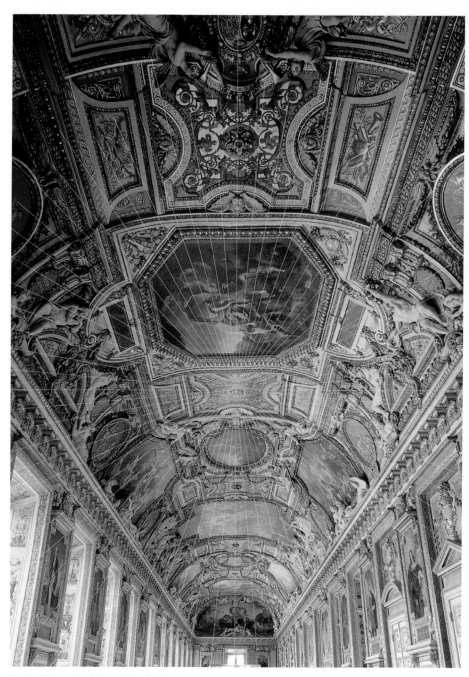

The Apollo Gallery after its restoration in 2004.
Opposite page: **FRENCH SCHOOL,** *The Apollo Gallery circa 1880,* 19th century. Oil on canvas, 46 x 55 cm.

The Apollo Gallery

♛ LOUIS LE VAU (17TH CENTURY), FÉLIX DUBAN (RESTORATIONS, 19TH CENTURY),
Å FRANÇOIS GIRARDON, GASPARD AND BALTHAZAR MARSY, THOMAS REGNAUDIN
● 17TH CENTURY: CHARLES LE BRUN, JACQUES GERVAISE, LÉONARD GONTIER, JEAN-BAPTISTE
MONNOYER; 18TH CENTURY: ANTOINE-FRANÇOIS CALLET, LOUIS-JACQUES DURAMEAU,
JEAN-JACQUES LAGRENÉE, ANTOINE RENOU, HUGUES TARAVAL; 19TH CENTURY:
LOUIS ARBANT, EUGÈNE DELACROIX, JOSEPH GUICHARD, CHARLES-LOUIS MÜLLER

The Gazette reports that on February 23, 1653, "the grand, royal *Ballet of the Night* was performed at the Petit-Bourbon". During the final tableau, Louis XIV, 15 years old, appeared as the sun, surrounded by Honor, Victory, Valor, and Fame. It is to this king, who thought himself to be starlike, that the Apollo Gallery, named after the sun god, is dedicated.

In 1661, following the fire in the Petite Galerie, Le Vau was put in charge of its reconstruction, and Charles Le Brun of its decor. An early version of the Hall of Mirrors at Versailles, it has remained unfinished since the time of Louis XIV. Le Brun did three large paintings. The sculptor Girardon, the brothers Gaspard and Balthazar Marsy, and Thomas Regnaudin did the stuccos.

In fact, work on the Petite Galerie continued up until 1851, when the architect Felix Duban undertook to restore the original splendor of the royal project. He asked the painter Eugene Delacroix to create new pieces, among them the celebrated *Apollo Conquering the Serpent Python,* which has adorned the center ceiling ever since.

The gallery features busts of architects, painters, and sculptors who have left their mark on the history of the Louvre. Representations of the twelve months of the year, the four seasons, and the astrological signs are mixed with allegorical and mythological compositions. Over more than 200 years, dozens of artists have succeeded one another in order to realize the 41 paintings, 118 sculptures, and 28 tapestries that make up this unique decor.

Since 1861, the gallery has housed Louis XIV's collection of hard stone vases. And since 1887, the crown jewels have been displayed there.

In November 2004, the Apollo Gallery was newly opened to the public following three years of restoration.

Where was the 1810 marriage of Napoleon and Marie Louise of Austria celebrated?

?

The Square Salon

♛ LOUIS LE VAU (17TH CENTURY), PIERRE-CHARLES SIMART (19TH CENTURY)

The first bays of the Grand Galerie of the Louvre were damaged by the fire of February 1661 in the Petite Galerie. When they were rebuilt, the architect Louis Le Vau replaced them with a vast rectangular hall. In spite of its shape, the public has never hesitated to call it, without quite knowing why, the Square Salon.

Beginning in 1725, the Royal Academy of Painting and Sculpture displayed the works of its members there. This display came to be called a salon. The term was eventually used, by extension, to designate all sorts of fairs and expositions: salons of water sports, agriculture, the automobile...

As the years passed, the salon became an essential part of the artistic life of Paris. Paintings were hung cheek by jowl, their frames sticking to one another in spectacular profusion. Sculptures were on tables in the middle of the room. The painter Chardin for a time had the delicate task of hanging the paintings, with each artist clamoring for a good place among good neighbors.

The press could not disregard this vast theater to which people flocked. Before long, the reviews of these expositions themselves came to be called salons. During the eighteenth century, Diderot wrote some pretty piquant accounts of his

In the Square Salon, which had been done up for the occasion as a chapel with tapestries decorated with bee motifs.

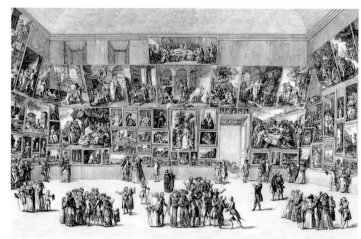

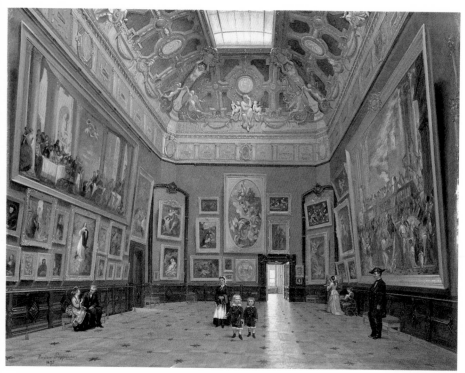

visits. At the end of the nineteenth century, as a salon had not been given in the Square Salon since 1848, art critics became known as "salonniers." Baudelaire was one of the most celebrated among them. Then the artists themselves, tired of being subjected to the whims of the jury, organized their own salons: the Salon of Independent Artists (1884), whose motto was "No jury, no prizes"; the Autumn Salon (1903)... Since the beginning of the eighteenth century, the Royal Academy has printed a list of works to guide visitors through the exhibition in the Square Salon. For the first time, the public could consult a written work about the art

at hand. This pamphlet, titled *Explication of the Paintings, Sculptures and Engravings,* was the first instance of what would become the exposition catalog, the publication of which is one of the principal missions of the Louvre museum.

Today, the Square Salon houses thirteenth-to-fifteenth-century Florentine masterpieces by Giotto, Fra Angelico, Cimabue, Lippi, Ucello, Boticelli...

K. LUCJAN PRZEPIORSKI,
The Salon Carré of the Louvre,
19th century. Oil on canvas, 73 x 92 cm.

Opposite page:
BERNET, *View of the Paintings as They Were Hung at the Salon at the Louvre in 1785.* Engraved from memory, and finished at the time of the exhibtion.

Facades of the Louvre
What do these projects have in common?

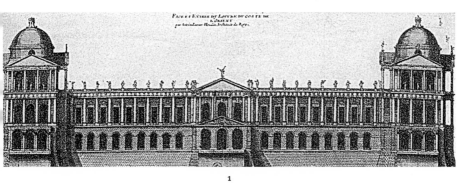

2

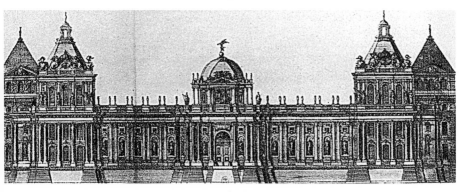

1

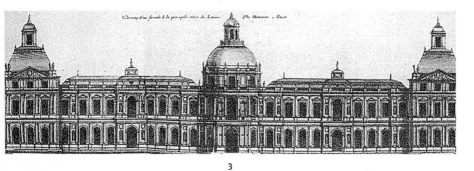

3

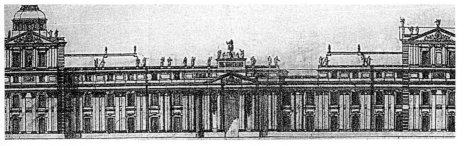

4

Palace of the Academies

Square Salon and surrounding rooms.

The Academy of Painting and Sculpture is organized according to a strict hierarchy: director, chancellor, rector, professors, academics, members. Charles Le Brun, the king's favorite painter, was named director. He outlined an agenda for royal artists, including his theories on art, which accorded history painting the greatest importance. For the longest time, one could not make a career of painting without being a member of this royal institution. In 1793, Jacques Louis David, one of the most illustrious members, in a famous address before the National Convention, had the Royal Academy dissolved and re-created as the French Institute.

Even if the Louvre has not been a royal residence since Louis XIV left it for Versailles, it has never been empty. Far from it. In 1672, Charles Perrault, a member of the French Academy, obtained permission from Colbert for that body to hold its meetings at the Louvre. In 1685, the Academy of Arts and Letters moved into the ground floor of the Lemercier wing, and since 1699 the Academy of Sciences has met in the king's apartments.

In 1692, the Academy of Architecture took its place in the apartments of Maria Theresa, and in the same year the Royal Academy of Painting and Sculpture took the

But academies and artists are not the only ones who occupy places at the Louvre. The first newspaper, the *Gazette de France,* has its offices and press there. Chalcography (copper engraving), libraries, workrooms, the navy and engineering departments, and the Office of the King's Pictures are all located there. The military studies strategy in the great hall from

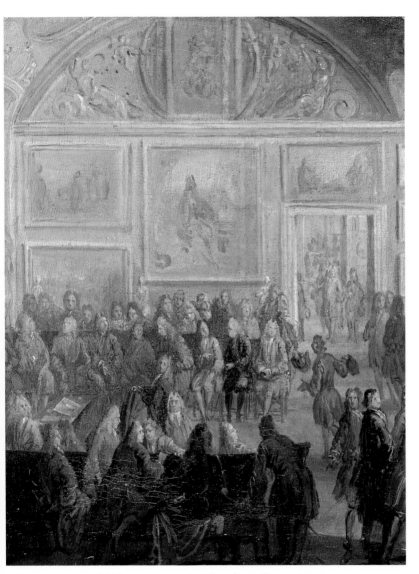

relief and street maps of French cities.

But so many diverse activities cannot help but cause serious incidents. In 1720, a fire that broke out in the workroom of the cabinetmaker Boulle caused the destruction of several works of art.

Napoleon himself, not mincing words with the occupants of the palace, ordered dryly: "Get them out of the Louvre! They'll eventually burn up all my conquests."

When was the first museum in the Louvre opened?

Why Not Have a Museum at the Louvre?

After having spent time in Paris during the Regency, Louis XV once again settled into Versailles and his other royal residences: Marly, Fontainebleau, Compiègne. At this time, improvements were being undertaken only at the garden of the Tuileries. The statues from the gardens at Versailles and Marly were moved there. The Louvre was occupied by courtesans, artists, and sometimes the artists' widows. It was also home to the archives for foreign affairs, the Conseil du Roi (King's Council), and the Conseil des Finances (Finance Council).

In 1747, a certain La Font de Saint-Yenne, unknown until then, published in La Haye *Reflections on Some Causes of the Present State of Painting in France.* He noted the decline of painting and proposed a solution to remedy the situation. He thought of the Louvre: "The means that I propose for the quickest benefit, and at the same time the most effective for a durable restoration of painting, would be to choose in this palace, or somewhere in the surrounding area, a suitable place to house the priceless masterpieces of Europe's grand masters, which make up

His Majesty's collections of paintings."

Three years later, eighty or so of the king's pictures were made accessible to the public at the palace of Luxembourg, and not at the Louvre.

Louis XV had another project for this palace. At the bottom of a memorandum that had been sent to him, he wrote in his own hand in 1768: "My intention is to have my library at the Louvre." This same year, a Reboul stated, in the *Essay on the Mores of the Times,* that the Galerie d'Apollon would be restored and that "the king's valuable collection of paintings would then be placed in this immense gallery at the Louvre, where the public would enjoy all its richness." But by the end of Louis XV's reign, nothing had been done.

In 1778, d'Angivillier, the director of buildings, put together a committee to make a detailed and definitive examination regarding the establishment of a gallery at the Louvre. The architect Soufflot was one of the committee's members. He imagined light coming from the vault and dreamed, "What pleasure it will be to have a gallery that measures

August 10, 1793.

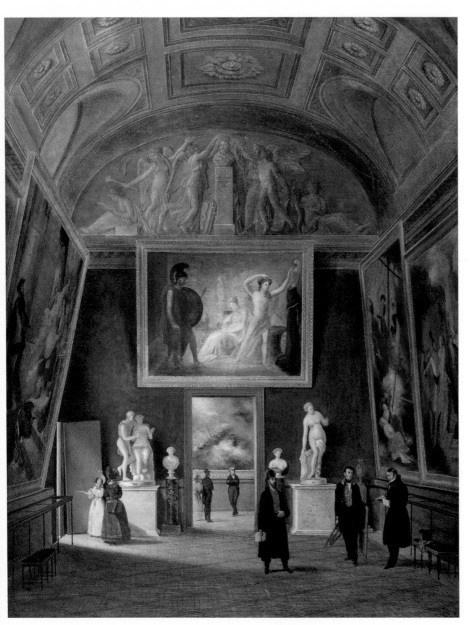

120 *toises* (6.5 feet), adorned with precious paintings that can be viewed and enjoyed without outside distractions." On his death in 1780, with the exception of one staircase, no work had been undertaken. The people of Paris were angry: "In this country, nothing is completed, no plan is ever followed. We will never have a national gallery."

Hubert Robert
The Grande Galerie
Find the imaginary view

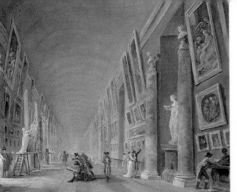

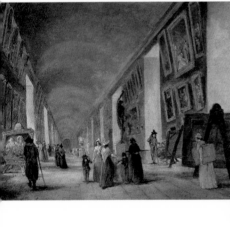

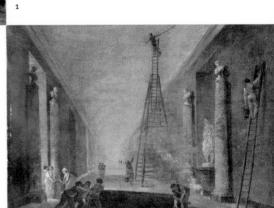

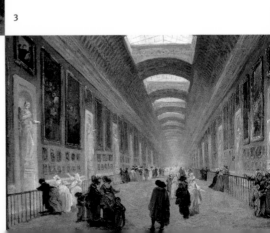

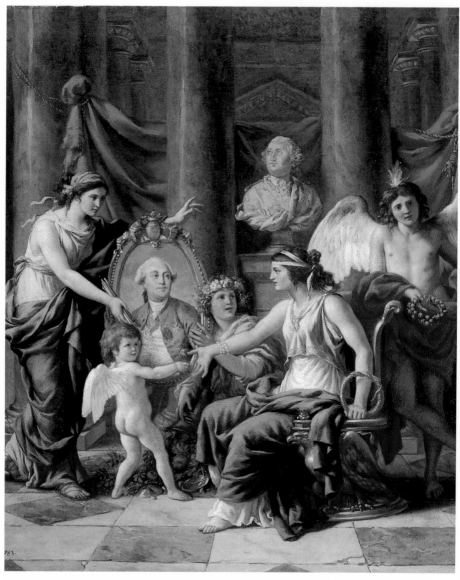

JEAN-JACQUES LAGRENÉE THE YOUNGER, *Allegory Relating to the Establishment of the museum in the Grande Galerie of the Louvre* (detail), 1783. Oil on canvas, 52 x 68 cm.

Opposite page:
Plan of a Section of the City of Paris, Renovation Project for the Louvre, the Tuileries and Surroundings by the architect Charles Mangin, 1794. Copper engraving. Paris, Bibliothèque nationale.

The Louvre at the Time of the Convention

Two years after the revolution of 1789, on May 26, 1791, the Constituent Assembly voted a decree for "the Louvre and the Tuileries together" to become a "national palace for the king's dwelling and the collection of all the monuments to the sciences and the arts." And on October 17, 1792, Roland, minister for the interior, wrote to the painter Jacques-Louis David: "The museum must be the development of the nation's great riches in drawings, paintings, sculptures, and other monuments of art. Thus, as I conceive it, it will attract foreign visitors and draw their attention. It should nurture a taste for fine arts, entertain lovers of the arts, and serve as a school for artists. It should be open to everyone. It will be a national monument. There will be no one who does not have the right to enjoy it. It will have such an elevating influence on minds, it will so lift spirits, it will so warm the heart, that it will be one of the most powerful ways to bring fame to the French Republic." On the strength of this decision, the Convention voted for the museum to officially open officially on August 10, 1793. The painter David (1748–1825) was appointed president.

When the museum opened its doors to the public, it had slightly more than 500 paintings. Its first catalog was published on November 18, 1793.

The Louvre at the Time of Napoleon I

♕ NAPOLEON I (1769–1821), CROWNED EMPEROR IN 1804 (FROM 1804 TO 1815)
Å CHARLES PERCIER, PIERRE-FRANÇOIS-LÉONARD FONTAINE

Below:
ADRIEN DAUZATS,
Parade Day during the Empire,
19th century. Oil on canvas, 101 x 161 cm.

In 1801, the architects Charles Percier and Pierre-François-Léonard Fontaine were made responsible for the Louvre. Nicknamed the Dioscuri, because they were as inseparable as Castor and Polux, they fulfilled this responsibility until 1814.

In 1803, the museum was renamed the "Musée Napoléon" after the First Consul Napoleon Bonaparte. The museum was in his debt for all the works he brought back from his military campaigns. Napoleon was to make this institution, which henceforth carried his name, the theater of his glory.

As early as 1805, the emperor made his plans known: "The architects would like to adopt a single order and

change everything. Economy, common sense, and good taste have a different idea. Each of the existing parts should keep its century's flavor and adopt the most economical style for new works." Percier and Fontaine scrupulously kept to restorations and work that did not require any great demolition. They thus kept "works that friends of the arts would have been disappointed to see destroyed," and together, started to raise a wing whose height would be the same as that of the Grande Galerie that faced it, starting from the Marsan Pavilion to the north of the Tuileries. The emperor was faithful to the "grand design" of the kings, but he also wanted to make his own contribution to the palace,

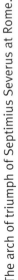

The arch of triumph of Septimius Severus at Rome.

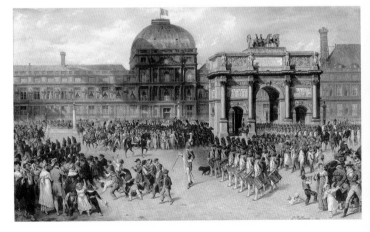

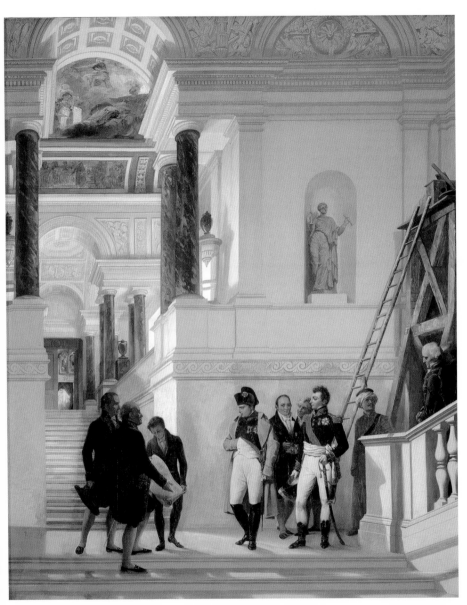

with its rich history of the great men of France.

Napoleon tried to join the palace of the Tuileries to that of the Louvre, but he did not approve any of the forty plans submitted to him, hesitating to divide up a space "the main advantage of which was its grandeur." Thus it would be the Arc de Triomphe du Carrousel, started in 1806 and completed in 1808, that would highlight his own grandeur.

AUGUSTE COUDER,
Napoleon I Visiting the Louvre Museum Escorted by the Architects Percier and Fontaine, circa 1833.
Oil on canvas,
177.50 x 135 cm.

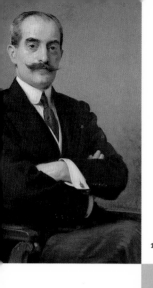

1

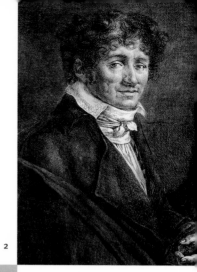

2

NIEUWERKERKE

•

KAEMPFEN

•

PUJALET

•

DENON

3

4

Dominique-Vivant Denon, the First Director

- DOMINIQUE-VIVANT DENON (1747–1825)
- JEAN-ARNAUD RAYMOND

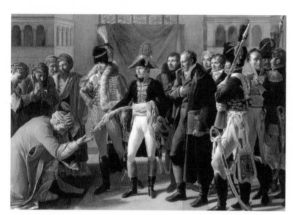

FRANÇOIS-HENRI MULARD, *General Bonaparte Presents a Saber to the Military Chief Mohammed El Koraïm, Governor of Alexandria, July 3-6, 1798*, 1808. Oil on canvas, 221 x 290 cm. Château de Versailles and de Trianon.

Right:
BENJAMIN ZIX, *Imaginary View of the Workroom of Dominique-Vivant Denon*, circa 1809–1811. Bistre wash, pen, 49.60 x 40.90 cm.

Opposite page:
ROBERT LEFÈVRE, *Baron Dominique-Vivant Denon*, 1808. Oil on canvas, 92 x 78 cm. Châteaux de Versailles and de Trianon.

When the revolution broke out in 1789, the Baron Denon was 42 years old and had already lived several lives. He first learned to draw from the painter François Boucher (1703–1770); he had been an ordinary gentleman in Louis XV's court; he wrote a play for the Comédie Française; he went to Russia and Switzerland on behalf of the Department of Foreign Affairs and took advantage of this trip to meet Voltaire in Ferney and paint his portrait; he published *No Tomorrow* (1777), a libertine story that made a scandal; he was secretary to the ambassador to Naples where he collected Etruscan vases (which he later sold to Louis XVI); he became a member of the Académie Royale de Peinture et de Sculpture (Royal Academy of Painting and Sculpture) as an engraver; and he lived in Venice, from where he was expelled in 1793, when the Venetian Republic took him for a spy of the Convention. Despite this intensity, his life seemed to start only after his meeting with Napoleon.

In 1798, Denon accompanied Bonaparte to Egypt. On his return, Denon published *Travel in Lower and Upper Egypt,* which was a huge success.

On November 19, 1802, he was named director of the Louvre, then called the Musée Central des Arts; he renamed it the Musée Napoléon. To enrich the collections, Denon decided

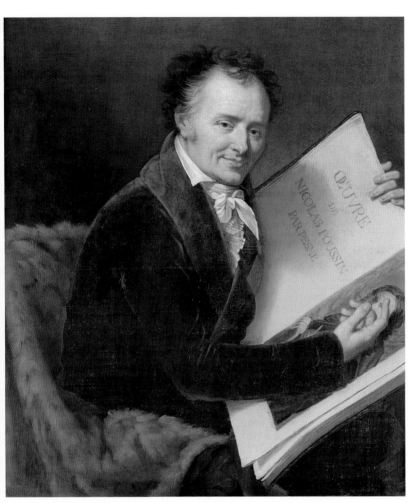

to travel across Europe starting in 1805; Germany, Spain, Austria, Italy— everywhere he went, he visited galleries and libraries. He made long lists of what should be sent to Paris. These absences did not prevent him from choosing works to be sent to the provincial museums, overseeing the progress of the restoration of the Louvre, and keeping an eye on the layout of the new rooms for the collections. When Napoleon had to abdicate for the second time on June 22, 1815, the Baron Denon could be certain of having made the Louvre "the most beautiful institution in the universe." After having returned the Allies' works of art to them, all he had left to do was resign, but not before recommending his staff to King Louis XVIII.

From then on, he devoted himself exclusively to his own fabulous, eclectic collection.

What did Louis XIV do in 1674?

The Louvre at the Time of the French Restoration

♛ LOUIS XVIII (1725–1824), BECOMES KING OF FRANCE IN 1795, REIGNS FROM 1814 TO 1824

On December 20, 1797, a banquet in honor of General Bonaparte was organized in the Grande Galerie of the Louvre. It was decorated with greenery for the occasion, and flags taken from the enemy were displayed on the cornice. After numerous works of art had been brought from Belgium by the Republic, it was the turn of the Italian masterpieces (after the Treaty of Tolentino) to make their entrance into the Louvre during a fabulous procession that traversed Paris from the Jardin des Plantes to the Champ de Mars to finally turn back toward the Louvre. In front of the *Apollo Belvedere,* the *Horses of Saint Mark,* or the *Laocoon* parading by, Parisians could read: "Greece gave them up; Rome lost them. Their fate has twice been changed; it will not change again." A few years later, still more artworks arrived from Germany and Austria. Once in the Louvre, by the emperor's will, they would never leave. How could anyone doubt that the only place suitable for them was the Louvre, the museum collecting all the masterpieces of Europe?

"Monuments to the glory of the French armies survive, and the masterpieces belong to us henceforth by rights more stable than those of victory." These words of Louis XVIII "legitimizing" the plunder from his empire's conquests, allowed the France of 1814 to keep the works of art and the paintings. However, the defeat at Waterloo resulted in a European coalition that was no longer disposed to respect any treaty signed under duress from Napoleon. The plundered nations wanted to recover what had been taken from them. And so the masterpieces left again. Vivant Denon, museum director, was threatened with ending his days in the fortress of Prussia if he insisted on wanting to keep them, and had to resign.

The *Horses of Saint Mark* had to leave the Arc de Triomphe du Carrousel and return to Venice. A sculpture was commissioned from the Baron François Joseph Bosio to replace them. It was entitled *The Restoration.*

! He left the Louvre and moved into the château of Versailles.

68

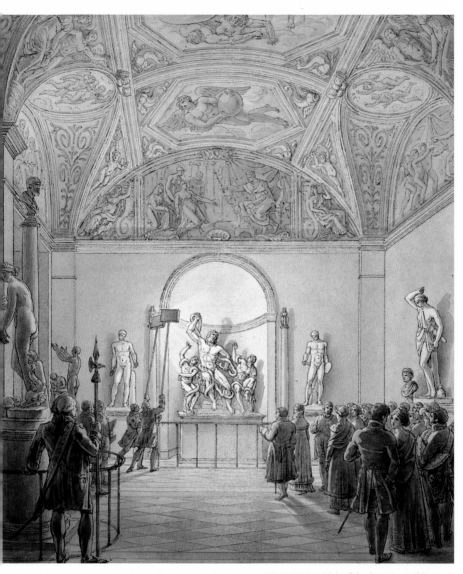

BENJAMIN ZIX, *Visit of the Emperor and Empress to the Laocoon room of the Louvre,* circa 1804–1814. Brown and gray ink, brown wash, pen, 26 x 29 cm.

The Mona Lisa

LEONARDO DA VINCI, *Portrait of Mona Lisa*,
called *La Giocanda*,
circa 1503–1506. Oil on poplar wood, 77 x 53 cm.

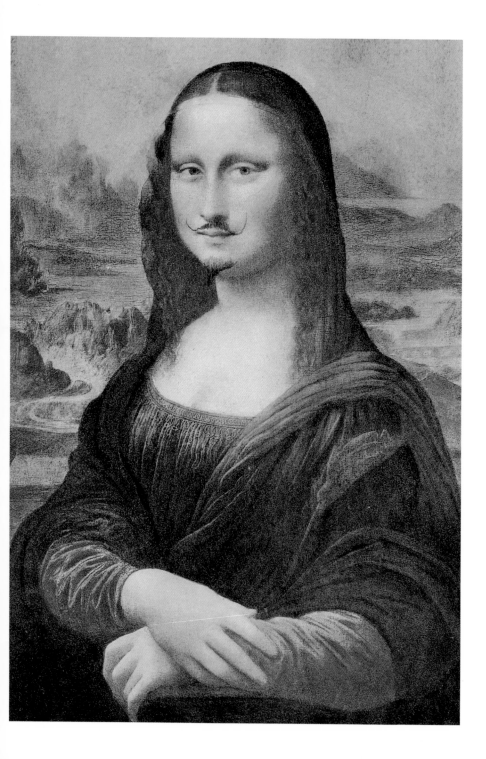

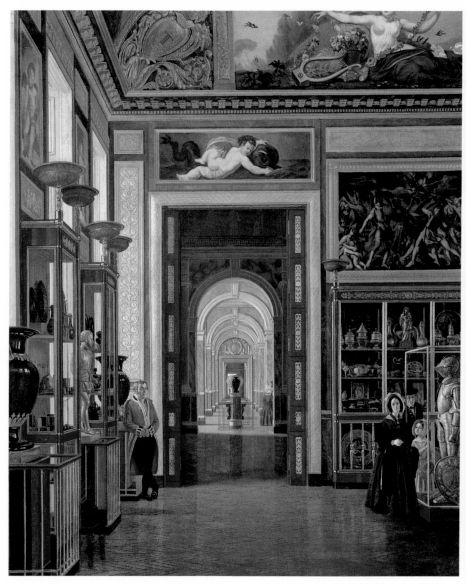

JOSEPH AUGUSTE, *La Salle des bijoux (Jewel Room) at the Louvre and the Enfilade of the Charles X rooms,* circa 1835. Oil on canvas, 100 x 81 cm.

Opposite page:
GUILLAUME LARRUE, *Next to the Great Sphinx,* 1885. Oil on canvas, 69 x 88 cm.

The Charles X Museum

♛ CHARLES X (1757–1836), REIGNS FROM 1824 TO 1830

The imperial bees had been hammered flat, and the royal lilies had taken their place. Even though the Allies' experts had spurned the Italian primitives, and they had given up on taking back the overly large *Wedding at Cana,* by Veronese, this did not prevent the Louvre from looking empty. But somehow, year after year, the transfer to the Louvre of the Rubens paintings dedicated to Maria de' Medici of Luxemburg, the closing of the Petits-Augustins museum, the purchase of several collections, the gift made by Louis XVIII in 1821 of the Venus discovered at Milo a year earlier, which had been presented to him by the Marquis de Rivière, ambassador to Constantinople, saved the museum from losing face. And Fontaine continued the work planned with Percier. Large staircases were completed here and there throughout the Colonnade; decorations of marble, gold, and bronze were undertaken. On the other hand, Fontaine confined himself to a lack of ornamentation on the ground-floor installation of a gallery for sculpture, inaugurated on July 8, 1824. In honor of the crown prince, it was called the Galerie d'Angoulême. On December 15, 1827, the Charles X museum was opened on

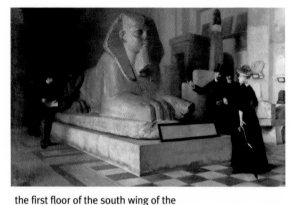

the first floor of the south wing of the Square Court; it included nine rooms decorated with new ceilings that had been entrusted to the best-known artists. In the first of them was the *Apotheosis of Homer,* by Ingres. These rooms were reserved for Egyptian antiquities. Jean-François Champollion, who deciphered the hieroglyphs in 1812, was the curator. Along with his work in history, linguistics, and philology, he had also made a study of several Middle Eastern languages and scripts: Arabic, Hebrew, Coptic, Aramaic, Sanskrit, Persian, Ethiopian, and others. Among the pieces purchased in 1826 from Salt, England's consul general in Egypt, the large pink sandstone *Sphinx* from Tunis, a major work, gave its name to the courtyard where it was set, the Sphinx courtyard.

What painter did the ceiling of the vestibule Henry II in 1953?

73

The Louvre at the Time of the Second Republic

• SECOND REPUBLIC: 1848–1852
FÉLIX-LOUIS-JACQUES DUBAN

This statement made in the Chambre des Députés in February 1840, "The completion of the Louvre is a popular idea," did not seem to concern Louis-Philip. Because for him, the only museum that counted was the one he was creating at Versailles, which he was devoting to "all the glories of France." It would therefore fall to the Republic created after the 1848 revolution to "accomplish what the monarchy could not do." Its provisional government also decreed the completion of the palace of the Louvre and specified in Article 4 of the same decree that "the entire nation of workers is called on for the work to complete the Louvre." The Second Republic gave Félix Duban the job of restoring the Galerie d'Apollon, which had long been in a pitiful state. Between December 1848 and June 1851, Duban not only consolidated the entire building but also restored and perfected its decoration. He restored Le Vau's pediment on the Seine side, but he could only replace the military trophies with an allegory of what was called the Second Republic. At

the time, no one imagined that there would be a third. Duban was scrupulous in his restoration work, without taking the liberties of his contemporary Viollet-le-Duc, who tended to reinvent. This is true even if Duban called on Delacroix to finish the ceiling, whose center had remained empty. On June 5, 1851, the prince-president Louis-Napoleon Bonaparte inaugurated the new rooms. A few months later, there was a coup d'état. And it was Napoleon III who finally decreed, on March 12, 1852, the completion of the Louvre.

Georges Braque, who painted *The Birds*.

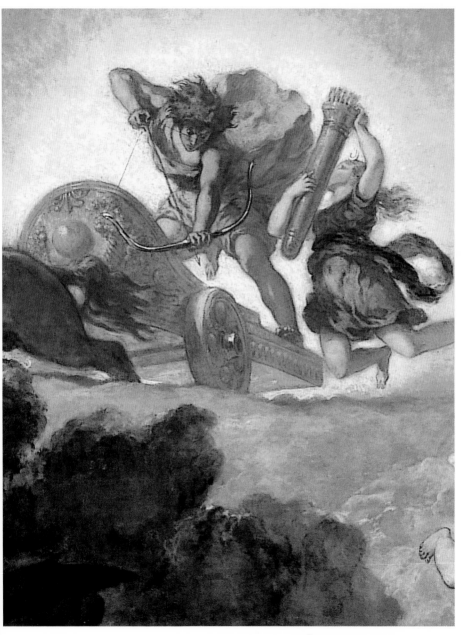

EUGÈNE DELACROIX, *Apollo Slays Python,*
central painting on the ceiling of the Apollo Gallery (detail),
commissioned in 1850, painted between 1850 and 1851, 800 x 750 cm.

Kings and Queens
Match them...

Answer

1. **MARIE LECZINSKA** (Louis Tocque, oil on canvas, 18th century) **AND LOUIS XV** (Maurice Quentin de La Tour, pastel, 18th century). - 2. **ELISABETH OF AUSTRIA** (François Clouet, oil on wood, second half of the 16th century) **AND CHARLES IX** (François Clouet, oil on wood, 16th century). - 3. **CATHERINE DE' MEDICI** (French School, oil on wood, second half of the 16th century) **AND HENRY II** (François Clouet, oil on wood, 16th century). - 4. **MARIE DE' MEDICI** (Frans Pourbus the Younger, oil on canvas, circa 1609–1610) **AND HENRI IV** (Frans Pourbus the Younger, oil on wood, circa 1610). - 5. **ANNE OF AUSTRIA** (Peter Paul Rubens, oil on wood, 17th century) **AND LOUIS XIII** (Simon Vouet, oil on canvas, 17th century). - 6. **MARIA THERESA OF AUSTRIA** (Jean Nocret, oil on canvas, 17th century) **AND LOUIS XIV** (Hyacinthe Rigaud, oil on canvas, 1701). - 7. **CLAUDE OF FRANCE** (French School, drawing, 16th century) **AND FRANCIS I** (Jean Clouet, oil on wood, 16th century). - 8. **THE EMPRESS JOSÉPHINE** (Daniel Saint, miniature on ivory, 1805–1810) **AND NAPOLEON I** (Peter Mayr, miniature, 19th century). - 9. **THE EMPRESS EUGÉNIE AND NAPOLEON III** (both : Philippe Prochet, miniatures on an articulated bracelet, Second Empire (1852–1870). - 10. **MARIE-JOSÉPHE OF SAVOY** (Joseph Boze, pastel, circa 1786) and **LOUIS XVIII** (French school, miniature on ivory, 19th century).

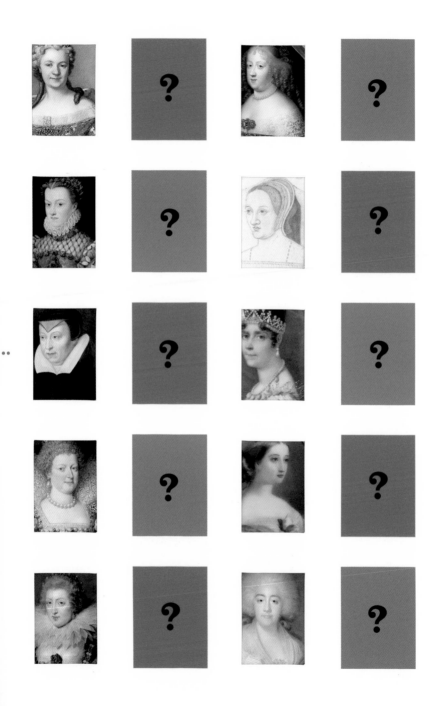

The Louvre at the Time of Napoleon III

NAPOLEON III (1808–1873), EMPEROR FROM 1852 TO 1870

The first stone of the buildings in the Cour Napoléon was laid on July 25, 1852. The "new" Louvre was inaugurated on August 14, 1857. On Visconti's death in 1853, the architect Lefuel was put in charge of finishing the work.

Starting in 1859, the Salle des États welcomed members of the Assembly and special sessions. Two years later, the Pavillon de Flore, then in very bad condition, was demolished. At the same time, decoration work was being carried out in the Salle du Manège (the old stables), located under the Salle des États. In 1863, the museum took the name of Napoleon III. That same year, *The Victory at Samothrace* arrived at the Louvre as well as the Campana collection that Napoleon III had acquired. The product of archeological excavations and purchases, the Marquis of Campana's collection included Greek and Etruscan vases as well as four hundred antique marbles and numerous paintings.

In 1866, excavations carried out in the Cour Carrée uncovered the ruins of the medieval castle. In 1869, the museum received the famous La Caze bequest, including numerous masterpieces of French painting

CHARLES-SÉBASTIEN GIRAUD, *Musée Napoléon III, Terracotta Room of the Louvre,* Salon of 1866. Oil on canvas, 97 x 130 cm.

Opposite page: The grand salon in Napoleon III's apartments at the Louvre.

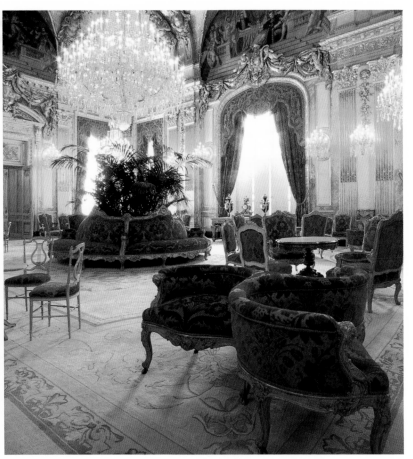

from the eighteenth century. The new buildings were not to be part of the museum, however. Most were destined for receptions or administration functions. The Louvre was at the center of Paris and it was large. Everyone took advantage of this fact. One by one, the Louvre became home to the Ministry of the Interior, the Telegraph Office, a library, apartments to accommodate foreign heads of state, and on the first floor of the north wing of the Cour Carrée a seventeen room

apartment for the handsome Emilien, Count of Nieuwerkerke—called the beau batave (handsome Batavian)—lover of the princess Mathilda and director of the Imperial Museums. The Louvre Museum had to make do with its small share of the space. A contemporary made this disillusioned remark: "It is perfectly useless to lodge curators; it is even unnecessary to give them a decent office; an attic would be sufficient."

Which king made a royal palace out of the Louvre?

79

Ludovico Visconti

• LOUIS-TULLIUS-JOACHIM VISCONTI (1791–1853)

Napoleon III did not approve of "the meanderings, twistings, and jagged lines" of which the architect Duban was guilty in his eyes. He preferred the work of Ludovico Visconti. It was Visconti who, in 1841, had won the competition for the tomb of Napoleon I at Les Invalides, with an open crypt under the dome. When the emperor gave him the task of completing the Louvre, Visconti chose to be humble: "The character of the new architecture will be religiously borrowed from the old Louvre. All the details have already been molded, and the architecture will renounce all pride to keep the character that its predecessors have imprinted on this monument."

Joining (finally) the Louvre and the Tuileries meant solving two basic problems. The first had to do with the fact that the Louvre and the Tuileries did not run parallel to each other. The second was due to the difference in level between the part on the Seine side and the part that extended along the rue de Rivoli to the north. Built during the reign of Napoleon I, this street ran from the Place de la Concorde (named by King Louis-Philip) to the Pavillon de Marsan through the Tuileries. Visconti built several new buildings whose purpose was to create architectural symmetry. Of course, the work caused a controversy. Some were sorry that Visconti had

Charles V. Work on the conversion began in 1364.

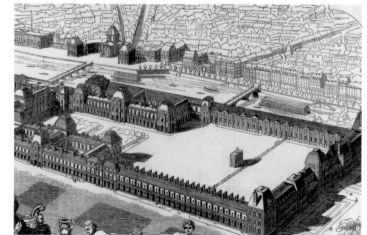

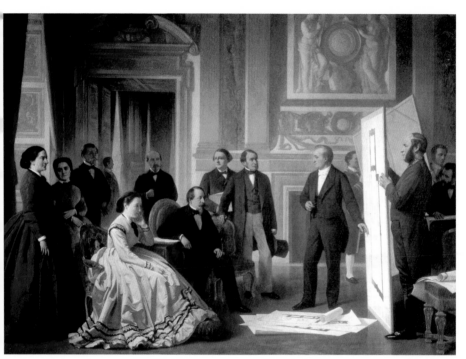

not thought of an immense square, a monumental entrance similar to that of the Propylaea of the Acropolis. Others mocked the mediocrity of the project that showed no daring because it was too respectful of the past. Visconti died suddenly in December 1853, leaving behind detailed plans and 196 drawings that made it possible for his project to be completed.

ANGE TISSIER,
Visconti Gives the Building Plans of the Louvre to Napoleon III and Eugénie, 1853, 1865. Oil on canvas, 178 x 231 cm. Châteaux de Versailles and de Trianon.

Opposite page:
The Louvre and the Tuileries Are Joined by Visconti, 19th century. Print.

1. JACQUES LEMERCIER (circa 1585–1654), *Cour carrée.* - 2. CHARLES PERCIER (1764–1838) AND PIERRE FONTAINE (1762-1853), *Duchâtel room, called "Percier et Fontaine" room.* - 3. CLAUDE PERRAULT (1613–1688), *Colonnade of the Louvre.* - 4. FÉLIX DUBAN (1797–1870),*Gallery at the water's edge, east side (restoration).*

Answer

Who did what?

Architecture

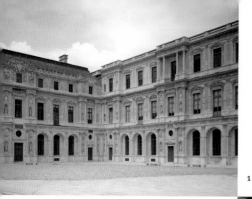

1

CLAUDE PERRAULT

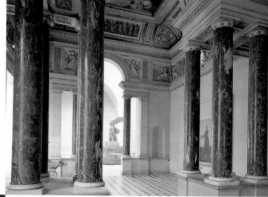

2

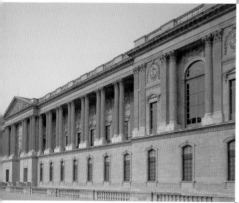

3

JACQUES LEMERCIER

PERCIER AND FONTAINE

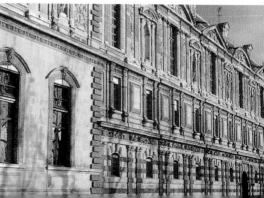

4

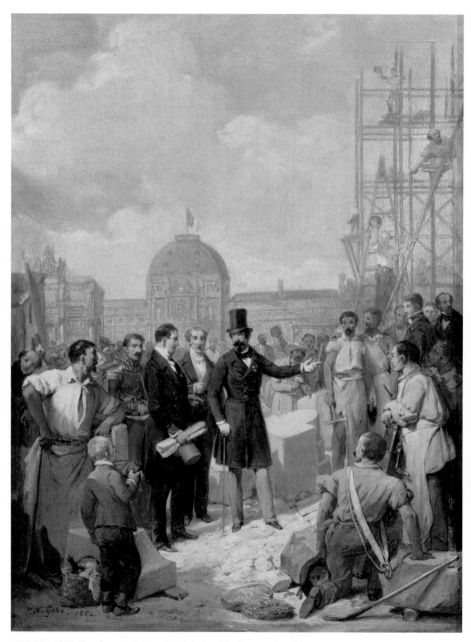

NICOLAS GOSSE, *Napoleon III Visiting the Worksite of the Louvre*, 1854. Oil on canvas, 34 x 23 cm.

Opposite page:
ÉDOUARD DENIS BALDUS, *Destruction of the Western Part of the Grande Galerie of the Louvre, from the Pavillon Lesdiguières to the Pavillon de Flore*, 1855–1856. Proof on albumin paper, 45 x 39 cm. Paris, musée d'Orsay.

Hector-Martin Lefuel

• HECTOR-MARTIN LEFUEL (1810–1880)

Napoleon III appointed the architect Hector-Martin Lefuel to succeed Visconti. Visconti may have chosen a course of humility and loyalty, but this was not true of Lefuel.

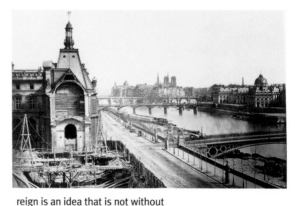

He topped the Pavillon de l'Horloge with a dome and placed a portico in front of the facades of the wings built by Visconti. Did the empress feel that great men should be honored? Lefuel had effigies of eighty-four of them sculpted and lined up along the balustrades. Did the emperor feel it necessary to raise the buildings? Lefuel added a floor. He obeyed and satisfied the wishes of both the emperor and the empress.

On the other hand, in 1861, when a commission suggested rebuilding exact reproductions of the Pavillon de Flore and the waterside Grande Galerie, which were in very bad condition, Lefuel rebelled and put an end to the idea: "It is impossible to think about restoring the defective constructions in all respects." The proposed solution was a subtle compromise. It was both a sign of loyalty to Visconti and a homage to the judgment of the emperor who had approved him: "Erecting buildings that bear no relation to the old styles and have more in common with the current reign is an idea that is not without charm, but perhaps gives rise to the fear that the construction will clash too much with the rest, and would it not be more prudent to freely adopt the style of the magnificent gallery that is one of the marvels of French art?" This question was answered with the gates to the Louvre (between the Pavillon Lesdiguières and that of La Tremoille) facing the Pont du Carrousel. An inscription was engraved at the base of an equestrian sculpture of Napoleon III:

NAPOLEON III, EMPEROR, REBUILT BETWEEN 1861 AND 1868 THE WING OF THE TUILERIES PALACE THAT WAS BUILT BETWEEN 1607 AND 1663 BY HENRY IV, LOUIS XIII, AND LOUIS XIV.

The statue of the emperor, unseated by the Third Republic, was replaced by the *Génie des Arts*.

What is the origin of the name "Cour carrée"?

Gifts

- CHARLES SAUVAGEOT, LOUIS LA CAZE, AIMÉ-CHARLES-HORACE HIS DE LA SALLE, ADOLPHE THIER ERNEST GRANDIDIER, ADOLPHE DE ROTHSCHILD, ALFRED CHAUCHARD, BARON BASILE SCHLITING MARCHIONESS ARCONI-VISCONTI, ISAAC DE CAMONDO, ÉTIENNE MOREAU-NÉLATON...

JEAN-ANTOINE WATTEAU, *Pierrot, also called Gilles,* circa 1718–1719. Oil on canvas, 185 x 150 cm.

The cour is a perfect square measuring 400 feet on each side.

France. There were 582 paintings in this collection, from which he had chosen 272 works for the Louvre, including ten by Fragonard, thirteen by Chardin, and eight by Watteau. The quintessence of eighteenth-century French painting, these painters were not then represented at the Louvre, which had only one painting by Watteau—a paradox for a museum created in the eighteenth century! La Caze used to enjoy telling how he had "found" a Chardin for an ecu (a small sum), and how he only paid 600 francs for the *Gilles* by Watteau.

In 1894, it was the turn of Ernest Grandidier, an Oriental art enthusiast, to transfer his collection of several thousand pieces. On his death, an additional 8,000 works of art entered the museum's collections.

Under the Third Republic, several rooms named after donors made their appearance. De La Salle's collections of drawings are on display in several rooms; objets d'art from Adolphe Thiers are in the Salle Marengo, as well as those of Adolphe de Rothschild, Alfred Chauchard, and the marchioness Arconi-Visconti.

Since the creation of the Louvre museum, nearly 3,000 donors have enriched its collections through their donations and their legacies. Some particularly fine and generous gifts have marked the museum's history.

In 1856, Charles Sauvageot, a violinist with the Opéra de Paris, gave his personal collection of Objets d'Art to the Louvre. These included several glasses created between the seventeenth and eighteenth centuries in Europe. Sauvageot became the curator of his own "little museum" in the Louvre.

On his death in 1869, the philanthropist Louis La Caze left his collection to the museums of

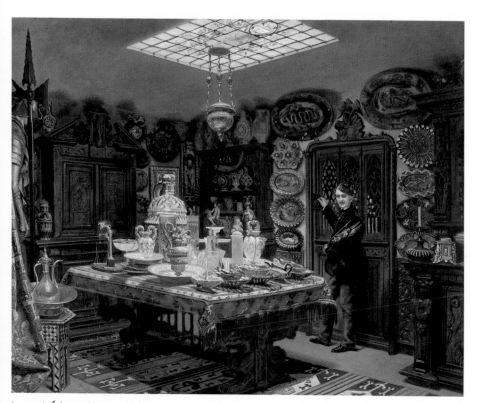

In 1906, Étienne Moreau-Nelaton presented a very important collection of nineteenth-century paintings that, because of a lack of space, were first displayed in the Musée des Arts Décoratifs (Museum of Decorative Arts). In 1914, the Camondo legacy allowed Impressionists and painters such as Manet and Degas to enter the Louvre for the first time. Although the Louvre appreciates the generosity of these donors, it must be selective. Therefore, it is up to the curators to accept or refuse the works offered. Aware of the importance of gifts to the national artistic heritage, the government has tried to encourage them by voting in several tax laws that entitle companies and individuals who make these gifts to benefit from various tax deductions.

ARTHUR HENRI ROBERTS, *Inside the Cabinet of Mr. Sauvageot,* 1856. Oil on canvas, 48 x 59 cm. Charles Sauvageot is shown in the dining room of his apartment at 56, rue du Faubourg-Poissonnière in Paris, just before the transfer of his gift to the Louvre.

The Tuileries
in time
Find the chronological
order

Answer

4. 1661: After a drawing by Henri de Gissey, *Carousel given by Louis XIV, in the courtyard of the Tuileries Palace, July 5, 1661*, 1670. Oil on canvas, 285 x 365 cm. Châteaux de Versailles et de Trianon. - 3. 1810: Joseph-Louis-Hippolyte Bellangé and Adrien Dauzats, *Parade Day under the Empire*, 1810, 1862. Oil on canvas, 101 x 161 cm. - 2. 1848: Anonymous, *The Taking of the Tuileries by the Parisians, February 24, 1848*, 19th century. Colored lithograph. Paris, musée national des Arts et Traditions populaires (Folk Art Museum). - 1. 1871: Anonymous, *Panorama of Paris, the Burning of the Tuileries, May 24, 1871*, 19th century. Print. Paris, musée Carnavalet.

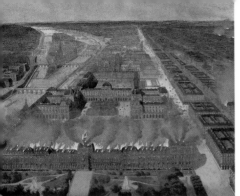

1

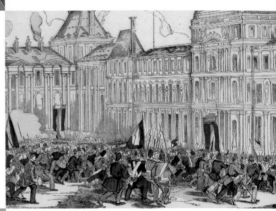

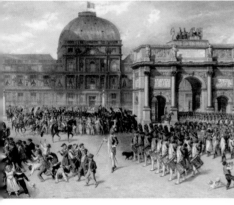

2

3

4

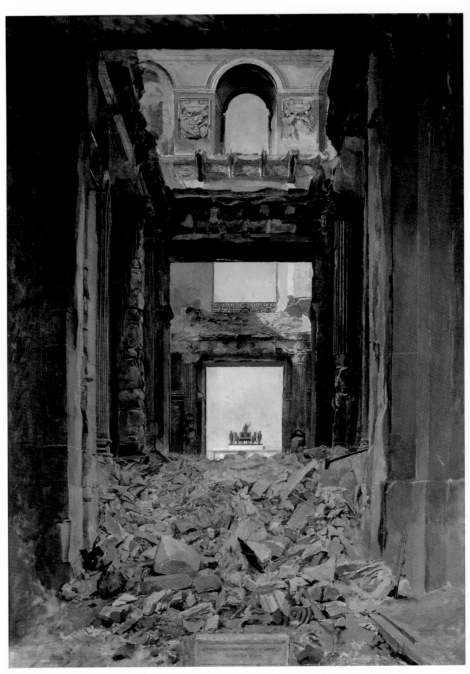

ERNEST MEISSONIER, *The Ruins of the Tuileries,* 1871.
Oil on canvas, 136 x 96 cm. Musée national du château de Compiègne.

The Tuileries

On either side of the peristyle of the Tour de l'Horloge, two inscriptions can be read:

FRANCIS I STARTED THE LOUVRE IN 1541 CATHERINE DE' MEDICI STARTED THE TUILERIES IN 1564, and NAPOLEON III CONNECTED THE LOUVRE TO THE TUILERIES 1852–1857

From Philibert de l'Orme to Lefuel, the Tuileries, like the Louvre, were continually being rebuilt, and like the Louvre, they told the history of France. Only one king died there (Louis XVIII) from the time Louis XVI returned to Paris until the end of the Second Empire, but France was governed from the Tuileries. The constitutional monarchy, the Convention, the Committee of Public Safety, the Directoire, the Consulate, the Empire, the French Restoration, the July Monarchy, the Second Republic, and the Second Empire followed one after the other.

The arts were also present in these magnificent buildings, but they revolved more around the theater built by Soufflot and Gabriel, where the Opera gave performances from 1764 to 1770, before the Comédie Française took up residence from 1770 to 1782. Beaumarchais created his *Barber of Seville* in 1775, and three years later, in Paris on tour,

Wolfgang Amadeus Mozart, age 22, presented his thirty-first symphony, known at the Tuileries as "The Parisian." In 1787, Haydn in turn gave six "Paris" Symphonies.

A century later, in 1871, government troops entered Paris to put an end to the Commune. Two days later, during the night of May 23 to May 24, 1871, the Communards set fire to the royal library and the Tuileries Palace. The fire could not be controlled. The Louvre was only just saved; the Tuileries building was in ruins. It would stay that way for eleven years. On June 28, 1882, Jules Ferry, then the minister de l'instruction publique et des Beaux-Arts (minister of public instruction and fine arts), issued a challenge to the floor of the Senate: "So, gentlemen, I repeat, true supporters of the reconstruction must start by voting for demolition. It is the surest and fastest way to bring it about." The vote for demolition passed, but the reconstruction never took place. The "Grand Design" for the unification of the Louvre and the Tuileries had lasted for nearly three centuries. It was a reality for only thirteen years.

What is the length of the Grande Galerie?

The Medici Gallery

The Grande Galerie measures 866 feet. Up until 1861, it was even larger, as it then extended as far as the Pavillon de Flore.

I. M. Pei was given the delicate task of fitting out a space specifically designed for the exhibition of the twenty-four large-format pictures by Rubens showing scenes from the life of Maria de' Medici. Ordered by Maria de' Medici in 1622, twelve years after the assasination of her husband, King Henry IV, the series was completed in record time in Rubens's Antwerp studios and installed in 1625. The painting originally hung in one of the galleries of the Palais du Luxembourg, then occupied by the queen mother. The works were hung side by side and were supposed to face another series of paintings on the life of Henry IV that was never completed.

The birth of Maria de' Medici, her education, her arrival at Marseilles, her marriage, the birth of her son Louis XII, Henry IV leaving for war... Rubens transformed each one of these episodes from the life of the Regent and her late spouse into a series of allegories in which both mythological and historical figures appeared. When the Senate took up residence in the Palais du Luxembourg at the beginning of the nineteenth century, the pictures were moved for the first time. In 1815, they were sent to the Louvre, where they were hung helter-skelter in the Grande Galerie.

In 1900, eighteen of these canvases were brought together in the third Salle des États. They were shown in a sumptuous red and gold setting conceived by Gaston Redon, brother of the painter Odilon Redon. A few years later, a more solemn decor was chosen for them, dominated by red and black. A masterpiece of Baroque painting, this series, unique among its kind, may be seen today in a room in the middle of the Richelieu wing. In a space of about 5,382 square foot lit by natural light from above, the canvases are integrated with the

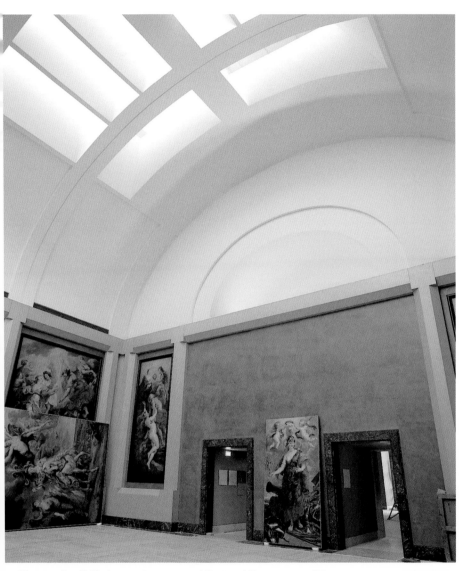

architecture itself. Their sumptuous colors are enhanced by the different shades of green on the room's walls. The new setting for this edifying series of history paintings, now once again in proper sequence, is much like the original one, and is the result of a joint effort by the

architect and the curators of the Painting department.

The Medici Gallery during an installation, 1993.

Opposite page:
PIERRE-PAUL RUBENS,
*The Disembarcation of Maria de' Medici at the Port of Marseilles,
November 3, 1600* (detail),
1621–1625. Oil on canvas,
394 x 295 cm.

1. HOLLAND: Willem-Claesz Heda, *A Dessert,* 1637. Oil on wood, 44 x 55 cm. - **2. FRANCE: Antoine Vollon,** *Fruits and Artworks on a Table With the Ewer of Francis I,* 19th century. Oil on canvas, 73 x 59 cm. - **3. ITALY: Francesco Fieravino,** *Still Life: Citrus and Violon,* 17th century. Oil on canvas, 72 x 93 cm. - **4. SPAIN:** Francisco José de Goya y Lucientes, *Still Life With a Sheep's Head,* circa 1808–1812. Oil on canvas, 45 x 62 cm.

Answer

What is the school of origin?

Still Life

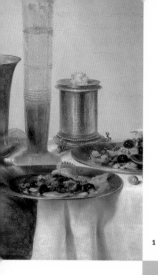

1

2

FRANCE
•
SPAIN
•
HOLLAND
•
ITALY

3

4

The Société des Amis du Louvre

By the end of the nineteenth century, one thing was clear: the budget that the state had granted the Louvre for acquisitions was insufficient. So, a few politicians and high-ranking officials in the Administration of Fine Arts decided to create the Société des Amis du Louvre (the Friends of the Louvre) in 1897. It received official approval the following year.

ÉTIENNE MOREAU-NÉLATON, *Portrait of Raymond Koechlin* (a collector, he was one of the founders of the Société des Amis du Louvre, in 1897), 1887. Blacklead pencil, pastel, 65 x 48,5 cm. Paris, musée d'Orsay.

The first members of the board of directors all belonged to the well-to-do, cultured bourgeoisie. With time, the society was opened to contributors of more modest means. Today the Société des Amis du (henceforth, Grand) Louvre numbers more than 70,000 members and the cost of membership is fifty euros. The annual budget is approximately three million euros, which makes it possible to "enrich the Louvre's collections; acquire and give the Louvre, as a gift, objects that have artistic, archeological, or historical value." One of the most recent purchases is on exhibit in the Galerie d'Apollon: it is a diamond and emerald necklace and earring set. These jewels, created by Napoleon I's jeweler, François-Regnault Nitot, were a gift from the emperor to Marie-Louise for their wedding in 1810.

In little more than a century, more than 600 works of art (for all departments combined) have thus been acquired by the Louvre. A few examples: *The Pietà of Villeneuve-lès-Avignon,* by Enguerrand Quarton (acquired in 1905); *The Gisants of Charles IV the Fair and Jeanne d' Evreux,* by Jean de Liège (in 1906);

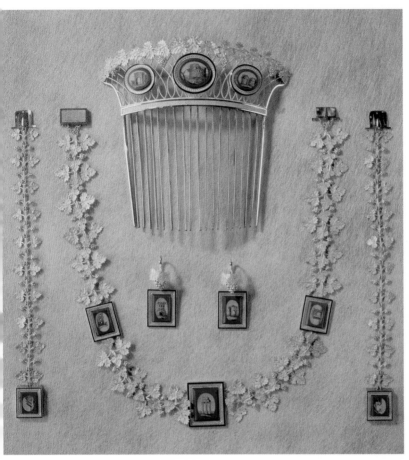

study sketches by Eugène Delacroix for *The Death of Sardanapalus* (in 1938); a ewer with a cock's head (in 1970); and a bed by the Jacob brothers made for Madame de Récamier (acquired in 1991).

FRANÇOIS-RÉGNAULT NITOT,
Parure of the Empress Marie-Louise, circa 1810.
Gold, micromosaics depicting Roman ruins.
Former collection of the Crown Jewels.
Gift of the Société des Amis du Louvre, 2001.

How many of the acquisitions have been made by the Société des Amis du Louvre?

The École du Louvre

A required institution for all future antique dealers, auctioneers, and national heritage specialists, this school is also a hallowed place for all those who simply want to broaden their knowledge of art history.

Founded in 1882 by Jules Ferry, its first mission was to train "curators, missionaries, and diggers." Starting in 1920, the first courses in general art history were given, as well as gallery talks in front of the works. And in 1927, it was at the École du Louvre that museography was taught for the first time.

When the school started, archeology was its predominant discipline, but this is no longer the case; today more than thirty disciplines are taught, from Egyptian archeology, to contemporary art, to Oceanian and African arts, not to mention the history of cinema. Nothing to do with art has been neglected. Specialized courses given by curators, directed studies, and gallery talks are among the activities in the three levels of study, interspersed with research trips.

A public institute of higher learning since 1998, its premises are in the Pavillon de Flore. The school is, however, independent from the museum. Three degrees are offered: a three-year undergraduate degree, a one-year master's degree, and a three-year graduate degree, as well as preparatory classes for the competitive exams for national heritage curators. There are hundreds of candidates, but only thirty curator positions are available for 2005, for example. Professional training for specialists in certain national heritage classes is also given. The school offers evening classes, summer courses, and regional courses. It organizes scientific conferences and publishes manuals for students, as well as specialized research works.

Students may start their studies in the first year after a preliminary test, or they can join a degree course by passing an equivalency test. And just like the museum that is open to everyone, specialists and those who are simply curious, the École du Louvre also welcomes auditors.

Since its creation in 1897, the Société des Amis du Louvre has made possible the acquisition of some 650 works.

The Rohan amphitheater at the École du Louvre.

Artists' words
Who said what?

Voltaire

Paul Valéry

Honoré de Balzac

Marcel Pagnol

Victor Hugo

Antonin Artaud

Gustave Flaubert

Charles Baudelaire

Antoine Quatremère de Quincy

Alphonse de Lamartine

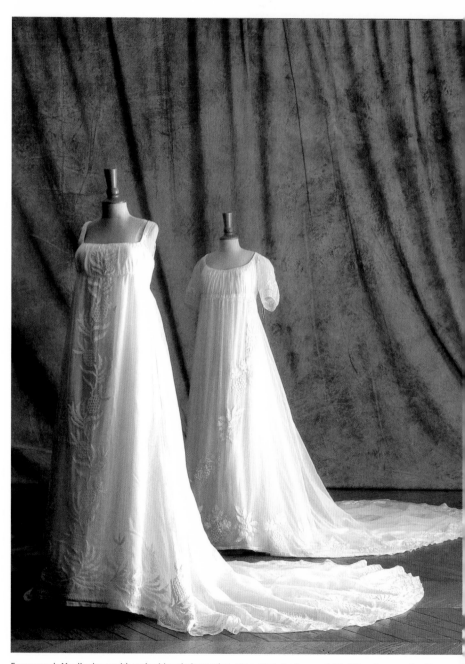

Foreground: Muslin dress with embroidered pineapples, 1804–1806. Background: Wedding dress made of lawn, with embroidered vine leaves and cherries, circa 1805.

Opposite page: The Union des Artistes Modernes (Union of Modern Artists) on display at the musée des Arts décoratifs.

Decorative Arts

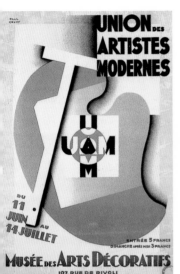

In 1882, the Union Centrale des Beaux-arts Appliqués à l'Industrie (Central Union for Fine Arts Applied to Industry) became the Union Centrale des Arts Décoratifs (Central Union of the Decorative Arts). In 1905, the Musée des Arts Décoratifs (Museum of Decorative Arts) is inaugurated in the Rivoli wing of the Louvre; it includes a library specialized in Decorative Arts. In 2004, the Union Centrale des Arts Décoratifs (UCAD) changed its identity once again, adopting the name Arts Décoratifs (Decorative Arts). The institution's name may have been simplified, but its reason for being remains the same: "To keep alive in France the culture of art that strives to make the useful beautiful." It is to fulfill this ambition that it provides training and has special relationships with industrialists in a wide variety of activities. These partnerships result in productions. Some are inspired by ancient objects; others bear witness to contemporary creativity. In both cases, the library and collections of the Arts Décoratifs are a source of inspiration.

The library has some 120,000 volumes, and has recently had a reading room installed on the ground floor of the Marsan wing. It is a gold mine for experts in the decorative arts as well as for theater set designers, art critics, interior designers, landscapers, and stylists. The collections make up one of the most astonishing treasure troves that can be imagined. All types of applied arts are represented here: from jewelry to advertising materials, from old fabrics to glassware, from the first movie posters to computerized images, from faience to wallpaper, from gold plate to toys, from furniture to fashion. The museum, with its entrance located at 107, rue de Rivoli, is the perfect extension of the Grand Louvre.

Why was a "patriotic workshop" set up in the Louvre during the revolution?

The Louvre and the Wars

Each of the terrible wars of 1870, 1914–18, and 1939–45 caused the Louvre to be evacuated.

In 1871, on the night of May 23 to 24, the Tuileries were in flames, and it was Barbet de Jouy, then the curator of the Objets d'Art, who, along with some infantrymen that he had brought up onto the roof the Grande Galerie, managed to stop the fire from spreading to the Louvre. The paintings and more valuable objects had been taken to the arsenal of Brest in August 1870 and were safe, but thanks to these men, the building itself was also saved.

On August 28, 1914, when war had just been declared, the order was given to move the works as soon as possible, whatever the cost. Seeing the works collected in one of the courtyards, a curator thus described the scene: "In the harsh light of day, without frames, laid on their side or even upside down, they have the miserable, pitiful look of paintings on sale at a secondhand shop." During the war, the works found refuge in Toulouse, far from the Louvre. The city had enormous warehouses and seemed to be sheltered from attack by Germany. Things were different during the Second World War, because from 1938 on, everything was planned so that, if it proved necessary, the evacuation of the works could be done without haste. At the start of the war, the Louvre's collections

For the wives of the artists living at the Louvre, who sewed shirts for the soldiers there.

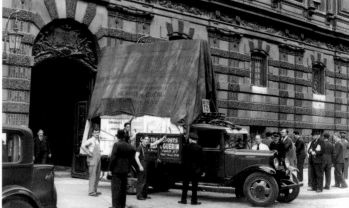

were ready to leave. Thirty-seven convoys left Paris for the Château de Chambord between August 27 and December 28, 1940. Then the works were divided up between fifteen other châteaux in the Loire. In some of them—Chambord, Brissac, and Sourches—were boxes containing works that Jewish collectors had entrusted to the national museums. All the statuary of the Louvre, from antiquity to modern times, was taken to Valencay, to the estate of the Talleyrand-Périgord family. Among the sculptures were the famous *Victory of Samothrace* and *Venus de Milo,* crated with some difficulty by staff from Paris department stores. Toulouse also again welcomed part of the Louvre. But this time, it was the Egyptian antiquities that were brought by covered trucks to the Château de Saint-Blancard. The *Mona Lisa* was also evacuated in 1939. First stored at the Château de Louvigny, it next went to Tours, near the Château d'Amboise, where Leonardo da Vinci himself had stayed and worked, before being "deported" once again to the Montauban Museum until the end of the war. Between 1945 and 1946, all the works were returned intact to the Louvre.

A room in the Louvre, in 1942.

Opposite page: Putting the Louvre's masterpieces under protection (shelter), in 1939.

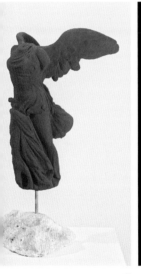

1

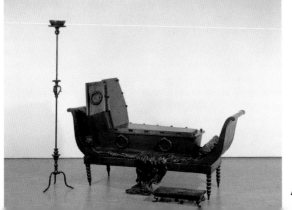

2

THE LACEMAKER

•

MADAME RÉCAMIER

•

THE VICTORY OF

SAMOTHRACE

•

THE WOMEN OF ALGIERS

3

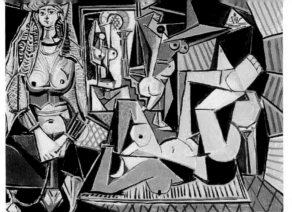

4

Reinventing the Louvre

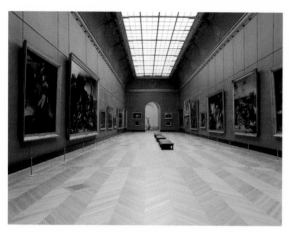

The Daru room.

Opposite page:
The Daru staircase, large work by H. M. Lefuel, redesigned by E. Guillaume, then by A. Ferran. Center: *The Victory of Samothrace.*

In 1926, Henri Verne, the director of the Louvre, undertook to modernize and reorganize the entire museum. At that time, the Louvre was divided into collections, which were themselves subdivided into "museums." Henri Verne developed two main proposals for the work: one consisted of reordering the works within the museum; the other was more revolutionary and called for giving all of the Louvre's buildings to the museum, including the Pavillon de Flore and the Richelieu wing, then occupied by the Ministry of Finance. Although the second possibility was not accepted, the idea took root and allowed some to dream about what could become the largest museum in the world. Between 1927 and 1939, several

departments were reorganized, especially the departments of Oriental Antiquities and Sculpture. The architects Camille Lefèvre and Albert Ferran designed a space that was simple, refined, and monumental. In order to show the works in bright, unadorned stone spaces, Albert Ferran removed many of the embellishments. Ellipses, arcs of circles, cradle vaults—his architecture was made up of trim, precise lines. This was also when the glass roofs were built over the Cour du Sphinx, making it possible to exhibit the Greek and Roman sculptures outdoors. Once electricity was installed, the museum could be visited at night.

During the war, the Musée de la Marine (Navy Museum) left the Louvre for the Chaillot Palace. In 1945 the Musée Guimet welcomed the collections of Asian art that the Louvre was relinquishing. The Impressionist paintings were moved to the Musée du Jeu de Paume at the Tuileries. Then, in the 1980s, the creation of the D'Orsay museum led the Louvre to part with all of its works dated after 1848. From the end of the war to the start of the 1950s, the Salle Daru and Salle Mollien, the Salle des États, the

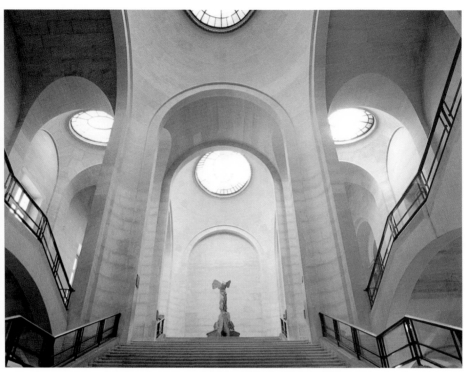

Grande Galerie, and the Salon were renovated in the classical style by the architect Jean-Jacques Haffner. The stucco cornices and pilasters he used foreshadowed the decoration of the Louvre in the 1950s, marking the creation of a period style at a low cost. It was during this period that the Salle Rubens, where the paintings of this master from Antwerp were hung, was entirely redesigned under the direction of the curators to conform to that historical period. The 1960s were marked by major work and the clearing of the trenches at the foot of the Perrault Colonnade, ordered by the minister of culture André Malraux. The department of

Painting, and then, sometime later, the department of Greek and Roman Antiquities in turn benefited from major modernization work. But it would be another twenty years, until the arrival of François Mitterrand, before the Louvre that Verne dreamed of became a reality.

?

When did the work on the Grand Louvre start?

Creation of the Grand Louvre

- FROM 1981 TO 1999 (AND FURTHER)
- FRANÇOIS MITTERRAND (1916–1996), PRESIDENT OF THE REPUBLIC FROM 1981 TO 1995
- IEOH MING PEI, MICHEL MACARY, LÉONARD JACOBSON WITH YANN WEYMOUTH, ANDRZEJ GORCZYNSKI, STEPHEN RUSTOW, MASAKAZU BOKURA
INTERIOR FITTINGS: GÉRARD GRANDVAL (CAROUSSEL ROOMS), DOMINIQUE BRARD, JEAN-MICHE WILMOTTE AND JEAN-PAUL BOULANGER AND GENEVIÈVE RENISIO...

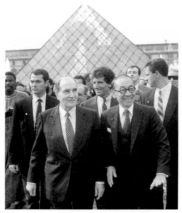

In 1983. It was finished in 1998.

As we have seen, as early as 1926, Henri Verne, the director of the Louvre, had thought about a general remodeling plan for the museum that included the possibility of reclaiming the rooms occupied by the Ministry of Finance. More than fifty years later, Jack Lang, then the minister of culture, sent the following note, dated July 27, 1981, to the president of the republic, François Mitterrand: "As regards the 'major projects' we were dreaming of for Paris, there is one big idea we should get started on: re-creating the Grand Louvre by giving the entire building to the museums (...) By making it one again, the

Louvre would become the largest museum in the world." The minister concluded with these words, which could only be favorably echoed by the recently elected president: "Only a sovereign act can make this ambitious plan for the Grand Louvre a reality." The letter bears a note written in the president's own hand: "Good idea, but difficult (by definition, like all good ideas)." Finally, Mitterrand carried out this sovereign act suggested by his minister of culture. In 1983 the Établissement Public du Grand Louvre (EPGL) was created to undertake the contracting of the entire project. The president also made the decision to move the 5,000 civil servants who worked for the Ministry of Finance to Bercy.

The budget of more than one billion euros was financed by the state. The objective was to double the museum's exhibition areas, thus exceeding 646,000 square foot; to appreciably increase the areas for scientific, technical, and administrative work; and to open up new, larger spaces for reception and

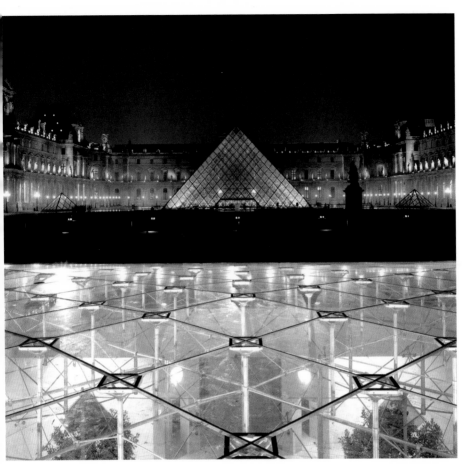

services for the public. Excavations were carried out during this work. They uncovered the ruins of the medieval château under the Cour Carrée, as well as the Louvre district and Le Vau's wall under the Cour Napoléon.

Five years after the inauguration of the Pyramid, on November 18, 1993, the day of the bicentennial of the Louvre museum, the Richelieu wing was inaugurated by President Mitterrand. During a speech given at the Élysée Palace the same day, the president honored all those who had helped make the project a reality. He mentioned one person in particular: "I must say that the core person, as in any team, the one without whom nothing would have been possible—I have to mention him—it was Émile Biasini." A former colleague of André Malraux's, Biasini presided over the Établissement Public du Grand Louvre from 1984 to 1988. He was also the instigator of the decisive meeting between François Mitterrand and the architect Ieoh Ming Pei.

View of the Pyramid at night, taken from the inverted pyramid (in the foreground).

Opposite page: President François Mitterrand inaugurates the Pyramid of the Louvre, June 14, 1988.

113

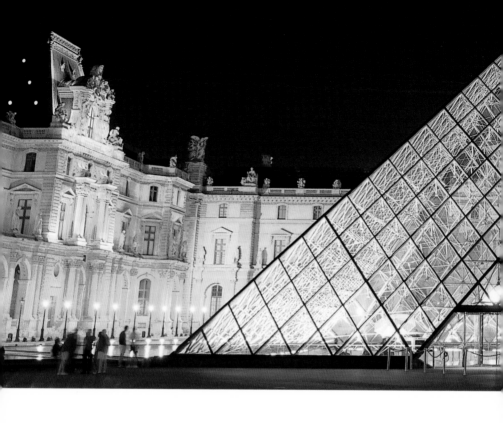

The Grand Louvre

View of the Pyramid of the Louvre at night, with the Sully Pavilion in the background.

When the president of the Republic awarded a Grand Louvre project to the Chinese-American architect I. M. Pei, Mr. Pei hesitated. He was well aware that such a challenge was like no other: "Architecture is not just a matter of design. It must convey the political, cultural, and economic aspects of the community. The Louvre is a piece of history." President Mitterand's decision not to subject the contract to a competition removed the architect's remaining scruples.

After several visits to the Louvre, Pei got the idea for a pyramid. He said it occurred to him, "Because it is one of the most classic of shapes that would also be an indication of a major change. More than a break, it would be a bridge between the Louvre of the past and the twentieth-century museum. The fact that it would be transparent was essential: it would not conceal the palace but enhance it." This rationale did nothing to prevent the impassioned protests that followed. For some, the plan did not stand up to serious examination, while for others it was a mere obscenity. Wary, the mayor of Paris, at the time

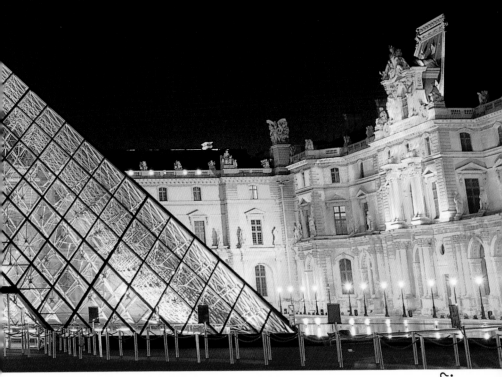

Jacques Chirac, suggested making a model in order to better judge from the rendering. At the beginning of May 1985, cables were stretched across the courtyard, the outlines of a pyramid took shape, and the mayor was seduced: "Taking account of what I have just seen, and if the pyramid will be both transparent and reflective as we have been promised, then I have no objections."

The Pyramid was opened on March 4, 1988. It rises in the Napoleon courtyard to a height of seventy-one feet, measures 116 feet on each side, and weighs 200 tons, 105 of which consists of 673 panels of glass. Surrounded by three little pyramids, whose function is to illuminate the three wings of the museum, the chief role of the main pyramid is to illuminate the main entrance to the museum.

Within a year, admiration had quelled most of the vituperation, which, in a France little disposed to change, can be strong and even violent. After all, it was only a century ago that the construction of the Eiffel Tower provoked similar outcries.

How much did it cost to build the Grand Louvre ?

From Paris to Atlanta to Lens

Today the Grand Louvre is at a crossroads in its history. Under the aegis of its CEO, Henri Loyrette, this huge world-renowned institution will for the first time undertake a decentralization. This involves a worldwide network of affiliated organizations where the museum's fabulous collections can be displayed. The grand premiere, in 2006, will be in Atlanta, Georgia, in the new buildings of the High Museum; then, in 2009, another "Louvre" will open in Lens, in the north of France.

For some time now, many large American museums have been

privileged partners of the Louvre, from whose collections regular exchanges of exhibitions have taken place. Following the premiere of the "Louvre in Atlanta," the Louvre museum will have its own building, designed by architect Renzo Piano. The exhibitions to be shown there will be organized by curators from the Louvre, along with their Atlanta counterparts. These "themed exhibitions" might cover such diverse subjects as the decorative arts at the end of the eighteenth century, objects from the collection of Joséphine and Napoléon, or the royal drawing collection. In exchange, the American partners will contribute to the renovation of the eighteenth-century furniture rooms of the Grand Louvre.

At Lens, it is a matter of building a new museum whose opening is planned for 2008–2009. For its new 237,000-square-foot building, this "new" Louvre will acquire pieces that the Paris museum has no room to display. Six or seven hundred works of major importance will be shown there in regular rotation. Temporary international expositions and

About 1 billion euros (6.2 billion francs at the time).

themed exhibitions will also be arranged. But above all, the Lens museum will permit the collections to be shown differently, in cross section, with the works of any one era displayed all together rather than by department. This development is evidence that the museum will truly be a "school of observation."

New building project by Renzo Piano for the High Museum of Atlanta, which will expand the current construction by Richard Meier (left-hand page).

1. **EUGÈNE DELACROIX,** *Study of a Female Nude Lying on a Sofa, also called "The Woman with White Stockings,"* circa 1825–1830. Oil on canvas, 26 x 33 cm. - **2. THÉODORE CHASSÉRIAU,** *Venus Anadyomene (Emerging From the Sea), also called the "Marine Venus,"* 1838. Oil on canvas, 65 x 55 cm. - **3. JEAN-AUGUSTE-DOMINIQUE INGRES,** *Woman at Her Bath of Valpinçon,* 1808. Oil on canvas, 146 x 97 cm. - **4. PETER PAUL RUBENS,** *The Disembarcation of Maria de' Medici at the Port of Marseilles* (detail), 1721–1725. Oil on canvas, 394 x 295 cm.

Answer

Who painted what?

Nudes

1

DELACROIX
•
INGRES
•
RUBENS
•
CHASSÉRIAU

2 3

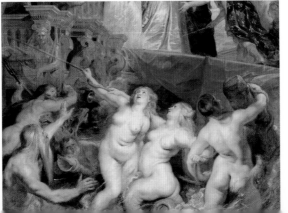

4

Museology

The new rooms for French paintings on the second floor of the Cour Carrée (salle des frères Le Nain).

Opposite page: The department of Objets d'art as redesigned and reconfigured by Jean Michel Wilmotte.

At the Louvre, museology, the science or art of museums, is the business of a group of professionals whose role is to ensure not only that the museum is well managed today, but also to reflect on the future development of the world's largest museum.

To remain faithful to its encyclopedic vocation, to exhibit but also preserve and conserve, and to instruct and inform more than five million visitors each year are among some of the challenges of museology at the Louvre. These past years, the architects I. M. Pei, Stephen Rustow, Michel Macary, and Jean-Michel Wilmotte, in conjunction with the curators, have redesigned and remodeled the pathways through the collections. It was decided to use different color schemes for the picture rails to represent the different

periods: light beige for seventeenth-century French paintings, pale green or caramel for those of the eighteenth century, dark green or red for the Romantics. Classification by department or by school is still used to determine the presentation of the works, but taking advantage of the increased space, major works are hung alone at eye level.

Because of the richness of the collections, however, many pictures are still hung fairly close together. Today lighting remains a crucial concern in presenting works at the Louvre. The choices take into account the diversity of the museum's exhibition rooms and, for the most part, are on the leading edge of research in museology. For the department of Objets d'Art, for example, Jean-Michel Wilmotte designed display cases where the simply presented objects are lit using fiber optics; and for the reconstruction of the entrance to the palace of Sargon II (gigantic winged bulls with human heads, each one 16.4 feet high and weighing 25 tons), the engineer Peter Rice designed glass roofs that overhang the Khorsabad as well as the Marly and Puget courtyards. For a long time, the

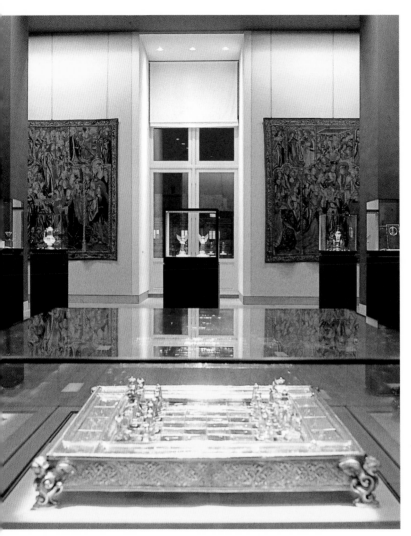

works' sole illumination came from the rooms' windows. Three light sources are used in the rooms, sometimes all together: overhead natural lighting modulated with screens and strips of staff (plaster), lateral light from the windows, and electrical lighting.

The information aspect, crucial in any museum, is considered particularly important at the Louvre, where as much work is done on background information as on the form of any display—audio guides, plans, guides, lectures, signs, and other things— thus allowing visitors to walk through 646,000 square foot of museum and see the approximately 35,000 works on display without getting lost (or almost).

?

The Scientific Laboratory

Identify the creator of a table through the analysis of its wood fibers, or of a canvas by its pigments. Follow the stages of a painter's work and perhaps discover a hidden image with X-rays. Make an invisible inscription appear with ultraviolet light. Learn how cosmetics were made in Egypt. Restore a work according to its chemical makeup. Date a work with carbon 14. These are a few of the delicate daily tasks performed in the laboratories of the Louvre. Madeleine Hours, who has directed the laboratory for many years, has popularized the many aspects of the scientific life of the museum in books, on radio and television, and in exhibitions, including the celebrated "The Mysterious Life of Masterworks," shown in 1980 at the Grand Palais in Paris. Since Francis I, artists themselves had traditionally been entrusted with the maintenance and restoration of the royal collections, but since the beginning of the twentieth century, they have been replaced by technicians. For while there is no known scientific way to create a masterpiece, there are many such means to preserve one.

The first tentative attempts at the technical analysis of paintings by X-ray took place at the Louvre in 1920. Twelve years later, the Louvre created the laboratory of the Painting department. Developed by Madeleine Hours over forty years, it became the Research Laboratory of the Museums of France in 1968, and was replaced in 1998 by the C2RMF, the Center for Research and Restoration of the Museums of France. Its activities, as the name implies, concern not just the Louvre, even if its laboratories are in the basement of the Carrousel and its workrooms are in the Flora pavilion. The center has four departments:

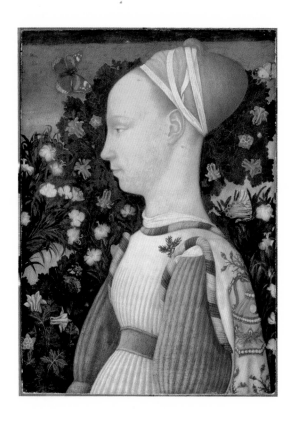

ANTONIO PUCCIO,
(PISANELLO),
Portrait of a Young Princess,
circa 1435–1440.
Oil on wood,
43 x 30 cm. X-ray
analysis.

Opposite page:
X-ray of the *Mona Lisa.*

research, conservation and
restoration, preventive conservation,
and documentation. These
departments are as complementary
as they are different. There are
about 160 regular employees:
curators, chemists, physicians,
librarians, engineers, art
technicians, master craftsmen...

The architect Visconti undertook the work on the New Louvre of Napoleon III with the construction of the rue de Rivoli wing. The architect Lefuel would assume the task upon his death, in December 1853. He would finish the buildings and create the trapezoidal courtyards to correct the alignment between the Napoleon Courtyard and the rue de Rivoli. **1. PUGET COURTYARD.** Sculptures from the time of Louis XIV are brought together on the lower terrace of the courtyard. - **2. KHORSABAD COURTYARD.** This room displays the decor of the town and palace of King Sargon II at Dur-Sharrukin, today's Khorsabad, near Mosul. - **3. SPHINX COURTYARD.** Department of Greek and Roman Antiquities; here, the *Personification of the Tiber River* and Le Vau's wall. - **4. MARLY COURTYARD.** Foreground: *The Loire and the Loiret* by Van Cleve.

Answer

Courtyards of the Louvre
What is their name?

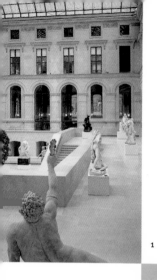

1

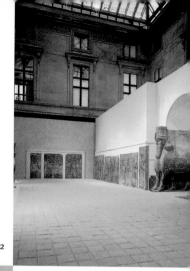

2

MARLY COURTYARD

•

SPHINX COURTYARD

•

PUGET COURTYARD

•

KHORSABAD COURTYARD

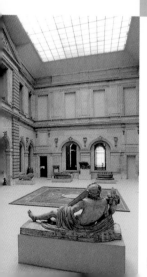

3

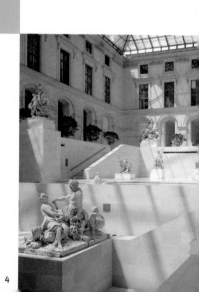

4

The Courtyards of the Louvre

- NAPOLEON COURTYARD, SQUARE COURTYARD, KHORSABAD COURTYARD, PUGET COURTYARD, MARLY COURTYARD, LEFUEL COURTYARD, VISCONTI COURTYARD, SPHINX COURTYARD.

Courtyard from the palace of Sargon II, Gate of the Bulls, Mesopotamia, Neoassyrian era, circa 710 B.C. Gypsum.

Opposite page:
Marly Courtyard, glass roof and layout by I. M. Pei and M. Macary (1993). The statuary comes from the parc de Marly, layed out principally under Louis XIV and Louis XV (*The Marly Horses* were completed in 1745).

The eight courtyards of the Louvre are major spaces that lend both rhythm and structure to the complex of buildings.

The oldest is the Cour Carrée (the Square Courtyard). A perfect square of 394 feet on each side, it was created in the seventeenth century, when, during the reign of Louis XV, the area was cleared of several buildings in order to "air out" the general aspect of the palace. The Napoleon courtyard has become the center of gravity of the Grand Louvre since the birth of the Pyramid in 1989. The courtyards alongside the Richelieu wing were named only with the advent of the Grand Louvre.

Before being taken over by the museum, they had served over the years as parking spaces for the finance ministry. Today, nestled among the buildings and covered with immense glass roofs, they afford the sculptors a space on a suitable scale with natural light. The Puget Courtyard owes its name to the sculptor Pierre Puget (1620–1694), whose celebrated *Milo of Crotona* was in the gardens of Versailles before coming to the Louvre.

The horses that were originally ordered for the park of the château of Marly gave their name to the second courtyard of the Richelieu wing. Actually, these horses have "come back" to the Louvre, because it was in a courtyard of this very palace that the sculptor Guillaume Ist Coustou (1677–1746) had his studio, where he filled Louis XV's order for his château at Marly. Casts of these same horses face one another in the Place de la Concorde, from either side of the Champs-Élysées, where the painter David had them placed in 1794.

As for the third courtyard of the Richelieu wing, Khorsabad, it owes its name to a very spectacular

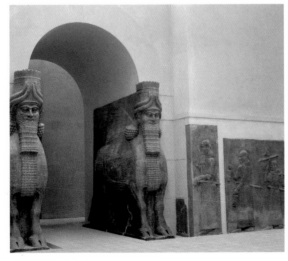

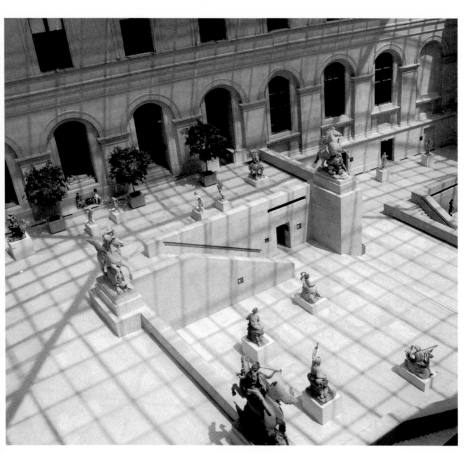

reproduction of the Assyrian palace of Sargon II (721–705 B.C.) at Khorsabad.

The courtyard beside the Denon wing, built by Louis Le Vau in 1663, was given a glass roof in 1934. Called the Sphinx Courtyard (Cour du Sphinx), it is the first place name at the Louvre that derives from its actual function: the great *Sphinx* discovered at Tanis, which was displayed in this courtyard during the first half of the nineteenth century, gave it its name. As for the Visconti and Lefuel courtyards, they will no doubt retain their names in spite of the changes made—they are, after all, the names of the architects who finished the Louvre under Napoleon III.

?

Which is
the longest facade of the Louvre?

The Sculptors of the Louvre

Even if we decided to empty the Louvre of all the statues on display, it would still be an exceptional museum displaying French sculpture from the Renaissance to the end of the nineteenth century.

To appreciate this, you have only to look at the ceilings. The Galerie d'Apollon alone contains the work of four remarkable sculptors: François Girardon (1628–1715), Thomas Regnaudin (1622–1706), Gaspard Marsy (1624–1681), and Balthazar Marsy (1628–1674). The Baroque-influenced sculptures that decorate Anne of Austria's apartment, which were done by Michel Anguier

(1614–1686). In the Grande Galerie, the Bacchic figures of Albert Carrier-Belleuse (1826–1887) that decorate the two rotundas.

On the outside, the palace's facades provide a historic panorama of French sculpture. During the reign of Henry II, Jean Goujon (1510–1566), connected to the construction of the first wing of the "new" Louvre through Pierre Lescot, sculpted all the allegories that surround the large œil-de-bœuf windows of this wing's three avant-corps. He was also entrusted with the window lintels, and created the beautiful frieze where the children are holding garlands of leaves. In 1554, the three large frontispieces of the building's last floor: *Mars and Minerva Surrounding the Captives, Euclid and Archimedes Surrounding Science and Knowledge,* and finally, *Ceres, Bacchus, Pan, and Neptune Accompanying Nature.*

Jacques Sarazin (1592–1660) designed the caryatids of the Pavillon de l'Horloge; François-Frédéric Lemot (1772–1827) decorated the pediment of the

The one facing quai François Mitterand, measuring 2,200 feet.

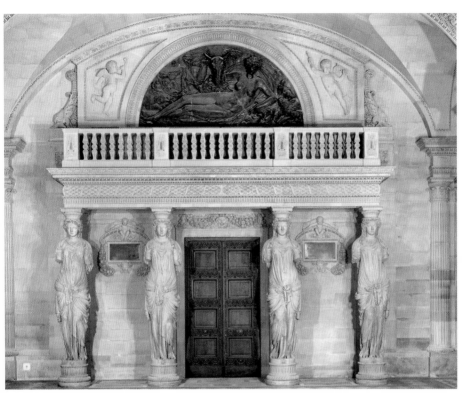

Colonnade. Antoine-Louis Barye (1795–1875) built the pediment of the Pavillon Sully and did the decoration of the Grand Guichet (Great Gate), and Auguste Préault (1809–1879) sculpted the allegories of Peace and War that decorate the far end of the Cour Napoleon. The history of sculpture at the Louvre ended with Jean-Baptiste Carpeaux (1827–1875). On the south facade of the Pavillon de Flore, which was rebuilt by Lefuel at the start of the 1860s, Carpeaux honored Emperor Napoleon III with *Imperial France Bringing Light to the World*. By choosing to sculpt the goddess Flore, he paid homage to

the history of the pavilion that bears her name since the 1669 performance of a great ballet dedicated to the goddess.

JEAN GOUJON, based on a design by Pierre Lescot, Gallery in the Salle des Caryatides, 1550–1154.

Opposite page: JEAN-BAPTISTE CARPEAUX, *Flora or the Triumph of Flora*, 1875. Terracotta, 137 x 180 x 79 cm.

1. GIOVANNI FRANCISCO ROMANELLI, *Esther Fainting Before Ahasuerus*, ceiling of the apartments of Anne of Austria, Salle des Antonins, 1655–1658. - **2.** HUGHES TARAVAL, *Autumn, or the Triumph of Bacchus and Ariane*, ceiling of the Apollo Gallery, 1769. - **3.** JOSEPH-BENOÎT GUICHARD, after a drawing of Charles Le Brun, *The Triumph of the Earth or of Cybele*, ceiling vault of the Apollo Gallery, 1850. - **4.** CHARLES MEYNIER, *The Triumph of French Painting*, medallions by Poussin and Le Brun (detail), ceiling of the Salle Duchâtel, 1820–1828.

Answer

Ceilings of the Louvre
Who painted what?

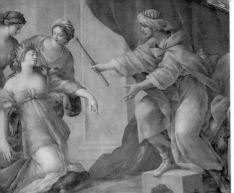

CHARLES LE BRUN

1

CHARLES MEYNIER

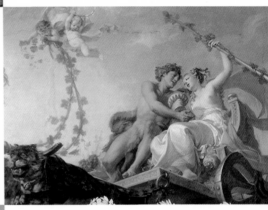

2

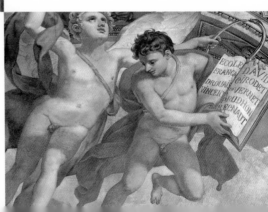

GIOVANNI ROMANELLI

3

HUGHES TARAVAL

4

The Ceilings of the Louvre

- 17TH CENTURY: NICOLAS POUSSIN (PROJECTS), GIOVANNI FRANCESCO ROMANELLI, EUSTACHE LE SUEUR, CHARLES LE BRUN
- 18TH CENTURY: HUGHES TARAVAL, LOUIS-JACQUES DURAMEAU, ANTOINE-FRANÇOIS CALLET
- 19TH CENTURY: FRANÇOIS GÉRARD, ANTOINE-JEAN GROS, ALEXANDRE-ÉVARISTE FRAGONARD, JEAN-AUGUSTE-DOMINIQUE INGRES, HORACE VERNET, EUGÈNE DELACROIX
- 20TH CENTURY: GEORGES BRAQUE...

GEORGES BRAQUE,
Les Oiseaux
(The Birds), 1953.
Central panel of the
ceiling of the salle
Henri II. 270 x 212 cm.

Opposite page:
GIOVANNI FRANCESCO
ROMANELLI, *Apollo and*
Marsyas, 1655–1658.
Fresco from the
ensemble of Apollo
and Diana, *The*
Seasons. Ceiling
of the apartments
of Anne of Austria,
salle des Saisons.

You have only to raise your eyes heavenward in the Louvre to contemplate three centuries of painting. Starting with the Mars rotunda (in the south wing of the Cour Carrée), from where Anne of Austria's apartments begin. Here there is a mixture of seventeenth- and nineteenth-century decor, including a remarkable fresco by Merry-Joseph Blondel. From there, go on to the Salle des Fleuves, designed under the Second Empire, to admire frescoes by Victor Biennoury.

The apartments of the Queen Mother Anne of Austria were decorated in the seventeenth century by the Italian painter Giovanni Francesco Romanelli

and the French sculptor Michel Anguier. In the antechamber, there are scenes from Roman history painted in fresco and various subjects included in the medallions (Acteon and Diana, the torture of Marsyas, Diane and Endymion, allegories of spring, summer, and the four elements). Her chamber is decorated with pictures depicting Judith and Holopherne, as well as allegories of the royal virtues; there are also paintings by Philippe Auguste Hennequin and stuccos by Claude Dejoux. Next is the Salle des Empereurs. In 1854, the architect Lefuel called on the painter Louis Matout and the sculptor Duchoiselle to decorate the apartments in the style of Anne of Austria. This was the first of the Louvre's antique rooms during Henry IV's time.

The ceilings of the Charles X museum, which houses the Egyptian antiquities collected by Champollion, are decorated with paintings by François-Édouard Picot and Abel de Pujol; the work is reminiscent of Egyptian art. Those of the Galerie Campana (located parallel to the Charles X museum) were done by different

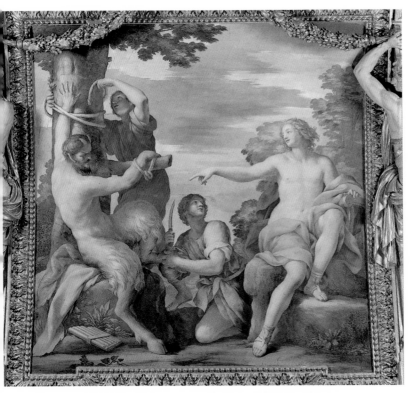

artists who worked during the time of Louis Philip. Pierre Fontaine entrusted the ceiling to Baron Charles de Steuben, who painted *The Clemency of Henry IV* on it between 1828 and 1833, and decorated the arch moldings with coats of arms and portraits of important contemporary people (Sully, Crillon, Mornay, and others).

Not far is the antechamber of Henry II, where, in 1953, Georges Braque painted the large blackbirds on an azure background, commissioned by André Malraux.

After the Percier and Fontaine rooms is the Denon wing, where we discover *The Triumph of French Painting,* by Charles Meynier, and the famous painting *France Protecting the Arts.* If we continue by the Mollien staircase, we can appreciate the decor painted by Gaston Redon and Charles-Louis Müller. The latter also painted the ceilings in the Salon Denon. Alexandre Dominique Denuelle's red and gold decor has been preserved in the large Mollien rooms, created for the Napoleon III museum.

We reach the end in the sumptuous Apollo Gallery, where the eclectism and combination of styles, periods, and names recall the palace's long history: Charles Le Brun, Hugues Taraval, Louis-Jacques Durameau, Antoine-François Callet, and Eugène Delacroix, to name just a few.

What was celebrated at the Louvre on August 18, 1572?

The Staircases of the Louvre

There are twelve remarkable staircases at the Louvre.

In the Sully wing is the Henri IV staircase and the north and south stairs of the Perrault colonnade. You can also discover the compartmentalized vault of Henry II's staircase, sculpted with aspects of the hunt, dogs rushing forward, and punctuated by the letter *H,* the king's initial. This staircase replaces another that was destroyed in 1556, when Henri II gave the order to enlarge the first wing built by Pierre Lescot. Most of the staircases in the Louvre were destined to be either destroyed or transformed.

The Daru staircase does not owe its fame to Lefuel, who was its architect, nor to the service record of the Count Daru, the quarter master general of the Grande Armée in Austria and Prussia and the war secretary who gave it its name. Its fame comes from the *Victory of Samothrace,* which has been on exhibit here since 1882. The architect Edmond Guillaume obtained approval from a commission to decorate it with mosaics in 1883, and the painter Jules-Eugène Lenepveu devised a procession of allegories showing great moments in art history, from antiquity to modern times, under the cupolas. This job was unfinished in 1934, when the architect Albert Ferran was put in charge of refining its architecture and stripping the decor. Since then, plain stone, the rhythm of the vaults, and daylight have made a veritable showcase for the *Victory of Samothrace.*

In the Denon wing are the Mollien staircase and the horseshoe staircase from the Cour Lefuel. Three other staircases by Lefuel adorn the Richelieu wing: one bears the architect's name, another the name "Colbert," and the third is called the Escalier du Ministre (Minister's Staircase). Leading to the

The marriage of Henry de Bourbon, king of Navarre, the future Henry IV, and of Marguerite de Valois, sister of Charles IX, called Queen Margot.

134

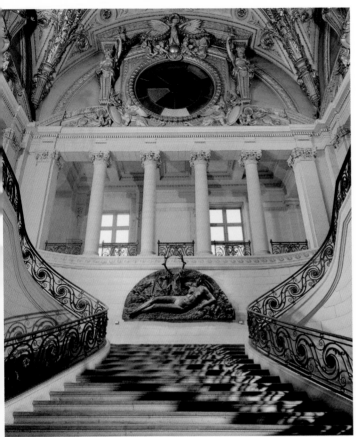

View of the Mollien grand staircase. In the center: Benvenuto Cellini, *Nymph from Fontainebleau*, 1542–1543. Bronze, 205 x 409 cm. Formerly part of the Porte Dorée (golden door) of the château de Fontainebleau.

Opposite page: Stairwell of the Pyramid, by I. M. Pei (1988). In the center, the elevator.

private apartments belonging to a minister during the Second Republic, it was decorated by the sculptors Jean-Baptiste Révillon and Marie-Étienne Cousseau. Jean Crapoix did the ceiling, and the painter Charles-François d'Aubigny painted two landscapes depicting the palace and gardens of the Tuileries and the Pavillon de Flore. The banister for the staircase and the chandelier were ordered from the house of Christofle.

It is useless to look for the first of the Louvre's staircases, the Grande Vis of Charles V's palace. It was razed under Louis XIII. In the north part of the Grosse Tour's circular moat, only its base remains. Its shape is remembered in the majestic spiral staircase designed by I. M. Pei, which provides access to the Hall of Napoleon. He is also responsible for the large escalators leading to the Richelieu wing. Bordered by large round windows that look out over a covered courtyard, they offer a unique perspective of the museum.

THE LOUVRE NEWS

NEWS IN BRIEF & TIDBITS

1666: ROYAL DEATH!

Anne of Austria dies at the Louvre and her son Louis XIV decides to move to the Tuileries palace. The Louvre will be abandoned.

AROUND 1605: INCIDENT... It was reported that Queen Catherine de' Medici had opened her window at the Louvre a few days ago. Underneath it, she saw and heard soldiers who were roasting a goose. They were singing vile songs about her at the top of their lungs. She contented herself with shouting, "Why do you say such bad things about poor Queen Catherine, who never did anything to you? It is thanks to her money that you are roasting this goose!" King Henry IV, who was with her, wanted to go down to punish the knaves. The queen held him back with these words: "Stay here. This is going on too far beneath us."

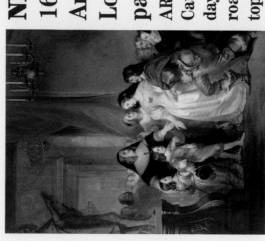

THEATER & MUSIC

October 24, 1658: Molière Appears Before Louis XIV for the First Time

Yesterday, October 24, 1658, Molière's troupe, after spending a long time touring the provinces, performed *Nicomède*, a tragedy by Corneille in the guardroom of the Vieux Louvre. At the end of the show, after having thanked the king, Molière "very humbly begged him to be allowed to perform for the king one of the small entertainments for which he had acquired a reputation, and with which he regaled a provinces." The king accepted. Molière's troupe then performed *Le Docteur amoureux (The Doctor in Love)*. The king laughed at this farce until he cried. He gave the troupe permission to install itself in the Théâtre du Petit-Bourbon, which will henceforth share with the Italian actors directed by the famous Scaramouche.

January 18, 1668: Lully at the Louvre

Tomorrow, January 18, 1668, a new work by Lully, *Le Carnaval (The Carnival)* will be presented at the Louvre. The text was written by Monsieur Isaac de Benserade. Some will no doubt remember that Lully was also indebted to Monsieur de Benserade for the libretto of the ballet *Le Temps (Time)*, the first of his works to be performed at the Louvre on November 30, 1654. They will also remember that, throughout these fourteen years, Monsieur Lully gave performances at the Louvre of *Les Plaisirs (Pleasures)* on February 4, 1655; *Psyché ou de la puissance de l'amour (Psyche or the Power of Love)* on January 16, 1656; *Amour malade (Sick Love)*, one year later in the palace's great room, on January 17, 1657. *Xerxes*, a musical comedy, was performed on November 22, 1661; and finally, the ballets *L'Impatience (Impatience)*, on February 19, 1661, and *Le Mariage forcé (The Forced Marriage)*, on January 29, 1664 were also performed at the Louvre.

The inverse pyramid by I. M. Pei. The point is 4.6 feet from the floor.

Opposite page:
Entrance to the Carrousel du Louvre from the rue de Rivoli by the escalators.

The Carrousel of the Louvre

The vastness of the Grand Louvre (the modern renovation of the former museum) is not visible at first sight. The spectacular sight of the Pyramid, with the three smaller pyramids and the basins surrounding it, represents only a small part of the whole complex. In fact, you must go under the museum in order to appreciate the amount of space that has been created. A veritable underground village unto itself, the Carrousel complex extends through the Hall of Napoleon, where some five and a half million visitors pass each year. These areas, designed by the architect Michel Macary, connect with the ramparts of Charles V, discovered during the excavations for their construction. The museum shop is located there, as well as many restoration workshops. The shop benefits from the natural light from one of the inverted pyramids, whose point comes to within 4.6 feet of the floor, at the place where one may findr the little stone pyramid so well known to readers of *The Da Vinci Code*.

Within this complex, which contains both monumental spaces and intricate detail, aside from many shops in the retail space, are rooms that accommodate, according to the season, fashion shows, a fair of modern and contemporary art (Art Paris), a photography exhibition (Paris Photo), and a prestigious antiques show (Biennale des Antiquaires). You can also attend a play put on by the Studio-Théâtre of the Comédie Française. A metro station will eventually connect this area of the museum with Paris.

How many panels of glass are in the Pyramid of the Louvre?

Mysteries of the Louvre (1):
The Da Vinci Code

With its 16 million readers, Dan Brown's novel has made a cynosure of the Louvre for a whole new category of visitors with strong convictions. These conspiracy buffs come to the museum in order to retrace the steps of Robert Langdon and Sophie Neveu in their search for the murderer of the curator Jacques Saunière.

The itinerary begins at the Denon staircase, passes by the Salon Carré, crosses the Grande Galerie (1,640 feet) with its collection of Italian masterpieces (Caravaggio, Titian, Veronese...), and ends in the Salle des États, the scene of the crime, that houses the *Mona Lisa*. Some even choose to come on Wednesday or Thursday, when the Louvre is open in the evening, in order to better replicate the atmosphere of the crime and to slip more easily into Langdon's footsteps as, having decrypted the anagram for "O Draconian Devil! Oh Lame Saint!", he finds himself in front of the secret: "Leonardo da Vinci! The *Mona Lisa!*" The setup for the curator's murder— of devilish inspiration—is actually a coded message left to help solve the mystery. The pentacle (one of the oldest symbols in the world, dating

from 4,000 years before Christ), the goddess Venus, the Catholic Church, and among many other artists, Leonardo da Vinci and his most famous works: *The Vitruvian Man, the Virgin of the Rocks,* and naturally, the celebrated *Mona Lisa*... They are clues and symbols at the same time. A subtle mix of fact and fiction, *The Da Vinci Code* informs us that the Carrousel Arch was once the scene of orgiastic rituals, but that it is also the best place from which to view everything from the Louvre to the Jeu de Paume (Tuileries Garden). It's up to you...

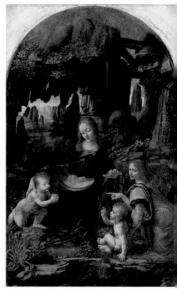

673, and not 666 as Dan Brown's novel would have it.

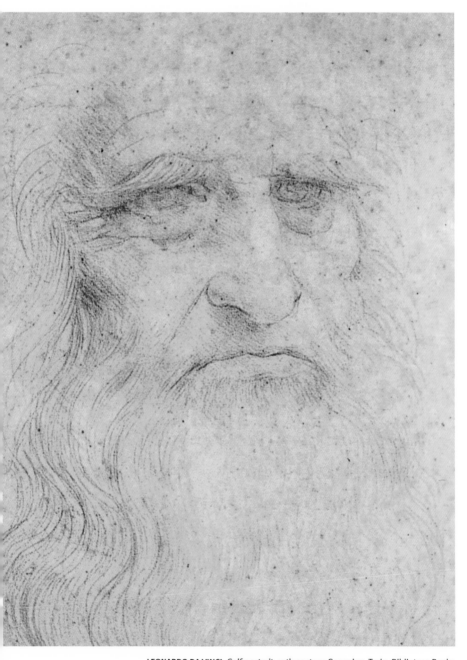

LEONARDO DA VINCI, *Self-portrait,* 15th century. Sanguine. Turin, Biblioteca Reale.

Opposite page: top: The cover of a worlwide success. Bottom: **LEONARDO DA VINCI,** *The Virgin, the Infant Jesus, Saint John the Baptist and an angle, called the Virgin of the Rocks,* 1483–1486. Oil on wood transferred to canvas, 199 x 122 cm.

Detail
Guess the artwork

DOMENICO GHIRLANDAIO
Portrait of an Old Man With a Young Boy,
circa 1490. Oil on wood, 62 x 46 cm.

Belphegor: 1965–2001, from the TV movie by Claude Barma to the feature film by Jean-Paul Salomé, from Juliette Gréco to Sophie Marceau, from studio reconstructions to the Grand Louvre live... all of France is dumbstruck by the phantom of the Louvre.

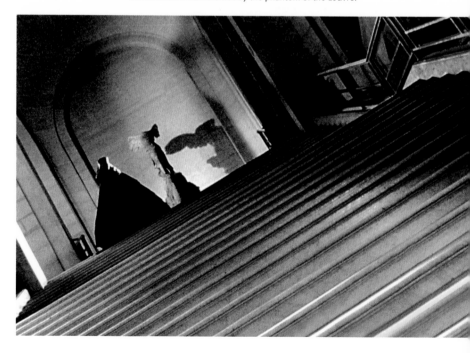

Mysteries of the Louvre (2): *Belphegor, The Phantom of the Louvre*

In March 1965, France held its breath. Each week the small black and white screen took the nation into the Louvre Museum, an unexpected set for tragic happenings. Week after week, *Belphegor* led millions of bemused viewers on a merry dance. But who was Belphegor?

"Belphegor is a mystery. The most disturbing mystery that can be imagined, and we don't have the right to unveil it," the newspaper *Le Petit Parisien* had announced when it was preparing to publish the novel by Arthur Bernède (1871–1937) as a serial in 1927.

Some forty years later, the director Claude Barma directed "the Belphegor mystery" for the only television channel of the ORTF (the office of French radio and television). Belphegor, a distant cousin of Baal-peor from the Bible, an idol symbolizing the sun worshipped by the Moabite people, here took on the features of the Egyptian god Osiris, and became the hero of a cult series.

France held its collective breath for four episodes during which it learned of the terrible things happening there after the visitors left. They were even more frightened when the watchman hiding in the museum was savagely killed. People feared for the Rosicrucian treasure and worried about the nuclear threat throughout the film.

In 2001, the director Jean-Paul Salomé attracted more than 2 million filmgoers in France with his screen adaptation starring Sophie Marceau (with an appearance by Juliette Gréco, the star of the television series). This time, the Louvre, which had refused authorization for filming in 1965, agreed to let the filmmakers in. Although it reached out to a new public that does not usually go to museums, the Louvre also took the risk of having its new public continually bothering the staff by asking where the statue of Belphegor could be found—this statue obviously does not exist!

What is the meaning of the magic formula "O Draconian Devil! Oh Lame Saint!" given by the curator Jacques Saunière in the *Da Vinci Code*?

?

The Collections

- DEPARTMENTS: ANCIENT ASIAN, ISLAMIC ARTS, ANCIENT EGYPTIAN, ANCIENT GREEK, ROMAN AND ETRUSCAN, PAINTING, SCULPTURE, OBJETS D'ART, GRAPHIC ARTS
- SECTIONS: HISTORY OF THE LOUVRE AND MEDIEVAL LOUVRE, ARTS AND CIVILIZATIONS OF AFRICA, ASIA, OCEANIA, AND THE AMERICAS

On entering the largest museum in the world (about 645,000 square foot), containing more than 30,000 works of every kind, you must inevitably confront the issue of where to begin. How to avoid getting lost in this labyrinth of galleries, salons, stairwells, and courtyards displaying works ranging from Mesopotamia to the middle of the nineteenth century.

If you want to stick with the permanent collections, you must choose among the eight departments into which they are divided: Ancient Asian; Ancient Egyptian; Ancient Greek; Roman and Etruscan; Islamic Arts; Painting; Sculpture; Objets d'Art; Graphic Arts. You must then follow one of the three wings of the Louvre : Denon, to the south; Sully, to the east; or Richelieu, to the north. You may come upon rooms dedicated to the history of the Louvre itself, from the medieval château built in 1190 to the Pyramid, which opened in 1989, or walk down into what were the moats of the Louvre of Philip-Augustus and of Charles V, under

the Square Courtyard. Or you may also wish to visit one of the many temporary exhibitions organized by the museum alongside its permanent collections: Florentine Drawing at the Time of the Medici, Roman-style France at the Time of the Capetians, Masterpieces of Islam, or Faiences from antiquity, to cite only a few of the exhibitions the museum proposes.

It is a perfect anagram of "Leonardo da Vinci! The Mona Lisa!" — which indicates the place where the curator has left a clue for his niece Sophie Neuveu and the professor Robert Langdon.

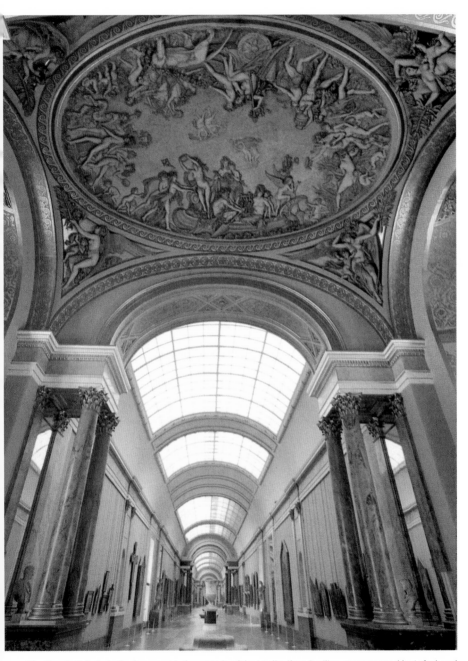

The Grande Galerie. In the foreground, the rotonda of the Lesdiguières Pavilion, reconstructed by Lefuel, and decorated with a white stucco cupola with a gilded base by Auguste Carrier-Belleuse.

1

2

THE LOVERS ON THE
BRIDGE

•

BELPHEGOR (1965)

•

FUNNY FACE

•

BELPHEGOR (2001)

3

4

CHARLES LE BRUN, *Depiction of Psychological Emotions: Anger,*
17th century. White paper, black crayon, 23.40 x 18.10 cm.

Graphic Arts Department

- FROM THE 14TH CENTURY TO THE 19TH CENTURY
- FRANCE, ITALY, SPAIN, GERMANY, FLANDERS, NETHERLANDS, GREAT BRITAIN...

Judging by the number of works it keeps—more than 100,000—the Graphic Arts department is the most important in the Louvre museum. It is also the oldest. It is the direct descendent of the Cabinet des Dessins, created in 1671 by Louis XIV. All schools and techniques, from the fifteenth to the nineteenth centuries, are represented there.

In 1671, Louis XIV acquired part of the exceptional collection of Everhard Jabach (1618–1695). A descendant of a family of German bankers, Jabach moved to Paris, where, among other things, he fulfilled the duties of chairman for the East India Company and the Gobelins factory. With this purchase, the Cabinet des Dessins gained 5,542 drawings all at once, including 2,000 particularly accomplished works, which were called at the time "prescriptive drawings." Many of these works went into the museum's collections. The rest comes mostly from painters with studios at the Louvre.

In 1775, 1,031 drawings were bought at the sale of the Mariette collection; Mariette was the most important collector of his time.

In 1790, 10,999 pieces were listed. This number was soon doubled when the possessions of émigrés were seized, among which were the collections of the Comte d'Orsay and those of the Comte de Saint-Morys.

The collection was later enriched by purchases and especially by sometimes prestigious gifts and legacies. In 1936, for example, the heirs of Baron Edmond de Rothschild made a gift to the Louvre of his collection, which included more than 40,000 prints, 3,000 drawings, and 500 illustrated books.

The department also has more than 16,000 engraved copper plates for chalcography (the workshop where the metal plates are inked and passed through the press). Print runs are still made today. They are sold through the Réunion des Musées Nationaux (Meeting of the National Museums). The first exhibition of drawings took place in the Grande Galerie in 1797. Nearly 400 works were shown. Since then, many temporary exhibitions have made it possible to gradually discover the secret riches of the graphic arts collection.

One last detail about this unusual department: researchers and amateurs are welcome to view the works in a special consultation room—but only by appointment.

How many rooms does the Louvre have?

Graphic Arts: Icons

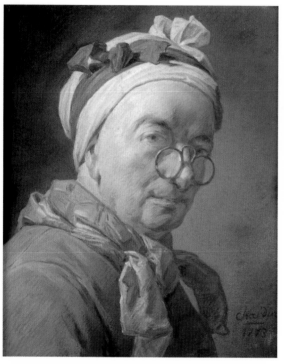

they tell us that the shepherdess who made a portrait of her lover had only an awl for both color and brush, or at most a pencil with which she traced the image of the one she loved." Drawing, which was first attached to painting, slowly emerged as an art in its own right in the eyes of both artists and collectors. As we look at the remarkable sheets preserved by the Graphic Arts department we are reminded of at least two remarks said by the artists for whom the Louvre was a studio. Jean-Auguste-Dominique Ingres (1780–1867), who painted for the Louvre, proclaimed, "Drawing is the true test of art." And Paul Cézanne (1839–1906), who kept coming back to the Louvre to "learn to read" from the masters, said, "Pure drawing is an abstraction." Outlines, sketches, first sketches, first ideas for a composition, thumbnail sketches—all drawings have the power to share with us the intimacy of the artists' work, whatever technique was used: pencil, wash drawing, charcoal, black chalk, red chalk, or ink. The Louvre's admirable collection, where we find birds of paradise sketched by Rembrandt, or Ingres's

On January 9, 1672, during one of the first meetings of the Académie Royale de Peinture et de Sculpture (Royal Academy of Painting and Sculpture) that was held at the Louvre, Charles Le Brun, court painter to King Louis XIV, gave a lecture. He assured his fellow members: "If we go back to what the ancients told us of the origins of painting, we will see it was not discovered through color—because

! About 400. It varies depending on the work in progress.

154

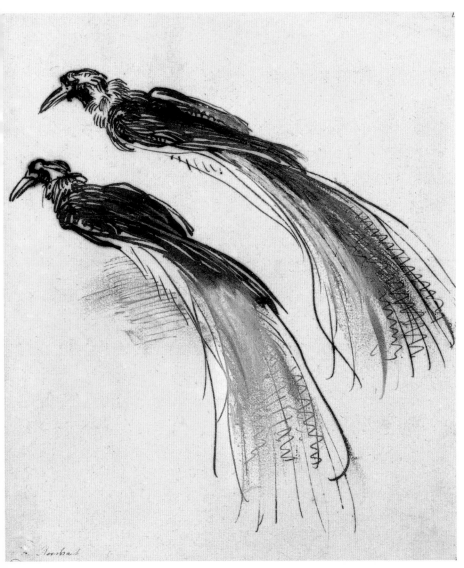

studies for *The Turkish Bath,* or even Chardin's last self-portraits done in pastel, allows us a unique glimpse in the intimacy of the artists' work.

HARMENSZ VAN RIJN REMBRANDT,
Two Studies for the Bird of Paradise,
circa 1640. Pen and ink, brown wash
with white highlights, 181 x 154 cm.

Opposite page:
JEAN-BAPTISTE-SIMÉON CHARDIN,
Self-portrait "with spectacles", 1771.
Pastel on gray paper, 45.9 x 37.5 cm.

Art & Engraving
Which technique was used?

1. ETCHING: **Jean and Pierre Le Campion**, *Demolition of the Bastille*, 1789, Aquatint, etching, 19.10 x 28.50 cm. Former Rothschild collection. - 2. METAL POINT: **Harmensz van Rijn Rembrandt**, *Jesus Healing the Sick*, first stage, circa 1649, Metal point, chisel, 28 x 39,20 cm. Former Rothschild collection. - 3. XYLOGRAPHY: **Albrecht Dürer**, *The Rhinoceros*, 1515, Xylography, Former Rothschild collection. - 4. LITHOGRAPHY: **Louis Haghe**, *The Royal Ship Victoria and Albert Louis*, 19th century, Lithograph.

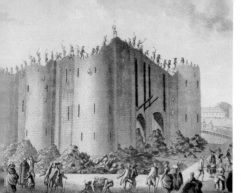

XYLOGRAPHY

1

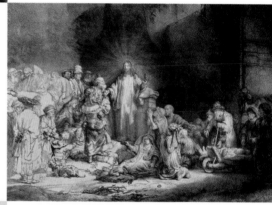

ETCHING

2

LITHOGRAPHY

3

METAL POINT

4

Chalcography

Among the 130,000 pieces collected by the Graphic Arts department, 16,000 are chalcographic plates. This scientific-sounding word is derived from the Greek words *khalkhos,* meaning copper, and *graphein,* to write. It refers to a technique that consists in engraving a copper plate to be able to print and reproduce several copies of an image. This technique made its appearance toward the middle of the fifteenth century, at the same time as printing.

The French Revolution developed the Cabinet des Dessins, which had belonged to the kings of France since Louis XIV, by seizing the possessions of the aristocratic émigrés. The arrival of these collections doubled the number of works in the collection. During this same period, the meaning of the word *chalcography* changed: whereas, before, it referred to the workshops where plates were inked and printed, the same word also came to be used for all stamps, whether or not they were engraved on copper.

The Chalcographie of the Louvre was founded in 1797. The creation of the Réunion des Musées Nationaux in 1895 made it possible to sell the plates produced by the Chalcography. Today the most recent editions of chalcography are still used according to a technique identical to the originals, which means anyone and everyone can

ALFONS MUCHA,
Poster for the printers
Cassan & sons of
Toulouse, 1897.
Colored lithograph,
179 x 72.50 cm.
Paris, chalcographie
du musée du Louvre.

Opposite page:
FORSELL AND LONGPRE,
Description of Egypt,
plate 10 *(Zoology, shells)*, 1809–1822.
Aqua fortis on copper,
60 x 43 cm.
Paris, chalcographie
du musée du Louvre.

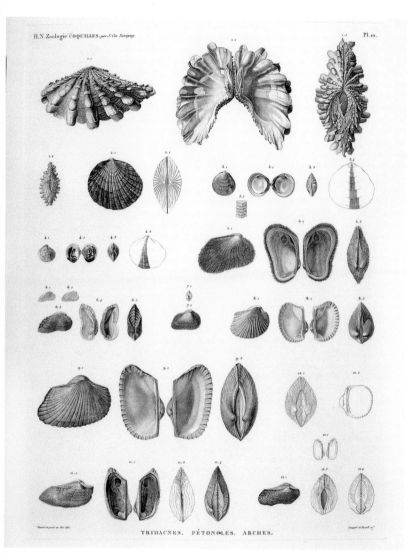

TRIDACNES. PÉTONCLES. ARCHES.

have a work from the Louvre, or from any other museum, such as the Musée d'Orsay, if they so desire. Chalcographic plates are not the only prints kept by the Graphic Arts department. Its collections have hundreds of exceptional works and all techniques are represented: engraving on wood or xylography, etching or aquatint, metal-point engraving, monotype, lithography, and others. Great artists rub shoulders with a host of anonymous artists and craftspeople who have contributed to distributing the most famous works of their time.

How many departments does the Louvre have?

Painting Department

- FROM THE 14TH CENTURY TO THE 19TH CENTURY
- FRANCE, ITALY, SPAIN, GERMANY, FLANDERS, NETHERLANDS, GREAT BRITAIN…

Eight: Asian Art, Egyptian Art, Greek Etruscan and Roman Art, Islamic Art, Painting, Sculpture, Graphic Art, and Objets d'Art.

Approximately 6,000 works are exhibited over 194,000 square foot and some 7,700 are kept in reserve in the Painting department at the Louvre. These paintings have two things in common: they were all painted between the end of the thirteenth century and the middle of the nineteenth century, and they are all European works.

The history of the collections began with Francis I as he started a collection of paintings at the Château de Fontainebleau at the start of the fifteenth century. This collection, the Cabinet du Roi (the King's Exhibition), was brought to the Louvre, then regularly expanded by his successors. At the end of the reign of Louis XIV, the royal collection already numbered nearly 1,500 paintings.

With the opening of the Muséum des Arts in 1793, the Louvre opened the royal collections to the public for the first time. In addition to royal property, these collections contained property that had belonged to émigrés and the Church, whose possessions were confiscated to become the property of the Republic. Century after century, purchases (like that of the Campana collection in 1862) and gifts (like those of La Caze in 1869) expanded the museum's collections. With a few rare exceptions, these gifts were classified according to a system chosen in 1794: by national schools, and then, within each school, by chronological order. Since the opening of the D'Orsay museum in 1986, paintings dating later than 1848 are no longer housed in the Louvre.

The extensions to the Grand Louvre make it possible for the collections of the Painting department to be spread over three areas of the palace measuring 194,000 square foot. The northern schools are exhibited in the Richelieu wing, and Italian and Spanish painters in the Denon wing. And, as it should be, because they are so numerous and their formats so diverse, from the miniature to the "larger-than-life," French paintings are everywhere: in the Richelieu wing, the Denon wing, the Sully wing, and on the second floor of the Cour Carrée. Religious or secular works, historical paintings, genre paintings, battle scenes, paintings of the hunt or celebrations, scenes of chivalry, portraits, nudes, landscapes, still lifes, allegories are all there—the Louvre is one of the rare museums in the world that offers a veritable encyclopedia of painting.

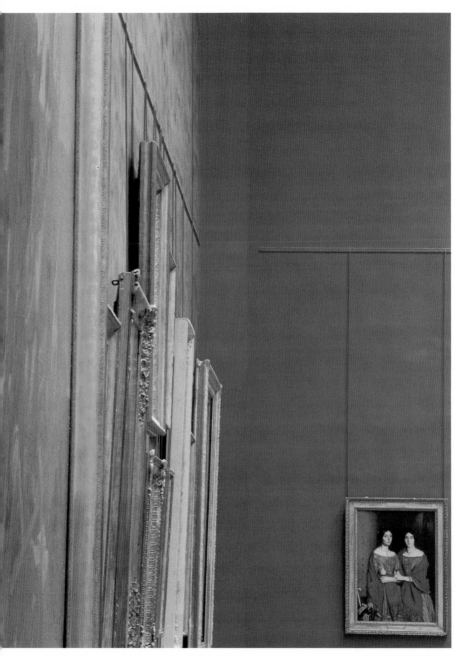

View of the salle Daru. In the background: **THÉODORE CHASSÉRIAU,**
Mesdemoiselles Chassériau, also called "The Two Sisters," 1843.
Oil on canvas, 180 x 135 cm.

Homage to the *Mona Lisa*
Who painted what?

Answer

1. ANDY WARHOL, *Thirty Are Better Than One*, 1963. Mixed media on canvas. Private collection. -
2. FERNANDO BOTERO, *Mona Lisa*, 1977. Oil on canvas, 183 x 166 cm. Colombia, private collection. -
3. FERNAND LÉGER, *Gioconda With Keys*, 1930. Huile sur toile, 91 x 72 cm. Biot, musée Fernand Léger. -
4. KAZIMIR MALEVITCH, *Composition With the Mona Lisa, Partial Eclipse*, circa 1914. Oil and collage on canvas, 62,50
x 49,30 cm. Saint Petersburg, Russian National Museum.

2

1

FERNAND LÉGER

•

KAZIMIR MALEVITCH

•

FERNANDO BOTERO

•

ANDY WARHOL

3

4

Painting: Icon

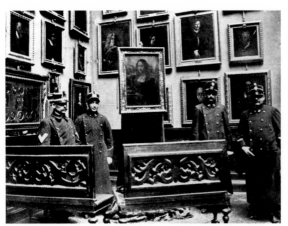

The *Mona Lisa* and the guards assigned to protect her, in the Italian portraits room of the Uffizzi Gallery in Florence in 1913. The picture had just been recovered after its theft from the Louvre Museum by Vincenzo Perrugia, on the 21st of August 1911.

Opposite page:
The *Mona Lisa* greets visitors to the renovated Salle des États, 2005.

Chiaoscuro, sfumato, delicately contoured flesh, the ghost of a smile, hands gently crossed, head and shoulders tightly held within the painting's frame: simply describe her and she is instantly recognizable. If there is one work that symbolizes the Louvre, it is the *Mona Lisa*!

The *Mona Lisa* is the most famous painting in the world. But this is almost the only thing that is certain about this masterpiece, except perhaps its size, 77 x 53 cm, and the technique used, oil on a panel of poplar. The date it was painted is uncertain, but was probably between 1503 and 1506. As to the rest, she remains an enigma.

The mystery that still surrounds the identity of the model keeps producing a number of hypotheses and reams of writing. Some even claim that Leonardo da Vinci himself was the model. "Not true!" others cry, "it was Isabella d'Este." "No! It was Giuliano de' Medici's mistress, Pacifica Brandano." "Absolutely not! It is a portrait of Lisa Gherardini, the wife of Francesco del Giocondo, whom he married in 1495." Still others claim it is the portrait of Mona Lisa (Mona is the affectionate diminutive of Madonna) described by Vasari in the first biography of Leonardo.

Another mystery is how the Mona Lisa became part of the collection belonging to Francis I. Leonardo started the painting in Florence around 1503, then took it to France after he was arrested in Milan. Some say the king bought the painting from Leonardo himself, others that he acquired it from his heirs; still others say that on Leonardo's death, the portrait went back to Italy. However it came about, the painting found its way into the collections of Francis I; it went to Versailles under Louis XIV, and the Tuileries under Napoleon I. Finally, during the Restoration, it went to the Louvre.

And then, on August 21, 1911, it disappeared. The *Mona Lisa* was

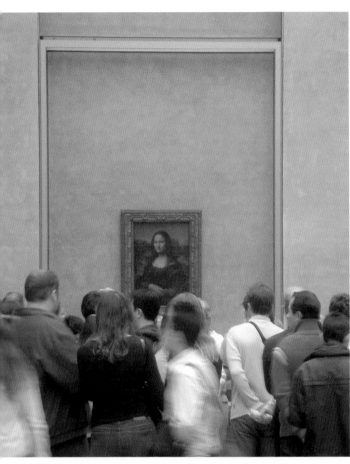

stolen—what a scandal! The police investigated every lead. The poet Guillaume Apollinaire was arrested because he had wanted to "burn down the Louvre." But that trail led nowhere. Two years later, the painting was found in Italy. Vincenzo Peruggia, a construction painter, had wanted to take it home to Italy.

Since its return to the Louvre, the painting has stayed there, except for two "official visits." In 1963 it went to Washington, and in 1974 to Tokyo. And each time it caused great excitement

and was treated like a star.

Since April 2005, Leonardo da Vinci's *Mona Lisa* has been on display in the Salle des États, which was entirely renovated after four years of work. It sits under a spectacular glass covering, designed by the architect Lorenzo Piqueras, and is surrounded by the Louvre's collection of sixteenth century Venetian paintings and *The Marriage at Cana,* by Veronese. Due to multiple attempts to steal or degrade the painting in the past, the *Mona Lisa* is now protected by a bulletproof glass.

French Painting (15TH/16TH CENTURY)

- 15TH CENTURY: HENRI BELLECHOSE, JEAN FOUQUET, ENGUERRAND QUARTON, JEAN HEY (MASTER OF MOULINS)
- 16TH CENTURY: JEAN DE GOURMONT, JEAN CLOUET, FRANÇOIS CLOUET, JEAN COUSIN THE ELDER, ANTOINE CARON, FONTAINEBLEAU SCHOOL…

Classifications by national school—French, Italian, Spanish, and others—were set up immediately after the French Revolution (1789), at a time in history when the notion of "nation" was essential. Before this time, the notion of French painting was less important, so artists evolved with a European awareness instead. At the very beginning of French painting were two major influences, which would gradually take the fore in the search for a uniquely French style: that of the Avignonais masters, who were themselves influenced by the Siennese painters, and that of the

painters who worked for the dukes of Burgundy, who were in their turn marked by the works of the Flemish painters.

To understand this better, take a look at the *Altarpiece of Saint Denis,* by Henri Bellechose, and the *Pietà of Villeune-lès-Avignon,* by Enguerrand Quarton. Bellechose's *Altarpiece,* through a style that combines realism and grace, is one of the last representative paintings of the Franco-Flemish school and one of the masterpieces of what is known as international Gothic. The *Pietà,* painted forty years later, also on a background of gold, reveals the

The Louvre possesses five pictures by Leonardo da Vinci: four are in the Grande Galerie, and the *Mona Lisa* is hung in the salle des États.

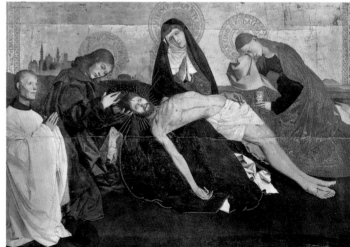

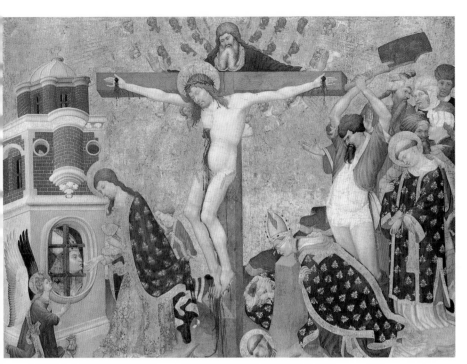

crucial role of the Italian influence when, after the installation of the papacy in Avignon in 1330, the popes had painters come to them, like the Siennese Simone Martini (c. 1282–1344), who moved there in the fourteenth century and stayed a long time.

It was with the work of Jean Fouquet, who spent several years in Italy around 1445–1448, that the Italian influence on French painting became predominant. It would become exclusive when Francis I called to his service painters such as Rosso and Primatice, who started the Fontainebleau school. But at the same time, the Italian painters were imposing the refinement of mannerism. François Clouet, without disregarding mannerism, combined it with the meticulousness of the Flemish masters to develop a specifically French portrait style that was a combination of charm and discipline.

HENRI BELLECHOSE,
Altarpiece of saint Denis, for the Église de la Chartreuse at Champmol, near Dijon, 1415–1416.
Gold background, 162 x 211 cm.

Opposite page:
ENGUERRAND QUARTON, *The Pietà of Villeneuve-lès-Avignon,* circa 1455. Oil on wood, 163 x 218 cm.

Nicolas Poussin
Guess the artworks

Answer

NICOLAS POUSSIN (Villers, 1594–Rome, 1662)

1. *The Shepherds of Arcadia*, also called *Et in Arcadia Ego*, circa 1638–1640. Oil on canvas, 85 x 121 cm. In bucolic Greek and Latin poetry, Arcadia is represented as a land of calm and serene happiness. Renaissance literature took up this fiction, which was a staple of classical art.

2. *Moses in the Bulrushes*, 1638. Oil on canvas, 94 x 121 cm. Prophet, founder of the religion and of the nation of Israel, Moses, born into the tribe of Levi, was abandoned as an enfant on the banks of the Nile, where he was found by the Pharaoh's daughter.

3. *The Judgment of Solomon*, 1649. Oil on canvas, 101 x 150 cm. King of Israel, son of David and Bathsheba, Solomon was know for his wisdom. In the "judgment" in which two women claim to be the mother of a child, he orders the child to be cut in two; the real mother is the one who would deny the child in order to save it: this typifies his perspicacious and equitable judgment.

4. *The Rape of the Sabines*, circa 1637–1638. Oil on canvas, 159 x 206 cm. After the founding of Rome, Romulus, in order to procure wives for his companions, organized some games to attract neighboring tribes. The Romans would then abduct the young women, mostly Sabines (a people from central Italy), thereby provoking a war, which ended in a treaty of alliance.

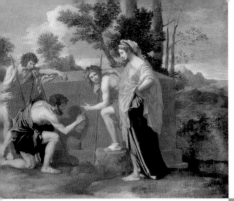

THE JUDGMENT OF SOLOMON

1

HE RAPE OF THE SABINES

2

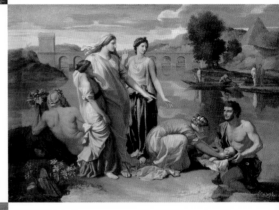

THE SHEPHERDS OF ARCADIA

3

OSES IN THE BULRUSHES

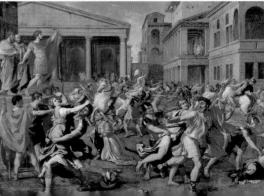

4

French Painting (17TH/18TH CENTURY)

- 17TH CENTURY: CLAUDE VIGNON, VALENTIN DE BOULOGNE, LUBIN BAUGIN, LOUISE MOILLON, GEORGES DE LA TOUR, LOUIS LE NAIN, ANTOINE LE NAIN, SIMON VOUET, PIERRE MIGNARD, EUSTACHE LE SUEUR, CLAUDE GELLÉE (LE LORRAIN), NICOLAS POUSSIN, PHILIPPE DE CHAMPAIGNE, CHARLES LE BRUN, FRANÇOIS DESPORTES, JOSEPH PARROCEL, HYACINTHE RIGAUD
- 18TH CENTURY: NICOLAS DE LARGILLIÈRE, JEAN-ANTOINE WATTEAU, FRANÇOIS LEMOYNE, PIERRE SUBLEYRAS, JEAN-BAPTISTE PATER, NICOLAS LANCRET, JEAN-BAPTISTE SIMÉON CHARDIN, JOSEPH VERNET, FRANÇOIS BOUCHER, JEAN-BAPTISTE GREUZE, MAURICE QUENTIN DE LA TOUR, HUBERT ROBERT, JEAN-HONORÉ FRAGONARD, JACQUES-LOUIS DAVID, ÉLISABETH VIGÉE LEBRUN, LOUIS-LÉOPOLD BOILLY, FRANÇOIS GÉRARD, PIERRE-NARCISSE GUÉRIN...

The will and the taste of Louis XIV have influenced decisively the development of French painting. Not only did he create the

Académie Royale de Peinture et de Sculpture (Royal Academy of Painting and Sculpture), but he was also an avid and single-minded collector: single-minded because his choices always favored the aesthetics of classicism. Poussin (1594–1665) was then the absolute standard, and Louis XIV acquired thirty-one of his works—even though, paradoxically, most of them were painted in Rome. Poussin agreed to leave Italy in 1640 only to serve King Louis XIII, and he stayed in Paris two years, during which time he devoted himself to projects on the Grande Galerie of the Louvre, before returning to Rome.

Louis XIV also acquired several canvases by Claude Gellée, called Le Lorrain (1600–1682), and inherited the collections from the studios of his first painters, Charles Le Brun (1619–1690), and Pierre Mignard (1612–1695) on

their deaths. He was also interested in the works of Le Sueur (1617–1655) and de Bourdon (1616–1671). But the Louvre would have to wait until the nineteenth century to inherit the works of the Le Nain brothers, thanks to the fabulous legacy of La Caze.

It was this same legacy that finally brought eighteenth-century French painting into the Louvre. Thanks to La Caze, works by Watteau (1684–1721), Chardin (1699–1779), and Fragonard (1732–1806) finally found their way into the Louvre. Before this date, because Louis XV had not assembled a collection as had Louis XIV, because Madame de Pompadour's private commissions were scattered after the death of her heir, and because the art of his time displeased Louis XVI, the Louvre only had works from the Académie Royale.

JEAN-HONORÉ FRAGONARD,
The Lock (detail), circa 1777.
Oil on canvas, 73 x 93 cm.

Opposite page:
JEAN-BAPTISTE-SIMÉON CHARDIN,
The Monkey Painter,
Salon of 1740.
Oil on canvas, 73 x 59 cm.

Where did David stage the official display of his painting, *The Sabines?*

French Painting (19TH CENTURY)

- ANTOINE-JEAN GROS (BARON), PIERRE-PAUL PRUD'HON, JACQUES-LOUIS DAVID, JEAN-AUGUSTE DOMINIQUE INGRES, THÉODORE GÉRICAULT, EUGÈNE DELACROIX, PAUL DELAROCHE, HIPPOLYTE FLANDRIN, THÉODORE CHASSÉRIAU, THÉODORE ROUSSEAU, CHARLES-FRANÇOIS DAUBIGNY, JEAN-BAPTISTE-CAMILLE COROT...

In 1818, the Luxembourg Museum was considered to be the premier museum of contemporary art, as it collected works purchased mainly during the Salons, such as paintings by Girodet (1767–1824), Gérard (1770–1837), Guérin (1774–1833), and Prud'hon (1758–1823). Soon considered an "antechamber" of the Louvre, the Luxembourg became used to sending artists' works to the larger museum after their death. There they joined the works Napoleon Bonaparte commissioned from Gros *(Napoleon at the Pesthouse of Jaffa)* and David *(The Coronation of Napoleon I)*.

During this period, some French museums did not hesitate to buy works that questioned the neoclassicism imposed on the French school by David at the end of the eighteenth century. Thus was acquired, in 1825, but not without much tension and debate, the very famous *Raft of the Medusa,* by Géricault (1791–1824).

The emergence of Romantism only emphasized this misunderstanding between the painters and the government. *Liberty Leading the People* by Eugène Delacroix (1798–1863) was one of the first signs of this. In three days, July 27, 28, and 29, 1830, a new revolution

In his Louvre studio, in 1800.

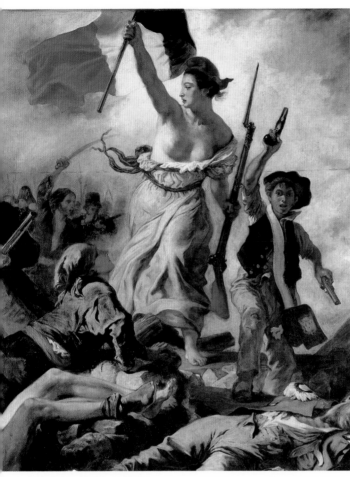

EUGÈNE DELACROIX,
*July 28, 1830: Liberty
Leading the People*,
1830. Oil on canvas,
260 x 325 cm.

Opposite page:
THÉODORE GÉRICAULT,
The Raft of the Medusa,
Salon of 1819. Oil on
canvas, 491 x 716 cm.

ousted the Bourbons from the throne and Charles X was sent into exile. Eugène Delacroix did not take part in the fighting, but he was a witness to it. He wrote that he may not have fought for the revolution, but he wanted to paint for it. This painting, paradoxically acquired by King Louis-Philip at the Salon of 1831, was almost immediately given back to the painter, before finally finding its place in the Louvre in 1874. With the introduction of "realism" in 1850, then the appearance of the beginnings of Impressionism around 1860, this misunderstanding between painters and power quickly became a veritable divorce.

In 1848, the Salon was organized at the Louvre. This date is important because today it marks the separation of the collections between the Louvre Museum and the D'Orsay Museum—the latter contains most Fine Arts and Decorative Art works, from 1848 to 1914.

Jacques-Louis David
Guess the artworks

Answer

JACQUES-LOUIS DAVID (Paris, 1748–Bruxelles, 1825)

1. *The Oath of the Horatii*, 1784. Oil on canvas, 330 x 425 cm. The three Horatius brothers, chosen by the Romans to challenge the Curiatii, who fought for Alba, swore to conquer or to die as they received their swords from their father.

2. *The Loves of Paris and Helen*, 1788. Oil on canvas, 146 x 181 cm. Picked by the gods to choose the most beautiful among Hera, Athena and Aphrodite, Paris awarded the golden apple to Aphrodite, who then favored him with the love of Menelaus' wife, Helen, whose abduction would provoke the Trojan War.

3. *Leonidas at Thermopylae*, 1814. Oil on canvas, 395 x 531 cm. Leonidas I, king of Sparta, was charged with defending the narrow passage at Thermopylae with a small Greek contingent against the army of Xerxes. He put up fierce resistance, but in the face of the overwhelming superiority of the enemy he and three hundred Spartans were killed.

4. *The Sabines*, 1799. Oil on canvas, 385 x 522 cm. The Sabine women stand between their Roman husbands (at the right) and their Sabine brothers (at the left), and show them their children. At the sight of his wife, Hersilia, Romulus suspends in air the javelin that he was about to throw at the woman's father, Tatius, king of the Sabines. Struck by the courage of the women, the two sides lay down their arms.

THE SABINES

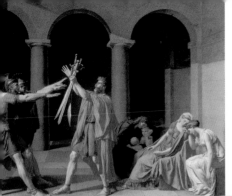

HE OATH OF THE HORATII

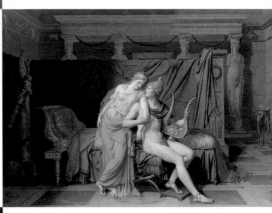

LEONIDAS AT THERMOPYLAE

LOVES OF PARIS AND HELEN

Italian Painting (13TH CENTURY/MID-15TH CENT

- FLORENCE, SIENA
- CENNI DI PEPI (CIMABUE), GIOTTO DI BONDONE, SIMONE MARTINI, PIETRO DA RIMINI, FRA ANGELICO, ANTONIO PISANO (PISANELLO), STEFANO DI GIOVANNI (SASSETTA), FILIPPO LIPPI, PAOLO UCELLO, PIERO DELLA FRANCESCA...

SIMONE MARTINI,
The Carrying of the Cross, circa 1335. Oil on wood, 30 x 20 cm.

The richness of its collections makes the Louvre one of the most important...Italian museums. How could it be otherwise? The Roman Empire has never ceased to haunt the memory of Christian Europe. It was through Rome's will that Europe was converted to Christianity. Perspective, a technique that would affect paintings for the next five centuries, was developed in Florence during the Quattrocento. And the collections of the kings of France continued to be enriched by works that came from Italy

The Louvre collections bear witness to the fact that France has always been—admiringly and sometimes jealously—fascinated by Italy. They enable us to see the development and measure the diversity of Italian art from the "primitives" to the Renaissance. And this is true even if the Louvre has only a part of a work. This is the common point of two major works in the Italian department: the *Carrying of the Cross,* by Simone Martini (c. 1284–1344), and the *Battle of San Romano,* by Paolo Ucello (1397–1475), which are both parts of larger works separated by history.

The *Carrying of the Cross,* by Martini, is one of the panels of an altarpiece painted for a cardinal

from the Roman Orsini family. Parts of this altarpiece are in Paris, Anvers, and Berlin. If Martini is classed as "primitive," despite a composition that shows the movement of the crowd leaving Jerusalem, despite the diversity of expressions that describe the pain and violence aroused by Christ's ascent to Golgotha, it is only because he did not use the artifice of perspective.

The *Battle of San Romano,* by Ucello, which tells of Florence's victories over Siena, was commissioned by Cosme de' Medici on three panels. The first is in the National Gallery of London, the third in the Galleria degli Uffizi in Florence, and the central panel is in the Louvre. If Martini did not know about perspective, Uccelo was one of the first to master all its

possibilities. The foreshortening of the painted horses and the rhythms of the raised lances eloquently bear witness to this fact. A complex exercise that is a mix of the arts of color, drawing, and geometry, this work still shows some Gothic influences and is a symbol of the Florentine Renaissance.

PAOLO DI DONO, (UCCELLO), *The Battle of San Romano: The Counterattack of Micheletto da Cotignola,* circa 1435–1440. Oil on wood, 182 x 317 cm.

?

What was the use of the room called "des États"?

177

Italian Painting (MID-15TH CENTURY/18TH CENT

- ROME, FLORENCE, VENICE, BOLOGNA...
- ANDREA MANTEGNA, ANTONELLO DA MESSINA, COSME TURA, SANDRO DI MARIANO FILIPEPI (BOTTICELLI), DOMENICO BIGORDI (GHIRLANDAIO), RAFFAELLO SANTI (RAPHAEL),LEONARDO VINCI, TIZIANO VECELLIO (TITIAN), LORENZO LOTTO, PAOLO CALIARI (VERONESE), JACOPO RO (TINTORETTO), MICHELANGELO MERISI (CARAVAGGIO), GUIDO RENI, GIANDOMENICO TIEPOLO FRANCESCO GUARDI...

Before housing Italian paintings, the Salle des États was a parliamentary assembly room.

The *Portrait of Balthazar Castiglione* painted by Raphael, is, as much because of its drawing as because of the harmony of its singular shades, an affirmation of the power of drawing that Raphael imposed on Rome.

Veronese's *Marriage at Cana* is a veritable hymn to the color that distinguished Venetian painting.

Their qualities of form and their importance from the point of view o art history are sufficient to make them significant works: they represent a synthesis of the issues tackled by Italian and Renaissance painting. But some of the anecdotes that are part of their history make them even more remarkable.

The *Portrait of Balthazar Castiglione,* for example, is the only work at the Louvre that was copied by Rembrandt. Since Rembrandt died in 1669 and the Louvre became a museum in 1793, this could seem surprising. In fact, the painting was sold at auction in 1639 in Amsterdam; Rembrandt was among those bidding in the salesroom. The painting went for 3,500 florins: too expensive for him, even though he was sometimes capable of spending ruinous amounts to quench his passion for collecting. Unable to outbid the person buying for the king of France, Rembrandt made a quick copy in ink of the painting he had lost.

The *Marriage at Cana* arrived in France as a prisoner of the

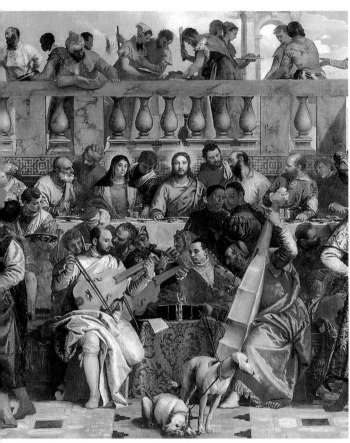

PAOLO CALIARI,
(VERONESE),
The Marriage at Cana
(detail), 1563.
Oil on canvas,
677 x 994 cm.
In the foreground,
dressed as musicians,
are the Venetian
masters Titian, Jacopo
Bassano, Tintoretto
and Veronese himself,
dressed in white.

Opposite page:
RAFFAELLO SANTI,
(RAPHAEL), *Portrait of
Baldassare Castiglione*,
circa 1514–1515. Oil on
canvas, 82 x 67 cm.

Napoleonic troops returning from the Venetian Republic. Despite its large size (21.8 feet high, 32.5 feet wide), it was taken down from the wall of the refectory of the convent of Santa Maria Maggiore to be rolled and taken to Paris.

In this work, Veronese had chosen to represent the famous biblical episode in a Venetian setting, scattering the great masters of Venetian painting throughout the assembled crowd: Titian, Bassano, Tintoretto, and himself dressed in white.

In 1815, when the conquerors of Napoleon I demanded that France return all the works the emperor had plundered, this painting was not taken back, and it remained at the Louvre with some Italian primitives that no one was interested in at this time. It is one of the rare works at the Louvre that was "pillaged" by Napoleon that the museum was able to keep.

Arcimboldo
Which seasons are represented?

GIUSEPPE ARCIMBOLDO (Milan, 1527–Milan, 1593) This series of the seasons was commissioned in 1573 by Emperor Maximilian II of Habsburg as a gift for the elector Augustus, whose arme, the crossed swords of Meissen, are embroidered on the cloak of *Winter*. The flowered frames were probably added in the 17th century.
1. SUMMER, 1573. Oil on canvas, 76 x 64 cm. - **2. SPRING**, 1573. Oil on canvas, 76 x 64 cm. -
3. WINTER, 1573. Oil on canvas, 76 x 64 cm. - **4. AUTUMN**, 1573. Oil on canvas, 76 x 64 cm.

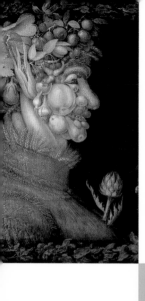

1

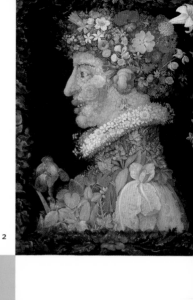

2

SPRING

•

SUMMER

•

WINTER

•

AUTUMN

3

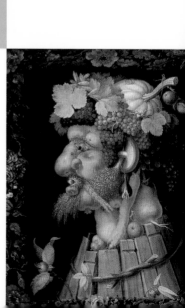

4

Dutch Painting

- 16TH CENTURY AND 17TH CENTURY
- AMSTERDAM, HARLEM, DELFT...
- AMBROSIUS BOSSCHAERT, FRANS HALS, PIETER JANSZ SAENREDAM, HARMENSZ VAN RIJN REMBRANDT, PIETER DE HOOCH, GABRIEL METSU, GÉRARD DOU, JACOB VAN RUISDAEL, JAN VERMEER...

JAN VERMEER,
The Lacemaker,
circa 1669–1670.
Oil on canvas on wood,
24 x 21 cm.

Opposite page:
**HARMENSZ VAN
RIJN REMBRANDT,**
Bathsheba at Her Bath,
1654. Oil on canvas,
142 x 142 cm.

"Dutch" refers to all of the United Provinces of the North, who broke free from the Habsburg yoke at the end of the sixteenth century and became permanently independent in 1648. The city of Amsterdam, the capital of Holland, because it was one of the largest ports in Europe, then became the capital of Dutch painting.

The seventeenth century was a golden era for Dutch painting. But in this new state, which had fought and driven out Catholic Spain to affirm its Calvinist faith, painters were deprived of orders from the Church. Something new started to happen, painters started selling their paintings to a middle class made up of ship owners, shopkeepers, and bankers. These were the ones for whom Hals (1581/1585–1666), Rembrandt (1606–1669), and Vermeer (1632–1675) painted their masterpieces.

At the Louvre, three women—*The Bohemian Girl,* by Hals, *Bathsheba at Her Bath,* by Rembrandt, and *The Lacemaker,* by Vermeer—show the extraordinary diversity and talents of these outstanding artists.

The Bohemian, by Hals, was a subject very much in fashion in Europe at the time. A courtesan or fortune-teller, she was a key character in the taverns where people went to drink, to dance, and to embrace. Painted with passion and mastery, this portrait is as much the picture of a face as of the deep cleavage where so much flesh is on display.

Bathsheba at Her Bath, by Rembrandt, dreams. She is naked

and has aroused King David's desires. Although absent, King David is at the center of the painting in the form of a letter that Bathsheba is holding. What resigned, worried thoughts occupy her mind? Does she sense that the king will get rid of his rival, her husband, by sending him into a battle from which he will not return? One has to get close to discover *The Lacemaker,* by Vermeer. The painting measures only 24 x 21 cm. The young woman is bent over her work, puts in a pin, holds the bobbins. Her face and hands capture the light that bathes the scene. Her precise, attentive gestures remain hidden, invisible to the eye.

Still lifes and vanitas, floral compositions, interior scenes, landscapes, battle scenes, and also religious scenes: the Louvre's collection of Dutch paintings offers not only a broad view of the grand masters of this school, but also, through these works, an arresting vision of this world where artifice rivals nature, where the trivial mixes with the sublime, and where feasting and celebration counterpoint work and discipline.

How many pictures did Vermeer paint?

Flemish Painting

- FROM THE 15TH CENTURY TO THE 17TH CENTURY
- BOURGOGNE, ANTWERP…
- NETHERLANDS (15TH/16TH CENTURY): JAN VAN EYCK, ROGIER VAN DER WEIDEN, QUENTIN METSYS, JAN GOSSAERT (MABUSE), PIETER I BRUEGEL THE ELDEST, CORNELIS VAN HAARLEM… FLANDERS (17TH CENTURY): PETER PAUL RUBENS, ANTOON VAN DYCK, JACOB JORDAENS…

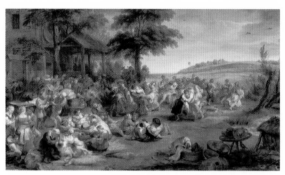

Thirty-four are attributed to him with certainty, two of which are at the Louvre: *The Lacemaker* and *The Astronomer.*

The expression "Flemish primitives," which some insist on using to describe painters such as Jan Van Eyck (c. 1390–1441) and Rogier Van der Weyden (c. 1399–1464) is one of the most troubling in existence. On the one hand, the term *primitive* was used in the nineteenth century with a certain amount of scorn to refer to those artists who had supposedly not yet perfectly mastered perspective. On the other hand, these painters worked in France, in the duchy of Burgundy, to which Flanders then belonged. In truth, "Flemish primitives" were not Flemish, and had nothing of the primitive about them.

The expression "Flemish painting" refers to a world that, from these "primitives" to Peter Paul Rubens (1577–1640), never stopped being faithful to the Roman Catholic religion.

One of the threads running through this school goes from Hieronymus Bosch (c. 1450–1516) to Pieter Bruegel, called Bruegel the Elder (c. 1525/1530–1569), to Rubens (1577–1640). The Louvre is one of the rare museums that makes it possible to untangle this thread. From *The Ship of Fools,* by Bosch, to *The Bazaar,* by Rubens, the same sense of humor, the same witty eloquence, the same loquaciousness is represented. This way of exposing something and laughing at it; revealing vices and describing pleasures; creating a whole where truculence and sensuality, burlesque anecdote and sordid detail, joie de vivre and recklessness interact.

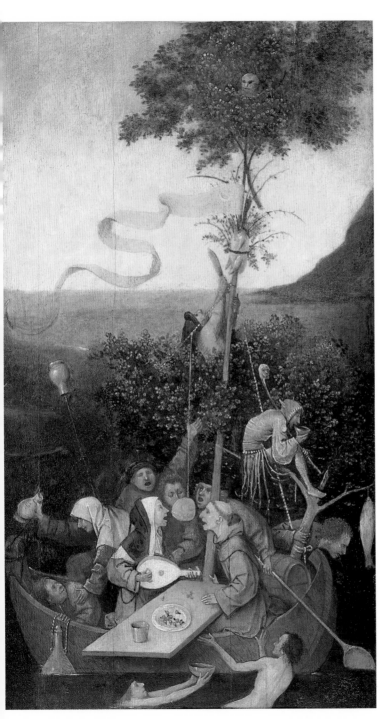

HIERONYMUS BOSCH
VAN AKEN, (BOSCH),
*The Ship of Fools, or
Satire of the Drunken
Revelers,* after 1491.
Oil on wood,
58 x 33 cm.

Opposite page:
PETER PAUL RUBENS,
*The Kermesse, or
Village Wedding,*
circa 1635–1638.
Oil on wood,
149 x 261 cm.

1. FLEMISH SCHOOL, *The Marriage at Cana* (detail), first quarter of the 16th century. Oil on wood,
59 x 36 cm. - **2.** PAOLO CALIARI (VERONESE), *The Marriage at Cana,* 1563. Oil on canvas, 677 x 994 cm. -
3. GHEERAERT DAVID, *The Marriage at Cana,* circa 1501–1509. Oil on wood, 100 x 128 cm. -
4. LEANDRO DA PONTE (LEANDRO BASSANO), *The Marriage at Cana,* after 1578. Oil on canvas, 152 x 214 cm.
The Bible story of the marriage at Cana recounts the first miracle wrought by Jesus: when the wine ran out
at a wedding banquet attended by Jesus and the Virgin Mary, Jesus had six jugs filled with water, which he then
changed into wine. Early representations of the Marriage at Cana, of great simplicity (a few people gathered around
Christ and the Virgin Mary), evolved during the Renaissance and baroque era into scenes of aristocratic pagan
banquets that found their apogee in Veronese.

Answer

The Marriage at Cana
Who painted what?

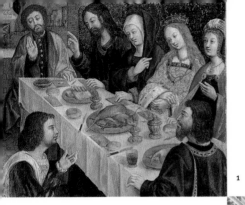

LEANDRO BASSANO

1

VERONESE

2

FLEMISH SCHOOL

3

GHEERAERT DAVID

4

THOMAS GAINSBOROUGH, *Lady Alston,* circa 1760–1765. Oil on canvas, 226 x 168 cm.

Opposite page: **JOSEPH MALLORD WILLIAM TURNER,** *Landscape with a River and a Bay in the Distance,* circa 1845. Oil on canvas, 94 x 124 cm.

English Painting

● 18TH CENTURY AND 19TH CENTURY
● THOMAS GAINSBOROUGH, JOSHUA REYNOLDS, JOHN CONSTABLE, RICHARD PARKES BONINGTON,
JOSEPH MALLORD WILLIAM TURNER...

The Louvre's collection does not allow one to fully appreciate the diversity of English painting, even though it includes several typical works from this school. Despite this fact, several perfectly "English" canvases in the collection are sufficient to reveal the school's most remarkable qualities. Two of these are particularly notable, one in the field of portrait painting and another in landscape painting. The *Portrait of Lady Alston,* by Thomas Gainsborough (1727–1788), is an example of the portraits of the English gentry painted in the eighteenth century by other great artists such as Sir Joshua Reynolds (1723–1792) or Sir Thomas Lawrence (1769–1830), who had devoted themselves to painting landscapes before the fashion for portraits (Van Dick was instrumental in this) impelled them to try this genre. Thomas Gainsborough associated handling colors with rendering textures, celebrating both the charm of the model and that of nature. Characteristic of the painter's style, said to be of the Bath period—a bathing resort highly prized by the elite of English society—this canvas was recently added to the Louvre thanks to the baron de Rothschild.

The *Landscape with a River and a Bay in the Distance,* by Joseph Mallord William Turner, painted around 1845, reveals a new regard for the landscape. It is sketched with a technique that closely resembles the medium of watercolor. This regard where forms and contours dissolve and space and light are determined only by color still influences European—particularly French—painting. During the few months they spent in London at the beginning of the 1870s, the painters Camille Pissarro (1830–1903) and Claude Monet (1840–1926) closely observed Turner's paintings. A few years later, they would be known as the "Impressionists."

Who was the first director of the Louvre?

German Painting

- FROM THE 16TH TO THE 19TH CENTURY
- ALBRECHT DÜRER, HANS BALDUNG GRIEN, LUCAS CRANACH, HANS HOLBEIN THE YOUNGER, CASPAR DAVID FRIEDRICH...

There is no lack of emblematic German works at the Louvre. To be convinced of this, it is enough to go from Albrecht Dürer's *Self Portrait,* painted in 1493, to the painting by Hans Baldung (called Baldung Grien), *The Knight, the Young Girl, and Death,* which are two of the best-known paintings in the world by these two great artists. But a quick look confirms that most of these paintings belong to the same period, the Renaissance.

Among these works, the five portraits painted by Hans Holbein the younger, that of Anne of Cleves (the fourth wife of Henry VIII, the

English king) and those of Sir Henry Wyatt (a counselor at the court of Henry VIII), the court astronomer (Kratzer), the archbishop of Canterbury, and Erasmus of Rotterdam (the celebrated humanist who taught at Cambridge) are of special interest. This incomparable collection was bought by Louis XIV in 1671 from one of the most extraordinary collectors of the seventeenth century, the banker Eberhardt Jabach. It was Louis XIV again who bought from the heirs of the cardinal of Mazarin a painting by Hans Sebald Beham, another masterpiece that is part of the very heart of this collection of German painting.

The Louvre is clearly less rich in German paintings from the centuries that followed, although each period is represented. Still-lifes from the seventeenth century, religious and mythological paintings from the eighteenth century, canvases by Angelica Kauffmann and landscapes by Caspar David Friedrich representing the neoclassicism and the Romanticism of the nineteenth century, manage to give a true indication of the changes in German painting throughout five centuries.

Dominique-Vivant Denon. A close associate of Napoleon Bonaparte, he was named to the post on November 19, 1802.

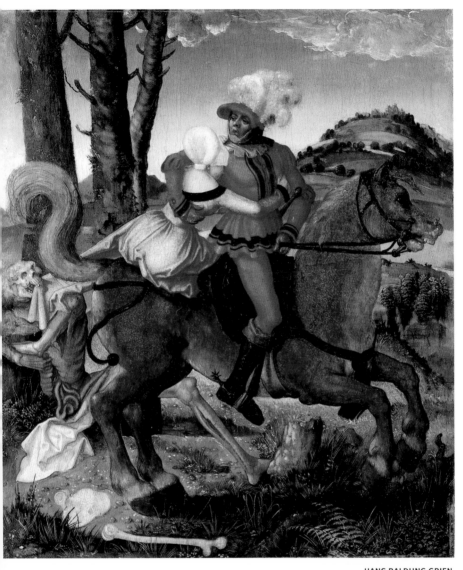

HANS BALDUNG GRIEN,
The Knight, the Girl and Death, 16th century.
Oil on canvas, 35 x 29 cm.

Opposite page:
LUCAS CRANACH THE ELDER,
Venus Standing, 1529.
Oil on wood, 38 x 25 cm.

1. ENGLISH SCHOOL: Sir Joshua Reynolds, *Master Hare,* 1788–1789. Oil on canvas, 77 x 64 cm. - **2. GERMAN SCHOOL:** Hans Holbein the Younger, *Erasmus,* 1523. Oil on wood, 43 x 33 cm. - **3. FLEMISH SCHOOL:** Samuel Van Hoogstraten, *Slippers,* 1658. Oil on canvas, 103 x 70 cm. - **4. SPANISH SCHOOL:** Theotokopoulos Domenikos (El Greco), *Saint Louis, king of France, and a page,* circa 1585–1590. Oil on canvas, 120 x 96 cm.

Answer

What is the school of painting of origin?

1

2

GERMAN SCHOOL

•

FLEMISH SCHOOL

•

SPANISH SCHOOL

•

ENGLISH SCHOOL

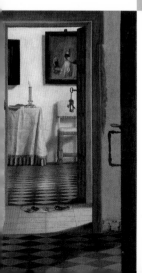

3

4

Spanish Painting

- FROM THE 15TH CENTURY TO THE 19TH CENTURY
- BARCELONA, TOLEDO, SEVILLE, MADRID...
- BERNARDO MARTORELL, DOMENIKOS THEOKOPOULOS (LE GRECO), FRANCISCO DE ZURBARÁN, JOSÉ DE RIBERA, BARTOLOMÉ ESTEBAN MURILLO, FRANCISCO JOSÉ DE GOYA Y LUCIENTES...

DIEGO VELÁZQUEZ (AND STUDENTS OF ?), *The Infanta Maria Margarita*, 1653. Oil on canvas, 70 x 58 cm.

Opposite page: FRANCISCO JOSÉ DE GOYA Y LUCIENTES, *Portrait of Mariana Waldstein*, end of the 18th century. Oil on canvas, 142 x 97 cm.

The Louvre's department of Spanish painting is one of its most comprehensive. And this, in spite of a tumultuous history full of reversals. Today one can find examples of Spanish painting from the Gothic through the beginning of the nineteenth century. The greatest names are here: Zurbaran (1598–1664), Ribera (1591–1652), Dominikos Theotokopoulos, called El Greco (1541–1614), Velázquez (1599–1660), Murillo (1618–1682), Goya (1746–1828). If not one great Spanish painter is missing, the Louvre has the Romantic era to thank for it. Romanticism put Spanish passion in the spotlight, the most famous instance being Prosper Mérimée's *Carmen*. Several incidents led to this fascination: a few years earlier, the Napleonic wars led to the discovery of Spanish painting, which until then the French had disdained, even though Murillo's *Young Begger Picking Lice* (1650) had been acquired during the reign of Louis XVI.

In 1815, with the fall of the empire, the canvases stolen from churches, which made up most of the war's booty, had to be returned to Spain. The Louvre emptied out.

In 1838, Louis-Philippe gave the Louvre a fabulous collection acquired for him by Baron Taylor, but after the revolution of 1848 removed him from power, the former king demanded that the 412 Spanish paintings bought with his own funds be returned to him. Once this was done, the Louvre was once again emptied. The collection was sold at auction in London in 1853. A few years later, the Louvre acquired El Greco's *Christ on the Cross with two Donors*. But none of the other 411 works of this collection, which allowed Manet to discover Velazquez and Goya, has ever returned to the Louvre.

What was the use of the vaulted rooms
in the Denon wing, where Italian sculpture is now shown?

Self-portraits

- FRANCE: JEAN FOUQUET, JEAN-BAPTISTE GREUZE, EUGÈNE DELACROIX, THÉODORE CHASSÉRIAU, JEAN-BAPTISTE-CAMILLE COROT, JOSEPH DUCREUX...
- ITALY: RAFFAELLO SANTI (RAPHAEL), JACOPO ROBUSTI (TINTORETTO)...
- FLANDERS: JOOS VAN CRAESBEECK...
- NETHERLANDS: ALBRECHT CUYP, GERARD DOU, HARMENSZ VAN RIJN REMBRANDT...

Greuze, Tintoret, Corot, Raphaël, or Fouquet and to compare styles, execution, and the way in which each one chose to represent himself. Under the mocking gaze of Joseph Ducreux (1735–1802), with his index finger pointed at us, the self-portrait seems to suggest with malice that, much more than a picture, it is the instrument of a dialogue.

As we go from one to another of these works, it is also possible to discover the entire department of Painting. A logical progression if we consider that, according to Leon-Battista Alberti (1404–1472), who wrote Europe's first treatise on painting in 1435, the inventor of painting was Narcissus.

The self-portrait allows one, perhaps more than other themes, to travel through the different centuries and the various schools of painting represented in the Louvre's collections. The self-portrait and the representation of objects are among the few rare constants in the history of Western painting.

The Louvre makes it possible to go from Rembrandt to Delacroix, Dürer,

When Giorgio Vasari (1511–1574) — the first author of biographies of artists in Christian Europe, entitled Lives — wrote his thesis, he stated that the inventor of painting was a certain Gyges the Lydian and that his first work was a portrait of himself.

These rooms housed the stables for the horses of Emperor Napoleon III.

JOSEPH DUCREUX,
Portrait of the Artist in the Guise of a Mocker,
circa 1793. Oil on canvas, 91 x 72 cm.

Opposite page:
LUIS EUGENIO MELÉNDEZ,
Portrait of the Artist Hholding an Academic Drawing,
1746. Oil on canvas, 100 x 82 cm.

1. **ALBRECHT DÜRER,** *Portrait of the Artist with a Thistle,* 1493. Parchment restretched on canvas, 56 x 44 cm. -
2. **EUGÈNE DELACROIX,** *Portrait of the Artist,* circa 1840. Oil on canvas, 65 x 54,50 cm. -
3. **HARMENSZ VAN RIJN REMBRANDT,** *Portrait of the Artist at the Easel,* 1660. Oil on canvas, 111 x 85 cm. -
4. **JEAN-BAPTISTE-CAMILLE COROT,** *Portrait of the Artist,* 1825 (?). Paper on canvas, 32 x 24 cm.

Answer

Who is who?

Self-portraits

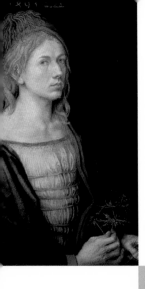

1

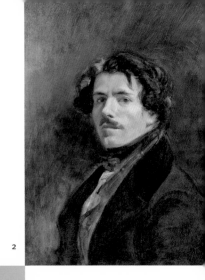

2

COROT
•
REMBRANDT
•
DÜRER
•
DELACROIX

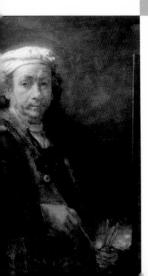

3

4

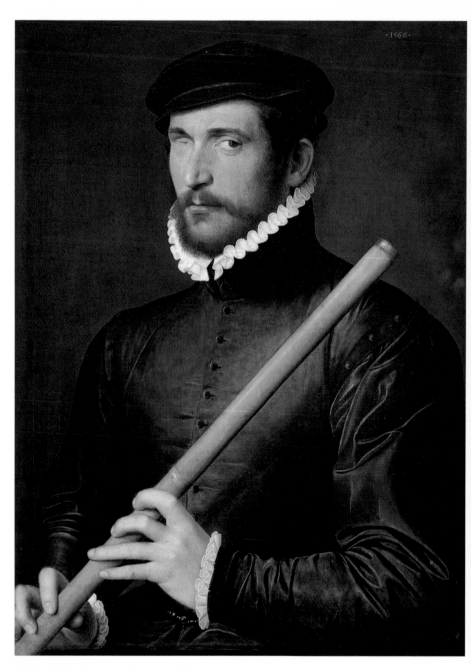

FRENCH SCHOOL, *Portrait of the One-eyed Flutist,* 1566.
Oil on wood, 62 x 50 cm.

Anonymity

Sometimes there is little information about a work because until the sixteenth century, few artists signed their works. For want of any better way to identify artists, the designation "Master of—" was invented. Thus, at the Louvre, there are works by a Master of Demi-figures, a Master of Olympia, a Master of the Observance, a Master of the Aenid, and a Master of the Games, among others. The style and technique suggest that the master is undoubtedly Siennese, or Burgundian, or Flemish. The subject and the composition make it possible to recognize a work from the seventeenth century or the first half of the fourteenth century.

The Master of Rebel Angels, for example, takes his name from the easily identifiable subject of the painting. The technique and the style let us assume the work was probably painted in the 1340s, perhaps in France or Italy. We have to resort to hypotheses and suppositions. And the confusion is perhaps still more intense when we find ourselves in front of certain portraits, because for this genre, if we know nothing about either the artist or the model analyzing the work depicted becomes a delicate matter. It is said that the *Portrait of the One-eyed Flutist* recalls the style of François Clouet. But apart from the fact that it is a flutist, there is nothing to help us discover the model's identity or the meaning of the work.

The Louvre has nearly thirty "anonymous" paintings, as well as a hundred or so attributed to a "Master of—." Like other museums, it is constantly looking for precise information about the works in its collections. Exhibiting works that have resisted the many evaluations and examinations they have undergone gives us the opportunity to concentrate on what we see and not on what we know or think we know.

Which French king died at the Louvre?

?

Portraits of Power

The Louvre has one of the largest collections of official portraits in the world. Each of them is the work of one of the uncontested masters in the history of art and signals the monarch's choice of artist. All these portraits were, of course, the opportunity for a meeting between power and art, except for one, that of Francis I, by Titian (1488–1576). The painter and the model never met; the portrait was painted in Venice, probably from a medal created by Benvenuto Cellini (1500–1571). The Louvre's gallery of ceremonial portraits is immense. Some of them

are essential to understanding the genre. Among these are paintings of *Sigismond Malatesta* (1417–1468), *condottiere* of Italy and captain of the church, painted around 1451 by Piero della Francesca; *Charles Quint jeune,* painted by Bernard van Orley (1492–1541); *Dona Isabel de Requesens,* vicereine of Naples, a masterpiece by Raphael (1483–1520); *Mariana of Austria,* the queen of Spain and second wife of Philip IV, painted by Velázquez (1599–1660); *Charles I,* king of England, descendent of the Stuarts beheaded in 1649, painted around 1635 by Antoon Van Dyck (1599-1641); *Charles VII,* king of France, by Jean Fouquet (1420–1481); *Henry IV and His Wife Maria de' Medici,* painted by Frans Pourbus (1545–1581); and *Louis XIII,* by Philippe de Champaigne (1602–1674).

The portrait of *John II the Good,* king of France (1319–1364), occupies a remarkable place in the history of Western art as it is probably the first individual portrait painted since the start of the history of Christian Europe. Painted around 1355, it shows the

Louis XVIII. He died in 1824, and was the only king to do so at the Louvre.

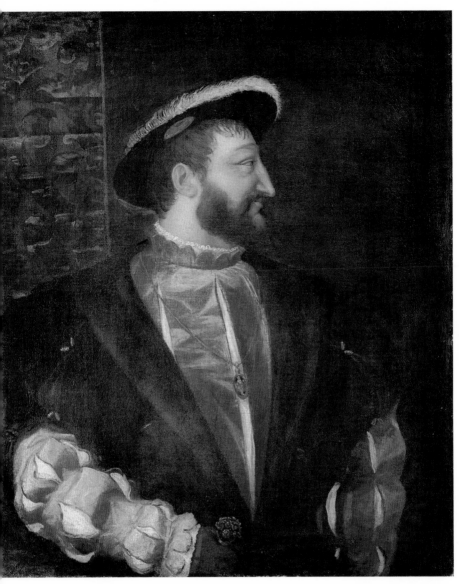

king in profile, following the
fashion of medals from antiquity.
The gold background behind the
face is reminiscent of icons.

TIZIANO VECELLIO (TITIAN),
Portrait of Francis I, 1539.
Oil on canvas, 109 x 89 cm.

Opposite page:
FRENCH SCHOOL, *John II the Good,* Paris,
before 1350. Oil on wood, 60 x 45 cm.

Kings of France
Who is who?

Answer

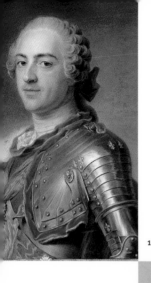

1

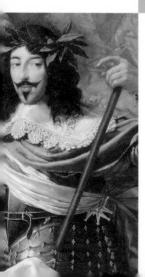

2

HENRY IV

·

LOUIS XIII

·

CHARLES IX

·

LOUIS XV

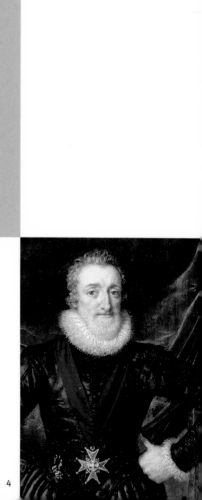

3

4

Diane Supported by a Deer, Known As "La Diane d'Anet," mid-16th century,
completed by the sculptor Pierre-Nicolas Beauvallet in 1799–1800.
France, marble, 211 x 258 x 134 cm. Former château d'Anet.

The Department of Sculpture

- FRANCE, FROM THE MIDDLE AGES TO THE 19TH CENTURY
- ITALY, FROM THE 7TH TO THE 19TH CENTURY
- NORTHERN EUROPE, FROM THE 16TH TO THE 19TH CENTURY

The department of Sculpture was only created in 1893, a century after the museum opened. Strange as it may seem, not all the sculptures presented to the Louvre museum "belong" to it.

The slaves sculpted by Michelangelo (1475–1564) for the tomb of Pope Julius II, seized as possessions of émigrés, have been part of the Louvre's collections since 1794. For a long time, only ancient sculptures were considered worthy of being in a museum. So, lacking an appropriate department, Michelangelo's sculptures joined the Antiquities collection. It was the same for sixteenth- and seventeenth-century sculptures (which were exhibited starting in 1824 in a group of five rooms called the Galerie d'Angoulême), sculptures from the Middle Ages (which entered into the collections in 1850), and Italian sculptures (which joined them in 1863).

On the creation of the department of Sculpture, those from antiquity remained in the department of Greek, Etruscan, and Roman Antiquities, and the Egyptian sculptures are still in the department of Egyptian Antiquities. All types of sculpture, from bas-relief to sculpture in the round, are represented in the department, as well as all the types of materials that the sculptors used, from stone to terra-cotta, as well as wood, marble, and bronze. However, the smallest bronzes and most of the ivories belong to the department of Objets d'Art, because they have been put in the same category as the work of goldsmiths and silversmiths.

Since the Grand Louvre opened in 1993, more sculptures have been exhibited thanks to the annexation of two immense glass-covered courtyards in the Richelieu wing that make it possible to exhibit them magnificently. In the Cour Marly are the open-air sculptures from the seventeenth and eighteenth centuries, many of which come from the park at the fortress of Marly and have given their name to this courtyard. Pierre Puget (1620–1694) gave his name to the second of these courtyards, where several of his works are on display, among some other beautiful pieces from the seventeenth and nineteenth centuries. Finally, there are the sculptures from Italy, Spain, the Netherlands, and Germany, grouped together by school in the Denon wing.

How many former courtyards of the Louvre have been covered over and turned into museum space?

Sculpture: Icons

Six: Puget, Marly, Khorsabad, Sphinx, Visconti, and Lefuel.

There are many sculpted masterpieces in the Louvre. Among them, two striking examples of the transcendence of the subject have gradually acquired the status of major icons in this great museum. One is the *Dying Slave,* by Michelangelo (1475–1564), carved from marble. The other is *Saint Mary Magdalene* by Gregor Erhart (?–1540) in polychrome linden wood. The body of this handsome young man who is perhaps falling into the sleep of death is one of the slaves that Michelangelo began sculpting in 1513 for the tomb of Pope Julius II. It is an exceptional creation and inevitably arouses emotions. Julius II wanted this tomb to stand under the cupola of Saint Peter's in Rome, but from renunciation to abandonment, this project did not see the light of day, even though the sculptures themselves were completed. So, Michelangelo offered two of them to one of his Florentine friends, Roberto Strozzi, who made a gift of them to the king of France, Francis I. The *Saint Mary Magdalene,* by Erhart, acquired in 1902 from the Siegfried Lämmle collection, is certainly one of the most beautiful examples of German polychrome sculpture from the time of the start of the Renaissance. Legend has it that the saint went alone to the grotto of Sainte Baume in Provence, where, covered only by her hair, without food or water, she prayed to God in repentance. Sculpted from linden wood, she is shown in perfect nudity. The work was undoubtedly created for the church of Saint Mary Magdalene in the Dominican convent at Augsbourg. Suspended from the vault of the church, it was, at the time, surrounded by a group of angels made from the same polychrome wood.

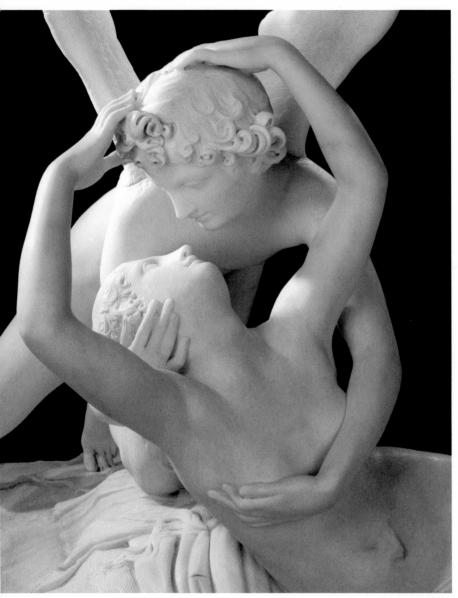

ANTONIO CANOVA,
Psyche Brought to Life
by Cupid's Kiss,
circa 1787. Marble,
155 x 168 x 101 cm.

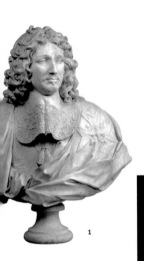

1

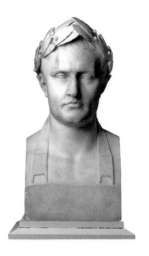

2

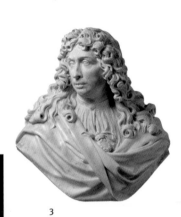

3

VOLTAIRE

MIRABEAU

ROUSSEAU

LE BRUN

COLBERT

NAPOLEON I

4

5

6

Religious Sculptures

FRANÇOIS GIRARDON,
Mater Dolorosa, 1657.
Marble, 85 x 65 x 10 cm.

Opposite page:
DANIEL MAUCH
(WORKSHOP OF), *Two
Popes, A Cardinal, A
Bishop, A Canon and
Seven Monks in Prayer*,
Fragment of the *Vierge
de Miséricorde* (*Our
Lady of Mercy*), circa
1505. Limewood,
original polychromy,
120 x 57 x 27 cm.

Before works of art were hung on picture rails and considered to be historical testimony or artistic expression, the object of painting and sculpture was religious. The artists were in the service of religion. This explains in part why there are so many works devoted to the Christian faith in the department of Sculpture. When the Louvre became a museum in 1793, a large number of the works in its collections had been taken from convents and churches during the French Revolution—as biens nationaux. The only two "modern religious" sculptures in its collections are the two *Slaves* by Michelangelo (intended for the tomb of Julius II).

The Louvre's extraordinary collection of religious sculptures could tell us the history of both theology and the liturgy if a knowledgeable guide accompanied the visitor. More obvious, perhaps, is the history of the evolution of techniques and the evolution of forms: multicolored wood, clay, marble, bronze, gold, silver. From Gothic to the Renaissance and Mannerism, the works in this department make it possible to compare different artists' interpretations of the same themes: Virgin of the Annunciation, Virgin and child, Christ on the cross, Mater Dolorosa, Saint John at Calvary, and Saint George overcoming the dragon are among the subjects most often dealt with, from the Middle Ages to the eighteenth century.

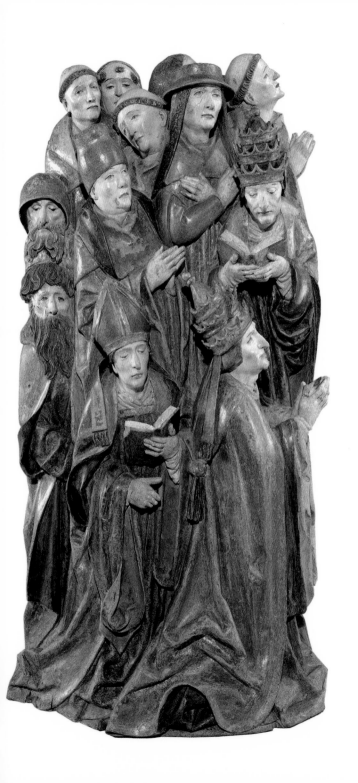

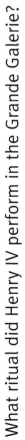

What ritual did Henry IV perform in the Grande Galerie?

Open-Air Sculptures

- PIERRE FRANQUEVILLE, FRANÇOIS ANGUIER, PIERRE PUGET, ANTOINE COYSEVOX, GUILLAUME I COUSTOU...
- 17TH CENTURY

Senators, Grove of Agrippina. In 1694, he commissioned Anselme Flamen (1647–1717) to make a representation of Diana on a fountain of shells and rockwork. This commission was far from being his last. The sculptors Coysevox, Coustou, Van Cleve, Prou, Poirier, Magnier, and others would be charged with filling the park with gods, goddesses, nymphs, and fauns. During the Regency, a number of these sculptures were moved to the gardens of the Tuileries, where Louis XV lived. Then came the Revolution, the Directoire, the Empire—the park was abandoned, the château was destroyed, and the sculptures dispersed.

Louis XIV abandoned the Louvre. As a sign of his disdain, he even left the Colonnade wing without a roof. In 1674 he went to live in Versailles. To rest from the implacable etiquette of the court, he chose Marly, where he found "one view, of the water and the woods" that gratified him. From 1686 on, he stayed with his family and a few guests he invited himself. At Versailles, the king's main concern may have been the architecture, but at Marly, it was the gardens. He decided to place sculptures from his collections in the gardens. The first were ancient statues; then came copies of ancient statues. The groves in the park were named for the sculptures: Grove of the

Today the most important of the sculptures commissioned by Louis XIV can be found in the Cour Marly at the Louvre, the palace he abandoned. The king wished to forget the Louvre,o but the Louvre did not forget him.

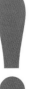

He touched tuberculosis patients to affirm his royal power to heal them.

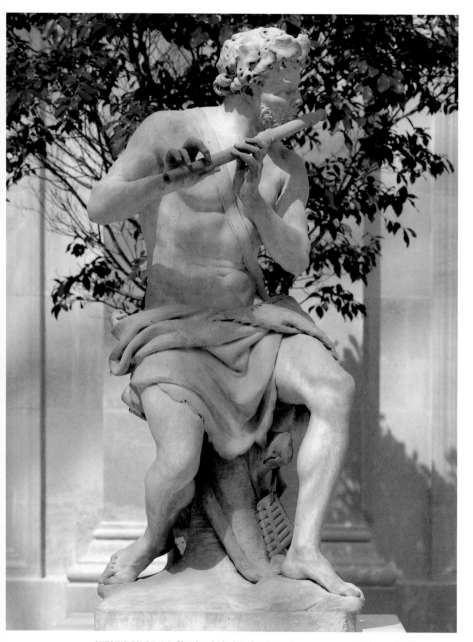

ANTOINE COYSEVOX, *Shepherd Playing the Flute,* circa 1707–1710. Marble, 178 x 84 x 101 cm.

Opposite page:
GUILLAUME COUSTOU I, *Horse Held by a Groom, called The Cheval de Marly,*
Paris, 1739–1745. Carrara Marble, 340 x 284 x 127 cm.

Mythology
Who is who?

1. *Palatine EROS,* circa 80–90 A.D. Marble. Ancient Rome, Palatine hill, eastern fountain of Domitian's Palace. -
2. *MORPHEUS,* by Jean-Antoine Houdon, 1777. Marble, 36 x 70 x 35 cm. - 3. *The Fall of ICARUS,*
by Paul-Ambroise Slodtz, 1743. Marble, 38 x 64 x 54 cm. - 4. *CUPID Fashioning an Arrow from Hercules' Club,*
by Edme Bouchardon, 1750. Marble, 173 x 75 x 75 cm. Formerly Versailles, salon of Hercules.

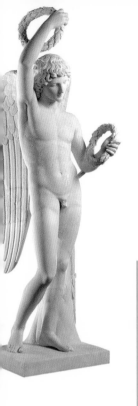

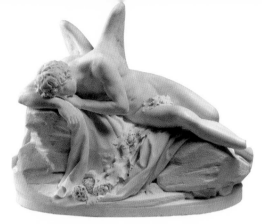

2

EROS

•

MORPHEUS

•

ICARUS

•

CUPID

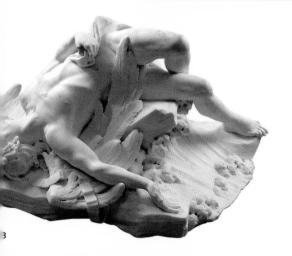

3

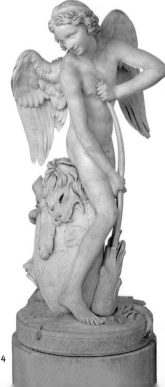

4

Polychromes

There are two ways to achieve polychrome sculpture: the sculptor can use different colored materials or he can paint the sculpted surface. Since ancient times in Greece, the color of sculptures is due not only to the materials used, but often to pigments used to hide the aspect of imperfect material; both the style of the time and a desire for realism pushed artists to use this type of technique. Often rock crystal or colored stones were used for the eyes. The same was true for Egypt, which produced incredibly lavish creations that are on display in the Louvre, and for Italy, which has offered magnificent polychrome sculptures throughout its long history of art. The *She-wolf Nursing Romulus and Remus* (a sixteenth-century copy of an ancient sculpture) was cut from two different colors of marble, red for the body of the animal and white for the bodies of the children; and the *Belle Florentine* is sculpted from multicolored wood. Named in the nineteenth century, the work is thought to be of Italian origin, although no one knows who the sculptor is and whom it represents. The attitude and look of the young woman is peaceful. She is richly dressed, and her headdress is very refined. The work is distinguished by the special care given to the carnation of the face and the red that emphasizes the mouth and cheeks. In France, the *Tomb of Philippe Pot,* grand seneschal of Burgundy, was also painted. This monument is one of the most unusual in existence. It was carefully prepared during the lifetime of its sponsor. A veritable life-size funeral procession, it is composed of eight mourning figures with faces hidden by their poses and their hoods. The monarch is depicted supine and armed, the hands joined as if in prayer. The lack of "nobility" of the material from which it was cut— simple stone—was one of the reasons for choosing polychromy.

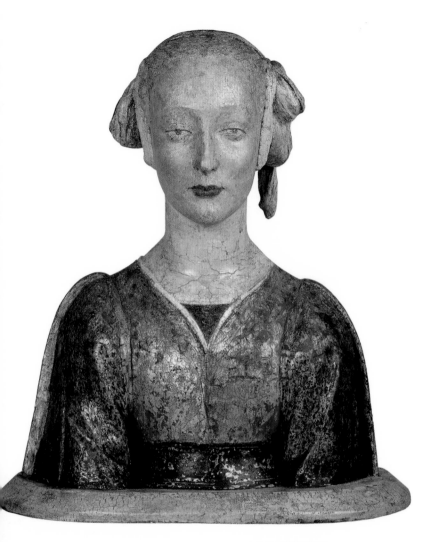

FLORENTINE SCHOOL,
*Unknown Woman, called "La Belle
(the Pretty) Florentine,"*
Florence, third quarter of the 15th
century. Polychromed and gilded
wood, 55 cm.

Opposite page:
GREGOR ERHART,
Mary Magdalen,
circa 1515–1520. Polychromed
limewood, 177 x 44 x 43 cm.

Where at the Louvre are the large temporary exhibitions?

Department of Objets d'Art

- FROM ANTIQUITY TO THE MIDDLE OF THE 19TH CENTURY
- ROMAIN EMPIRE, BYZANTINE EMPIRE, OTTOMAN EMPIRE...
- FRANCE, ITALY, SPAIN, GREAT BRITAIN, GERMANY, AUSTRIA, FLANDERS, SCANDINAVIAN COUNTRIES...

Paten, Rome, 1st century before or after Christ. Setting: Court of Charles the Bald, 2nd half of the 9th century. Divided cabochon, gold, pearl, precious stone, serpentine, 17 cm. Former Treasury of Saint-Denis.

Below:
Works of Saint Denis the Aeropagite, 1403–1405 (manuscript), end of the 14th century (rebound). Illumination, ivory, parchment.

Under the Pyramid, in two spaces off the Sully entrance.

Where can you find armor worn by Henry II, a cup once held in the hand of Napoleon I, and a bed Charles X slept in, to name only a few of the objects that once belonged to people who played an essential role in the history of the Louvre? Quite simply, in the department of Objets d'Art. This department contains bronzes (dating from the end of antiquity to the first half of the nineteenth century), ivories, tapestries, pieces of porcelain, furniture, jewelry, glasses, games, clothing. Its collections, made up of objects that range from the very valuable to the very humble, make the department one of the most ill-assorted in the museum. No other department includes pieces from so many diverse periods, with so many enigmatic "uses" or none, and decorations of varying styles.

Some have been used for sacred liturgies and others for personal hygiene. Some are attributes of glory, while others are tools. This department, where sometimes the "unclassifiable" sits next to the "strange," is spread over three wings in the Louvre: Richelieu (Middle Ages, Renaissance, nineteenth century), Sully (seventeenth and eighteenth centuries), and Denon, where the Crown Diamonds of France are on display. Everywhere, the department finds its place; everywhere, it has its raison d'être. It has inherited the "regalia" of the coronations of the kings of France as if it were the Crown's storehouse.

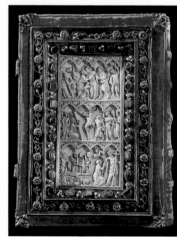

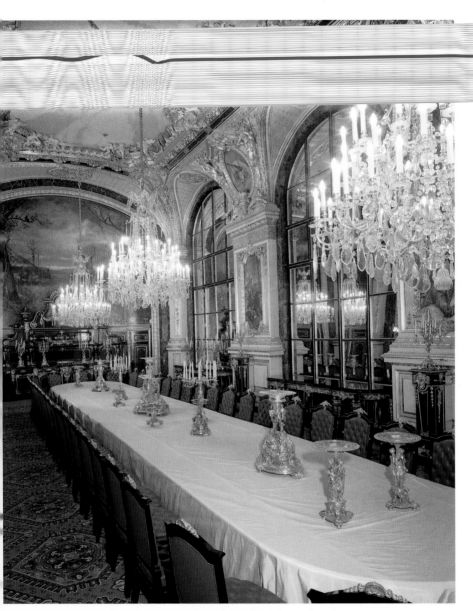

And since the opening of the Grand Louvre, it has become the storehouse for the Napoleon III apartments that belonged to the minister of the imperial house in the Richelieu wing. If there is a department in the Louvre where "bric-a-brac-ology," the science that tells us which object is which and which owes its name to Balzac, is absolutely necessary, this is the one.

Banquet hall of Napoleon III's apartments, decorated by Lefuel, 1856–1861.

Quotes
Who said what?

Chuck Palahniuk

Albert Cohen

Louis Pons

Henry de Montherlant

Paul Cézanne

André Gide

Henri Focillon

Paul Valéry

Jules and Edmond de Goncourt

Objets d'Art: Icons

Kept in the Louvre's department of Objets d'Art, the *Eagle of Abbot Suger* and the *Rustic Basin,* by Bernard Palissy, belong to those extraordinary, unique objects that cannot be separated from their history.

Suger was a fellow student of Louis VI (c. 1080–1137). A historian and a valued advisor to the king, we are indebted to him for the first volume of the *Grandes Chroniques de France (Great Chronicles of France)*: the life of King Louis VI. He is also famous for having helped introduce Gothic art to France, for example, in the basilica of Saint Denis, where numerous kings of France were buried. Suger loved objects because he was convinced that the contemplation of beauty brought the soul closer to God. Among his treasures was an antique vase of red porphyry. The abbot decided to transform it and had it mounted with an eagle's head and wings of silver. This creation has become a symbol of the quest for God through beauty.

Bernard Palissy was born in Agen around 1500. A glass painter by trade, he discovered, one day, a cup of enameled earthenware and from then on devoted his life to producing such wonders himself. Married and the father of two children, he abandoned his trade and experimented until the point of exhaustion for nearly twenty years. Ruined, he would have used his furniture and the floorboards from his house to fuel his oven. Finally, his tenacity paid off. His splendidly colored earthenware attracted the favor of the king, who gave him a royal warrant to create rustic royal figurines, as well as lodgings, which earned him the nickname Bernard des Tuileries. But neither the title nor the fact that he had decorated a grotto in the gardens of the Tuileries with shells and extraordinary ornaments for

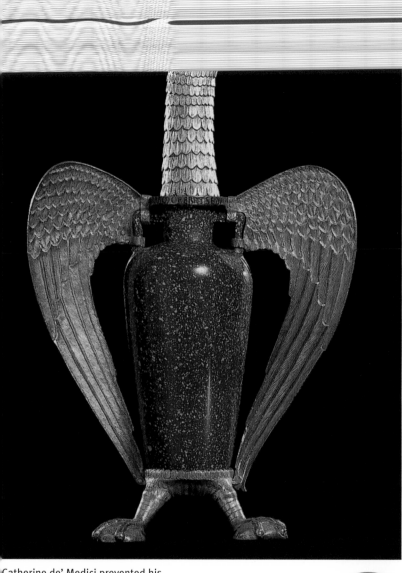

Catherine de' Medici prevented his arrest in 1589. For refusing to renounce his Protestant faith, he was locked in the Bastille, where he died, leaving behind a fantastic world of colored plants, animals, and insects.

How many people were seated in the Grande Galerie in 1797, on the occasion of a dinner given in Bonaparte's honor?

?

Regalia

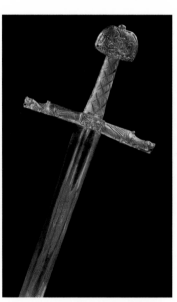

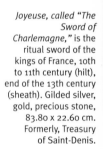

Joyeuse, called "The Sword of Charlemagne," is the ritual sword of the kings of France, 10th to 11th century (hilt), end of the 13th century (sheath). Gilded silver, gold, precious stone, 83.80 x 22.60 cm. Formerly, Treasury of Saint-Denis.

700 people.

The kings of France were crowned at Reims, but the regalia was kept in the basilica of the Abbey of Saint-Denis from the thirteenth century on. The word "regalia" refers to the coronation accessories, two of which are the insignia of chivalry: the spurs and the sword. They accompanied the king from Saint-Denis to Reims, with the ring, the scepter, the Hand of Justice, and the crown. Most of this regalia was stolen and destroyed during the revolution. The crown said to be Charlemagne's has disappeared, but his spurs and his sword, named Joyeuse (Joyful), are

today at the Louvre. This sword, which was taken into the Louvre on December 5, 1793, is an exceptional object, the result of the work of several different craftsmen. At the center of the hilt, the pommel and the plate, both decorated with a foliate design, seem to date from the Middle Ages; the grip (the part of the sword that forms the handle) seems to be Gothic. Until 1804, the year it was used to crown Napoleon, it was decorated with fleur-de-lis inside diamond patterning. These motifs are no longer on the sword, but they can still be seen on its jewel-encrusted scabbard. The cross-guards (the two branches of the cross at the base of the handle), in the form of winged dragons whose eyes are inlaid with pearls, date from the second half of the twelfth century. All the details attest to the authenticity of this sword, which does not stop some from stating that the only real sword of Charlemagne is that of the Weltliche Schatzkammer in Vienna, and that the one in the Louvre, which we know was in the hands of Philip the Bold during his coronation in 1270, is a fake. However, there is absolutely no doubt regarding the authenticity

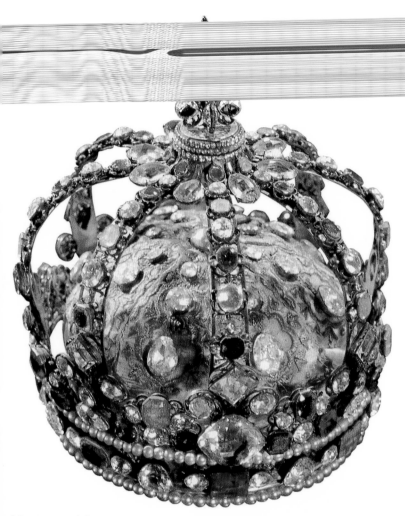

of the Sancy and the Regent. Pear-shaped, the first weighs 55.23 carats. It was bequeathed to Louis XIV by Cardinal Mazarin. Its name comes from Nicolas de Harlay, Sieur de Sancy, who acquired it at the end of the sixteenth century. The second, weighing 140.64 carats, was mounted on the crowns of kings Louis XV, Louis XVI, and Charles X. It was also set into Bonaparte's consular sword and the imperial sword of Napoleon I. The Sancy and the Regent no longer embellish the coronation crown of Louis XV, the only crown from the Ancien Régime in the Louvre. The original stones (282 diamonds, 64 colored stones) and the 230 pearls were replaced with copies after the king's coronation. Today the Sancy and the Regent are displayed individually.

AUGUSTIN DUFLOS AND CLAUDE RONDÉ, Crown of Louis XV, Paris, 1722. Gilded silver, stones and imitation pearls, 24 x 22 cm. Former Abbey of Saint-Denis.

THE LOUVRE NEWS

NEWS IN BRIEF & TIDBITS

APRIL 2, 1810: WEDDING AT THE LOUVRE: Napoleon married his second wife, the archduchess of Austria, Marie-Louise, niece of the late queen. The procession filed through the museum's Grande Galerie. Marie-Louise's long coat was held up by the queens and princesses of the family, while the crowd squeezed into the narrow gallery.

- **1830: A dog at the Louvre:** Médor, the faithful dog who stayed by his dead master's tomb during the "Trois Glorieuses," was buried at the foot of the Louvre's colonnade.

- **1875: The Louvre Transformed into an Arms Room**

The guards at the Louvre are learning to fire revolvers in the Louvre's basements. The room where they are learning to shoot is today a stockroom, but it is still called the Revolver Room.

- **1875: Rules for Guards:**

"Will be punished: quarrels between guards, dishonest answers to a visitor or artist, inappropriate clothing, Drunkenness, disloyalty, desertion of one's post during the night, improper suggestions to female visitors or artists, will result in immediate loss of employment."

F. Reiset, Louvre Palace, director of national museums

ACTUALITIES

- **1752: The Shadow of the Great Colbert, the Louvre & the City of Paris**, a dialogue by Monsieur La Font de Saint Yenne, was offered in this year 1752 in a new, corrected, and expanded edition. An explanation on the frontispiece plate of this new edition draws attention to the "deplorable state of the Louvre, dishonored by a multitude of ignoble, indecent buildings." It depicts the Louvre itself as "covered in dust, ready to expire from grief, appalled and crushed under the weight of insults and humiliation." In this new edition is found the complaint of a Louvre that, in this dialogue, says "that it is not only abandoned and a sanctuary for owls, but exposed to impending ruin by this abandonment, and delivered to an excess of indecency and dishonor by everything around it."

- **July 27, 1793: Birth Certificate for the Louvre Museum:**

"First Article. – The Minister of the Interior will give the necessary orders for the Museum of the Republic to be opened on August 10 in the gallery that joins the Louvre to the National Palace." (by decree of the Convention Nationale, on the report of its Committees for Public Instruction and Monuments)

Carrousel, with their cavalrymen, their lan... guards, their royal guard, their artillery, th... thousand men in the garrison—how were four or five thousand insurgents? This is ho... were brought against the Louvre: the first t... palace; the second through the rue des Pré... Germain-l'Auxerrois and the quay of the scl... the Pont des Arts, and the fourth by the Pon... the rest, one event will suffice to give an ide... assailants' courage. Like a chimneysweep, a... years climbed up one of these wooden pipes the colonnade that was used to dump the rul... the noses of the Swiss Guard, he planted the... Louvre." (Alexandre Dumas father, *Mes Mém...*

Reliquaries

Reliquary of the hand of Saint Martha, arm reliquary of Saint Louis of Toulouse, statuette reliquary of the finger of Saint Lawrence—the Louvre has several of these objects in its collections. Inside them are found fragments of bone, a few hairs, or a piece of fabric from a saint or a king. It can also be an urn or a case, or even a sculpture imitating part of a body. Thus, several head or bust reliquaries contain bones from the skull, or even the entire skull, sometimes visible through a cleverly placed oculus.

For many centuries, it was believed that emperors and kings received their temporal power from God, and their body were consequently conserved with religious fervor as well. Pope Leo III crowned the Emperor Charlemagne in Saint-Peter's Basilica in Rome, and French kings were crowned, and anointed with holy oils, at the cathedral in Reims. In 1165, when Charlemagne was canonized, Emperor Friedrich Barbarossa (1152–1190) ordered a reliquary in which were deposited pieces of the arm of the first emperor of the Christian Empire of the West. During a tournament given as part of the festivities celebrating the marriages of his daughters to the king of Spain, Philip II, and the duke of Savoy, a lance pierced the visor of Henry II's helmet (1519–1559) and mortally wounded him. This king had made the Louvre that his father, Francis I, had wanted become a reality. One of the staircases at the Louvre is marked with his initial, *H.*, and still bears his name. Henry II was buried in the Saint Denis Basilica. But to preserve his heart and have it kept in the church of the Celestines that he especially loved, his widow, Catherine de' Medici, had a reliquary sculpted by three sculptors, who shared the work: Domenico del Barbiere, called Dominique Florentin (the pedestal); Germain Pilon (the three Graces); and Jean Picard (the urn).

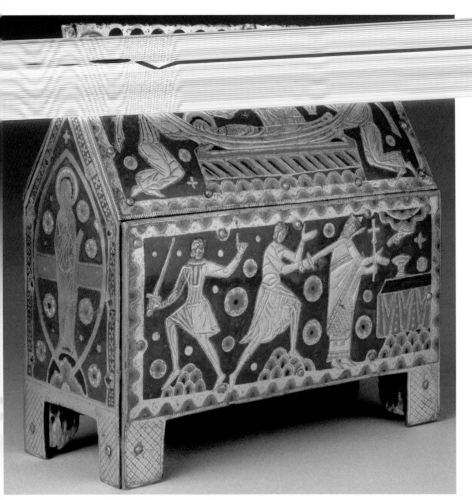

The king's heart did not survive the revolution of 1789. It was destroyed, as were many other reliquaries and symbols of bygone power.

Reliquary of Saint Thomas Becket, France (Limoges), circa 1180–1190. Gilded and engrave copper, champlevé enamel, 20.80 x 19.70 cm.

Opposite page:
Monstrance, or *Reliquary for the Hand of Saint Martha,* Venice, 1472–1474. Gilded and enameled silver. 71 x 23 cm.

What is the "Regent"?

?

Clothing, Jewels, and Finery

The Louvre is a veritable encyclopedia of shapes and forms. It is unparalleled in all fields, including one of the most unexpected—fashion. Fashion designers and jewelers are always coming to the Louvre to find inspiration for their creations.

The Louvre's imaginary big history book of fashion would start with Botticelli's pastels, go to the drapings of Pontormo or Zurbaran, the robes of the infantas by Velazquez, Vermeer's laces, Fragonard's taffetas, Rembrandt's silks, and so on. There is an infinite list of masterpieces of jewelry immortalized and often glorified in painting and—less frequently—in sculpture.

Each period has created its own finery, and the Louvre shows us the finest examples: a pendant in the form of a bird of prey with a ram's head from the time of Ramses II in the department of Egyptian Antiquities, earrings worn by a Persian princess around 350 B.C. in the department of Oriental Antiquities, but most of this finery is found in the department of Objets d'Art, which has a collection of the most lavish and unexpected jewels. These treasures take us across the centuries, from Queen Arnegunde, one of the wives of King Clotaire I (497–561) to Queen Marie Amelie, who, as the wife of Louis-Philip I, was the last queen of France; she was ousted from the throne by the revolution of 1848.

Property of the crown of France, the Regent is one of the most beautiful diamonds in the world. Of an exceptional clarity, it weighs 140.64 carats.

Cloak of an officer of the Ordre du Saint-Esprit, France, 17th century. Embroidered black velvet.

Opposite page:
Hook from a royal cloak ornamented with a fleur de lys (lilly), France, 1365–1367. Gilded silver, champlevé enamel, fine stone. Formerly, Abbey of Saint-Denis.

Jewels
What era?

Answer

1. **EGYPT, 20TH DYNASTY**, Ring with ducks, with the name Ramses IV, Egypt, 20th dynasty, 1153–1147 B.C. Gold, 2 cm. -
2. **EMPIRE**, Parure of Queen Hortense and of Queen Marie-Amélie, circa 1810. Diamonds, saphires. -
3. **MEROVINGIAN GAUL**, Ring of Queen Arnegonde, Merovingian Gaul, circa 570. Gold. -
4. **RENAISSANCE**, Pendentive, Renaissance, third quarter of the 16th century. Enamel on gold relief, jewels, 12 x 72 cm.

1

2

RENAISSANCE

•

MEROVINGIAN GAUL

•

EMPIRE

•

EGYPT, 20TH DYNASTY

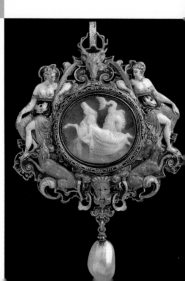

3

4

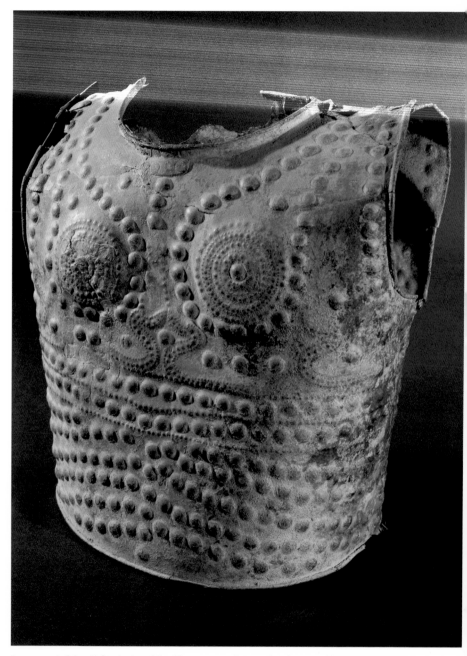

Armour, end of the 7th/beginning of the 6th century B.C. Repoussé and engraved bronze, 45 x 44 cm.

Opposite page: **PIERRE REDON,** ornamental buckler/shield of King Charles IX, Paris, circa 1572.
Chased iron and chiseled gold plate, translucent and opaque enamels, gold-embroidered velvet lining, 68 x 49 cm.

As unexpected as it might seem, the Louvre is an arsenal. For the most part, the collections display lavish, ceremonial weapons that once belonged to the kings and princes of history. Some of them were undoubtedly never used in battle. Included in these ceremonial weapons are the hatchet of King Ountash Napirisha of Elam, created in the thirteenth century B.C., which is on display in the department of Oriental Antiquities, or the shield in the department of Objets d'Art with the gold-plated iron that was decorated in enamel for the French king Charles IX in the sixteenth century A.D.

Most of these ceremonial objects were identified by means of documents or simply through inscriptions engraved on them. However, they still hold the mystery of their past, and invite us to dream. What blade was sharpened on the schist whetstone with the lion-shaped golden handle? At what victory or defeat was the bronze armor dating from the end of the seventh century B.C. worn? What leather or reed was cut with this terra-cotta ax?

If they so desire, weapons enthusiasts can choose to follow this theme when touring the Louvre by looking for the numerous representations of weapons in paintings and the graphic arts. In addition to ceremonial weapons, the collection contains less prestigious weapons that have certainly been used. Heroism, cowardice, good cause or bad—we will never know. They are often side by side with collections of tools (another history of humanity, if not of art) so that, at first glance, the Louvre seems to be a rather large hardware store.

Which czar refused to stay at the Louvre, saying he "preferred small places over l

Furniture

Obviously, the largest collection of furniture at the Louvre is found in the department of Objets d'Art. Most of it comes from the grandest of residences. A large number of the pieces are "stamped," particularly those designed from the last quarter of the seventeenth century on, a time when it was necessary to furnish the palace of Versailles as no other royal residence had ever been before, a fact that drew the most inventive cabinetmakers to Paris. These stamps bear the names André-Charles Boulle (1642–1732), Étienne Avril (1748?–1796), Jean-François Œben (1720–1763), and Jean-Henri Riesener (1734–1806), who was the greatest cabinetmaker of all time according to specialists, or bear the names of the cabinet-making dynasties such as Bellangé, the Jacobs, and others.

This incomparable collection of armchairs, chairs, pedestal tables, chests, desks, commodes, writing desks, and other pieces is one of the best ways to learn about decorative styles. From the Renaissance style, to the heavy ornamentation in vogue under Francis I, to the Napoleon III style with its famous padding, as well as the Louis XIII, Louis XIV, Regency, Louis XV, Louis XVI, Directoire, Empire, Restoration, and Louis-Philip styles, a visit to see the furniture at the Louvre makes it possible to understand how forms developed, to learn how to differentiate the various "historical" periods, and to recognize the inventions of the various artists or artisans. Such a visit often creates a desire to learn more. This would entail a visit to the Museum of Decorative Arts and its wonderful library, which are only a few steps further on.

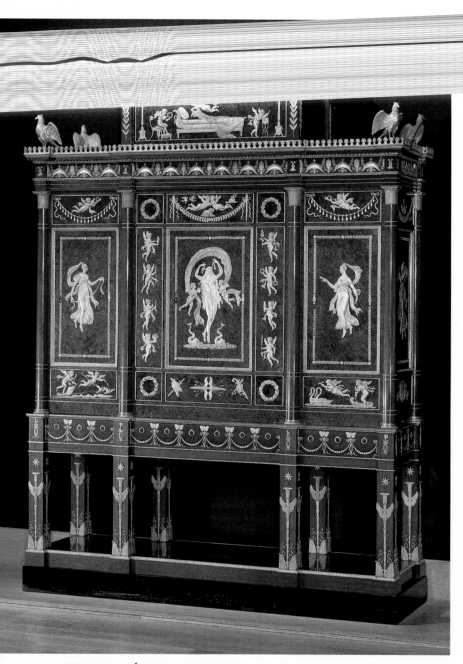

FRANÇOIS-HONORÉ-GEORGES JACOB-DESMALTER, after Charles Percier and Antoine-Denis Chaudet, Jewel box of Empress Josephine, also called the "grand écrin," Paris, 1809. Yew, amaranthe, mahogany, ebony, mother-of-pearl, gilded bronze, 276 x 200 x 60 cm. Former master bedroom of the Tuileries.

3. FRANCIS I FURNITURE: Caquetaire (gossip settee), France, second half of the 16th century. Wood. - **6. LOUIS XIV FURNITURE:** Armchair (from a suite of furniture of Marshal d'Effiat), France, mid-17th century. - **4. LOUIS XV FURNITURE:** Attributed to Michel Cresson, armchair "à la reine," Paris, circa 1750. Painted and carved beechwood, with original silk petit point lace embroidery. - **1. LOUIS XVI FURNITURE:** Jean-Baptiste-Claude Séné, Hooded armchair "en cabriolet" (from a set of three and three chairs, from the large sitting room of Marie Antoinette at Saint-Cloud), Paris, 1787. Gilded walnut, carving by Nicolas-François Valois, gilding by Chatard. - **2. NEO-GOTHIC FURNITURE:** Claude-Aimé Chenavard, Armchair (of a pair), Paris, circa 1835. Stained wood, gilded bronze, tapestry. - **5. SECOND EMPIRE FURNITURE:** Michel-Victor Cruchet, Armchair (from a suite of furniture for the audience chamber of the Duke de Nemours, at the Tuileries), Paris, 1847. Gilded wood, Beauvais tapestry.

Answer

Armchairs
Find the chronological order

Department of Greek, Roman, and Etruscan Art

- FROM THE NEOLITHIC (6TH MILLENNIUM B.C.) TO THE 6TH CENTURY
- AREAS SURROUNDING THE MEDITERRANEAN SEA

Antinoüs Mandragone,
Italy, Roman Empire,
circa 130 A.D.
Marble, 95 cm.

Opposite page:
Apartments
of Anne of Austria,
become the musée
des Antiques in 1799.

The 45,000 works in this department constitute one of the rarest collections in the world. Sculptures, sarcophagi, vases, paintings, bronzes, and jewels are witness to all the civilizations of the Mediterranean basin from the fourth century B.C. to the fifth century A.D. No other collection has changed as much over the course of its history than this one. The "antiques" came to the Louvre with Francis I and Henry IV. In the seventeenth century, the collections of Cardinal de Richelieu and Cardinal de Mazarin were added to the royal collections.

When the museum was opened, the antiquities collections did not amount to much because there was nothing exceptional among them. That all changed with the arrival of the fabulous booty from Bonaparte's Italian campaigns. From the *Apollo Belvedere* to the *Laocoon,* all the most important and remarkable sculptures from antiquity were unloaded in Paris. However, this unusual period lasted only fifteen years, because Italy demanded the return of its treasures. And in spite of some of the pieces having been purchased, the same terms were applied, and none of these works remain in the Louvre today.

The collection achieved its present status in the nineteenth century as a result of purchases and gifts, but also thanks to digs. One of the most important purchases is that of the Campana collection, which was bought by Napoleon III and which came to the Louvre in 1862. Giampietro Campana di Cavelli (1807–1880) started it in 1829, and he stopped at nothing in order to gather thousands of Greek and Etruscan vases and more than 400 antique marbles. He led digs in Ostia, Frascati, and Cerveteri, as well as along the principal Roman roads, and

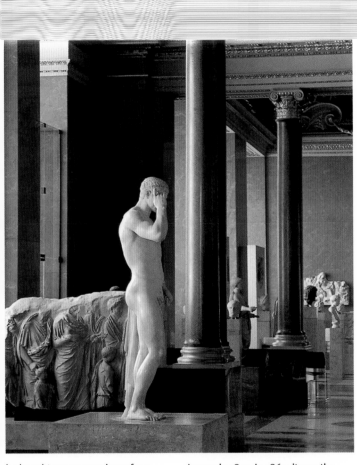

he bought numerous pieces from Italian collectors.

As for discoveries, some were exceptional. In April of 1820, the *Vénus de Milo* was discovered on the island of Mélos by Jules Dumont d'Urville, an officer in the French navy, and was bought by the Marquis de Rivière, the ambassador of France to Istanbul, who gave it to King Louis XVIII. The king then gave it to the Louvre in 1821. In 1863, it was the turn of Charles Champoiseau to play his role in the story of the Louvre, with the discovery of hundreds of fragments of the *Victory of Samothrace;* the fragments were assembled at the Louvre. Her right hand, discovered in 1950, is displayed separately in a glass case, but her head has yet to be found.

What is the size of the *Mona Lisa?*

Greek, Roman, and Etruscan Art: Icons

One is without arms; the other has neither arms nor a head. No one knows who sculpted either one of them. But that hasn't prevented them from being, since the time of their discovery, the most valuable testimony to the craft of antique sculptors.

The *Vénus de Milo* was discovered in 1820 on the island of Melos, from which it takes its name. It was acquired by Charles-François de Riffardeau, duc de Rivière, peer of France, and ambassador of King Louis XVIII to the Ottoman Empire. He gave it to Louis XVIII; the king gave it to the Louvre. Even though the statue had been found in two pieces that were easily reassembled, what was one to do about the missing arms? The controversy raged. It was even more

important to determine the identity of the statue from her attributes. If she held an apple, it was certainly Venus, called the most beautiful of goddesses by Paris. If she was playing a lyre, she ought to be a muse. Then again, if she had held a shield, she would have been the protective divinity of the island. If... No one came up with a definitive answer. It was decided not to restore the arms. And from her beauty alone, she has been called Venus.

The *Victory of Samothrace* was discovered by French archeologists in 1863. It was discovered at and named for Samothrace, an island in the Aegean Sea. But that doesn't mean that the victory she celebrates took place at Samothrace. It is thought that she was sculpted to mark the victory of Demetrius Poliorcetes at Salamis in 306 B.C. Unless she is dedicated to the victory won at Silée by Rhodes, allied with Pergamum, over the fleet of Antiochos III of Syria in 191 B.C. And in the end, beauty wins over incertainty...

77 x 53 cm.

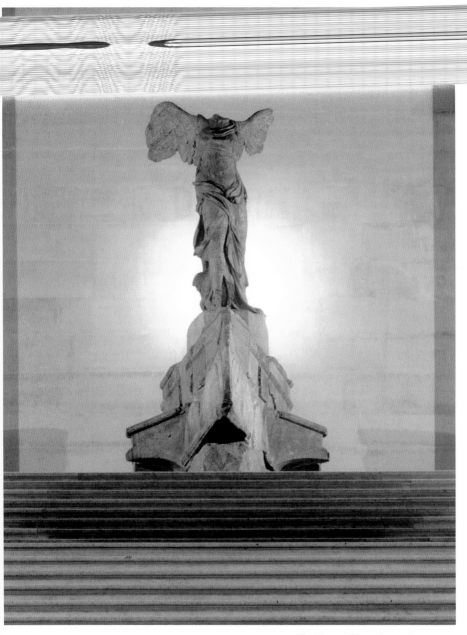

The *Victory of Samothrace,* circa 190 B.C.
Gray marble from Lartos for the boat, marble from Paros for the statue, 328 cm.

Opposite page: *Aphrodite,* also called the *"Venus de Milo,"* circa 100 B.D. Marble, 202 cm.

1

2

PIERRE REYMOND

•

RAPHAEL

•

WILLEM DROST

•

PHIDIAS

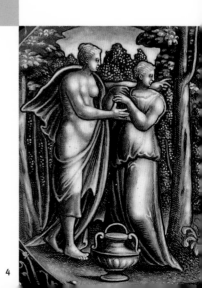

3

4

Greek Perfection

The names Aphrodite and Apollo are both synonymous with beauty. How can anyone doubt the beauty of Aphrodite? The Trojan shepherd Paris found her more beautiful than Athena and Hera. And when Zeus gave Adonis the possibility of choosing between Persephone and her, it was Aphrodite who won. For both these men, and for everyone, she was the embodiment of absolute beauty. In 340 B.C., when

AFTER PRAXITELES, *Apollo*, of the *Lycian Apollo* type, Roman work of the imperial era, second quarter of the 2nd century A.D., Marble, 216 cm.

Opposite page:
AFTER PRAXITELES, Head of a woman of the type of the *Aphrodite of Cnidus*, called the Kaufmann head, circa 150 B.C. Marble, 35 cm.

the Greek sculptor Praxiteles offered the city of Cos the first perfectly nude representation of this sublime goddess, he caused a scandal. The inhabitants of Cos refused the sculpture. The people of Cnidus accepted it—to such an extent that they had it reproduced on their money. The representation of Aphrodite thus traveled around the ancient world, where it became a symbol of beauty, a symbol that inspired poets and artists and was the subject of numerous copies. Like Aphrodite, Apollo was a child of Zeus. Accompanying the Muses, playing on the lyre given him by Hermes, or inspiring poets did not prevent him from being unhappy in love. The nymph Daphne, whom he faithfully pursued, changed herself into a laurel tree at the very moment he thought he had her. And the beautiful youth Hyacinthus, whom he loved, was killed by a discus thrown by the god himself. It was once again Praxiteles who sculpted the first ideal representation of this god. The *Lycian Apollo* carved by Praxiteles would be as copied as the statue of Aphrodite.

These two symbols of Greek perfection would be repeated many

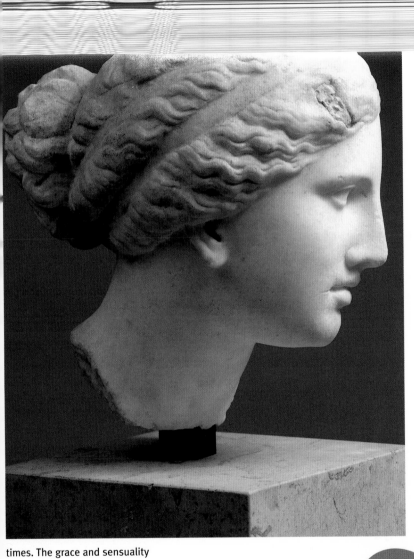

times. The grace and sensuality
devised by Praxiteles became the
standard, and a constant source of
inspiration for the Western
imagination.

What ceremony took place at the Louvre in 1961?

Etruscan Mysteries

Of all the civilizations with works in the Louvre's collections, the Etruscan civilization is the only one that remains an enigma. There are two reasons for this: we know nothing of their origins, and their writing is still indecipherable.

From ancient times, questions were raised concerning the origins of this people. In the fifth century B.C., the Greek historian Herodotus stated that the Etruscans came from Lydia and that they fled this country because of famine, but another Greek historian, Dionysius of Halicarnassus (first century B.C.), stated that they came from nowhere and that they had never left their territory, between the Adriatic to the east and the Mediterranean to the west.

If this civilization's origins remain a mystery, what it was in itself is another mystery, because the Roman power obliterated it even before Rome became the head of an empire. The Etruscan language, which is not an Indo-European language, has become indecipherable. Because they were written with Greek characters, the inscriptions, which are for the most part funerary in nature, are understandable, as are the commemorative plaques and epitaphs. Longer texts, however, remain an enigma.

One of the rare things we know for certain about the Etruscans is that they traded extensively with the Mediterranean peoples. Knowledge of this forgotten language would perhaps explain why the faces or costumes represented on an Etruscan sarcophagus were influenced by the art of ancient eastern Greece. For want of explanation, all hypotheses are possible and compel our imagination by inviting us to dream of mysteries.

The keys to the Pavillon de Flore were solemnly handed over to the Louvre by the minister of finance.

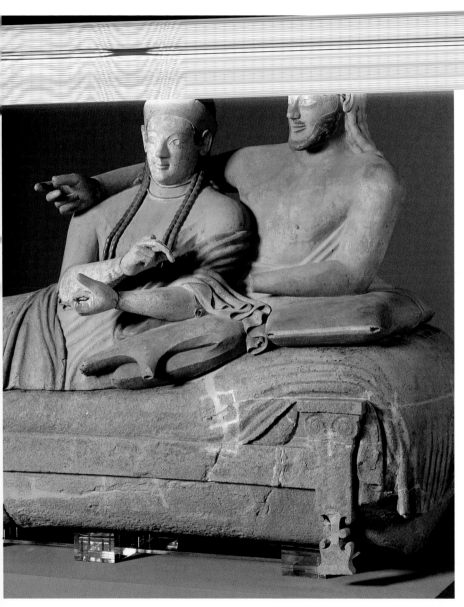

Sarcophagus, called the Sarcophagus of the
spouses, circa 520–510 B.C. Cerveteri, Etruscan
era, polychrome terracotta, 111 x 194 x 69 cm.

Opposite page:
Statue of Aphrodite, circa 350 B.C. Etruria,
bronze, solid casting, 50.50 cm.

Detail
Guess the artwork

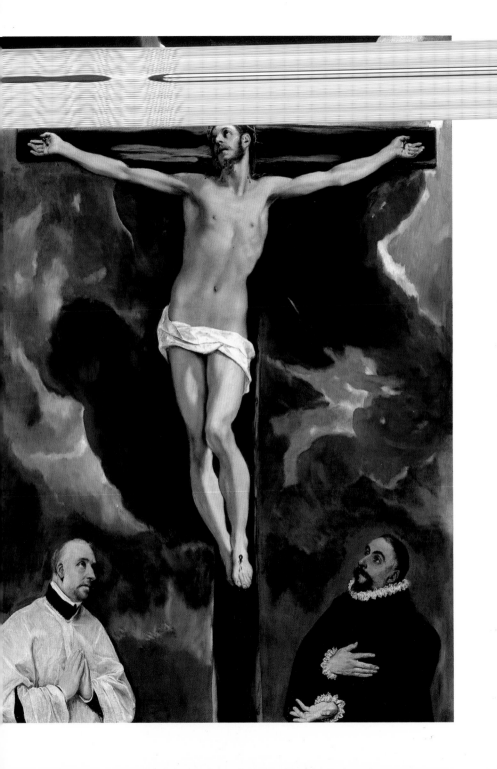

Imperial Presences

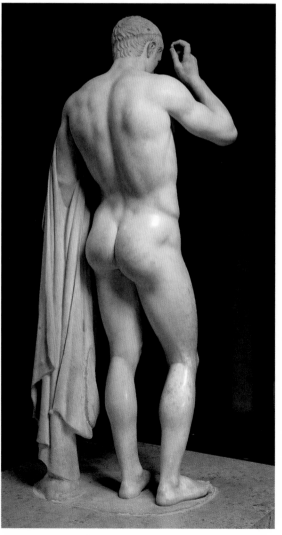

Following his victory at Actium in 31 B.C., Octavius became the sole ruler of Rome. He had already received the title of emperor in the year 38. In 28, he was awarded the title of *princeps senatus.* One year later, he received the name Augustus. This word of religious origin confirmed his divine mission. Proclaimed "great pontif" in 12 B.C., he became the religious head of the empire, and soon afterward, the worship of the *Genius Augusti,* the adoration of divine power incarnated in the person of the emperor, was decreed throughout the empire.

The divinity of the emperor meant the unity of the empire, which stretched from the North Sea and the Danube to the Saharan Desert, from the Atlantic to the Black Sea and the Euphrates. Every portrait of the emperor was declared divine as well.

Augustus turned to Cleomenes for an idealized portrait of Marcellus, his nephew (and son-in-law), whom he wanted to make his successor as head of the empire. The sculptor was of Athenian origin and brought to Rome his complete knowledge of the sculpture of the classical era of the fifth century B.C. He was, notably, the successor to Polycleitus, who had established and codified the ideal proportions of the human body. In the emperor's eyes, it was the rigor that

Cleomenes brought to his work that, without a doubt, would make it possible for the artist to forcefully express the divine dimension of his imperial nature, which was the source of his power.

When, after the death of Augustus, the official workshops of the Roman Empire would have to provide all the provinces of the empire with portraits of the late emperor, they would try to apply the same rigor that Polycleitus had done, for it was his concept of the ideal, invented in Greece in the fifth century B.C., that still set the standards for a beauty that would yield the most perfect image of the gods. These standards had served the emperor-gods throughout the empire of Rome, who would continue to make their imperial presences felt beyond the grave.

The Emperor Augustus, posthumous portrait dating from the reign of the emperor Claude, 41–54 B.C. Marble, 35 cm.

Opposite page:
CLEOMENES THE ATHENIAN,
Statue of Marcellus,
Rome, circa 20 B.C.
Marble, 180 cm.

When was the École du Louvre opened?

Department of Egyptian Antiquities

- FROM THE 4TH MILLENNIUM B.C TO THE 10TH CENTURY: PREHISTORY-MIDDLE AGES (3800–1550 B.C.), NEW EMPIRE (1550–1069 B.C), LAST DYNASTIES AND PTOLEMAIC ERA (C. 1069–30 B.C.), ROMAN EGYPT, COPTIC EGYPT
- SURROUNDINGS OF THE NILE

Below:
Statue of a standing woman, no doubt Nefertiti, Egypt, reign of Amenophis IV, 1353–1337 B.C
Quartzite, 29 cm.

During the Restoration, both the department of Egyptian Antiquities and Egyptology as a science came into being. However, Egyptomania had already been all the rage in France for nearly thirty years. It had been inspired by General Napoleon Bonaparte—who had made this famous statement from the foot of the pyramids of Giza: "From atop these pyramids, forty centuries look down upon you."—and by Denon, who accompanied Napoleon to Egypt and published his *Travels in Upper and Lower Egypt,* which became an extraordinary best seller.

Ironically, neither the emperor nor the first director of the Louvre had anything to do with setting up the department of Egyptian Antiquities, which was created on the order of Charles X. On May 15, 1826, the king passed a decree, the first article of which specified that there would be two divisions for the conservation of antiquities in the royal museum, including one for Egyptian monuments from all periods. Champollion was named curator of this new division. Four years earlier, at age 32, he had succeeded in deciphering hieroglyphs that had remained silent for centuries. He was the author of the *Descriptive Notes on the Egyptian Monuments in the Charles X Museum,* the first guide published when the collections were opened to the public.

Throughout the nineteenth century, the collections expanded through the purchase of private collections and the sharing of objects discovered during excavations. In particular, the excavations led by Auguste Mariette (1821–1881) in Saqqara and those of the Institut Français d'Archéologie Orientale du Caire (French Institute of

It was founded in 1882 by Jules Ferry, minister of education and fine arts.

Oriental Archeology in Cairo).
Since then, the department, one of the largest in the world, has remained scrupulously faithful to the ambition defined by Charles X: the oldest works date back to the period of Nagada, around 4000 B.C., and the most recent date from the ninth century A.D.

Sarcophagus of pharaoh Sekhemre-Oupmaat Intef (detail), 17th dynasty, circa 1600 B.C. Gilded wood, 200 x 57 cm.

Egyptian gods
Who is who?

Answer

1. ANUBIS: *Statuette of the god Anubis, late period, 664–332 b. c. Bronze, 15 cm.* God of the dead and of embalming, conductor of souls. - 2. APIS: *Head of the sacred bull Apis, 26th dynasty, 664–525 b.c. Bronze, 14,10 cm.* God of fecundity. - 3. TOUERIS: *Figurine of the hippopotamus goddess Toueris, late period, circa 660–332 b.c. Egyptian faience, 9,30 x 3 cm.* Goddess of fecundity. - 4. THOTH: *Statuette of the god Thoth with the head of an ibis, late era, 664–332 b.c. Bronze, 14 cm.* God of wisdom, counselor to the gods. - 5. RA: *Figurine of the god Ra squatting and holding the plume of the goddess Maat, end of the 28th dynasty, New Kingdom, circa 1550–1069 b.c. Wood, 10.20 cm.* Sun god, creator of the world. - 6. HORUS: *Statue of the god Horus, third middle period, 1069–664 b.c. Bronze, 95.50 cm.* Lord of the heavens, he is the most regal of the gods. - 7. BASTET: *Statue of the goddess Bastet, with the name of the king Piankhi and of the queen Kerensat, 25th dynasty, circa 747–716 b.c. stone, inlayed eyes, 24 x 5.40 cm.* Goddess of joy and peace, and of womanhood, protector of children. - 8. SEKHMET: *Statue of Sekhmet, goddess with the head of a lioness, reign of Amenophis III, 1391–1353 b.c. Diorite, 218 cm.* Goddess of heat and of epidemics.

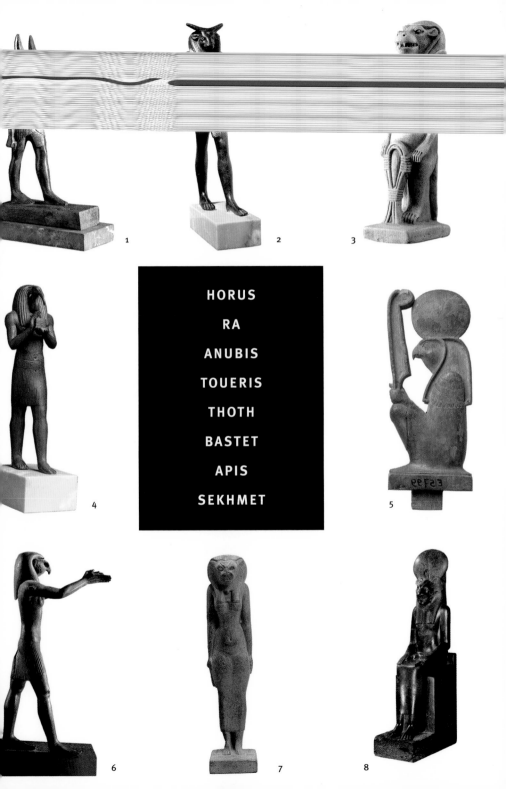

1

2

3

HORUS

RA

ANUBIS

TOUERIS

THOTH

BASTET

APIS

SEKHMET

4

5

6

7

8

Egyptian Antiquities: Icons

If it were necessary to symbolize the riches and quality of the department of Egyptian Antiquities throughout the long history of Pharaonic Egypt, the *Squatting Scribe* and the *Great Sphinx* would in all likelihood be the two emblematic works that everyone would approve.

No one has ever been able to discover the identity of the *Squatting Scribe,* discovered in the cemetery of the Old Empire at Saqqara during excavations by Egyptologist Auguste Mariette in the nineteenth century. If we judge by the quality of the materials, the pigments, and the execution, this statue could be that of an important man. Perhaps he was a prince or someone who held a high political office. This scribe is getting ready to write. His rock crystal eyes, inlaid into copper, stare at his observers. This personage is a sign of the high importance accorded to writing in Egyptian civilization, with its dual roles of exalting the power of the gods and describing the afterlife, as well as helping with government and commerce.

The *Great Sphinx* was discovered in 1825 in Tunis, in the ruins of a temple dedicated to Amon Ra. This statue, measuring nearly 16.4 feet,

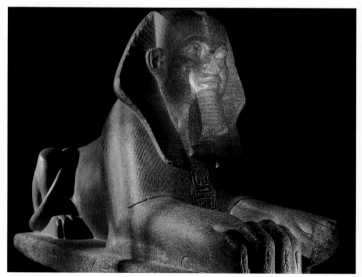

The Great Sphinx, reign of Amenemhet II, 12th dynasty, circa 1929–1895 B.C. Rose granite, 480 cm.

Opposite page: *Squatting Scribe,* 5th dynasty, circa 2500-2350 B.C. Alabaster, limestone, rock crystal, 54 x 44 x 35 cm.

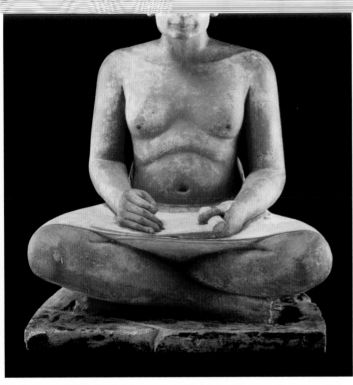

cut from a solid block of pink granite, was called *Sphinx* after the name of a Greek monster because of its form (a man's head on a lion's body). Although the names Merenptah and Sheshonk I are inscribed on this sphinx, we know that the sculpture did not originate with either of these pharaohs (the first was from the nineteenth dynasty; the second from the twenty-second) and it is uncertain what either of them could have used the sphinx for during their times.

Egyptologists cannot agree on the origins of this immense figure. According to some, it dates from the twelfth dynasty, while others are certain it is the sixth. Still others think it was created during the fourth dynasty. For now, the *Sphinx* continues to keep the secret of a mysterious and distant Egypt.

How many pyramids did the architect I. M. Pei create?

Pharaohs

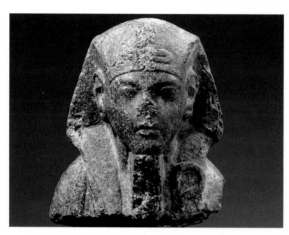

The word *pharaoh* made its appearance in the first millennium B.C. As surprising as it might seem, this title, which at first referred to the palace (the "great house"). and later to its master, was never used by any of the rulers of Egypt.

There were thirty dynasties of these masters of this "great house," reigning for a period that lasted more than 3,000 years, starting with the Thinite dynasty and ending with the Ptolemaic dynasty. Since Champollion deciphered the hieroglyphics, Egyptology has made it possible to make an almost flawless list of all these pharaohs. From Narmer, the first of them and the founder of Memphis, who reigned until 3100 B.C., to Ptolemy XVI Caesarion, son of Caesar

and Cleopatra VII, who was killed by Octavius in 30 A.D., the list is long. It goes without saying that to remember that Amenhotep belonged to the eighteenth dynasty, that the eighth dynasty had around twenty-five pharaohs, and that Nectanebo was the first pharaoh of the thirtieth dynasty, you have to be an Egyptologist.

However, it is not necessary to be an Egyptologist to be able to recognize the signs of the pharaoh's power throughout the centuries. After a few visits to the Louvre, even an amateur will be able to distinguish the distinctive signs of the various periods.

For example, in the twenty-sixth dynasty, the pharaoh wore the blue ceremonial crown called the *khepresh;* in its center was the *uraeus,* a symbol of a cobra that represented the eye of Ra. When he was not wearing this crown, the pharaoh wore a double crown (the *pschent*), red for Lower Egypt and white for Upper Egypt. In the twenty-eighth dynasty, the pharaoh wore a false beard that was itself divine. It is possible to make out the scepters in the hands of Amenophis IV, one of which is adorned with the head of Seth.

Five: the great pyramid and three pyramidons in the Napoleon Courtyard and an inverted pyramidon in the underground galleries of the Carrousel.

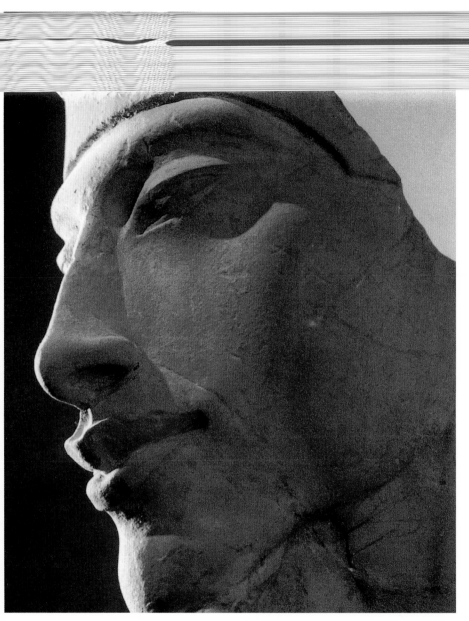

Fragment of a colossal osiriaque of Amenophis IV,
28th dynasty, 1365–1360 B.C. Sandstone, 137 x 88 cm.

Opposite page:
Fragmentary *Ouchebti* of the pharaoh Akhenaton-Amenophis IV,
reign of Akhenaton, 1353–1337 B.C. Diorite, 10 x 8 cm.

1. NECTANEBO I: Royal Head with the Blue Crown (Nectanebo I), 30th dynasty, late period, 664–332 B.C. Basalt, 6 cm. -
2. AMENOPHIS II: Head of a Sphinx (Amenophis II), Egypt, New Kingdom, 18th dynasty, 1427–1401 B.C. Red quartzite,
21 cm. - **3. AMENEMHAT III:** The King Amenemhat III, Egypt, Middle Kingdom, end of the 12th dynasty, circa 1830 B.C.
Dark green schist, 21.40 cm. - **4. AMENOPHIS III:** Head of the King Amenophis III, Egypt New Kingdom, 28th dynasty,
1427–1401 B.C. Diorite, 32.50 cm.

Answer

Pharaohs
Who is who?

1

2

AMENEMHAT III

•

AMENOPHIS II

•

AMENOPHIS III

•

NECTANEBO I

3

4

Coptic Syntheses

The Greeks used the word *aegyptos* to refer to the inhabitants of the Nile valley. The Arabs changed this word to *qubti,* which was the origin of the word *Copt.* When the Arabs arrived in Egypt in 641, the country was already largely converted to Christianity. The term *Coptic Egypt* refers to a Christian Egypt where the art is the result of an extraordinary synthesis of influences that have swept through centuries of history in the Nile valley—influences of an Egypt that for millennia belonged to the

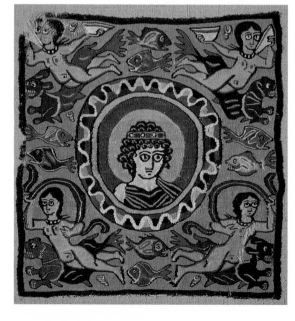

pharaohs, those of a "Greek" Egypt with Alexander the Great and the Ptolemies, and finally those of a "Roman" Egypt since the victory of Octavius.

On the strength of biblical accounts from the Gospel of Matthew that tell us that the Holy Family sought refuge along the banks of the Nile when fleeing from Herod's wrath, Christians have declared this ground to be "holy" and claim in their own way places, stones, and shapes handed down through a long and rich past.

Around 180, Demetrios, the bishop of Alexandria, created a school that, for the first time, tried to develop a synthesis between Greek philosophy and the new faith based on the Gospels. As did John the Baptist and Christ himself, hermits and monks withdrew to the desert. On the death of Saint Pachomius, in 346, the community to which, for the first time in the history of Christianity, he had given rules numbered nine convents for men and two for women. The paintings that decorated the walls of the chapels, oratories, and cells of the monks in the convents owed as much to the painting of antiquity as

to that being developed during the same time period in Byzantium. But among all the arts practiced by the Copts, the one they completely mastered was the art of textiles, to such an extent that the Arabs referred to the tapestries they found as "copts."

Christ and the Abbot Mena, Coptic Egyptian, 6th–7th century. Wax and distemper painting on figwood, 57 x 57 cm. Formerly, Monastery of Bawit.

Opposite page:
Shoulder-pad:
Nereid riding astride a sea creature,
Coptic Egyptian, 7th–8th century.
Linen and wool tapestry.

How many guards does the Louvre employ?

The Faiyum Collection

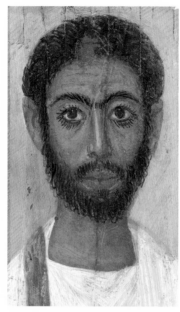

Portrait of a man
from Thebes,
circa 250 A.D. Encaustic
on wood panel,
33 x 18.50 cm.

Ritter von Graf discovered "an immense cemetery of the Roman era" in the necropolis of Arsinoë, the most important town of Faiyum. Yet more portraits emerged on the wood of exhumed mummies in often remarkable states of preservation due to the dryness of the climate. Most were life-size portraits painted on wooden boards (linden, sycamore, cedar, pine) and sometimes on linen. Almost all were done in encaustic (a mixture of beeswax with black, white, and red and yellow ocher pigments) and highlighted with gold leaf. All of these portraits are full face or three quarters, but never in profile, unlike the faces painted in Egypt over several centuries.

Painted between the first and fourth centuries B.C., they are products of Greco-Roman Egypt—an Egypt that continued to mummify its dead so they could attain eternity, but which borrowed from the Greek realist style as elaborated by Apelles, the painter of Alexander the Great.

The name Faiyum comes from the Arabic transcription of the Coptic word *Pa-Tôm,* meaning the sea. This "sea" was in fact a lake sixty-two miles southwest of Cairo, which emptied into the Nile by way of Bar-Yussuf.

When the Italian Pietro Della Valle (1586–1652) visited in the vicinity of the necropolis of Saqqara, he apparently was one of the very first to look upon the painted faces that would become known as the Faiyum portraits. A century later, in 1888, the Viennese merchant Theodor

About 900 people.

272

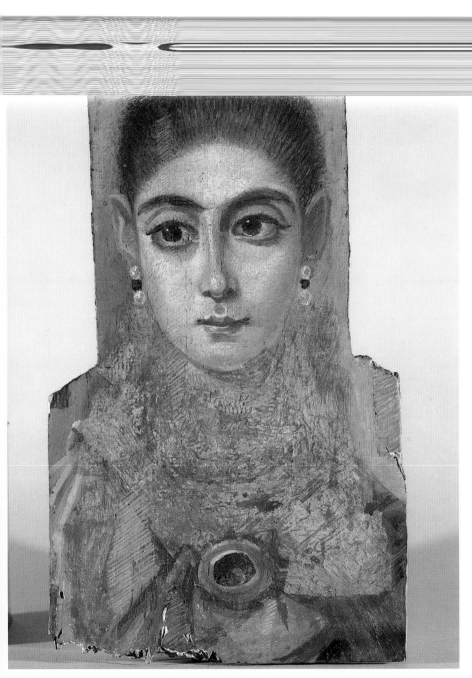

Portrait of a girl called the "European," from Antinooupolis, circa 117–138.
Encaustic on wood panel, gold leaf, 42 x 24 cm.

Madonnas

Find the detail that gives away the title of the work

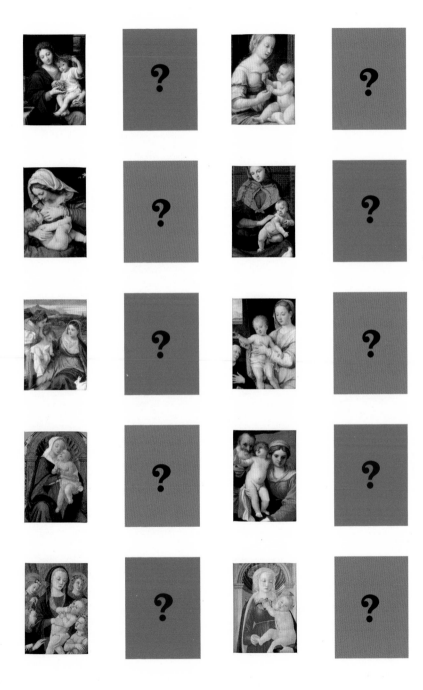

Department of Oriental Antiquities

- FROM THE 7TH MILLENNIUM B.C TO THE 7TH CENTURY
- FROM THE INDUS TO THE MEDITERRANEAN SEA

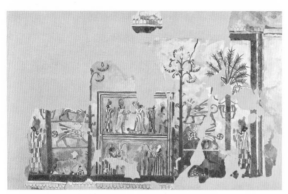

Palace of Zimrilim, painting of the investiture, 18th century B.C. Mesopotamia, Fresco over a layer of clay.

Opposite page: Composite statue, start of the second millenniun B.C. Iran, Bactrian, chlorite, and limestone, 17.30 cm.

Thanks to the archeological discoveries of Paul-Emile Botta (1802–1870), an archeologist and French diplomat, an Assyrian museum was inaugurated at the Louvre in 1847. In 1881, a special section was created to welcome the important discoveries made by Ernest Renan (1823–1892) in Phoenicia and those made by Ernest de Sarzec (1832–1901) regarding the Sumerian civilization.

The tens of thousands of pieces collected by the Oriental Antiquities department are from an immense territory that extends from the Indus to the Mediterranean and cover a period of human history from the Neolithic Age around 9500 until the seventh century B.C. Three large geographic and cultural groups are displayed chronologically: Mesopotamia (including the civilizations of Sumeria, Babylon, Assur, and Anatolia), Iran (Susa, the Iranian plateau, and the eastern limits of Iran), and the countries of the Levant (Syria, Palestine, and Cyprus). These last collections are on display in the Sackler wing of Oriental Antiquities, opened in 1997 thanks to a gift from the Mortimer and Theresa Sackler Foundation. Walking through these rooms, where majestic architectural restorations alternate with displays of works and objects, we begin a voyage of discovery to this part of the world where large cities governed by political, military, and religious administrations first appeared. Journey as far as Uruk in Mesopotamia, where writing was discovered around 3300 B.C. and where the first stelae were engraved, first with pictograms and then with cuneiform writing.

In the new Code of Hammurabi room is the stela on which were engraved at the start of the second millennium, the judicial decisions rendered under the reign of King Hammurabi (around 1792–1750 B.C.)

Around the stela, the bronze lion, paintings from Mari, and statues from Eshnunna can also be seen; all these works attest to the importance and power of the cities of Babylon and Mari. Going into the Cour Khorsabad, in front of the bulls and Assyrian reliefs, we can imagine the immensity and splendor of the palace of King Sargon II.

It may no longer be possible to examine the legendary hanging gardens of Semiramis in Babylon, considered to be one of the seven wonders of the world, but all the objects that surround us in these rooms testify to the fact that these civilizations were capable of the most wondrous things.

How many pieces are in the Asian Arts department?

Oriental Antiquities: Icons

Most of the statues of Gudea, the Sumerian prince of Lagash at the end of the twenty-second century B.C., show him with his hands joined in prayer. The magnificent representation of the prince at the Louvre is exceptional; this is due in part to the originality of his pose, as he holds in his hands a vase, from which water flows streaming down the length of his robe. This statue stood in the temple of the goddess Geshtinanna, wife of the prince's patron god Ningishzida. The statue reveals the relationship of the prince to the god Enki-Ea who, as lord of the underground waters, was in control of fertility.

Another masterpiece, a tall basalt stele from c. 1792–1750 B.C., represents Hammurabi, king of Babylonia, facing the god Shamash seated on his throne, who gives him the insignia of power. His is the power of light and of justice. The cuneiform text on the stele sets forth 282 statutes concerning the most diverse aspects of life and law such as commerce, the practice of medicine, the regulation of deposits and securities, theft, the family, injuries and wounds...As impressive as it is, this work also informs us of a highly-developed legal system thousands of years old. Hammurabi was charged to do everything "to eliminate evil and wickedness, so that the strong might not oppress the weak."

About 100,000 works.

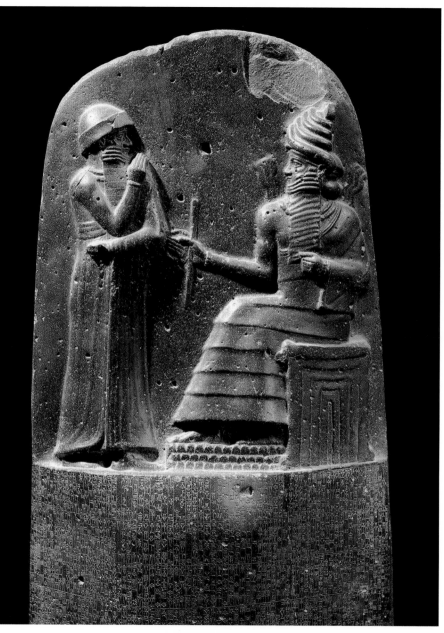

Stele of the Code of Law of Hammurabi (detail), 1st dynasty of Babylonia,
circa 1792–1750 B.C. Mesopotamia, diorite, 225 x 65 cm (ensemble).

Opposite page: *Gudea, Prince of Lagash, With a Flowing Vase,*
circa 2150 B.C. Mesopotamia, calcite, 61 x 25.60 cm.

THE LOUVRE NEWS

NEWS IN BRIEF & TIDBITS

SEPTEMBER 7, 1911: ONE MILLION OFFERED TO THE PERSON WHO STOLE THE *MONA LISA* BY THE NEWSPAPER *L'ŒUVRE*:

"Dear Thief, (…) I have the great honor of telling you that I have one million to give you in exchange for the *Mona Lisa*. That is right, I'll repeat it: ONE MILLION. This is not a trap or a joke. All you need to know is that, on your request, I will go to a place of your choosing and hand you one million. I

will not give you a check that you would be afraid to cash, but one thousand thousand franc bills. I don't want to know your name; I don't even want to see your face. If you like, you can come to the meeting with a wig, a false beard, sunglasses, or a mask. If you want to meet at the end of the earth, I will meet you at the end of the earth. (…) Whatever your motive, whether you want it or not, you are without question the best worker in our "work"; and I want to assure you, sir, that you have my highest regard." GUSTAVE TÉRY

SPEECHES & ACTUALITIES

- **November 1993: François Mitterand Inaugurates the Richelieu Wing:**

"For a long time, we have been dreaming of perfecting the Louvre, of freeing it from its other obligations, to make it purely a museum, but the decision was not made or could not be made. Return the Louvre to its first function as a museum—I was already talking about it when I was a student with one of my friends, who is still around, who from my first days here (at the Élysée) said, "You should complete the Louvre." So nearly forty years after our first conversations on the subject, what am I saying? It's nearly fifty years. (…) This is how what Georges Salles used to call, a long time ago—it was in 1950—the "wild dream" of making the Richelieu wing, occupied by the minister of finance, part of the museum, this is how this "wild dream" became reality. (…) It is a joy to live and I believe that effort needs no other reward, it finds it in itself. I would like to quote Marguerite Yourcenar who loved the Louvre and who wrote, I quote: "Then, there was the Louvre, there was a beginning to the great dream of history, the world of all those who had lived in the past." She added: "When you love life, you love the past because it is the present as it survives in the human memory." I would like to add, if I may: because it also draws the lines of the future. Ladies and gentlemen, let us serve life, let us serve creation, art, imagination, let us become part of history, we are but its humble workers, and for one night, let us rejoice."

- **October 2002: Jacques Chirac Inaugurates the Pavillon des Sessions:**

"The answer to today's problems is a dialogue between cultures, because it calls for a synthesis between the search for the efficiency of the industrial era and traditional societies' search for harmony. Let us be careful that the increasing place that commercial exchanges are taking in our lives be accompanied by an equal intensification in the exchange of ideas. This is why we must preserve the diversity of the world, a guarantee for the future of humanity. (…) This is why I wish to open a new department at the Louvre Museum dedicated to Islamic arts. It would reinforce the universal vocation of this prestigious institution and remind the French people and the world of the essential contribution Islam has made to our culture."

- **January 2005: Audrey Tautou chosen for the *Da Vinci Code***

Audrey Tautou was finally chosen from among all the French actresses approached to play the role of Sophie Neveu in the film adaptation of the best-selling novel the *Da Vinci Code*; Neveu is the young French cryptologist who helps Robert Langdon (Tom Hanks), an expert on art and religion, to discover who killed the Louvre curator and why. Last week the director Ron Howard (*Willow, Apollo 13, A Beautiful Mind*) finally decided after two months of meetings with a dozen other French actresses (some names mentioned were Sophie Mareau, Juliette Binoche, Vanessa Paradis, Sandrine Bonnaire, Judith Godrèche, Virginie Ledoyen, and Julie Delpy). The director of the Louvre and the minister of culture have agreed in principle to allow some scenes to be filmed inside the museum. The film should be released in 2006.

- **Contemporary art: Italian agitators at the Louvre**

In 1994, for his visit to the Louvre, the Italian artist Alberto Sorbelli donned stockings, a garter belt, and a miniskirt to tease the *Mona Lisa* and get himself thrown out by the security guards, who were immune to his appeal. At the end of 2004, at the Contrepoint exhibition, it was the Italian artist Maurizio Cattelan's turn to create disorder by perching on one of the museum's cornices, between the statues of Mansart and Poussin, a perfect replica of a young boy in short pants playing the drums. His antics had visitors shuddering and calling on the Louvre's security guards for help.

Byzantine Splendors

Triptych: *Deesis (Christ Enthroned) With Saints,* Constantinople, Mid–10th century. Ivory, traces of polychromy, 28.20 x 24.20 x 1.20 cm.

Opposite page: Plate and lid of the reliquary of the Holy Sepulchre: *The Holy Women at the Sepulchre,* Constantinople, Comnene dynasty (1081–1185). Wooden support, silver, wax, 42,60 x 31 cm.

In 313, the emperor Constantine agreed in the Edict of Milan that Christians could practice their faith. In 330, he left Rome and made Byzantium, on the banks of the Bosphorus, the capital of the empire, which was renamed Constantinople in honor of the emperor. Some of the most precious relics of Christendom began to accumulate in the great city, and it was there that the most sumptuous reliquaries were fashioned.

Over the course of many centuries, visitors from both the East and the West were drawn to the splendors of Constantinople.

In the ninth century, a visitor reported that the emperor's church "had ten doors, four of gold, and six of silver"; that the emperor's seat, like the altar itself, was "encrusted with pearls and rubies"; and that "all the ceilings of the church were vaulted and coated with gold or silver."

In the twelfth century, a crusader described the emperor's palace: "The beauty of the exterior is nearly incomparable, and that of the interior surpasses by far anything I could say of it. Wherever one looks, there are gildings and paintings of many colors ; the courtyard is paved in marble with exquisite skill. I wouldn't be able to say which contributes more to the great worth and beauty of this palace, the marvelous art that it contains or the precious materials that one finds there."

The materials of which he spoke were most often those of reliquaries: gold, precious stones, ivory...

Many of those marvelous treasures of Constantinople were looted by crusaders during the sack of the city in 1204. A few years later, the King Louis IX of France bought the

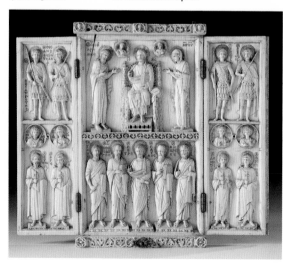

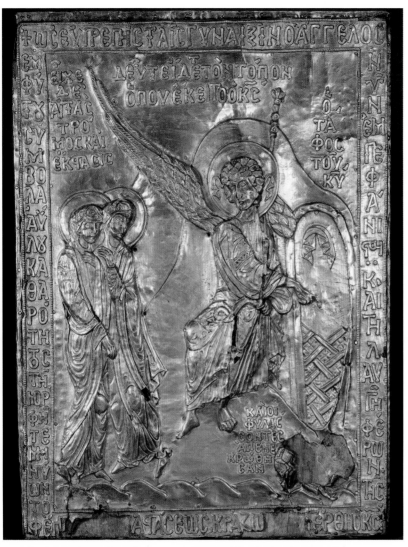

most important items from the
treasury of the Byzantine empire,
and it was for them that he had the
Sainte-Chapelle built in his royal
palace.

The French Revolution would
deposit these objets d'art in the
Louvre. They have since been part
of the permanent collections and
are shared by the department of
Oriental Antiquities (the Arabic
section on the ground floor of the
Sully wing) and the department of
Objets d'Art (Middle Ages section,
on the second floor of the Richelieu
wing).

How much space does the Louvre Palace occupy?

Mesopotamia

- FROM THE 6TH MILLENNIUM B.C. TO THE 6TH CENTURY B.C.
- MIDDLE TIGRIS, SUSA, SUMER, BABYLON, NINEVEH...

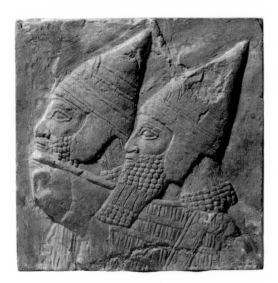

To envision Mesopotamia, one must lift the veil of time and peer back into the origins of civilization itself. A pictographic form of writing was invented there a thousand years before Christ. The wheel was also invented there. The name Mesopotamia is Greek, meaning "between two rivers." Those rivers, the Tigris and the Euphrates, run through present-day Iraq.

In this historic place, over the centuries, many empires and civilizations arose and faded away. The long history of Mesopotamia begins with the Sumerians in the fourth millennium before Christ.

and ends in the fifth century before Christ, with the Chaldeans and Nebudchadnezzar II, who, while king of Babylonia, built the famous Tower of Babel.

Three thousand years before Christ, during the Sumerian era, King Sargon founded an empire whose chief god was the sun. Later, in about 2150 B.C., Gudea, the prince of Lagash, proclaimed in Sumer the early principles of humanism. With the advent of the Amorites, a nomadic tribe from the west, the Sumerian era came to an end. The Amorites then created the kingdom of Babylonia and made Assyria a great power.

At the beginning of the sixteenth century B.C., the Amorites were routed in turn by the Kassites, who came from Persia, and the Kassites were then defeated by the kings of Elam. Following a series of invasions, the Assyrians finally took control of the region (from the ninth to the end of the seventh centuries B.C.), during which time they built the extraordinary palaces at Kalhu (Calah), Khorsabad, and Nineveh.

The Louvre is one of the few museums in the world to preserve

160,200 square meters.

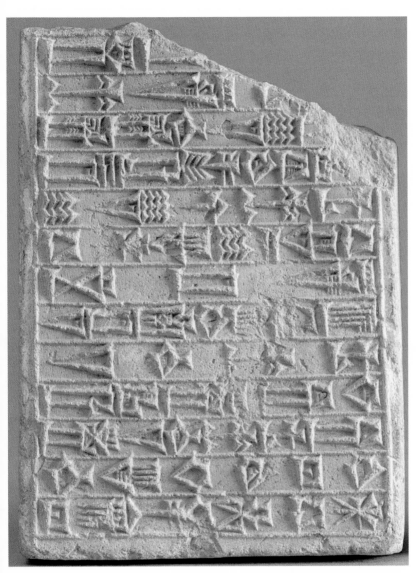

the remains of this fabulous
history: writing tablets, seals,
stelae, and statues, as well as
some exceptional architectural
fragments from temples and
palaces.

Mold for foundation bricks,
era of Isin-Larsa, 2000–1800 B.C.
Mesopotamia, terracotta, 9 x 6 cm.

Opposite page:
Two warriors (fragment of a bas-relief),
8th century B.C. Alabaster, 21.50 x 121.50 cm.

Oriental antiquities
Where do they come
from?

Answer

1. **IRAN:** *Divinities Among the Palms:* bull-men and goddesses carrying the inscriptions of Shilhak-Inshushinak, Iran, circa 1200 B.C. Enameled brick, 137 cm. - 2. **ASSYRIA:** Relief of the palace of Assurbanipal: The War on Elam: *Assurbanipal in His Chariot with Elamite Prisoners*, Assyria, circa 645 B.C. Limestone. - 3. **CONSTANTINOPLE:** Icon-reliquary of the Nativity, end of the 12th century, Constantinople. Wooden support, silver, wood, horn, copper, gold thread, ivory, parchment, stone, silk (textile), 26.30 x 24 x 3 cm. - 4. **MESOPOTAMIA:** Small plate decorated with a winged goddess (Ishtar) standing on two ibexes, era of Isin-Larsa, circa 1900 B.C. Mesopotamia, terracotta.

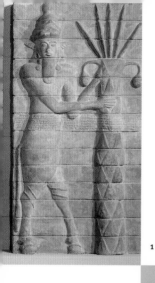

1

2

CONSTANTINOPLE

•

IRAN

•

ASSYRIA

•

MESOPOTAMIA

3

4

Ancient Iran

- FROM THE 4TH MILLENIUM B.C. TO THE 4TH CENTURY B.C.
- SUSA...

The long history of the kingdom of Elam was long ago eclipsed by that of Mesopotamia and the glorious city of Babylon. Elam, this "beautiful, vague name," as Paul Valéry expressed it, has gradually become a more tangible, better defined reality, thanks to archeological missions by the French and others.

This exceptional civilization, with its luxurious palaces and busy metropolises where writing was invented and craftsmen worked with bronze and ceramics, developed in the southwest of Iran. Elam, which means "high country," had two majors centers: the city of Anshan—today, the plateau of Fars—with a population of mountain-dwelling nomads, and that of Susa, located in an urbanized plain with a Semitic population. Susa was founded around 4000 B.C. Proto-Elamite writing appeared around 3300 B.C., as attested to by the first engraved documents that record the keeping of accounts. Already during the time of the Greeks, the civilization's origins were being made the stuff of legends: Memnon, the mythical son of Aurora, was supposed to

have been its founder. Bible texts make it the setting for the stories of Daniel and Esther. In 646 B.C., the time of the Elamites ended. The Assyrians and then the Persians in turn became masters of this land. Since 1848, this site has been the object of numerous French archeological missions, and France has benefited from a treaty that gave it all the antiquities it unearthed. Among these objects are many masterpieces from Babylon: the spoils of war and looting that attest to the close ties between the various kingdoms. The Code of Hammurabi is one of the most outstanding examples. Between 1884 and 1896, the Dieulafoys, a couple of French researchers, uncovered the palace of Darius I while excavating. Fragments of this architecture, including famous enameled brick friezes representing lions and archers, entered into the Louvre's collections. The archeological teams came one after the other until 1979, the date of the Iranian Revolution. The Louvre has preserved much evidence, both grandiose and modest, of this long and tumultuous history that led

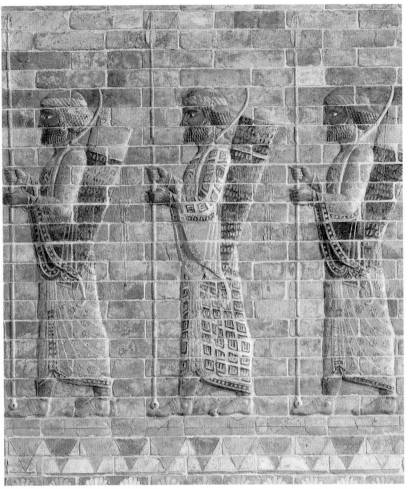

from Elam to Persia: statuettes and
statues of Elamite gods and
goddesses, writing tablets, objects
from daily life, bronzes and
ceramics, a bust of the king,
fragments from Darius's palace,
and more.

Frieze of the Archers of Darius,
Achaemenid empire of Persia,
reign of Darius I, circa 510 B.C.
Glazed silicious bricks, 200 cm.
Ancient Susa, palace of Darius.

How many curators work at the Louvre?

The Levant

- FROM 3500 B.C. TO THE 6TH CENTURY B.C.
- MIDDLE EAST, CYPRUS, TUNISIA...

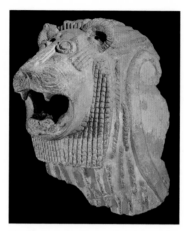

For the Europe of yesterday, the word *levant* always meant far-off Mediterranean countries where the sun rose. In the middle of the nineteenth century, the Louvre began to collect works from this region of the world. (As Egyptian art has its own department, Egypt it is not included in this category.) Excavations between the First and Second World Wars served to enrich these collections, as well as those of museums in Aleppo, Damascus, and Beirut. If the discoveries made in these countries are so troubling, it is because the Levant is one of the most extraordinary crossroads in the world. To the west is the Mediterranean, Greece, and Rome. To the south, Egypt. And to the east, the Levant opens upon Babylonia, beyond the nomadic steppes, and beyond that is Asia. The Levant is one of the rare crossroads of the world where all civilizations meet; it is hardly surprising that the alphabet should have been developed in this area, amid all the uncertainties and trials of the second millennium B.C. Or that it was on this side of the Mediterranean that the most fruitful commercial and cultural exchanges took place. In this part of the world, the Egyptians, the Hittites, and the Assyrians were able to exchange their goods as well as their knowledge. From this part of the world, the Phoenicians would depart for Cyprus, where they would encounter the Greeks, who would go to Sicily, Italy, and Spain. It was from here that the Phoenicians would establish their trading posts and cities such as Carthage in Tunisia....The Levant was the crucible where forms from all over the Mediterranean, such as those developed in the East, met, confronted, influenced, and melded one into the other. It was certainly here that the first "globalization" took place and it is fascinating to try to penetrate its mysteries. Its remnants at the Louvre can take us there.

Sixty.

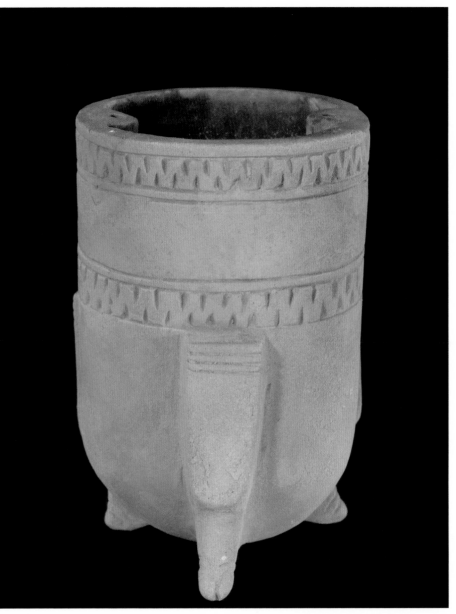

Three-footed Goblet in the Egyptian style,
Median-Assyrian era, circa 1400–1100 B.C. Mesopotamia, faience, 9 x 5.70 cm.

Opposite page:
Protome of a temple lion guardian, Babylonian era,
19th-20th centuries B.C. Mesopotamia, terracotta, 61 x 45 cm.

Mythology (2)
Who is what?

Answer

1. JUPITER: Statue of a male divinity, called the *Jupiter of Smyrna* (Roman Empire, 27 B.C.–476 A.D., marble, 234 cm). - **2. MARS:** *Mars* (Guillaume Coustou I, circa 1730–1740, terracotta, 39 cm). - **3. VENUS:** *Venus Rising From Her Bath,* also called *The Bather* (Christophe Gabriel Allegrain, 1767, Marble, 174 x 62 x 67.50 cm. Formerly, Château de Louveciennes). - **4. ARIANA:** *Bacchante or Ariane* (Roman Empire, second century A.D., marble, 220 cm). - **5. VULCAN:** *Vulcan* (Guillaume II Coustou, 1742, marble, 69.50 cm). - **6. ATHENA:** *Athena "Mattei,"* called *"The Peaceful Athena"* (classical era, circa 350–340 B.C. Marble, 230 cm). - **7. BACCHUS:** *Bacchus and a young satyr* (Giovanni Francesco Susini, 17th century, marble, 170 cm). - **8. JUNON:** Statue of Juno, called *La Providence* (Rome, second century A.D., marble, 198 cm).

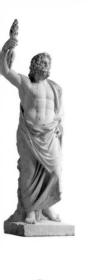

1

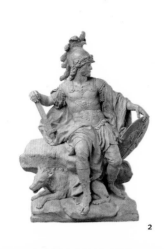

2

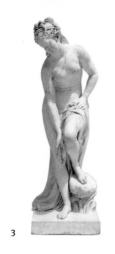

3

4

5

VENUS

JUNON

MARS

ARIANA

BACCHUS

JUPITER

VULCAN

ATHENA

6

7

8

Forgotten Gods

Statue of the goddess Narundi, Iran, paleo-Elamite era, circa 2100 B.C. Limestone, 109 x 47 cm.

The sacred, which gave rise to so many forms of beauty, is present throughout the Louvre, which has a virtual pantheon of forgotten gods in some of its departments. Whether Greek (Chronos, Zeus, Hera, Dionysos, Apollo, Athena, Aphrodite), Egyptian (Min, Amon-Ra, Osiris), or Canaanite (Réchep), these forgotten gods are displayed for our aesthetic pleasure, not because they demonstrate some scientific or archeological premise. Among the most beautiful examples are the god El, who was worshipped at the beginning of the second millennium B.C. in Syria, and the goddess Narundi, adored at Susa (Elam) at the end of the third millennium B.C. They are both seated on thrones and wear tiaras with horns, signifying gods of high rank. The thick braided border of the god's vestment, and the large woolen locks of the goddess's robe are traditional attributes of divine personages. The god El, father of men, symbolizes wisdom and the knowledge of all things. The goddess Narundi is the sister of seven beneficent spirits. Related to Inanna-Ishtar, the Mesopotamian goddess of love and war, her statue was worshipped in a sanctuary. Her face was probably covered in a precious metal set off with gems. She holds a palm frond and a goblet. Lions, her animal attributes, surround her throne in varying postures: lying at her feet, seated at the sides, and standing behind it. Today these gods, erased from the memory of men and belonging to no one, are merely artistic masterpieces.

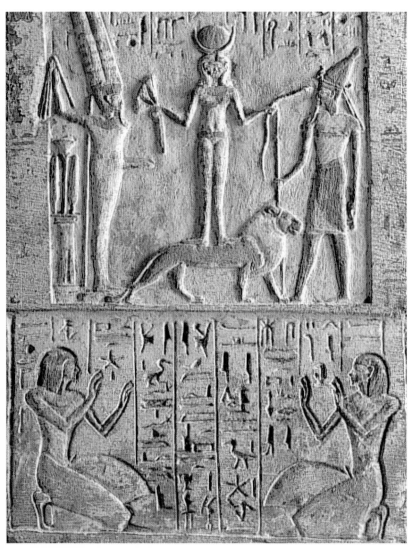

Stele of the goddess Kadesh, with the name of Houy,
19th dynasty, reigns of Sethi I or Ramses II,
circa 1290–1213 B.C. Painted limestone, 31 x 18 cm.

How many works of art does the Louvre contain from among all its departments?

Department of Islamic Arts

- FROM THE 7TH TO THE 19TH CENTURY
- EGYPT, MESOPOTAMIA, IRAN, SYRIA, TURKEY, SPAIN, CENTRAL ASIA, INDIA...

On October 14, 2002, the president of the republic, Jacques Chirac, expressed the wish that a department of Islamic Art be created at the Louvre. He also wanted to confirm "the prestige and the universal mission of the Louvre." There were certainly many examples of Islamic art at the Louvre, but they were displayed in different sections, which made it hard to appreciate them. The "Baptistry of Saint Louis," a copper basin inlayed with gold and silver, a masterpiece of Syrian art from the beginning of the fourteenth century, and several jade cups set off with gold and precious stones from Turkey were displayed in Objets d'Art. The same was true of the eleventh-century rock crystal ewer that was owned by Abbé Suger. Other works, many from the royal French collections, had been kept in the department of Oriental Antiquities since 1890. The oldest of these works were from the seventh century, and the most recent from the nineteenth: On display are ottomans from Syria and Egypt, rugs, textiles, ceramics, glasses, stained glass, stuccos from Egypt and Syria, ivories, miniature

!

Nearly 370,000, of which only 35,000 are on display.

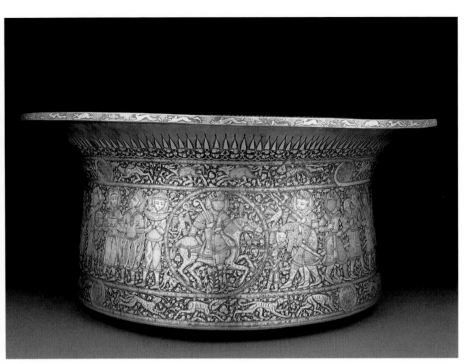

collections from Turkey and Iran, woodwork...

On the August 8th, 2003, the department of Islamic Art became the eighth department of the museum. The collections assembled under its aegis include important archeological finds, as well as documents on papyrus from the early centuries of Islam. Many works are examples of the refinement of the medieval arts in Iran, Arabia, and the Ottoman Empire. There are also works from central Asia and India. The loan of works from the Islamic collection of the Union Centrale des Arts Décoratifs (about 10,000 objects, 4,000 of them ceramic) add to the objects on display. All fields of Islamic art are

covered, geographically from Spain and the Maghreb to the Indian subcontinent, and chronologically from the seventh to the nineteenth centuries. In order to display more of this unique collection, additional space will be devoted to it in the Visconti courtyard of the Denon wing in the year 2010.

MUHAMMED IBN-AL-ZAYN, Font from the Saint Louis Baptistry, Egypt or Syria, 14th century. Hammered brass, engraving inlayed with engraved silver and gold.

Opposite page: Round cup, Persia, 16th century. Jade incrusted with gold, 4 x 15 cm.

Arts & Civilizations
What is their use?

1

2

COOKING

•

PERFUME

•

ASTRONOMY

•

MAKEUP

3

4

Islamic Arts: Icons

On the July 16, 622—the first year of the Islamic calendar—the Hegira took place: the prophet Mohammed and his first disciples left Mecca in secret for Yathrib (today, Medina in Saudi Arabia).

The first expressions of Islamic art that appeared during this period developed from different traditions and were influenced by Roman, Christian, and Byzantine styles, as well as by the decorative art of Sassanid Persia. Islamic art was ultimately influenced by the arts of central Asia during the period of the Turk and Mongol invasions. Islam's prohibition of "graven images," arbitrarily enforced by local authorities, did not apply to nonreligious art, as one can see from this cylindrical box carved from an elephant's tusk. A lute player, some knights, lions devouring antelopes, falcons and cheetahs are all shown there. This masterpiece was carved and sculpted in the workrooms of Madinat al Zahra, not far from Cordoba, in the Spain that was occupied by the Moors from 711 until the "reconquest" in 1492. The date 968 is carved on the lid with the name of the prince for whom it was made, al Mughira, son of the caliph Abdul Rahman III. Displaying true technical prowess—the base is carved from a single piece of ivory—this pyxis is a superb example of the remarkable art from the time of the powerful Umayyad dynasty.

Ceramic arts, along with weaving, are among the most refined traditions of Islamic art. Works done in Turkey in the studios of Iznik and Kütahya, between the end of the fifteenth and the beginning of the seventeenth centuries, are

Cylindrical box (pyxis) with a flat lid and animal decor, 13th century. Sicily, carved and engraved ivory.

Opposite page: Peacock platter, Iznik (Turkey), second quarter of the 16th century. Silicious ceramic with overglaze, 37.50 x 8 cm.

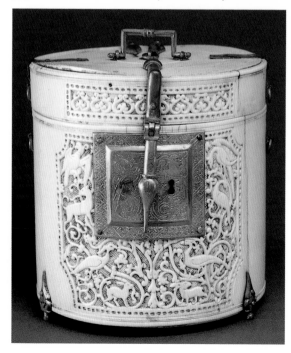

particularly well-known. They are made from a paste composed of ninety percent silica of a remarkable whiteness, itself often covered with a fine coating of lead silica—the casing—on which the artists apply their designs. Dating from the second quarter of the sixteenth century, this ceramic plate is a masterpiece because its subject, a peacock in a vegetal decor, is done with such finesse in a remarkable harmony of shades (dusty rose and lime green). The glaze over the decoration gives the plate the lacquered look that is so characteristic of works produced during this golden age of Ottoman ceramic art.

?

What is the most visited museum on earth?

Arts and Civilizations of Africa, Asia, Oceania, and the Americas

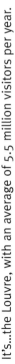

In 1990, the newspaper *Libération* published a manifesto entitled "All Artistic Masterpieces are Born Free and Equal." Cosigned by 150 celebrities, the text militated in favor of the creation of a section in the Louvre dedicated to what are called the primitive or primal arts. The author, Jacques Kerchache (1942–2001), is known as one of the greatest authorities on the arts that are the expression of four fifths of humanity. A world traveler and organizer of important international exhibitions, he had already written several articles and books on this subject. He first came to attention in 1960, at the age of 18, when he opened a gallery displaying works of contemporary artists alongside primitive works of art. His commitment and dedication caused him to be appointed scientific councilor to the future Musée du Quai Branly and also to convince the authorities of the soundness of his project. And, on the thirteenth of April 2000, President Jacques Chirac dedicated a new exhibition space in the Pavillon des Sessions, where nearly 120 masterpieces selected by Jacques Kerchache are displayed in a space designed by the architect Jean-Michel Wilmotte.

The works Kerchache selected for the Louvre are grouped by geographical area. They come from various public collections, such as the Musée National des Arts d'Afrique et d'Océanie and of the Musée de l'Homme (Museum of Man). Many purchases and loans have enriched the selection. The oldest African piece is a statue of a man of the Nagada period (predynastic Egypt: fourth

It's...the Louvre, with an average of 5.5 million visitors per year.

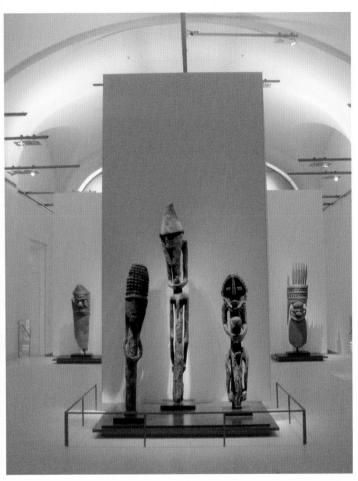

The Pavillon des Sessions, 2005.

Opposite page:
Statue of a man, Egypt, period of Nagada I, circa 3800–3500 B.C. Ivory.

millennium B.C.) lent by the department of Egyptian antiquities of the Louvre. Among the Asian works is an emblematic work from the former collection of André Breton, a wooden statue of an ancestral spirit from Nias Island. Statues from Easter Island and funerary works from New Ireland bear witness to the splendors of Oceanic art.

The arts of the Americas are represented by some exceptional pieces: a ceremonial Taïno seat from the Greater Antilles upon which Christopher Columbus might have sat; an Inuit mask Koniag, the centerpost from a Kwakiutl meeting house in British Columbia (bought by Max Ernst in 1942); and of course the ceramic piece from Chupicuaro, which was chosen as the emblem of the Musée du Quai Branly.

Artists' words
Who said what?

André Malraux

Joan Miró

Pierre Rosenberg

Paul Cézanne

Alberto Giacometti

Ieoh Ming Pei

Boris Vian

Napoleon III

André Malraux

François Mitterrand

Appendixes

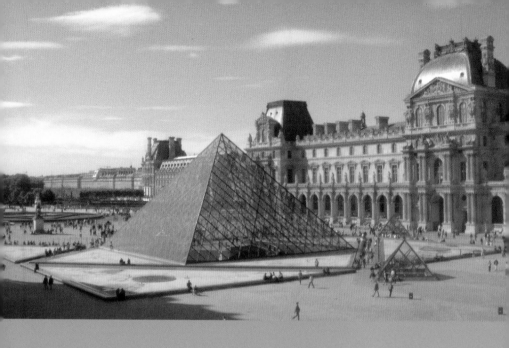

Chronology
of the Louvre

1180–1223
Reign of Philip Augustus.

1190
Start of construction of the Château du Louvre by order of King Philip II Augustus to ensure a defensive position to the west of Paris, outside the enceinte of the city that is being built at the same time. The structure is completed before he sets out on the Third Crusade.

1202
First mention of the Louvre's "tower." Construction of the château is completed. The enceinte forms a rectangle measuring 78 m by 72 m including ten towers. It is surrounded by moats and a circular keep known as the Grosse-Tour (Great Tower) that is 15 m in diameter and more than 30 m high. The château occupies one quarter of the current Cour Carrée (Square courtyard). Parts of its base can be found in the medieval area of the Louvre museum.

1214
Ferrand of Portugal, the count of Flanders, is imprisoned in the Louvre after the victory in Bouvines.

1240–1250
King Louis IX, "Saint Louis," makes some changes to the Louvre, including the vault of the Salle Saint-Louis (Saint Louis room).

1358
The city of Paris builds an enceinte on the right bank of the Seine encompassing the new districts and the Château du Louvre.

1364–1380
Reign of Charles V.

1364
King Charles V starts work on the château to transform it into a residence. This task is given to Raymond du Temple. The outside walls are opened with mullioned windows and the towers are capped with turrets. Wary of revolts by the Parisians, he leaves the moats and drawbridges in place. A new dwelling is built. The "grande vis"—a magnificent spiral staircase—is famous for its size and its sculptures representing the royal family (5 m in diameter, 20 m high). It ends in a small spiral staircase that leads to a terrace.

1515–1547
Reign of Francis I.

1528
On returning from captivity in Spain, King Francis I decides to settle in Paris. He razes the keep built by Philip Augustus to build a new château.

1528–1531
Royal apartments are built in the south wing.

1536
The construction of embankments makes it possible to keep traffic away from the Louvre.

1540
Reception of Charles Quint at the Louvre.

1541
The king decides to rebuild the Louvre. He first asks Serlio for plans, then Pierre Lescot, who has just finished the rood screen for the church in Saint-Germain-l'Auxerrois.

1546
Francis I chooses Pierre Lescot. The west wing of the château is razed and work begins on the central building of the Renaissance dwelling. A large staircase is placed in the center.

1547–1559
Reign of Henry II.

1549
After the death of Francis I, his son Henry II confirms the choice of Pierre Lescot. On the northern extremity of the west wing, he erects a staircase to create rooms along the length of the building on the ground floor and the first floor.

1550
Jean Goujon sculpts the caryatids of the Great Hall.

1551–1553
The project is altered to build three levels. The shape of the roof is changed to a gambrel roof. In the southwest corner, the Pavillon du Roi (King's pavilion) is built to house the royal apartments. The sculptures on the facade are by Jean Goujon.

1553
The south wing is demolished; Pierre Lescot starts construction on the new wing, the queen's apartment, which will be similar to the west wing. Construction of the stables. Start of work on the staircase.

1554
Jean Goujon sculpts the reliefs in the attic.

1558
Scibecq of Carpi creates chiseled ceiling in the chamber of Henry II.

1560–1574
Reign of Charles IX.

1560–1565
Construction and decoration of the south wing.

1564
Start of construction on the Château des Tuileries for Catherine de' Medici.

1565
Construction of the south wing is interrupted at the second avant-corps.

1566–1567
Construction, to the west of the palace, of the Petite Galerie ("Small" gallery) on the ground floor with a terrace perpendicular to the Seine by Pierre II Chambiges, from designs by Pierre Lescot or Philibert Delorme. Access is through the Pavillon du Roi by a passage that straddles the moat. New Paris enceinte.

1572
Saint Bartholomew's day massacre.

1574–1589
Reign of Henry III.

1588
Day of the barricades. Flight of Henry III.

1589-1610
Reign of Henry IV.

1593
The Estates General of the Parisian League in the Louvre.

1594
In March, Henry IV enters Paris and the religious wars end. The king decides to complete construction of the south wing of the Cour Carrée according to Pierre Lescot's plans. In October, first mention of the "grand design" for the construction of the Louvre Palace, which would serve as a guide for the construction until the nineteenth century. Objective: quadruple the surface of the courtyard (Cour Carrée) and build a large gallery along the Seine to connect the Louvre to the Tuileries.

1594–1596
Construction of a floor above the Petite Galerie to form the Galerie des Rois (Kings' gallery).

1595–1608
Construction of the single main-story pavilion of the Grande Galerie (currently the pavilion of the Salon Carré or "Square room") by Louis Métezeau. The Ambassadors' room on the ground floor was decorated in 1608.

1595–1610
Construction of the Grande Galerie, or Galerie du Bord de l'Eau (Waterside gallery), in two parts: the east part (from the main pavilion to the enceinte built in 1358; the architect is Louis Métezeau) and the west part (from the 1358 enceinte to the Tuileries palace, including the Pavillon de Flore; the architect is Jacques II Androuet du Cerceau). The Charles V enceinte is crossed by means of the quay on the Porte Neuve.

1608
The royal artists are installed on the mezzanine of the Grande Galerie.

1610
Henry IV is assassinated. He dies at the Louvre.

1610–1643
Reign of Louis XIII.

1615
After the assassination of Henry IV, work is suspended. Some interior design work is carried out after Louis XIII's marriage to Anne of Austria.

1617
Concini is assassinated at the Louvre.

1624
Jacques Lemercier, first architect of the king, is appointed to complete construction of the Cour Carrée. Construction of the Pavillon de l'Horloge (Clock pavilion) also known as the Pavillon Sully. The sculptures are based on models by Jacques Sarrazin. Construction of the Lemercier wing, reproducing Lescot's west wing with a staircase against the Pavillon de l'Horloge.

1639
Jacques Lemercier starts construction of the north wing of the Cour Carrée.

1641–1642
Nicolas Poussin starts to paint the life of Hercules on the vault of the Grande Galerie, but returns to Rome before finishing it. These paintings disappear in the eighteenth century.

1643–1715
Reign of Louis XIV.

1652
Anne of Austria and Louis XIV move into the Louvre. The king has Jacques Lemercier make some alterations. After Lemercier's death in 1654, Louis Le Vau replaces him as first architect of the king. All that remains of these changes are the queen mother's summer apartments on the ground floor of the Petite Galerie wing and the king's bedchamber in the Pavillon du Roi.

1653–1655
Anne of Austria's winter apartments are decorated.

1654
Guérin completes the ceiling of the king's chamber.

1655
The royal chapel is installed on the first floor of the Pavillon de l'Horloge.

1655–1659
Anne of Austria's summer apartments are decorated. The vaults are painted by Francesco Romanelli.

1659
Construction of the Salle des Machines (a custom-built theater) at the Tuileries.

1660
Le Vau's plan for the Louvre.

1661–1663
Construction of the south wing. Le Vau builds a counterscarp wall starting from the moat located to the west of the Pavillon de l'Horloge. This back-filled wall was rediscovered during the excavations in 1981 in the Cour Napoléon (Napoleon courtyard).

1661
Fire in the Galerie des Rois in the Petite Galerie. Louis Le Vau rebuilds the gallery; then Charles Le Brun paints it, using Apollo as his theme. It would not be completed until the nineteenth century. Le Vau doubles the width of this gallery to the west and constructs buildings all around the Cour de la Reine (Queen's courtyard). This is currently called the Cour du Sphinx (Sphinx's courtyard). He adds a second story to the Pavillon du Salon Carré to make it an Italian style room and completes the north wing of the Cour Carrée.

1662
A carousel is built in honor of the birth of the Dauphin.

1662–1666
Colbert, hostile to Louis Le Vau, asks François Mansart for a plan to enlarge the Louvre. Mansart proposes several plans but refuses to choose one; he dies in 1666.

1663
Pediment of the Cour du Sphinx.

1664
Colbert seeks advice from Italian architects; Carlo Rainaldi, Pierre de Cortone, and Le Bernin send plans. Start of Le Nôtre's work on the Tuileries gardens.

1665
Le Bernin is called to Paris. The first stone is laid for his plan for an Oriental facade for the Louvre. Louis Le Vau extends the south wing of the Cour Carrée by reproducing the architecture of the Pavillon de l'Horloge in the central pavilion.

1666
Anne of Austria dies at the Louvre.

1667
Creation of the "Petit" Conseil, which includes Louis Le Vau, Charles Le Brun, and Claude Perrault, to design the plan for completing the Cour Carrée. Proposal of a design for the central avant-corps facing the city. Sculpture of the facades is done by Le Hongre, Tuby, Legendre, and Masson. Start of work on the Colonnade (plan by the Petit Conseil for the main east facade on the side facing the city).

1668
Louis Le Vau is put in charge of the construction of the palace of Versailles, so Claude Perrault becomes the sole architect at the Louvre. Perrault doubles the width of the Pavillon du Roi and the south wing toward the Seine. An adaptation of the colonnade plan to the east is built by Claude Perrault.

1672
Installation of the Colonnade's pediment. The Académie Française moves into the Louvre.

1674
Louis XIV leaves the Louvre for good.

1678
Work is stopped on the Louvre palace in favor of the palace of Versailles. The outer structure of the Louvre is finished, but the roof is never installed. The Louvre is left in a state of semi-abandonment.

1692
Transfer of the king's collections of antiquities to the Salle des Cariatides. The Académie de Peinture et Sculpture is installed at the Louvre.

1699
First exhibition by the Académie de Peinture et Sculpture at the Louvre.

1715–1774
Reign of Louis XV.

1715–1723
Regency. Louis XV is moved to the Tuileries.

1722
The Infanta of Spain, Louis XV's fiancée, lives at the Louvre.

1756
Clearing of the Colonnade.

1757–1758
Marigny has Jacques-Germain Soufflot build the second floor of the east wing (Colonnade wing) on the Cour Carrée side. Guillaume Coustou sculpts the pediment for this story.

1766
Decoration of the Galerie d'Apollon is completed.

1767
Soufflot submits a plan for the Louvre.

1768
A plan is proposed for a museum at the Louvre.

1774–1792
Reign of Louis XVI.

1774–1789
The Count d'Angiviller's museum plan.

1776
Hubert Robert, responsible for the king's collections, makes suggestions for converting the Grande Galerie to display the royal collections to the public.

1789
French revolution. Louis XVI is installed in the Tuileries.

1792
Fall of the royalty. The Convention holds its first session at the Tuileries.

1792–1795
Convention.

1793
July 27, decree to found the Museum Central des Arts in the Louvre palace. August 10, opening of the museum in the Louvre's Grande Galerie. After closing on September 30 due to organizational difficulties, the museum reopens on November 18.

1795
Creation of the Institut at the Louvre.

1795–1799
The Directoire.

1798
Arrival of paintings and antiquities from Italy.

1798–1799
Work is carried out in Anne of Austria's apartments for the Musée des Antiques (Antiquities museum).

1800–1804
Consulate.

1800
Opening of the Musée des Antiques in Anne of Austria's apartments.

1802
Denon is made director of the museum.

1803
Musée Napoléon (Napoleon Museum).

1804–1815
Emperor Napoleon I.

1804
Napoleon I chooses Pierre-François-Léonard Fontaine and his associate Charles Percier as architects of the Louvre. They oversee the work site until 1848.

1805–1810
Fontaine and Percier install the roofs on the wings and finish decorating the facades and the interiors.

1806
Work on the roof of the south wing of the Cour Carrée is completed after transformation of the attic story, similar to that of the Lescot wing, to make it identical to wings built in the seventeenth century. Arc de Triomphe du Carrousel (Triumphal Arch on the Carousel square). The Institut and the artists are evicted from the Louvre.

1807
Decoration of the Cour Carrée attics.

1808–1810
Decoration of the Colonnade facade by Lemot and Cartellier.

1809–1812
Construction of the museum staircase in the wing located north of the Cour du Sphinx.

1810
Napoleon I approves the plan proposed by Fontaine to link the Louvre and the Tuileries. Napoleon marries Marie-Louise in the Louvre.

1810–1824
Construction of a wing parallel to the rue de Rivoli that extends the length of the Louvre. The court-side facade is a reproduction of that of the Grande Galerie built by Jacques II Androuet du Cerceau.

1811
Sculpture of the pediments for the court side and Seine side of the Cour Carrée's south wing.

1811–1814
Decoration of the staircases on either side of the Colonnade.

1814–1824
Reign of Louis XVIII.

1815
Restoration. Restitution to the Allies of looted art.

1817
Decor of the chambers of the Pavillon du Roi is taken up to the first floor at the end of the Colonnade's south wing. The king's chambers are grouped together in the Salle des Sept Cheminées (room of the seven chimneys).

1818
Construction of staircases at the two ends of the Colonnade wing.

1819–1824
Painting of the ceilings in the Salle Duchâtel (Duchâtel room) and the Rotonde de Mars (rotunda of Mars).

1821
Arrival in Paris of the *Venus de Milo*.

1824
Opening of the Galerie d'Angoulême (Angoulême Gallery), for eighteenth-century Renaissance sculptures.

1824–1830
Reign of Charles X.

1826
Champollion becomes curator of the Egyptian antiquity collections.

1827–1835
Creation of the Musée Charles X (Charles X museum) on the first floor of the south wing of the Cour Carrée. Paintings by Ingres, Evariste Fragonard, Heim, Meynier, Gros, Picot, Abel de Pujol, Horace Vernet, Alaux, Deveria, Schnetz, Drolling. Creation of the Musée Dauphin (Dauphin museum).

1830–1848
Reign of Louis-Philip.

1831
Creation of a private garden in front of the Tuileries palace.

1831–1833
Completion of the decor of the future Galerie Campana (Campana gallery).

1843
Planning of the Galerie Campana on the first floor of the Seine side of the Cour Carrée's south wing.

1847
Arrival of the first Assyrian antiquities.

1848–1852
Second Republic.

1848
Decision to complete the Louvre. Félix Duban is appointed architect of the Louvre until 1852. He restores the part of the Grande Galerie built by Louis Métezeau and completes construction of the Galerie d'Apollon (Apollo Gallery); one of the painters is Delacroix. Last salon at the Louvre.

1850
Opening of the Musée Mexicain (Mexican museum)—subsequently called the Musée Américain (American museum); the Musée Algérien (Algerian museum); the Musée Éthnographique (Ethnographic museum). Restoration of the Grande Galerie and the Petite Galerie facades.

1851
Inauguration of the Salon Carré, the Salon des Sept Cheminées in the Pavillon du Roi, and the Galerie d'Apollon, restored by Duban.

1852–1853
Louis Tullius Joachim Visconti is appointed architect of the Louvre after Duban's resignation. Start of work on the Cour Napoléon. Plans for the project to link the Louvre and the Tuileries made in 1848 are adopted in 1852 shortly before his death. The project would be carried out by Hector-Martin Lefuel. Creation of the Musée des Souverains (Sovereigns' Museum).

1852
On March 22, a decree allocates the amount of 25,679,653 francs to the work of completing the Louvre and the Tuileries, which must be done within five years.

1852–1870
Reign of Napoleon III, emperor.

1853–1857
On the south side of the Louvre, Lefuel builds wings perpendicular to the Grande Galerie, between and around the Cours du Sphinx, and, with Visconti, the Denon and Mollien pavilions. These buildings were part of the palace and not the museum when they were created. On the north side, Lefuel builds the ministry buildings that will be occupied by the Ministry of Finance from 1871 to 1989. He redesigns the facade of the west wing of the Cour Carrée on the Cour Napoléon

side and redesigns the dome of the Pavillon de l'Horloge.

1854
Hector-Martin Lefuel replaces Visconti as architect of the Louvre (until his death in 1880).

1855
Lefuel demolishes the museum's staircase built by Fontaine and Percier. The Percier and Fontaine rooms are the remains of this staircase.

1856–1861
Construction of the apartments of the State Department in the Richelieu wing under the direction of Lefuel (inauguration: February 11, 1861).

1857
Inauguration of the Louvre by Napoleon III.

1859
First session in the Salle des États (Room of States).

1861–1864
Work is resumed. Decoration of the Salle du Manège (Royal Riding School). Lefuel builds the Pavillon des États (Pavilion of States) to accommodate a new room that breaks the continuity of the Grande Galerie.

1861–1870
Lefuel demolishes and rebuilds the part of the Grande Galerie built by Jacques II Androuet du Cerceau, as well as the Pavillon de Flore, which was part of the Tuileries palace. He copies the facades done by Jacques II Androuet du Cerceau on the Seine side and creates the current lighting for the Grande Galerie.

1863
Musée Napoléon III. Presentation of the Campana collection to the Louvre. Arrival of the *Victory of Samothrace*.

1866
Completion of the decoration of the Salle Denon on the first floor of the pavilion of the same name. Excavations by Berty in the Cour Carrée, which unearth the medieval castle.

1869
Stuccos by Carrier-Belleuse in the rebuilt part of the Grande Galerie. Bequest of the La Caze collection.

1870–1940
Third Republic.

1871
During the Commune de Paris, a fire in the Tuileries

palace damages a part of the Louvre. Installation of the Ministry of Finance in the Richelieu wing.

1873–1875
Reconstruction of the Pavillon de Marsan (Marsan pavilion), which was part of the Tuileries palace. On the courtyard side, running along part of its length, the wing built by Fontaine and Percier along the rue de Rivoli.

1881
Creation of the department of Oriental Antiquities.

1882
Demolition of the ruins of the Tuileries.

1888
Inauguration of the Salles de Suse (Susa rooms).

1900
Inauguration of the Salle Rubens (Rubens room).

1905
Inauguration of the Musée des Arts Décoratifs (Museum of Decorative Arts).

1914
The Mollien staircase in the Pavillon Mollien (Mollien Pavilion), begun in 1853, is completed. The museum was evacuated during the war.

1922
Inauguration of the Salle d'Art Islamique (Islamic Art room).

1926
Henri Verne, the director, comes up with a re-organization plan.

1932
Start of work on Verne's plan.

1934
First phase of Verne's plan in the Sculptures and Egyptian Antiquities departments. Daru staircase. École du Louvre (Louvre School).

1936
Second phase of Verne's plan for Egyptian, Greek, and modern sculptures.

1938
Third phase of Verne's plan for the departments of Oriental Antiquities, Objets d'Art, and Painting.

1939
Evacuation of a large part of the collections during the war.

1945–1958
Fourth Republic.

1947
Inauguration of the Jeu de Paume, a gallery that exhibits the Impressionist collections.

1949
Destruction of the decor of the Salle des États built by Lefuel.

1953
Georges Braque ceiling.

1958–present
Fifth Republic.

1961
The Pavillon de Flore is returned to the Louvre.

1964
Digging of the channels in front of the Colonnade. The foundations of one of Le Vau's first projects is unearthed.

1968
Inauguration of the Pavillon de Flore.

1981
Mitterrand launches the "Grand" Louvre program.

1983
Creation of the Établissement Public du Grand Louvre. The architect Ieoh Ming Pei is commissioned.

1983–1989
I. M. Pei supervises the first phase, redesigning the Cour Napoléon and designing a variety of pathways for circulating through the museum, with the construction of the main entrance at the center under a glass pyramid with metal framework (35.42 m wide by 21.64 m high, the same proportions as the pyramid of Gizeh). The architect Michel Macary designs the basement of the Carrousel, allowing access to the Pyramid's basement from the west. He keeps part of the Charles V enceinte.

Beginning of 1984
I.M. Pei submits a general design plan for the Louvre palace.

1984–1986
Excavations in the Cour Carrée (discovery of the medieval château) and the Cour Napoléon (discovery of the Louvre district and Le Vau's wall).

1986
Inauguration of the Orsay Museum, which exhibits works from the years 1848–1914.

1989
Inauguration of the first part of the work and the Pyramid. Departure of the Ministry of Finance to its new Bercy building, allowing the Richelieu Wing to be redesigned.

1989-1993
Richelieu wing interiors designed by I. M. Pei, Stephen Rustow, Michel Macary, and Jean-Michel Wilmotte.

1990
Archeological excavations of the Carrousel area. The Charles V moat is cleared.

1992
Inauguration of the rooms for French paintings on the second floor of the Cour Carrée.

1993
Inauguration of the Louvre Museum's Richelieu Wing for the Louvre's bicentenary. Peter Rice designs the glass roofs covering the three courtyards—Marly, Puget, and Khorsabad.

1994
Inauguration of the foreign sculpture rooms.

1995
Inauguration of the new premises of the Laboratoire de Recherche des Musées de France (Research Laboratories of the Museums of France).

1997
In December, 10,000 square meters of redesigned rooms in the old parts of the palace along the Seine—Denon Wing—and around the Cour Carrée—Sully Wing—open to the public.

1999
In May, new rooms devoted to Italian and Spanish paintings open to the public. They can be directly accessed through a new entrance in the Flore Wing. In December, seven additional rooms devoted to objets d'art, at the west end of the Richelieu wing, open to the public.

2004
In November, the Galerie d'Apollon is reopened after three years of work. It houses the Crown Diamonds, as well as a collection of heavy stone vases from Louis XIc. Louvre II: On November 30, a decision to build a 20,000 square meters antenna at Lens, in the Nord-Pas-de-Calais is announced (the opening is set for the spring of 2009).

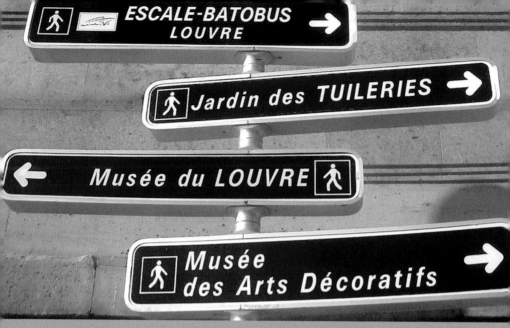

Chronology
of
civilizations

- 6900
Anatolia. Neolithic preceramic.

- 6300–6000
Mesopotamia. Appearance of ceramics in Iran.

c. - 3350–3000
Uruk: Appearance of monumental architecture. First sculptures in stone.

c. - 2800
Beginning of the Old Empire. Pyramid of Saqqara.

c. - 2750
Appearance of bronze. Appearance Cycladic idols.

c. - 2650
Egypt: Sphinx and pyramid of Giza.

c. - 2400–2150
Sumer: Statues of Gudea, the king of Lagash.

c. - 2000
Egypt: Start of construction of the temple of Karnak.

c. - 1900
First Cretan artifacts. Probable founding of Babylon.

c. - 1850
Europe: Construction of Stonehenge.

c. - 1750
Disappearance of the civilizations of the Indus.

c. - 1580–1500
Egypt: Beginning of the New Empire. Appearance of the tombs of the Valley of the Kings.

c. - 1450
Sumer: Construction at Uruk of a temple to Ishtar.

c. - 1350
Tomb of Tutankhamen.

c. - 1100–900
Greece: Protogeometric ceramics.

c. - 970–930
Jerusalem: Construction of the Temple of Salomon.

c. - 900–700
Greece: Geometric ceramics.

c. - 884–858
Mesopotamia: Founding of Nimrod.

c. - 722-705
Mesopotamia: Construction of the palace of Khorsabad by Sargon II.

c. - 680
Rebuilding of Babylon.

c. - 669–630
Palace of Niniveh (Ashurbanipal, king of Assyria).

c. - 605
Ishtar Gate at Babylon (Nebuchadrezzar II, king of Babylon).

c. - 600–590
Greece: Attic ceramics with black figures. Building of Heracleum temple at Olympia.

- 587
Destruction of Jerusalem.

c. - 560
Greek statuary develops the kouros and kore (statues of young men and women).

- 520
Rebuilding of the temple of Jerusalem.

- 478
Temple of Apollo at Delphi (6 x 15 Doric columns).

- 475
Myron sculpts the *Discobolus* and *Athena* and Marsyas.

- 468
Polycleitus develops the rules of proportion (the canon) to express the perfection of the human body.

- 465
Sculptures of the battle of the Centaurs and the Lapiths on the pediments and the Labors of Hercules on the metopes of the temple of Zeus at Olympia.

- 447
Start of construction on the Parthenon by Phidias and Ictinus, completed in - 432.

- 437
Start of work on the Propylaea on the Acropolis of Athens, completed in - 432.

c. - 430
Zeus of Phidias at Olympia.

- 420
Temple of Nike Athena on the Acropolis of Athens.

- 407
Erechteum on the Acropolis of Athens.

- 380–37
Temple of Asclepius at Epidaurus.

- 330
Theater of Epidaurus.

- 323
Death of Alexander. Division of the empire.

c. - 200
Invention of Roman cement.

c. - 185
Victory of Samothrace.

c. - 100
Appearance of the first style of Roman painting.

c. - 90
Greek painting uses perspective.

- 58–51
Conquest of Gaul by Julius Caesar.

- 16
Construction of the Pont du Gard and the theater at Orange.

c. 33
Death of Christ at Jerusalem.

60
Pompeian paintings of theater sets and use of perspective.

79
Pompeii and Herculaneum buried in the ashes from Mount Vesuvius.

80
Opening of the Colosseum Rome, the largest of the Roman amphitheaters.

105
In China, paper making is perfected by Ts'ai Lun.

125
Construction of Hadrian's Villa at Tivoli.

179
Equestrian statue of Marcus Aurelius.

216
Construction in Rome of the Baths of Caracalla.

c. 225
An early representation of the Virgin painted at the cemetery of Priscillus. First Christian churches built in Rome.

312
Following his victory over Maxentius at the battle of Milvian Bridge, Roman emperor Constantine joins the Christian church.

315
Building of the Arch of Constantine and the first "Constantinian" basilicas: Saint Peter's, Saint John Lateran, and Saint Paul outside the Walls.

323
Saint Pacomius founds the monastery of Baoui in Egypt. Appearance of the first Christian art.

c. 350
The cross begins to be used as a Christian symbol.

395
At the death of Theodosius, the Roman Empire splits in two: Eastern and Western.

410
Led by Alaric, Visigoths take Rome.

c. 430
Roman culture and Christianity reach Ireland. The Council of Ephesus proclaims the Virgin Mary the "Mother of God," and she is depicted enthroned in Heaven.

430
The emperor Theodosius orders the destruction of pagan temples.

435
The Vandal Genseric takes Rome.

476
The Goth Odoacer deposes the last Roman emperor of the West Romulus Augustulus.

493
Ravenna becomes the capital of the Ostrogoth Theodoric III.

500–510
Monasticism spreads in the West.

528
Saint Benedict retires to Monte Cassino in Italy, where he founds a monastery from which Byzantine art is spread in the West.

534
Construction beguins at Constantinople of the basilica of Saint Sophia, which was completed in 537.

556
Mosaics installed in the church of Sant Appolinare Nuovo in Ravenna.

575
Gregory of Tours begins to write his *History of the Francs*, finished in 592.

600–610
A style of wildlife painting using tracery and Christian symbols spreads from the Rhineland to northern Italy and from Byzantium to Scandinavia.

c. 600
Saint Gregory the Great founds the ScholaCantorum to train singers for the Roman basilicas and the papal chapel.

632
Death of Mohammed. Beginning of the Arab conquest.

677
A royal document is written on parchment for the first time.

700–714
Extension of Arabic conquests, particularly in Spain.

c. 700
Latin is no longer the only language spoken in Gaul.

726
First iconoclastic edict at Byzantium.

769
The iconoclasts are renounced at the Lateran Synod.

783
Aix-la-Chapelle becomes the capital of the Carolingian empire.

796
During the abbacy of Alcuin, a workshop devoted to the illumination of manuscripts is created at Tours.

800
San Juan de Compostella becomes a major European pilgrimage site. Charlemagne is crowned emperor of the West at Rome.

810
Founding of Venice.

843
The Treaty of Verdun ordains a new division of the Carolingian empire. Byzantium permits iconography.

873
Cologne cathedral.

905
Magyars invade central Europe.

910
Benedictine monastery founded at Cluny

930–940
Work begins on the second basilica of Saint Mark in Venice.

981
Consecration of the abbatial church of Cluny.

1023
The first chapel is built at Mont Saint-Michel.

1054
Great Schism separates the Roman Catholic Church from the Byzantine, or Eastern Orthodox, Church.

1063
Work begins on the cathedral of Pisa.

1070
Byzantine influences distinguish productions of the goldsmith and mosaic workshops of Monte Cassino.

1075
The Turks conquer Jerusalem. Start of work on the new church of San Juan de Compostello.

1084
Romanesque church is built at Mont Saint-Michel.

1098
Robert de Molesmes founds the Cistercian order.

1099
The crusaders take Jerusalem and create the French kingdom of Jerusalem.

1100
Appearance of the ribbed vault in England.

1110
Work begins on the porch of the church at Moissac.

1115
Saint Bernard founds the Cistercian abbey of Clairvaux.

1120
Work begins on the church of Madeleine de Vezelay, completed in 1140.

1125
The ribbed vault spreads into French territory.

1135
Work begins on the church of the Abbey of Saint-Denis; new construction techniques and the emergence of a new style signal the arrival of the "Gothic."

1163
Construction starts on Notre-Dame de Paris.

1173
Work begins on the tower of Pisa. After two years work stops and only resumes a century later. Tower isn't completed until 1372.

1196
Work begins on the cathedral of Chartres, completed in 1260.

1211
Work begins on Notre-Dame de Reims, finished during the fourteenth century.

1216
Pope Honorius III approves the establishment of the Order of Preachers by Saint Dominic. In a wordplay on their Latin name, the Dominicans jokingly call themselves "God's dogs" *(Domini cani).*

1225–1226
The University of Paris undertakes a translation of the Bible.

1236
Guillaume de Lorris finishes the first part of the *Roman de la Rose.*

1242
On the order of King Louis IX, Pierre de Montereau undertakes the construction of the Sainte-Chapelle in Paris. Consecrated in 1248, it contains relics of the Passion.

1247
The choir of Cologne's cathedral is the first indication that the Gothic style has become international.

1252
Florence begins minting gold florins.

1260
The cathedral of Chartres is consecrated.

1261
Michael VIII Palaeologus wins back Constantinople from the Venetians and reestablishes the Byzantine Empire.

1262–1263
Pierre de Montereau places funerary statues of the kings of France in the abbey church of Saint-Denis.

1265
Saint Thomas Aquinus begins writing the *Summa theologica.*

1280
Jean de Meung finishes the *Roman de la Rose.*

1288
Sienna acquires a public building that exemplifies Tuscan architecture.

1290
Giotto begins a series of frescoes on the *Life of Saint Francis* in the upper basilica of Assisi; the work is finished in about 1295.

1294
Florence starts building la Signoria.

1296
Florence puts architect Arnolfo di Cambio in charge of construction of a new cathedral, Santa Maria del Fiore. Work begins on the Doge's Palace at Venice.

1304
Giotto starts painting a series of frescoes in the Scrovegni chapel in Padua; the work is finished in 1306.

1309
The papacy is forced to leave Rome and reside in

Avignon until 1377. Joinville finishes his *Book of Holy Words and Good Deeds of our Holy King Louis.*

1310
Yellow-silver pigment is used for the first time in stained glass in the region around Paris.

1321
Death of Dante Alighieri.

1323
The Dominican Thomas Aquinus, author of the *Summa theologica,* is canonized.

1328
Simone Martini paints the frescoes of the palace of Sienna.

1334
Giotto draws up plans for the bell tower of the Florence cathedral.

1341
Petrach is crowned poet laureate at Rome.

1348
Boccacio starts writing the *Decameron,* whose framework is the Black Plague, then ravaging Europe.

c. 1364
Start of work in Dijon on the palace for the dukes of Burgundy.

c. 1370
Engraving techniques appear in France.

1375
In the Parisian workshop of Nicolas Bataille, work begins on the *Apocalypse* tapistry.

1378
The Great Schism of the West, which lasts until 1417. Urban VI is the pope in Rome, and Clement VII is pope in Avignon.

1389
Antonio degli Alberti opens an academy for artists, writers, and intellectuals at his Florentine Villa del Paradiso.

1391
Organization of the first painters guild in Paris.

1401
Ghiberti wins the competition to do the bronze doors of the Florence baptistery.

1405
Influence of Flemish style widens with the alliance of Flanders and Burgundy.

1406
Donatello's statues of the prophets ar installed in the church of Or San Michele in Florence.

1417
End of the Great Schism.

1420
Brunelleschi begins work on the dome of the Santa Maria dei Fiori Cathedral in Florence, which is finished sixteen years later.

1425
The Van Eyck brothers perfect the technique of oil painting.

1426–1427
Masolino and Masaccio finish the frescoes in the Brancacci chapel in the church of Santa Maria del Carmine in Florence.

1429
Cosimo de Medici founds the Platonist Academy in Florence. Brunelleschi builds the Pazzi chapel in Florence. The Bellinis do important work in Venice.

1430
Copper engraving techniques are perfected.

1434
Cosimo de Medici takes control of the government of Florence. Gutenberg invents the printing press.

1435–1436
Leon Battista Alberti finishes the first European treatise on painting, *De Pictura.*

1439
Following the proclamation of the reunification of the Eastern and Western churches, many Greek intellectuals come to Italy.

1440
Gutenberg produces the first texts printed with movable wooden type (incunabula). At Florence, Donatello casts his bronze sculpture of *David.*

1450
In his treatise on architecture, *De re aedificatoria,* Leon Battista Alberti updates the theories of Vitruvius. Gutenburg improves printing techniques with the development of movable metal type.

1452
Piero della Franscesca begins the series of frescoes *The History of the Holy Cross* at Arezzo.

1453
Fall of Constantinople.

1456
The Little Testament, by François Villon.

1461
The first book in the German language, *Der Edelstein,* by Ulrich Boner, is printed in Bamberg.

1463
Marsile Ficin translates Hermes Trismegistus into French.

1464
Treatise on Architecture, by Filarète.

1468
Hans Memling, *Sir John Donne of Kidwelly* Triptych.

1469
Laurenzo the Magnificent holds power in Florence.

1472
Jean Fouquet becomes painter to the king of France, Louis XII.

1474
Mantegna paints the *Bridal Chamber* frescoes for the Gonzagas of Mantua.

1475
Marsile Ficin, *Platonist Theology.* Memling, diptych of the *Descent from the Cross.*

1478
Botticelli, *La Primavera.*

1480
Piero della Francesca, *De Prospectiva pingendi (On Perspective in Painting).*

1482
Hugo Van der Goes's triptych, *The Adoration of the Shepherds,* ordered by the Portinari family, arrives in Florence.

1483
The first illustrated, printed book in the French language is published, a translation of Boccacio's *Falls of Illustrious Men.*

1485
Bartolommeo Diaz rounds the Cape of Good Hope.

1488
Giovanni Bellini, *Frari* Triptych *(Madonna and Child Enthroned).*

1490
Introduction to the Metaphysics of Aristotle, by Jacques Le Fèvre d'Étaples.

1492
Christopher Columbus discovers the New World.

1494
Luca Pacioli, *Summa de arithmetica, geometrica, proportione e proportionalita.*

1497
Vasco de Gama rounds Africa and opens a new maritime route to the East.

1499
Publication of *Hypnerotomachia Poliphili (Poliphil's Dream)* at Venice.

1501
Michelangelo, *David.* Hieronymus Bosch, *The Temptation of Saint Anthony.*

1504
Leonardo da Vinci, *The Virgin and Saint Anne.*

1505
Dürer's second trip to Venice; he stays until 1507.

1506
Bramante awarded the reconstruction of Saint Peter's in Rome. Pacioli, *De divina proportione.*

1508
Michelangelo begins painting the ceiling of the Sistine Chapel.

1509
Raphael paints the frescoes in the rooms of the Vatican.

1511
Erasmus, *In Praise of Folly.*

1513
Machiavelli writes *The Prince,* published in 1532.

1516
Ariosto, *Orlando Furioso.* Thomas More, *Utopia.*

1517
Publication of the ninety-five theses of Martin Luther and the beginning of the Protestant Reformation.

1519
Charles V is elected emperor. Magellan circumnavigates the globe. Construction of the château of Chambord.

1525
Pietro Bembo, *Prose della volgar lingua*, the first Italian "grammar."

1527
Sack of Rome by the troups of Charles V.

1528
Baldassar Castiglione, *The Book of the Courtier.*

1530
Founding of the Collège de France.

1531
Schism of the English church.

1532
Rabelais, *Pantagruel*. Holbein, English court painter.

1534
Rabelais, *Gargantua.*

1535–1541
Michelangelo, *The Last Judgment.*

1536
Calvin, the *Institutio christianae religionis,* translated into French under the title *Institution de la religion chrétienne (The Institution of the Christian Religion).*

1537
Ignatius Loyola establishes the Society of Jesus (Jesuits).

1539
Benvenuto Cellini arrives in France.

1544
Pierre Lescot is put in charge of rebuilding the Louvre.

1546
A group of statues is discovered in the Baths of Caracalla; their restoration begins.

1549
Joachim du Bellay, *Défense et illustration de la langue française (The Preservation and Illustration of the French Language).*

1550
Vasari's *Lives of the Artists* (the first book of art history); the second revised and expanded edition is published in 1568.

1555
Charles V recognizes the Lutheran confession by signing the Peace of Augsburg with the Protestant princes (the Schmalkaldic League).

1559
Publication of the first *Index of Prohibited Books* from the Roman office of the Inquisition. Plato's *Symposium* is translated into French as *Le Banquet* by Joachim du Bellay and L. Le Roy.

1560
Tintoretto, *Suzanna and the Elders.*

1562
Vasari founds the Academy of Art in Florence.

1565
Ronsard, *L'Art poétique (The Art of Poetry).*

1566
Roland de Lassus, *Laudate Dominum Mass.*

1570
Palladio, *Four Books on Architecture.*

1575
Tasso submits his *Jerusalem Delivered* to the censors. It would be banned in France for its anti-monarchical sentiments.

1577
Founding of the Academy of Saint Luke in Rome.

1579
Fondation of the United Provinces.

1580
Michel Eyquem de Montaigne, *Essays* (books I and II).

1584
Lomazzo, *Treatise on Painting.*

1585
The Carracci open the Accademia degli Desiderosi (Beginners' Studio) in Bologna.

1586
El Greco, *Burial of the Count of Orgaz.*

1600
Rubens works in Italy.

1602
Creation of the Gobelins tapestry workshop.

1607
Honoré d'Urfé, *L'Astrée.*

1608
El Greco, *Pentecost for the Hospital of San Juan in Toledo.*

1610
Oxford College is founded in England.

1613
Salomon de Brosse starts work on the Palais du Luxembourg for Maria de' Medici.

1616
Zurbaran, *Immaculate Conception.*

1619
Velasquez, *Adoration of the Magi.*

1624
Poussin moves to Rome. Bernini, baldachin for Saint Peter's in Rome.

1627
Claude Gellée, called Le Lorrain, moves to Rome.

1631
Founding of *La Gazette de France,* by Théophraste Renaudot.

1633
Rubens, *Adoration of the Magi.* Rembrandt, *The Philosopher.*

1637
Descartes, *Discourse on Method.* Corneille, *Le Cid.*

1642
Rembrandt, *The Night Watch.*

1644
Bernini, *Saint Theresa in Ecstasy.* Molière founds the Illustre Théâtre.

1647
Vaugelas, *Remarks on the French Language.*

1648
Creation of the Académie Royale de Peinture et Sculpture (Royal Academy of Painting and Sculpture) in Paris.

1654
Le Vau is named architect of the Louvre.

1656
Velasquez, *Las Meninas.* Pascal, *The Provincials,* finished in 1657.

1657
The architect Le Vau, the painter Le Brun, and the landscape designer Le Nôtre begin work on Vaux-le-Vicomte for Finance Minister Fouquet.

1661
Work begins on the château of Versailles.

1666
Colbert founds the French Academy in Rome. Great fire of London.

1669
Opening of the first public museum in Basle, Switzerland. Vermeer, *The Geographer.*

1670
Pascal, *Les Pensées.* Spinoza, *Political and Theological Treatise.*

1671
Libéral Bruant begins work the Hôtel des Invalides.

1672
Louis XIV moves to Versailles.

1675
Jules Hardouin-Mansart is named architect of Louis XIV.

1676
Antonio Giovanni Viscardi is named architect to the court of the elector of Bavaria.

1677
Francisco de Herrera the younger, is named architect of the king of Spain. Lulli, *Te Deum.*

1685
Revocation of the Edict of Nantes causes Protestant artists to flee France.

1687
Mansart builds the Grand Trianon.

1688
Charles Perrault begins his *Parallel Between Ancients and Moderns*, which he finishes in 1697.

1694
Publication in France of the first *Dictionary of the Academy*.

1695
Fisher von Erlach begins the reconstruction of the Schönbrunn Palace in Vienna.

1699
First painting exhibition of the French Academy, given in the Salon Carré of the Louvre. Fénelon, *The Aventures of Telemachus*.

1703
Founding of Saint Petersburg.

1707
Founding of the Society of Antiquaries in London.

1711
First archeological finds at Herculaneum. Domenico Trezzini begins work on the Summer Palace at Saint Petersburg, finished in 1714.

1716
At Saint Petersburg, French architect Le Blond begins work on the Summer Garden and on Peterhof and its pavilions.

1717
Antoine Watteau, *Embarcation for Cythera*.

1719
First organized digs begin at Herculaneum.

1721
Montesquieu, *Persian Letters*.

1722
Rameau, *Treatise on Harmony*.

1726
Servandoni broadens the scope of scenic design at the opera.

1726
Swift, *Gulliver's Travels*.

1731
Chardin, *le Menu gras, le Menu maigre* (The Festive Meal, the Meager Repast).

1732
Salvi builds the Trevi fountain in Rome.

1734
Voltaire, *Philosophical, or English, Letters*.

1735
Creation at Stockholm of the Royal Academy of Fine Arts.

1739
Chardin, *La Pourvoyeuse (The Purveyor)*.

1740
Boucher, *The Triumph of Venus*.

1742
Italian artists begin work on the interiors of the Schönbrunn Palace. The work will last twenty years.

1746
Canaletto goes to London.

1749
Gainsborough, *Portrait of Mr. and Mrs. Andrews*.

1750
Tiepolo starts work on the Episcopal Palace in Würzburg, Germany. The work will last three years.

1751
Diderot takes charge of the *Encyclopédie*. D'Alembert, *Preliminary Discourse on the Encyclopédie*. Rousseau, *Discourse on the Sciences and the Arts*.

1752
Count of Caylus, *Compendium of Egyptian, Etruscan, Greek and Roman Antiquities*.

1753
William Hogarth, *Analysis of Beauty*.

1755
Ange-Jacques Gabriel builds the Place Louis XV in Paris (today's Place de la Concorde).

1757
Soufflot builds the church of Saint Genevieve (today the Pantheon).

1758
French painter Louis Tocqué founds the Russian Academy of Fine Arts.

1760
Soufflot, *Dissertation on Gothic Architecture*.

1761
Greuze, *The Village Bride*.

1762
Rousseau, *Emile or on Education, The Social Contract*.

1764
Voltaire, *Dictionnaire philosophique*.

1765
Diderot, *Essay on Painting*.

1766
Lessing, *Laocoon, an analysis of the separate functions of poetry and the plastic arts*.

1768
Joshua Reynolds becomes the founder and first president of the Royal Academy in London

1770
Kant starts writing *The Critique of Pure Reason*, finished in 1781.

1775
Beaumarchais, *The Barber of Seville*.

1782
Choderlos de Laclos, *Les Liaisons dangereuses*. Schiller, *The Brigands*.

1784
Beaumarchais, *The Marriage of Figaro*. Sir Joshua Reynolds becomes painter to the king of England.

1785
David, *The Oath of the Horatii*. Villanueva begins works on the Prado Museum in Madrid, which is finished in 1830.

1790
Selva starts construction on the theater of La Fenice in Venice.

1793
Le Musée Central des Arts is put in place at the Louvre.

1795
Goya, *The Duchess of Alba*. David, *The Rape of the Sabines*.

1799
Italian artworks confiscated by Napolean arrive in France.

1800
Chaptal sets up provincial museums in France.

1801
Chateaubriand, *Atala*. Lord Elgin brings the Parthenon marble statues to London.

1802
Chateaubriand, *Le Génie du Christianisme (The Spirit of Christianity)*.

1804
Beethoven, *Eroica Symphony*. David is named chief painter to the emperor Napoleon.

1806
Start of construction on the Carrousel Arch by Percier and Fontaine. Start of construction on the Arc de Triomphe by Chalgrin. David, *The Coronation*, finished in 1807.

1807
Turner, *Sun Rising Through Vapour*. Hegel, *Phenomenology of the Spirit*.

1808
Goethe, *Faust*.

1810
German religious painters Overbeck and Pforr found the Nazarenes, or Lucas Brotherhood, in Rome.

1814
Goya, *The Second of May*. Ingres, *The Grand Odalisque*.

1816
Benjamin Constant, *Adolphe*.

1818
Creation of a museum in the Palais du Luxembourg devoted to living artists.

1819
Géricault, *The Raft of the Medusa*. Lord Byron, *Mazeppa*.

1820
Walter Scott, *Ivanhoe*.

1823
Robert Smirke starts construction on the British Museum in London, finished in 1829.

1827
Discovery of Etruscan civilization, digs at Tarquinia and Vulci.

1830
Victor Hugo, *Hernani*. Berlioz, *Symphonie fantastique*.

1831
Victor Hugo, *Notre-Dame de Paris*.

1833
Michelet starts writing his *History of France*, finished in 1857. Arcisse de Caumont founds the French Archeological Society.

1834
Ingres is named director of the French Academy in Rome, which is housed in the Villa Medici.

1836
Théodore Rousseau gathers a group of landscape painters at Barbizon.

1839
Proudhon, *Qu'est-ce-que la propriété ? (What is Property?)*

1842
Auguste Comte, *Cours de philosophie positive (Course in Positive Philosophy)*. Gogol, *Dead Souls*.

1843
Turner, *The Sun of Venice Going to Sea*.

1845
Boucher de Perthes makes the first prehistoric discoveries at Abbeville.

1847
Michelet starts writing his *History of the French Revolution*, finished in 1853.

Terminology
(Art)

ACIDS
Used since the end of the fifteenth century by engravers for their corrosive action on metals. The metal plates are given a coat of varnish into which the artist traces his design, exposing the metal. The plate is then given an acid bath, which bites into the exposed metal areas. The remaining varnish is removed with a dissolvent, and the plate is inked and put to the press.

WATWRCOLOR (AQUARELLE)
From the Italian word *acquarella,* which in itself comes from the Latin word *aqua,* meaning "water," aquarelle is the technique of diluting colors in a mixture of gum arabic and water. This technique has been known since ancient Egyptian times. Constable, Turner, Blake and Bonington, or Jongkind and Boudin, and even Cézanne frequently used it. The word "aquarelle" entered the French language in 1791, and is used to designate both the technique and works produced by that technique.

ANATOMY
Distinct from and at the same time dependent on scientific anatomy, artistic anatomy studies the proportions of human and animal bodies, as well as their movements, attitudes, and positions. The first known treatise dealing with anatomy dates from the fifth century B.C. and is attributed to the Greek sculptor Polycleitus. In Florence the painter, historian, and theoretician Giorgio Vasari (1511–1574) wrote his treatise, *De Pittura,* in which he exhorts painters to use perspective and anatomy in the service of history painting. Leonardo da Vinci, Michelangelo, and Dürer others, are just some of the artists who exerted a decisive influence on artistic anatomy during the Renaissance.

FLAT TINT
Said of a surface that has been uniformly covered by a color.

PRIMING
Protective coating or preparation applied directly to the surface (wood or canvas) that is to receive the colors.

HAND-REST
A wooden stick with a leather or fabric ball on one end. Used by painters to get a purchase on a canvas or panel in order to render delicate or complicated details on a painting. Ancient in origin, its use spread during the sixteenth century along with the practice of easel painting.

AQUATINT
An engraving technique that uses aqua fortis (nitric acid) as a corrosive agent. It allows for intricate shadings of lighting contrasts especially useful in color engravings. It probably made its appearance in Amsterdam during the seventeenth century. It has been widely used in France since the second half of the eighteenth century. (See Engraving.)

ATLANTES/TELAMON
The French word is based on the Italian *Atlante* for Atlas, the mythical giant, supporter of the earth, which itself comes from the Greek *atlantes*. This word is used in both architecture and sculpture to designate a standing or kneeling male figure supporting an entablature.

ARMATURE
Wooden or metal rods that are used to reinforce extended and otherwise unsupported limbs of clay, plaster, or wax sculptures.

ASSIETTE
Technique, in use since antiquity, of applying a varnish to wood, parchment, or any other surface in order to seal gold leaf or powder in place. Armenian bole is a fine clay that is used to facilitate the adhesion of gilding to water.

ATELIER
Term originally used by the craft industry to designate the place where an artist works—a particular building or the people who work there (master craftsmen, apprentices, and students). The term is also used to indicate a work of uncertain origin: "from the studio of..." or "by the circle of..."

THIN SLIP
A clay slurry used since antiquity as a binder in sculpture and ceramics.

BALM/BALSAM
A blend of resin and essential oil used by the Egyptians as a medication and for embalming. It is also used by painters in the form of turpentine.

BISTRE
A brown solution obtained from chimney soot and from gummy water. It was used during the Middle Ages for outlining and shading in manuscript illumination.

BITUMEN
Product made from coal tar or lignite or from evaporated petroleum; it is used by painters for subtle effects of shading and transparency.

BOLE
See assiette.

BRONZE

Since the seventeenth century—1694, in fact—this word has been used to designate both the material bronze, an alloy of copper and tin, and a work of art made from it. From the Italian word *bronzo,* the term first appeared in French in 1511.

BURNISHING

Polishing of gilding or silvering with an agate stone or a steel instrument in order to obtain a smooth and shiny surface.

CHISEL

Instrument with a wooden handle called the "champignon," or mushroom, and either a square- or diamond- shaped steel shank with a sharp point that is used in engraving to carve into the metal plate. The first burin engravings were made in Germany at the beginning of the fifteenth century. Dürer did some of the most beautiful engravings using this technique.

BUST

The Italian word *busto* designates the part of the body that is above the waist. The French word was derived from the Italian model in about 1540. The Latin word *bustum* was initially a funeral pyre, and by extension it came to mean the half-bodied representation of the deceased on the funeral urn.

CALLIGRAPHY

The art of drawing letters with decorative and aesthetic embellishments. The term literally means "beautiful writing." The new Islamic Arts department of the Louvre has some stunning examples of this art.

MONOCHROMES

Originally a type of painting that used different tones of a single color. This technique was used in antiquity and was revived during the Renaissance for use on large wall paintings or murals.

CAMERA OBSCURA

A system whereby light that is filtered through a single opening into a dark room produces an image upon a flat surface that is the inverse of the image outside. This principle had been noted since antiquity, but it was only in the fifteenth century that it appeared as a tool, the camera obscura, which has been used by artists since the Renaissance. Although it is a matter of some controversy, it seems that Vermeer used one himself to produce some of his works.

CANON

A collection of precepts that serves to define the relative proportions of a work of art. The first known example, called the Canon of Polycleitus (c. 480–420 B.C.), is named for the sculptor whose works established the ideal proportions for the representation of the human body. The *Vitruvian Man* of Leonardo da Vinci is another remarkable example. Sources vary as to whether the Canon was a written treatise, a specific statue by Polycleitus, or merely received tradition.

CARYATID

This word denotes a sculpture of a woman, or even of a man that takes the place of a column. When this word came into the French language in 1546, it was spelled Caryatides, with a capital *C.* According to Vitruvius, the women of the town of Karyai, sold into slavery for having been citizens of a town that sided with the Persians during the Medean wars, were the models for the statues. Others think it was the young women who took part in the cult of Artemis Karuatis who were the first caryatids.

CARTOON

A type of paper, but also the preparatory drawings for paintings, tapestries, or even small pictures that are done on this kind of material.

CAPITAL

The upper part of a column; the chapiteau comes into contact with the body, which is supported by the column or pillar. The form and decoration of the capital determines the style of the architecture according to the ancient orders: a simple extension of the column itself [how can a square block be called an extension of a round column?]—the Doric order; carved in double volutes—the Ionic order; ornamented with acanthus leaves—the Corinthian order. If a column has elements from different orders, it is called a composite. If it is enhanced with a scene from daily life, a trait of Roman art, it is termed "illustrated."

FRAME

An assemblage of wooden stretchers that hold a canvas taut for painting. It might be round, oval, or rectangular. Its use was first mentioned in the fifteenth century. Keys to control the amount of tension exerted on the canvas first appeared in the eighteenth century.

EASEL (CHEVALET)

A stand to support a work object at an adjustable height. A painting easel is usually a three-legged wooden frame. Roman bas-relief representations of easels reveal that they have been used since antiquity. Their use spread in the West during the fifteenth century.

WAX

A binder of natural animal (bee), vegetable (carnauba or cardilla), or even mineral (fossil or paraffin) origin used since ancient times in the preparation of colors.

Wax is also used to protect colors once they have been applied to a surface (encaustic). The sarcophagi and portraits of Faiyum, among others, were done with this technique. Wax is also used by sculptors to make models or molds for casting. In the lost wax technique, a model is coated with wax, which is then given a perforated coating of plaster or clay. When baked, the wax melts and pours through the holes; molted metal is poured into the space once occupied by the wax.

CHIAROSCURO

A technique employing light and shading in progressive gradations. Renaissance painters were fond of this method for the subtlety of modeling they could achieve with it.

COLUMN

A cylindrical or quadrangular shaft forming a vertical support to carry the weight of the upper portion of a building.

CORNICHE

The upper section of the entablature, the corniche is the stonework that projects out over the frieze. The term is also used to designate the interior molding in a room at the juncture of walls and ceiling.

CUPOLA

Dome built over a circular building element usually in the form of a half globe.

DRAWING

The word designates both the technique of drawing — whichever it might be, black stone or charcoal, graphite or red chalk, India ink, etc. — and the work itself, whether it be a finished work, a sketch, or a draft. The first academy of art, which was created in Europe in 1563 by Vasari, was called the Academia del Disegno (the Academy of Drawing). A prehistoric practice, drawing was only liberated from painting, little by little, to become an art in its own right during the Renaissance. According to Ingres, "Le dessin est la probité de l'art" ("drawing is righteous art"). Delacroix adds, "When you learn how to draw, your ideas are at the tip of your pencil as the writer's thoughts are at the top of his pen's." For Degas, "drawing isn't a form; it's a way of seeing form."

DISTEMPER

Since 1304, the expression *"faire destrempe les couleurs,"* ("dilute the colors,") attests to the existence of the distemper technique. It has been known for centuries. The technique consists of diluting color pigments with water or an oily emulsion. Distemper is the only liquid in which a vegetable or animal glue can be dissolved to obtain a matte surface. As one says in Italian, *"a tempera"* — distemper requires the addition of egg yolk or flaxseed oil. Needless to say, the invention of oil paint has relegated distemper to a secondary role.

DIPTYCH

This word only entered the French language in the nineteenth century, in 1838, in order to designate either of the two panels of a painting that could be folded over like a book, just like two parts of a literary work. As you might expect, this word is modeled on a Latin word, which is in turn modeled on the Greek *diptukha,* meaning tablets that can be folded over.

AQUA FORTIS/NITRIC ACID

See aquatint.

IMPASTO

Paint that has been thickly laid on the surface of a painting. There are some extraordinary examples among the paintings of Rembrandt and Rubens.

ILLUMINATION

If this word designates either the painted letters or the miniature paintings that ornament the pages upon pages of ancient manuscripts, it is because the verb *illuminate* has, since the twelfth and thirteenth centuries, designated the action of coloring and decorating a text in monastery scriptoria. When lay workshops arose in the thirteenth century, it was not long before a distinction was drawn between those who copied the text and the miniature painters who punctuated the frontispieces with cartouches and rubrics. This activity disappeared during the fifteenth century, when the printing press and new engraving techniques ushered in the era of mass production and each book was no longer a unique item.

PRINT

A print is the result of pressing an engraved block or matrix to a sheet of paper. By extension, the term applies to all artworks printed on paper.

EURYTHMIA

Term used by the Roman architect Vitruvius (first century B.C.) to designate the beauty resulting from the harmonious proportions of the height, length, and width of a building, as well as of its architectural rhythm.

FAR PRESTO ("TO HURRY")

An Italian expression that appeared during the Renaissance to denote a style of painting remarkable for the speed and virtuosity of its execution.

FLOSSING
A term used by Eugène Delacroix (1798–1863) to designate a pictorial technique of intermingling blended tones.

CASTING
A word used since 1498 to designate the act of founding. It can also mean the melting of snow, as well as of metal, as has been practiced since the thirteenth century.

FRESCO
It was toward the end of the seventeenth century, in 1680, that the word *fresco* began to be used to designate a work painted on a wall, which soon led to the word being applied to any large-scale work. The word was in use even earlier in French to indicate the process of applying thin colors to a freshly laid surface. But, in fact, painting *a fresco* had been done for some time. In 1398, Cennino Cennini reported in his treatise, the *Libro dell'arte:* "To work on a wall, you must know how to moisten it, lay the plaster, smoothe it, polish it, make the design, and apply the colors to the fresh surface... That is the order in which I learned it from the masters." The preparatory design for a fresco is called a sinopia because early examples were done on a freshly laid surface with either charcoal or clay from Sinope. Later, designs were done on huge sheets of paper, and the lines of the design were pierced with holes or traced with ground charcoal or the powdered red ocher of Sinope. The paper would then be tamped down, transferring the design to the wall. Once the design is in place, the painter can apply the color to the plaster that has just been laid. It must be a freshly laid surface to qualify in Italian as a *fresco.* The technique requires that the surface be laid the very morning of the day the painter will cover it, as the work must be completed within that day. Although the painter may still do work on it later, it will then be termed *"a secco,"* done in the dry. True fresco painting allows for neither hesitation nor second thoughts.

FRIEZE
The midsection of the entablature, between the cornice and the architrave. This median band may be bare surface, or it may have sculptures of the Ionic and Corinthian orders.

PEDIMENT
The triangular space, either depressed or raised, resulting from the horizontal line from the cornice to the roof, which ends at the top of a classical building or a gabled temple.

SCUMBLING
Term used by painters to designate the technique of laying a thin coat of paint with an almost dry brush, perhaps letting the bare surface show through. David did the backgrounds of some of his most famous paintings using this technique.

CHARCOAL
Carbonized wood coal (willow or linden, but also birch, boxwood, fig, or myrtle), which is equally good for drawing or stumping.

SHAFT
The body of the column, located between the capital and the base, that plays the role once taken by the tree trunk in the earliest buildings.

GISANT
The present participle of the verb *gésir*—to be laid out, immobile—designates funerary statues that are effigies of the dead laid out on their tombs.

GLAZING
A transparent layer of paint usually containing more binder than pigment. This technique was used in antiquity but became particularly widespread with the development of oil painting during the Renaissance. There are many magisterial examples of this technique at the Louvre among the works of Titian, Rubens, and Goya.

GLYPTIC
Borrowed from the Greek *gluptikos*, meaning "having to do with engraving." Present usage refers only to the art of engraving precious stones, to the exclusion of all other types of carving.

GOUACHE
The pigments used in a gouache—from the Italian word *guazzo*—are similar to those used in an aquarelle, but they are bound with gum and white lead. When diluted with water, a gouache has greater spreading ability than an aquarelle. And unlike the aquarelle, the colors of a gouache are opaque.

ETCHING
Etching means, above all, the act of tracing hollow lines into a wood, metal, or stone surface. The term comprises every kind of engraving and technique, from drypoint to copperplate, from aqua fortis to lithography, from xylography (etching on wood) to linocut. The French word *gravure,* ennobled by the suffix *-ure* on the model of *peinture* and *sculpture,* has also been used since 1568 to mean the work of the etcher: the action of etching out the design, which the word had signified thirty years earlier.

GRISAILLE
This term has been used since the fourteenth century to designate a monochromatic painting done in shades of gray, ranging from black to white. Some Gothic stained glass was done with this technique. In painting, the grisaille has sometimes been used to imitate sculpture.

HIGH RELIEF
It was only in the last years of the nineteenth century, perhaps 1875, that one took the trouble to use such a word for a carving that stands out in the round from a background. The expression *ronde bosse* ("rounded carving") had sufficed until then.

OIL
Jan and Hubert van Eyck are generally credited with having perfected the technique of painting with oil, a development hailed by Giorgio Vasari as an "admirable invention which affords great ease." Since the fifteenth century, the technique of oil painting has been conflated with the history of painting itself. Since 1752, the word *oil* has been synonymous with the word *canvas* in referring to a work of art. And as to whether the painter should use flaxseed oil or poppyseed oil, there is no longer a question, since, according to a treatise on painting published in 1755, flaxseed oil is, and remains, the best.

ICON
Usually denotes a religious painting done by an artist of the Eastern Orthodox Church (Byzantine or Russian).

CHALCOGRAPHIC PRINT
Designates all methods of transferring an image to paper: etching, copperplate, heliogravure (photoengraving), lithography and offset, stencil and seriography. [Translator's note: In English, chalcography refers to engraving on copper or brass; "chalco", after all, means copper.]

WASH DRAWING
In this technique, known since antiquity, the ink is "washed," then diluted, then laid on the surface. The more the ink is dissolved, the greater the transparency. The speed of the process makes it possible to limn the intensity of light and shadow with the immediacy of a sketch or draft, and to capture the fleeting images of dreams, hallucinations, and the apparitions conjured up by fantasy and daydreams.

LITHOGRAPHY
The term has been used since the beginning of the nineteenth century to designate a printing technique that uses a limestone matrix that has been chemically treated to retain ink, allowing a wide range of effects of both light and matter.

BLACK MANNER, OR MEZZOTINT
Sometimes used as a complement to aqua fortis, this etching technique uses a burnishing tool to achieve fine shading effects and lustrous blacks.

MAROUFLAGE
The act of pasting a work painted on canvas or paper onto a rigid supporting surface.

MINIATURE
This word was originally (in about 1645) spelled *mignature* to agree with the Italian word *miniatura*. These words derive from the Latin words *minus* and *miniare*, to paint red, and from *minium*—designating above all "small figures painted in vivid colors, to decorate books, parchments and small objects." The miniature requires minutiae... Miniatures were originally painted on parchment, vellum, and pasteboard. Then ivory and porcelain served the same purpose. The miniature has been dedicated to the art of portraiture more than to any other genre.

MODELING
It was only at the beginning of the nineteenth century that the term *modeling* came to mean working with clay. Given that, since the beginning of the seventeenth century, the same word meant modeling with any soft material. The word derives from the verb *to model*, which means to make to resemble a model.

MODELED
Technique of creating the illusion of volume in a painting or drawing of a body or object. In sculpture, it designates the rendering of the forms of the work itself.

MONOTYPE
The invention of this technique is credited to the Genoese G. B. Castiglione, called Il Grechetto (1610–1665). A drawing is pressed with a plate against another sheet of paper, in order to be reproduced several times. (All the term actually means is to make only one print from a plate. But this would require no one to invent it.) The term can be used to indicate both the technique and its product.

MOSAIC
An assemblage of tesserae—fragments of marble or colored glass cubes—on a cement base. The Louvre has many exceptional examples of Greek, Etruscan, and Roman mosaics.

MOLDING/CASTING

The reproduction of a sculpture or object by taking its imprint. The word also designates the object thus produced. *Surmoulage*—the *sur* prefix is an intensifier——means to make a copy of an existing original. The Réunion de Musées Nationaux (French National Museum Consortium) sells casts of certain works from the Louvre collections.

GOLDEN MEAN

This number was devised by Euclid in dividing a straight line in order to create an isosceles triangle. It is a ratio of approximately 0.618 to 1.000. Since antiquity, it has helped artists work out shapes in harmonious proportions. Many Renaissance studies were devoted to it, among them the treatise *De Divina Proportione* of Luca Pacioli (c. 1450–1514), which inspired many artists of the era.

PAPER

Material derived from rags and wood fiber. It was preceded historically by papyrus and parchment. Its use spread exponentially among artists from the beginning of the fifteenth century. The department of Graphic Arts has more than 130,000 works on paper that were done between the fifteenth and nineteenth centuries.

PAPYRUS

The name designates a plant from the banks of the Nile whose stalk was used in fabricating wickerwork and sheets for writing. The department of Egyptian Art has some remarkable papyrus fragments that are decorated in hieroglyphics.

PARCHMENT

The hides of sheep, lambs, or goats that have been blanched and prepared as material for both writing and illumination. Its use goes back to antiquity and extends into the Middle Ages. The Louvre has some exceptional parchments: for example, several illuminations by Jean Fouquet (c. 1420–1480).

PASTEL

Usually in the form of sticks, pastels are composed of a solidified powdered pigment mixed with talc or kaolin. They can be either oily or dry. Often used on [velours=velvet?] paper whose texture retains specks of color, pastels go back to the fifteenth century. Used by many artists in the sixteenth century, it became a genre in its own right in the seventeenth century. The Louvre has a drawing by Leonardo da Vinci that has been highlighted with pastels, as well as some magnificent examples of the work of such painters of the eighteenth century as Lyotard and Chardin.

LANDSCAPE

Since 1544, the suffix *age* joined to the common noun *pays* has formed the word *paysage,* which designates the representation of a natural site. This did not prevent painters from calling it *pésage* or "burden," during the seventeenth century. And this never prevented the same painters from reconfiguring their landscapes with sundry elements—a tree might have been here, a rock there, all rearranged in the same arbitrary space of the canvas. For a long time, landscape was nothing more than a framework for a historical painting—and nature only had to resemble what one thought it ought to be; that was Poussin's formula. It was only during the course of the nineteenth century that landscape became a "subject," thanks to Constable, Turner, Valenciennes, Corot, Boudin, and others. And with Cézanne, it became a "motif."

HISTORY PAINTING

De pictura, the first treatise on painting that was published in Europe, by Leon-Battista Alberti, readily asserted in 1435 that the representation of history is "the most important task of the painter." This led all the academies created in Europe in the seventeenth and early eighteenth centuries to affirm that history painting was the first and the most noble of genres. No one who wasn't a history painter could ever be appointed first painter to the king of France. For a long time, many painters considered it beneath their dignity to paint any subject that didn't come from the Bible or the Gospels or accounts from ancient history, and only Greek and Roman history. Not that painters were forbidden to paint contemporary scenes. And in France it was Millet and then Courbet, followed by Manet and the Impressionists, who, to the dismay of the authorities of the Institute, did just that and put an end to the tyranny of the genres.

GENRE PAINTING

The encyclopedia of D'Alembert and Diderot asserts: "Genre painters are those who indiscriminately choose such subjects as flowers, fruits, animals, woods, forests and mountains, and who paint scenes of ordinary domestic life." Such painters were at the bottom rung of the hierarchy: Genre painting was the domain of small talents— and yet Vermeer was one of them.

PERSPECTIVE

A technique of depicting volumes and spatial relationships on a flat surface. Beginning in the fifteenth century, artists in Italy made a concerted effort to develop a system of drawing from a fixed point of view outside the limits of the drawing (that of the viewer), and taking into account the proportions relative to the viewer's position. The paintings in the Louvre present a history of this type of representation with many

examples of the use of perspective drawn from several historical periods and different cultures.

PIGMENT

Usually in the form of dry powder, pigments may be made of vegetable, mineral, animal, or chemical matter. In order to be used, this material must be mixed with a binder (oil, water, etc.). Pigments are grouped by their chromatic quality, their coloring, and their covering abilities, as well as their luminosity. The chromatic gamut of pigments used by artists has progressively increased over time. The Louvre allows one to see this long history in all its richness, starting with the colors that were used by the Egyptians (clays, ochers, browns and reds, blue, black and white...) to those that were used by Renaissance painters and also by the first plein air painters.

PAINTBRUSH

An instrument comprising a wooden handle that holds the bristles. During the Middle Ages the skin of squirrels was often used. Marten, badger, skunk, kid, or even miniver, goat, and wolf were also used. During the Renaissance, painters usually made their own brushes. Starting in the seventeenth century, brushes began to be made by artisans. The great variety of size and shape allowed the painter to achieve many special effects. Some painters whose works are at the Louvre, such as Caravaggio, Rubens, and Rembrandt, used the handle of the brush to streak paint across their canvases.

PICTURESQUE

The Italian expression "alla pittoresca," designates something executed in a "painterly fashion." When the word came into the French language in 1648 as *pittoresque*, it was used to mean something both original and expressive. At the beginning of the eighteenth century, it came to mean something "related to painting." In 1718, Abbot Du Bos, in his *Reflections on Poetry and Painting*, said the word should only be used for works that "show at a glance and with stunning effect the intention of the artist."

PLASTER

Made from dehydrated, pulverized gypsum, plaster has been used since antiquity. Painters use it to coat or prime certain surfaces. Sculptors use it to take impressions or to make models to be cast in lead or bronze, for example.

LEAD

A natural element whose very low melting point (327.5 degrees Celsius) has allowed its use since antiquity. Lead can be worked and hammered once it's been melted. The Louvre has many examples of Greek and Roman sculpture made of this metal. In France, during the seventeenth and eighteenth centuries, lead was used, among other metals, to make large outdoor sculptures.

PEN

Made of animal, vegetable, or even metallic matter, the pen has been in use since antiquity. The first pens were probably fashioned from carved reeds. Goose quills were in widespread use from the eleventh century. Brass was used during the Renaissance and the first steel pens appeared in the nineteenth century. The department of Graphic Arts has many fine drawings that have been made with this instrument.

ROUGH SKETCH

A small oil sketch usually done on the spot.

STENCIL

A design cut into a piece of wood, pasteboard or any other material with which colors can be applied in a uniform pattern.

METAL POINT

A term used equally to designate an engraving technique, the finished work, and the instrument used: a pointed tool for incising plates that will then be inked and put to the press to make impressions (imprints). (See engraving.)

POLYPTYCH

The word's origins go back to the Greek via Latin. The word *poluptukhos* designates something with "several folds." It was at the beginning of the twentieth century that art historians began to use the word *polyptych* for retables, altar paintings in several sections whose panels could be folded over one another. Such a work in three panels would be called a triptych.

PORTRAIT

Derived from the French verb *pourtraire,* or *portraire,* the word was originally spelled *portret,* or *portraict.* The prefix *pour* intensifies the sense of the verb "traire," which means "to pull," and has an old meaning of "line" or "to draw." Leon-Battista Alberti wrote in this regard: "The faces of the dead have a second life in paintings." The Louvre has in its collections many portraits from different eras and artistic traditions. Suffice it to note, among them, the pieces from Faiyum and the portrait of Jean Le Bon, considered one of the prime examples of Western portraiture.

FORESHORTENING

The technique of representing a body in perspective, foreshortening sometimes produces stunning visual

illusions. Its use spread during the Renaissance, along with perspective.

RETABLE
This word designates a table placed behind an altar. It has been in the French language since 1426. It probably comes from the Medieval Latin *retrotabulum*, whose components are *retro*, meaning behind, and *tabula*, meaning table or altar.

IN THE ROUND
A sculpted work whose size and shape can be viewed from all sides and not just from a fixed frontal view, as is the case with high- and low-relief.

SANGUINE
Leaded red clay in either powdered form or in a stick. Used as a pigment since antiquity, it has been used by artists for drawing since the fifteenth century. The word first appeared in the French language in the seventeenth century.

SCULPTURE
The Latin word *sculptara*, which meant the work of shaping and etching on stone is the model for the French word that appeared in 1380. It took its present form in 1552. It was only during the Renaissance that what is little more than the size of the stone became an art in its own right.

SÉPIA
A coloring made from cuttlefish ink whose use goes back to antiquity.

SFUMATO (TONED DOWN)
An Italian term meaning a subtle gradation of tone and color to blur the distinction of forms in a painting. Leonardo da Vinci is considered the greatest master of this technique, as works of his at the Louvre attest.

SICCATIVE
Substance added to a painting material to reduce the time it takes to dry.

SOLDERING
The technique of joining two or more pieces of metal together. Its use goes back to antiquity. Although there has long been a distinction made between bold soldering, done with tin, and thin soldering, done with lead, since 1636 the word has meant the act of joining two solid bodies together. Today a distinction is made between autogenous (self-fused) sculpture and heterogenous soldering. The first is accomplished by melting two pieces of the same metal; the second requires the use of a specific metal to fuse two other different metals.

STATUARY
The art of the statue in general. (See: Statue.)

EQUESTRIAN STATUE
This pair of words designates the representation of a figure mounted on a horse. Michelangelo placed a rare example from ancient Rome of the emperor Marcus Aurelius on the Capitoline. And Verrocchio ushered in a new vogue for this type of statue in Europe when his statue of Colleone was put up in Venice following his death.

STATUE
The French word derives from the Latin *statua*, which itself comes from the verb statuare meaning "to establish, to position, to place upright, to stand." The word essentially means the lifelike representation of a person.

STELA
Since 1872 the French meaning of the word has been simply a monolithic monument with a funerary inscription. The word is a learned borrowing from the Latin *stela* and the Greek *stêlê*. The first means a column; the second a standing block.

STIACCIATO
An Italian term meaning a work that projects in relief only minimally from the surface.

STUCCO
A blend of chalk, plaster, or powdered marble, which gives the appearance of stone. Used for the interior decoration of buildings, stucco can be sculpted, modeled, and polished. There are many rooms in the Louvre, the most famous being the Apollo Gallery, that are decorated with stuccos done by artisans or even famous artists.

SURMOULAGE
See Molding/Casting.

EASEL PAINTING (TABLEAU DE CHEVALET)
A *chevalet* is a little *cheval* (i.e. horse; cf. Sawhorse). By analogy, since the fifteenth century the word has meant that which serves as a support. It was in the seventeenth century that the word came to mean the support used by a painter for the canvas he was working on. A canvas that was painted on such a support, stretched out on a frame, like the wood panel placed in the same position, came to be called easel painting. Although easels existed in Greece in ancient times, they only made their reappearance in Europe in the fifteenth century.

DIRECT CUT

A sculptural process of cutting directly into a hard material. Unlike modeling, in which the artist can remove or add material at will, direct cut always involves subtraction of the material.

TAPESTRY

A tapestry is a work of woven silk or wool whose design follows the design on the artist's "cartoon." It is used to cover the walls of palaces, châteaux, and churches. There are high-gloss and low-gloss tapestries. The first is done on a vertical loom, and the second on a horizontal one. The Louvre has some exceptional works made with these techniques, some of which come from royal manufactures.

TEMPERA

See Distemper.

CANVAS

The use of canvas goes back to antiquity, or as many texts of Ovid, describing painted theatrical sets, make clear. Some of the Faiyum portraits are painted on canvas with a wood backing. Paintings done on canvas didn't really appear in Europe until the fifteenth century. Many different materials are used in the making of canvas: linen, cotton, hemp, and flax... Canvas can be stretched on a frame, left alone, or hung from a rod (Chinese usage). Before it is painted, the canvas is coated with a primer. Many different methods may then be used for painting itself: distemper, wash, oil...

TONDO

An Italian word for a round painting or relief.

TORSO

Félibien, who was among the first members of the Academy of Painting and Sculpture founded by Louis XIV, borrowed the Italian word torso, which, since the time of Michelangelo, was no longer just about anatomy but also meant a work of art of a body without a head or limbs.

TRIPTYCH

See Polyptych.

VELLUM

The skin of young animals used as a base for writing, drawing, or illumination.

SOFT GROUND

A term used in etching to designate a technique of drawing a design on paper, which is placed on a plate covered with a soft earth. The plate is then passed through a light acid bath, cleaned, and put to the press.

XYLOGRAPHY

The technique of etching on wood, as well as the works so produced. (See Etching.)

Terminology
(Styles)

ACADEMISM OR ACADEMICISM

(From *Akademos*, the name of the owner of the garden where Plato taught and which became known as the *Akademeia*.) This term only came into use in the nineteenth century, when the Académie des Beaux-Arts (Academy of Fine Arts), created in 1795 as part of the institute, exerted its authority over the plastic arts to the exclusion of all innovation.

PALEOCHRISTIAN ART

Designates art of the early secret Christian communities of both the East and the West that developed from the beginning of the third century. It became official art after 313, when the emperor Constantine recognized and tolerated Christianity.

BAROQUE

The Baroque style—from the Portuguese word *barroco* meaning irregular pearls—developed after the Council of Trent (1545–1563), which launched the Counter-Reformation. Defined by movement, monumentality, and ornamental excess, it spread from Rome throughout the Catholic world from the beginning of the seventeenth to the middle of the eighteenth centuries.

CLASSICISM

First used to denote the style that flourished in Athens during the fifth and fourth centuries B.C. During the course of the Italian Renaissance and in the seventeenth century, the term designated the art of antiquity. In the second half of the nineteenth century, the adjective *neoclassic* designated the artistic movement that, between 1750 and 1830, attempted to reintroduce the forms of antiquity.

GOTHIC

At the beginning of the twelfth century, the combined use of the flying buttress and the groined vault made it possible to build cathedrals with stainedglass windows, flooding them with light, a sign of God's presence. The windows were possible because the walls no longer had to be load-bearing. The Gothic style developed in Europe during the thirteenth and fourteenth centuries. The Gothic of the fifteenth and sixteenth centuries, with its decorated pinnacles and balustrades in the shape of undulating flames, is often called flamboyant.

MANNERISM

The term *maniera* has been used since 1550 to indicate the style of a particular artist, as well as to acknowledge the use of unconventional shapes. Since the end of the eighteenth century, the word *Mannerism* has been used to designate a late Renaissance school of painters from the end of the sixteenth century.

NEOCLASSICISM

See classicism.

ORIENTALISM

An eclectic school of painting in the nineteenth century whose Oriental influences were the result of such political events as Napoleon's Egyptian campaign, the colonization of Algeria, the War of Greek Independence, the Crimean War, and the opening of the Suez Canal.

PRIMITIVE

This adjective designates painters whose works predate the perfection of perspective in Italy at the start of the fifteenth century.

RENAISSANCE

Since the nineteenth century, the word *Renaissance* has been used to designate the period during the fifteenth and sixteenth centuries following the perfection of perspective in Florence. Antiquity was rediscovered during this time through the works of Plato, Greek and Roman mythology, and a treatise on architecture written by Vitruvius in the first century. It spread from its three originating centers of Florence, Rome and Venice to all of Europe. Northern Europe contributed two essential discoveries to the development of the Renaissance: oil painting and the printing press.

ROCOCO

This name designates the pictorial and decorative works that followed the Baroque in the first half of the eighteenth century, and was initially used disparagingly. It comes from the studio term *rocaille,* for the rocks and shells used to decorate artificial grottoes and garden pavilions.

ROMANTICISM

This movement appeared in England and Germany during the 1770s and reached France in the nineteenth century. It popularized both Gothic architecture and old folk legends, mostly from Northern Europe. On a formal level, the movement was characterized by a poetic passion and romantic enthusiasm for the forces of nature, as well as a questioning of the rules and formal strictures of classicism.

TROUBADOUR

From the end of the eighteenth and in the first quarter of the nineteenth centuries, and particularly in France during the Restoration, the troubadour style was a fad for painting subjects from medieval history.

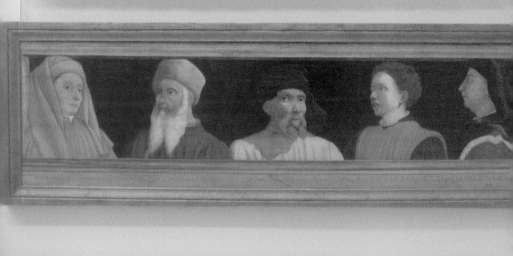

Florentine school, *A Cassone Featuring Five portraits of Masters from Florentine Renaissance*
(Giotto, Uccello, Donatello, Manetti, Brunelleschi), first half of the 16th century. Oil on canvas, 65 x 213 cm.

Architects
Painters
Sculptors

Raymond du Temple. Known from 1360 to 1403. Superintendant of Works for Charles V, who between 1364 and 1367 transformed the château of Philip Augustus into a royal residence, most notably in the building of the "grande vis," the monumental spiral staircase started by the young king the day after he learned of his father's death.

Pierre Lescot. Paris, circa 1510–Paris, 1578. After having collaborated with Jean Goujon on the roodscreen of Saint-Germain-l'Auxerrois (1541–1544), in 1546 he was put in charge of construction at the Louvre, a post he held through the 1560s. He built the wing that bears his name, the king's pavilion and the south wing of the future Square Court. Humanist, mathematician and man of letters, he was responsible for renovations to the Renaissance wing, the stairs with straight banisters and sculpted vault, the great Hall of the Caryatids, the broken roof cornice of the new wing, following where possible the precepts of Vitruvius.

Pierre II Chambiges. 1545–1616. The ground floor of the Petite Galerie is attributed to Pierre Chambiges, member of a family of construction supervisors.

Louis Métezeau. Dreux, circa 1562–Paris, 1615. Descendant of the architects Clément I and Thibaut Métezeau. Louis Métezeau, who started out at Dreux eventually did the sepulchre of Henry II at Saint-Denis, and his brother Clément II, helped shape the language of classicism under Henry IV and Louis XIII. In 1595, Henry IV put Métezeau in charge of the eastern part of the Grande Galerie. The two sides of the building were of different heights: the south façade along the Seine was a regular series of tiers adorned with royal emblems in relief and a frieze depicting children's games; the north was a succession of arcades on the ground floor, decorated with symbols of victory and the arts, with large gallery windows on the floor above.

Jacuqes II Androuet du Cerceau. Circa 1550–1614. Brother of Baptiste Androuet Du Cerceau (circa 1545–1590), Jacques II belonged to a family of royal architects. Henry IV gave him the construction of the western half of the Grande Galerie, as well as the pavillon de la Rivière, the future Pavillon de Flore. Du Cerceau decided to use the colossal order on both facades. The large scale of these buildings, which were destroyed by Lefuel in 1861, can still be seen in the north wing of the Carrousel, built by Percier and Fontaine on the model of the south wing.

Jacques Lemercier. Pontoise, circa 1585–Paris, 1654. Descendant of a family of master stonemasons and architects from du Vexin, Lemercier was Richelieu's architect for his château du Poitou, the Sorbonne, the Palais Cardinal and the church of Rueil. Chief architect of the king, he built the churches of Val-de-Grâce and Saint-Roch. At the Louvre, he built the Clock Pavilion (1639–1642) and the wing to its north, as well as the lower part of the pavillon de Beauvais and the wing that bisects it to the north. He did the interiors of the Council Chambers (1653), and Anne of Austria's bathroom (1653–1654). He made the obligatory trip to Rome in 1607, and although his style is certainly not unaware of Italian innovations, it is considered to be the basis of French classicism.

Louis Le Vau. Paris, 1612–Paris, 1670. Although Le Vau is considered one of the principal exponents of French classicism during the time of Louis XIV, he was also sometimes drawn to the rythmic scale of the baroque. He enlivens his monumental shapes with the play of columns, openings, or with historic ornamentation. Chief architect to the king in 1654, La Vau built many homes for individuals, often in collaboration with his brother François: hôtel Bullion, hôtel Lambert, hôtel Lauzun. He introduced a majesterial baroque quality to the great dome of Vaux-le-Vicomte, built for the minister of finance Nicolas Fouquet, which made the king himself jealous. And one can see a fondness for curved lines in the façade of the College of the Four Nations (today the French Institute). He built a new wing on the chateau of Vincennes for the queen mother and during the years 1655–59 he was engaged in laying out the summer rooms at the Louvre Palace. Beginning in 1661, he undertook an enormous construction project at the Louvre which included rebuilding the Petit Galerie which houses the gallery of Apollo, creating a wing parallel to it, rebuilding the facade of the Tuileries, quadrupled the square court, and, finally, contributed to the original work on the façade of the Colonnade. He designed the original sections of the chateau at Versailles, the Orangerie, the first Porcelain Trianon and the symmetrical façade with the flat roof that would be completed by Jules Hardouin-Mansart.

François d'Orbay. Paris, 1634–Paris, 1697.

Following a trip to Rome in 1660, François d'Orbay became Le Vau's collaborator, and eventually succeeded him at the Louvre after working under his direction. With this title he worked on the Colonnade with the medical doctor Claude Perrault. We have him to thank for the cathedral of Montauban and the Hôpital de la Trinité at Lyon.

Claude Perrault. Paris, 1613–1688.

Brother of Charles Perrault, medical doctor and architect, translator of Vitruvius, an inquiring mind who was open and eager to learn. He worked on the construction of the Paris Observatory and the château of Sceaux. His technical knowledge was instrumental in lifting the enormous stone blocks that make up the rampants of the Colonnade wing's central pediment.

Ange-Jacques Gabriel. Paris, 1698–Paris, 1782.

Brought up in a family of royal architects that included Gabriels, Mansarts and Cottes, in 1742 Gabriel became the chief architect of the king, for whom he built the Petit Trianon and the Opéra de Versailles, the buildings of today's Place de la Concorde and the École militaire, as well as the new wings of Fontainebleau and of Compiègne. From 1755 to 1757, he undertook the demolition of the buildings that cluttered the Square Court and cleared away the buildings that surrounded the Colonnade. He completed the eastern façade of the Square Court that forms the rear of the Colonnade. Faithful to the spirit of French classicism, he was director of the Academy of Architecture that met at the Louvre.

Jacques-Germain Soufflot. Irancy, 1713–Paris, 1780.

The architect of the church of Saint Genevieve, which later became the Pantheon, was Gabriel's successor at the Louvre where the king wanted to move the Grand Council, then the Museum. Most of his projects at the Louvre came to nothing, but we have him to thank for opening and decorating the passageway that leads from the Square Court to the rue de Rivoli.

Maximilien Brebion. 1716–1796.

Architect of the Louvre from 1780 to 1792, he built the museum stairway that was destroyed during the Second Empire.

Auguste Cheval de Saint-Hubert, called Hubert. Paris, 1755–Paris, 1798.

Following his stay in Rome (1784–1787), which resulted from winning the Grand Prix in Architecture, he became a close friend of the painter David whose sister-in-law he married, and with whom he worked to organize revolutionary festivals. Hubert came up with a plan to beautify the Tuileries gardens and, in the year of his death, he organized the museum of ancient art in the Petite Galerie of the Louvre.

Jean-Arnaud Raymond, 1742–1811.

Architect of the Louvre from 1797 to 1803, he completed the museum of ancient art according to Hubert's plans.

Charles Percier. Paris, 1764–Paris, 1838.

Following his stay in Rome (1786–1792), which resulted from winning the Grand Prix in Architecture, he worked with his friend Fontaine as an architect at the Tuileries, then at the Louvre from 1801 to 1812. He continued as a faithful advisor, even after giving up his responsibilities. A man of classical tastes and a remarkable designer, he also helped Fontaine organize imperial festivals, among them the marriage of Napoléon I and Marie-Louise in 1810.

Pierre-François-Léonard Fontaine. Paris, 1762–Paris, 1853.

After traveling to Italy at his own expense (1785–1790), in the company of his friend Percier, they both became architects of the Tuileries then of the Louvre, from 1801 to 1848. Under this title he was responsible for many of the changes wrought during the Empire and Restoration periods: the north wing along the rue de Rivoli, the arc de triomphe of the Carrousel, the sculpted ornamentation of the Square Court (pediments, northwest roof and œils-de-bœuf), of the Colonnade and the Marengo and Arts pavilions. Inside, he created the great staircase of the museum, of which remain the rooms named for Percier and Fontaine, the north stairs and the south of the Colonnade, the changes to the Hall of the Caryatids, the museum of ancient sculpture in the south wing of the Square Court, the gallery of Angoulême on the ground floor of the west wing of the Square Court (Lemercier wing), the Charles X Museum, the gallery today called the Campana, the State Council Chambers (Department of Objets d'art), the Jewel Room, the first Hall of Sessions; at the Tuileries, he built a new staircase, a large theatre and the Marshalls' Hall. He left a diary relating in minute detail his untiring activities at the Louvre.

Félix-Louis-Jacques Duban. Paris, 1797–Bordeaux, 1879.
A student of Percier, he won the Prix de Rome in 1823. Leader of the romantic rationalists, he was very active, as much in the restoration of monuments (château of Blois, the Sainte-Chapelle, the Louvre) as in prestigious new projects (the hall of studies of the École des beaux-arts, the château of Dampierre). At the Louvre, he renovated the gallery of Apollo, the gallery at the water's edge, redid the façade of the Petite Galerie, laid out the Square Court. His major work remains the decor of the Square Salon and of the Salon of Seven Chimneys. He laid out the Museum of Sovereigns on the second floor of the wing of the Colonnade. In disagreement with Napoleon III, he resigned in 1853.

Ludovio-Tullius-Joachim Visconti. Rome, 1791–Paris, 1853.
Son of the Roman archeologist Ennio-Quirino Visconti, who was the first curator of antiquities at the Louvre, this student of Percier had an important career in Paris (the Louvois, Molière and Saint-Sulpice fountains, the tomb of Napoléon, several private residences). In May of 1848 he was put in charge of the project to unite the Louvre and the Tuileries, under terms agreed to during the Republic, but the work was not actually begun until 1852, by order of Louis-Napoléon Bonaparte. He carried out the work with great respect for the buildings already in place and was struck down by death December 29, 1853.

Hector-Martin Lefuel. Versailles, 1810–Paris, 1880.
Son of a contractor of royal building projects, he took over from his father after winnng the Prix de Rome in 1839. Noticed by Napoleon III while working on the Palace of Fontainebleau, he was put in charge of construction at the Louvre and Tuileries and acquited himself well. From 1854 to 1857 he completed the first phase, the construction of the wings and court that frame the Napoleon Court, then from 1861 to 1868 he rebuilt part of the Grande Galerie and the Pavilion of Flora. His decorating talents can be seen in the stairwells (of the library, minister's office, Flora, Mollien, Daru, Colbert), in the great halls (of the Nations, Denon, Riding Academy), and also in the apartments (those of the Tuileries that were destroyed, of the Secretary of State and of the Riding Master). He also redesigned the eastern part of the Tuileries Garden. His eclectic and inventive style resulted in added ornamention to Visconti's classic layouts. After the Empire, he continued in charge of the Louvre, rebuilding the Marsan Pavilion and the north facade of the Pavilion of Flora.

Edmond-Jean-Baptiste Guillaume. Valenciennes, 1826–1894.
Winner of the Prix de Rome in 1856, he began working for the Louvre on archeological expeditions in Asia Minor. Architect of museum buildings from 1880 to 1894, he transformed the Hall of Nations, decorated the Daru stairwell with mosaics, placed the Hall of Africa on the ground floor of the Gallery of Seven Meters, as well as the Sarzec and Dieulafoy Galleries, the great hall of the Beauvais Pavilion and its neighbor. He created the garden of the Carrousel as a replacement for the destroyed Tuileries Palace.

Gaston Redon. Bordeaux, 1853–1921.
Brother of the painter Odilon Redon, he was architect of the Louvre from 1897 to 1910. He installed the Rubens Room (1900) and the Museum of decorative Arts (1905). He made some beautiful visionary drawings.

Victor-Auguste Blavette. 1850–1933.
Architect of the Louvre from 1910 to 1921, he finished the Mollien staircase, left unfinished since 1870.

Camille Lefevre. 1876–1946.
Architect of the Louvre from 1922 to 1929, he drew up the plans for the restructuring of the museum decided on by Henri Verne. He hung the *Waterlilies* of Monet in the Orangerie of the Tuileries.

Albert Ferran. San Francisco, 1886–Paris, 1952.
Winner of the Prix de Rome in 1914, he taught in Boston (1922–1924) before undertaking the renovation project as conceived by the Director of National Museums, Henri Verne. During the period of his achievements (1930–1943), he brought a sense of purist grandeur to the Louvre: the stairs of the *Victory of Samothrace*, the departments of Sculpture, Oriental Antiquities, ground floor Egyptian Antiquities, Hall of the Seven Meters, the conservation office in the south wing of the Square Court. In opening the crypts under the pavilions of the Square Court, he completed the museological circuit along the ground floor.

Ieoh Ming Pei. Canton, 1917.
Following his studies in Boston and at Harvard (Graduate School of Design), he became known for his important museum designs: enlarging the Des Moines

Museum (1968), the east wing of the National Gallery in Washington (1978), the west wing of Boston's Fine Arts (1981). Entrusted with the Grand Louvre in 1983, he created the Hall Napoleon and the Pyramid (1988), the new spaces in the Richelieu wing and the Carrousel (1993).

···❯ **THE PAINTERS**

Nicolas Poussin. Les Andelys, 1594–Rome, 1665.
In 1640, the most celebrated classical painter, at the behest of Louis XIII, interrupted his long stay in Rome, undertaken in 1624, to go to Paris and paint the interior decorations of the Louvre. As his rooms were off the garden, he was in the midst of things. He began working on a series of medallions depicting the labors of Hercules and Atlantes for the ceiling of the Grande Galerie. Work was interrupted by the deaths of Richelieu and of the king, and above all by Poussin's departure for Rome where his family awaited him. Even though Poussin promised to continue sending drawings, the project was never completed. Poussin was a painter of carefully composed and thought-out canvases and his temperament, hardly that of a decorator, was ill-suited to the work. Only a few drawings remain of this aborted project. Poussin's large, round canvas *Time and Truth,* painted for the Palais Cardinal, which in the seventeenth century was hung in the the Grand Cabinet of the king, is now at the Louvre.

Giovanni Francesco Romanelli. Viterbe, 1610–Viterbe, 1662.
Mazarin, "gung-ho for Baroque art", brought Romanelli, a student of Pietro da Cortona, to Paris in 1646. The artist decorated the gallery of the Palais Mazarin with episodes from the Trojan war and from *The Metamorphoses* of Ovid. This project was so successful that the cardinal brought the painter back again to decorate the apartments of the queen mother at the Louvre (1655–1659). Michel Anguier did the stuccos under Romanelli's guidance, but Romanelli reserved the frescoes for himself: Roman history in the Grand Cabinet (Mucius Scaevola, Cincinnatus, Scipio), strong women in the bedroom (Judith and Holofernes), Apollo and Diana, the seasons in the antichamber.

Eustache Lesueur. Paris, 1617–Paris, 1655.
He painted cycles of the life of Saint Bruno, did the cabinet de l'Amour, then the room of the Muses at the

hôtel Lambert (all of these works are now at the Louvre) and was hired to paint the king's apartments, but only a few preparatory drawings remain.

Charles Le Brun. Paris, 1619–Paris, 1690.
After the fire in the Petite Galerie in 1661, Le Brun, Louis XIV's chief painter, was asked to decorated what would become the Apollo Gallery. He came up with a design in honor of the sun god about the cycle of time and the muses. Le Brun's work, incomplete, damaged and restored, is known primarily through a few preparatory drawings and a series of engravings of Saint Andrew (1695). We still have, however, the *Triumph of the Waters,* or the *Cortège of Neptune,* a mural painting in the far south of the gallery, and two sections of the ceiling, *Evening, or Morpheus,* and *Night, or Diana.*

Hughes Taraval. Paris, 1729–Paris, 1785.
In 1769, on the order of the Academy of Painting and Sculpture, Taraval painted *Autumn or The Triumph of Bacchus,* which was placed in a compartment of the Apollo Gallery.

Louis-Jacques Durameau. Paris, 1733–Paris, 1796.
Winner of the Prix de Rome in 1757, Durameau was accepted into the Academy of Painting and Sculpture in 1766. In 1774, for his reception piece, he painted *Summer or Ceres and Her Companions Praying to the Sun* for a section of the ceiling of the Apollo Gallery. Higly favored by the royal administration, he was one of the great decorators of public buildings: *Apollo Crowning the Arts* on the ceiling of the Versailles Opera, two ceilings (destroyed) for the Opera of the Palais Royal, the ceiling of the Chancellery at Orléans. He also had a parallel career as curator: Keeper of the King's Pictures (1784–1792), and curator of the special museum of the École française (1795–1796).

Antoine-François Callet. Paris, 1741–Paris, 1823.
Winner of the Prix de Rome in 1764, Callet was accepted into the Academy of Painting and Sculpture in 1777 as a history painter. For his reception piece the Academy, in 1780, asked that he do a piece for the Apollo Gallery, *Spring, or Zephirus and Flora Crowning Cybele with Flowers.*

Michel-Martin Drölling. Paris, 1756–Paris, 1851.
During the reign of Charles X he got an order for two ceilings in the Louvre: *The Reign of Law on Earth* for the State Council (1827), and *Louis XII proclaimed "Father of the People"* (1828) for today's Campana Gallery.

Pierre-Paul Prud'hon. Cluny, 1758–Paris, 1823.
Son of a stonecutter from Cluny, Prud'hon was trained principally at Dijon where he won the Academy prize that allowed him to go to Rome. On his return to Paris he was a supporter of the Revolution and was forced to take refuge in Gray when the wind changed. Back in Paris, and now under Bonaparte's patronage, he was given some of the first official commissions. At the Louvre, after executing the medallion (*Study Guiding the Flight of Genius*) in 1800, for the bedroom of Anne of Austria, now enlarged as the final room of the museum of antiquities, in the south wing, Prud'hon finished the ceiling of the Hall of Diana, Diana imploring Jupiter not to subject her to the laws of marriage, ordered in 1801. Portraitist of Joséphine (1805) and of Napoleon, he soon achieved his moment of glory (*Innocence Chooses Love, Vengeance in Pursuit of Crime,* 1808 ; *Psyche Carried off by the Winds,* 1808), before falling from favor. Romantics, such as Delacroix, remained faithful to him.

Étienne-Barthélemy Garnier. Paris, 1759–Paris, 1849.
Student of Durameau and of Vien, he won the Grand Prix in 1788, and left for Rome, where the riot against the French forced him to flee and return to France. He received an order, along with Mérimée and Prud'hon, for the decor of the Hall of Diana which he did in 1802 in a tympanum *Hercules Receiving the Gold-horned Doe from Diana.*

Guillaume Guillon-Lethière. Sainte-Anne (Guadeloupe), 1760–Paris, 1832.
A Guadeloupean painter, Guillon, called Lethière, a pupil of Doyen, was both a portraitist and history painter. Caught up by revolutionary ideas, as was Hennequin, he worked on the first decorations ordered for the museum: the sections required to complete the ceiling in the bedroom of Anne of Austria, now enlarged as the final room of the museum of antiquities, along the Seine. In 1800 he painted a tympanum, *Victory and the Genius of the Arts.* As he was a government artist, he was director of the Villa Médicis (1807–1816), where he had Ingres as a student; professor at the École des Beaux-Arts (1819); and member of the Institute (1825).

Philippe-Auguste Hennequin. Lyon, 1763–Leuze (Belgium), 1833.
One of the most committed to the revolutionary movement, the Jacobin Hennequin was imprisoned from 1796 to 1797. When set free, he sought to express his ideals in the immense canvas *The Triumph of the French People* (1799), then *The Remorse of Orestes.* In 1800 he painted the medallion *The French Hercules* for the final room of the museum of antiquities, along the Seine.

Charles Meynier. Paris, 1768–Paris, 1832.
Student of Vincent, Prix de Rome in 1789, he was in Rome at the time of the insurrection against the French. One of the official artists of the Empire, he did religious paintings and especially works depicting the great deeds of the realm. Vivant Denon came to him for the drawings of statues and reliefs for the Triumphal Arch of the Carrousel to be used by the sculptors. First under the Consulat, then under the Restoration, Meynier received a series of orders to decorate the rooms of the Louvre. He devised compositions for ceilings, with delicate figures rising up in the clouds. In 1801 he completed a composition for the Museum of Ancient Art (former apartment of Anne of Austria), *Earth Receiving the Code of Roman Law From the Emperors Hadrian and Justinian.* In 1819 he turned to the ceiling of the museum stairwell (today's Percier and Fontaine Halls), painting *France Protecting the Arts,* which was followed in 1822 by the ceiling in the next room (Duchâtel), *The Triumph of French Painting.* Lastly, in 1827, he painted a ceiling of the Charles X museum, *The Nymphs of Parthenope Carrying the Penates Away From their Banks...,* which illustrates the placement of Campanian antiquities (Pompeii, Herculaneum) in the museum collections. Three sketches for these ceilings are displayed in the history rooms of the Louvre.

François Gérard. Rome, 1770–Paris, 1837.
He passed his childhood around the French embassy in Rome, where his father was an administrator, and came to France to study with the sculptor Pajou, then with David. Deciding not to try for the Prix de Rome, he nonetheless owed his rooms in the Louvre to David's influence. His first success at the Salon (*Psyche and Cupid,* 1798) established his reputation. As he was the official portraitist of the Consulat, then of the Empire, the baron Gérard sent all the big names of the era to his studio. All the while, he continued to work as a history painter, as witness the gigantic *Battle of Austerlitz* (1810, Museum of Versailles). During the reign of Charles X, the minister decided to create a "salon Gérard" in the Hall of Seven Chimneys, with large works, one of which was the *Coronation of Charles X* (Museum of Versailles). Louis-Philippe had other ideas, namely, get rid of the former king and exalt the

Orléans family. In 1832 he ordered a panel freize of colossal figures, Courage; Warrior; Clemency; Genius; Constancy. But this decor was never installed and the paintings were displayed at Versailles.

Antoine-Jean Gros. Paris, 1771–Meudon, 1835.
The son of a miniaturist, and a student of David, he was able to travel to both Milan and Genoa thanks to David's influence. It was through him that he met Bonaparte and did one of the most famous portraits of him, *Bonaparte at Arcole* (1796, Versailles). Contemporary illustrator of Napoleon's great deeds *(The Plague Victims of Jaffa, The Battle of Aboukir, the Battle of Eylau)*, he didn't lose any sleep over becoming official portraitist to Louis XVIII. Created baron by Charles X, Gros played a principal role in the decoration of the Charles X Museum with three large works in central sections of the ceiling of the Hall of Columns: allegories contrived to give fawning views of monarchical virtue *(True Glory Depends on Virtue, Mars Crowned by Victory Listening to Moderation,* and *Time Raising Truth Upon the Throne Where it is Received by Wisdom)*. Additionally, six trompe-l'œil pieces of busts of famous art patrons from Pericles to, of course, Charles X, and including Augustus, Francis I, and Louis XIV, evoking the merits of official art. Along the same lines, in 1827, Gros did the ceiling painting *The King Endows the Charles X Museum For the Arts* for that museum, which Louis-Philippe had removed (it is now at the Museum of Versailles) and replaced by a composition, also by Gros, less monarchical but very nationalistic, *The Genius of France Inspires the Arts and Protects Humanity.* After having been the prophet of cutting-edge modernism, Gros became narrowly interested in classicism, just at the moment when color and the romantic movement were triuphant. Gros was obviously out of step with the times. When he got a poor reception at the Salon of 1835 he threw himself in the Seine and died.

Alexandre-Évariste Fragonard. Grasse, 1780–Paris, 1850.
The son of Jean-Honoré Fragonard was a pupil of both his father and David, which gave him a sense of pure neoclassical design as well as for light and movement. After illustrating the feats of Napoleon I and the Empire, and working on the decor of the National Assembly, from 1819 he increased his output of historical, and especially nationalistic, subjects. His *Francis I Dubbed Knight by Bayard* (displayed at the Salon of 1819) was bought by the king and, in 1828, made part of the decor of the south gallery of the Square Court (today's Campana Gallery). Following this initial success, the Minister of the King's Household ordered *Francis I and Marguerite of Navarre Receiving the Paintings and Statues Brought Back from Italy by the Primatice,* originally placed in the Charles X Museum in 1827, before being moved to the same south gallery. Sketches of these romantic homages to the king-knight are displayed in the history rooms of the Louvre. Fragonard also painted many false bas-reliefs, in grisaille, for the Charles X Museum.

Jean-Auguste-Dominique Ingres. Montauban, 1780–Paris, 1867.
At first a student at the Academy of Toulouse (and also at the orchestra of the Capitole of the city), he joined David's studio in Paris in 1797. Winner of the Prix de Rome in 1801, he got to Rome five years later, which allowed him to hone his style beforehand: simple forms, authoritative line, giving primacy to artistry over conventional attitudes. During his long stay in Rome, then in Florence, he accomplished many drawings, "troubadour" scenes and portraits, while receiving many important orders from France. After retuning to France in 1824 his success in offical circles was sufficient to allow him to return to Rome, this time as director of the Academy (1835–1841). During his 1826 visit to Paris he received the commission for the ceiling of the main hall of the Charles X Museum, *The Apotheosis of Homer,* the most celebrated work in this ensemble. In 1855 the canvas was replaced on the ceiling with a copy done by the brothers Balze (Paul (1815–1884) and Raymond (1818–1909)), and the original was hung from the picture rail.

Merry-Joseph Blondel. Paris, 1781–Paris, 1853.
Prix de Rome in 1803, he worked principally on the decor of the Louvre during the Restoration. His compositions for the foyer of Henry II, ordered in 1818 *(The Contest of Minerva and Neptune, Peace, War)*, have been replaced by those of Braque, but one can still see some of his work on the Apollo Rotunda *(The Fall of Icarus, Air)* and two ceilings for rooms in the Council of State, today the department of Objets d'art, ordered in 1829 *(France Receiving the Charter from Louis XVIII,* and *French Victory at Bouvines)*.

Jean-Baptiste Mauzaisse. Corbeil, 1784–Paris, 1844.
In 1822, he completed the large figures in grisaille for the ceiling of the Apollo Rotunda, and the ceiling of the Jewel Room, featuring a gigantic figure of *Time Rising From the Ruins of Antiquity,* from which also

emerges a silhouette of the *Venus de Milo,* which had arrived at the Louvre the preceeding year. On the periphery, in 1828, he filled four voussures with allegories of the Seasons, and eight panels between the windows and over the doors, with spirits representing the Elements, the Arts, the Sciences, Commerce and War.

Alexandre-Denis Abel de Pujol. Valenciennes, 1785–Paris, 1861.

Entered at the age of 12 in the Fine Arts School of Valenciennes, founded by his natural father (whose name he would later take), he then went to Paris to study under David, and won the Prix de Rome in 1811. Thus began his long career as an official painter, providing works for state buildings, the Versailles Museum, the Luxembourg Palace, the stock exchange. In 1826 he was commissioned to do a room in the Charles X Museum that was for the display of Egyptian antiquities. In the center he did an allegory of *Egypt Saved by Joseph,* with trompe-l'œil compartments on the periphery in imitation bronze depicting episodes in the life of Joseph. Lower down, at the top of the walls, were eleven grisailles of daily life in ancient Egypt. He finished the decor of another room at the same time, where, under the ceiling and voussures painted by Vernet, he completed eight medaillons of great men of the Renaissance (Rabelais, Tintoretto, Titian, Erasmus, Montaigne, etc.)

Joseph Alaux. Bordeaux, 1786–Paris, 1864.

In 1832 he finished one of the ceilings ordered in 1828 for the south gallery (today's Campana Gallery), Poussin coming from Rome is presented to Louis XIII, in the center, and two allegorical figures of Philosophy and of Truth on either side.

François-Joseph Heim. Belfort, 1787–Paris, 1865.

Student of Vincent, Prix de Rome in 1807, Heim is the history painter par excellence, and even more so of official commissions, either religious or historic, destined mostly for churches but also for royal residences. He was twice asked to do work for the Louvre. For one of the rooms of the Charles X Museum devoted to the catastrophe of Pompeii and Herculaneum he painted the central composition in 1827, *Vesuvius Personified Receives From Jupiter the Fire that Will Destroy the Towns...*, as well as six voussure paintings, four devoted to scenes of desolation and two to the death of Pliny as he watched the phenomenon. The second order, in 1828, was for the decor of a room in the south gallery (today's Campana Gallery), that he finished in 1833: a large-scale section, *The Rebirth of*

the Arts in France, with voussures devoted to eight historical scenes of the sovereigns Charles VIII to Henri II.

Charles de Steuben. Bauerbach (Bade), 1788–Paris, 1856.

Creator of the ceiling in the State Council, *The Clemency of Henry IV at the Battle of Ivry,* ordered in 1828, as well as of the voussure medallions representing the principal collaborators of Henry IV: Sully, Lesdiguières, etc.

Horace Vernet. Paris, 1789–Paris, 1863.

Born at the Louvre, descendant the illustrious Vernet dynasty (Joseph and Carl), associate of the architect Chalgrin, student of Vincent, he was a child of the *seraglio.* History painter and portraitist, nostalgic for the Empire, Vernet belonged to a clan of bonapartists. Even so, the Minister of the King's Household wasn't very severe with him. In 1826, he became an officer of the Legion of Honor and member of the Institute, taking David's place, and was commissiond to do a ceiling for the Charles X Museum (1827) depicting *Julius II Ordering the Works of Saint Peter's in Rome From His Artists.* In 1828 he became director of the Academy of France in Rome.

Eugène Delacroix. Charenton-Saint-Maurice, 1798–Paris, 1863.

Delacroix, the hero of romantic painting, had already painted *The Massacres of Chios* when he exhibited *The Death of Sardanapalus,* which caused a scandal at the Salon of 1827. He also filled an order for a room of the State Counsil at the Louvre, *The Pandects of Justinian* (destroyed). But it was only at the middle of the century, when the artist's fame had spread, that Duban awarded him with a large order for the Louvre: the centerpiece of the ceiling in the Apollo Gallery. In two years (1850–1851), with the help of assistants, Delacroix painted the immense composition *Apollo Defeating the Serpent Python.*

Eugène Devéria. Paris, 1805–Pau, 1865.

Painter of historic episodes and genre scenes, Devéria had a success in the Salon of 1827 (the one of Delacroix's *Death of Sardanapalus*) with his *Birth of Henry IV.* He was thenceforth thought of as a colorist and romantic, a notion that was confirmed by the friends who gathered in his salon, Delacroix, Hugo, Musset, Liszt, Vigny, Gautier. In 1832 Devéria did the decor for a room in the south gallery of the Square

Court devoted to the patronage of Louis XIV: in the center was *Puget Presenting His Venus de Milo of Crotona to Louis XIV,* and in the voussures were different scenes of royal gestures toward philosophers and artists.

Louis Matout. Renwez (Ardennes), 1811–Paris, 1888. He is the creator of the gigantic ceiling in the Hall of the Emperors (today's Auguste), where the gods of Olympus, langorously reclining on clouds, stand out against a large blue background (1865).

Charles-Louis Müller. Paris, 1815–Paris, 1892. This history painter who specialized in large works no doubt got the most prestigious orders for the Louvre of Napoleon III. In 1850, after having redone a section of the vault of the Apollo Gallery after Le Brun, Aurora, he had to do the paintings for the Hall of Nations (1859), the Salon Denon (1863–1866) and the Mollien stairwell (1869). All that survives of the large painted canvases of the hall of Nations is a lovely series of preparatory drawings and the tympanum representing *The Triumph of Napoléon I*. To even the score, the entire ensemble of the Salon Denon remains, with its lunettes illustrating the patronage of Saint Louis, Francis I, Louis XIV and Napoleon I, and the great allegorical figures symbolizing the quality of the art of those periods (*Naïveté, Taste, Observation, Invention,* etc.). Of his work on the Mollien stairwell, there remains just the centerpiece of *Glory Handing Out Palms.*

Victor Biennoury. Bar-sur-Aube, 1823–Paris, 1893. This student of Drölling, Rome Prize-winner in 1842, official painter, put a lot of work into a series of scenes for the imperial palace. His work can still be seen in the great ensembles of Napoleon III at the Louvre (1860–1867): corner medallions in the great hall of the Minister of State, tympanums in monochrome gray against a red background in the Hall of Augustus, and in the first room of the apartment of Anne of Austria (Roman Sculpture, Greek Sculpture, French Sculpture), and sections of the ceiling in the following room (Religious History, Secular History).

Georges Braque. Argenteuil-sur-Seine, 1882–Paris, 1963. The cubist master was given an official order in 1953 to paint a ceiling in the foyer of Henry II. He installed three canvases of his famous birds in blue tones. Two years after his death, in 1965, an exhibition was given in this room of works of his that had been donated to the museum.

···⟩ **THE SCULPTORS**

Jean Goujon. Known in Rouen from circa 1540 to 1568 in the surroundings of Bologna. The most famous of French renaissance sculptors who was working on construction sites in Rouen in 1540. He came to Paris to work with the architect Pierre Lescot on the roodscreen of Saint-Germain-l'Auxerrois. Creator of the reliefs on the fountain of the Holy Innocents, his best work was done at the Louvre: the reliefs on the facade of the Henry II wing, and the stone caryatids supporting the musicians gallery in the great hall.

Jacques Sarazin. Noyon, 1592–Paris, 1660. After studying in Rome for eighteen years, upon his return to Paris, Sarazin was perfectly at home among the court artists, to whom he brought his knowledge of the first Roman Baroque style. Residing at the Louvre, he provided the models of the caryatids of the Clock Pavilion, built by Jacques Lemercier and decorated around 1639–1640.

Philippe De Buyster. Antwerp, 1595–Paris, 1688. De Buyster was a member of Sarazin"s group. Under his direction he and Gilles Guérin did the decor of the Clock Pavilion (1639–1640). The frieze of children playing with garlands is a very refined ensemble, especially at a time when the monumental qualities that characterize the robust caryatids were more likely to please the bigwigs.

Gerard Van Opstal. Bruxels, 1605–Paris, 1668. Educated at Antwerp, he joined Sarazin's team at an early age and, under his supervision, did an œil-de-bœuf relief for the Lemercier wing, *The Riches of the Earth and the Sea,* the only one to have been done during that time. He played a major role in developing the theme of childhood (*Family Children,* today at Vaux-le-Vicomte; marble reliefs in the king's Cabinet at the Louvre).

Gilles Guérin. Circa 1611–1678. With De Buyster and under Sarazin's direction, he did half the decor of the Clock Pavilion (1639–1640). He went from Sarazin's workshop to the château de Maisons-Laffitte. In filling many great royal orders he

did the ceiling of the king's chamber at the Louvre (1654), the marble statue of the young Louis XIV (château of Chantilly) before working on the park at Versailles.

Michel Anguier. Eu, 1614–Paris, 1686.
Educated in Picardy, then at Rome with his elder brother François, also a sculptor, Michel Anguier stayed for some time in Rome before returning in 1651 in order to work on large projects for the court and for Finance Minister Fouquet. The sculpture in the apartments of Anne of Austria at the Louvre, under the direction of the Roman painter Romanelli, and that of Val-de-Grâce, founded by the queen mother, are works of architectural decoration celebrated for their quality of execution, heavily influenced by the Italian Baroque, but tempered by French taste. He expressed both his dynamic and reflective character traits in the large nativity figures at Val-de-Grâce (today at Saint-Roch) and a series of small bronzes representing gods and goddesses from antiquity with temperament and expression.

Thomas Regnaudin. Moulins, 1622–Paris, 1706.
Student of François Anguier, collaborator and friend of Girardon, he worked with him on the first large orders of Louis XIV. Creator of four of the stuccos in the Apollo Gallery (the Marsys and Girardon were doing the others), he worked with the latter on the group *Horses of the Sun* in the grotto of Thetis at Versailles.

Gaspard and Balthazar Marsy. Cambrai, 1624–Paris, 1681 and Cambrai, 1628–Paris, 1674.
Students of their father at Cambrai, then of Sarazin at Paris, the Marsys joined quickly the king's team of sculptors. At the Louvre, they worked on the pediments of the Grand Gallery (now disappeared). Their chief work is their half of the stuccos in the Apollo Gallery where, under Le Brun's supervision, they did some remarkable figures of muses. The balance of their career took place, quite naturally, at Versailles, where the basin of Latona and that of the Encelade are evidence of their ability.

François Girardon. Troyes, 1628–Paris, 1715.
After a stay in Rome, the young Girardon joined the team of Gilles Guérin, who used him especially for the sculpture on the ceiling of the king's chamber. His work on the Apollo Gallery marked the beginning of his success. He did a fourth of the stuccos and got a special bonus for having done better than the others.

From that point he was recognized as a major sculptor at the court of Louis XIV (with Coysevox). The group *Apollo Served by the Nymphs, the Basin of Saturn, Winter, The Rape of Proserpina* in the park of Versailles—as well as many tombs, or the equestrian statue of Louis XIV in the place Vendôme—are the hallmarks of a dazzling career during which he assumed a sort of moral and technical leadership over the court sculptors.

Guillaume II Coustou. Paris, 1716–Paris, 1777.
The creator of the eastern pediment of the Square Court was the son of the sculptor of *The Horses of Marly*, and the spirited masterpiece of the French Baroque, to which he collaborated. Although he worked on every aspect of sculpture (funerary, mythological and religious), he specialized in large pediments: the one on the Gabriel buildings, place Louis XV, today's place de la Concorde, and those of the château de Bellevue and of Sainte-Geneviève—both destroyed.

Philippe-Laurent Roland. Marcq-en-Pevèle, 1746–Paris, 1816.
Creator of ambitious statues *(Homer)*, intimate busts *(Lise Roland)* or monumental reliefs (hôtel de Salm), Roland worked on the decor of the Museum of Ancient Art (relief in the Hall of the Emperors, 1798) and on that of the roof of the Lemercier wing of the Square Court, where in 1807 he did the relief of the central bay *(Victory and Abundance, Minerva and Hercules, The Tiber and the Nile)*.

Jean-Guillaume Moitte. Paris, 1746–Paris, 1710.
Contemporary of Roland, Moitte also worked on ambitious reliefs before the Revolution. In 1807, he created the decor of the south window of the roof of the Lemercier wing, on the Square Court, devoted to religious law and leaders (Moses, Isis, Numa, Capac, etc.).

Pierre Cartellier. Paris, 1757–Paris, 1831.
Originally a goldsmith, Cartellier illustrated all facets of neoclassical sculpture: portraits, allegorical and mythological statuary. Creator of one of the bas-reliefs of the arc de triomphe of the Carrousel, he also did the large typanum of the Colonnade, *Glory distributing Crowns*, in a symetrical composition inspired by an ancient cameo.

Antoine-Denis Chaudet. Paris, 1763–Paris, 1810.
Grand Prize for sculpture in 1784, Chaudet was an

excellent neoclassical sculptor of works of great moral force (Belisarius), or of subjects of a romantic nature (Eros playing with a Butterfly). He did the stucco medallions in the Mars Rotunda (The Spirit of the Arts and The Marriage of Architecture, Sculpture and Painting). In 1807, with Moitte and Roland, he completed the decor of the north window of the attic of the Lemercier wing, in particulier the figure suggested by the poet Homer.

François-Frédéric Lemot. Lyon, 1772–Paris, 1827.
Prix de Rome in 1790, this man from Lyon had a great career under the Empire and the Restoration, which conferred upon him the commissions for the equestrian statues of Henry IV on the Pont Neuf (1818), and of Louis XIV at Lyon, place Bellecour. At the Louvre, his works include the gilded Victories that lead the quadriga of the arc de triomphe du Carrousel, as well as the pediment of the Colonnade.

François Rude. Dijon, 1784–Paris, 1855.
The creator of the Marseillaise of the Arc de Triomphe and of Maréchal Ney in the place de l'Observatoire was asked at the end of his life to do the statuary for the place Napoléon. He did two of the statues of famous men, Poussin and Houdon, on the buildings surrounding the Napoleon Courtyard.

Antoine-Louis Barye. Paris, 1795–Paris, 1875.
The great sculptor of animals had a large hand in the ornamentation of the Louvre. His skill in depicting wild animals, developed during the Restoration, was founded on anatomical knowledge acquired at the Museum of Natural History and was nourrished by a romantic spirit. Showing animals both at rest and in mortal combat, he was recognized as a master of the bronze. Lefuel first ordered from him four large groups for the central part of the Denon and Richelieu pavilions: Peace and War, Strength and Order. The fame of these groups should not diminish the fact that Barye extended his work at the Louvre with the sculpture on the pediment of the Sully Pavilion, and the ornementaion of the Great Gates. The bronze equestrian statue of the emperor that he put there was toppled in 1870, and all that remains are a few shards at Compiègne, but up on the rooftops one can still admire two figures of young rivers at rest.

Francisque-Joseph Duret. Paris, 1804–Paris, 1865.
Prix de Rome in 1823, Duret was at first drawn to romanticism, painting scenes from Chateaubriand (Chactas, museum of Lyon) or about the happy life to

be had in Italy (Fisherman dancing the Tarantella). He filled large orders for the state and the city of Paris, for example the gigantic bronze of Saint Michael Slaying the Dragon of the fountain of Saint-Michel. Duban asked him to do the decor of the Salon of Seven Chimneys, which was opened in 1851. Lefuel then entrusted to him the sculpture of the Richelieu pavilion, so that the two sculptors of Duban's great rooms, Duret and Simart, would be working at the same time on the two major pediments of the Napoleon Courtyard, Richelieu and Denon. Professor at the Academy of Fine Arts and member of the Institute, Duret was the teacher of Carpeaux.

Pierre-Charles Simart. Troyes, 1806–Paris, 1857.
Prix de Rome in 1833 and a student of Ingres, Simart's classical sentiments were evident. While working on a salon piece of great height he also completed the great Chryselephantine (made of gold and ivory) Minerva for the château of Dampierre—a reproduction of a lost work by Phidias, done for the duke de Luynes, an archeologist and patron of the arts. As he was working for Duban at Dampierre, he was also entrusted by the architect of the Louvre with the decor of the Square Salon, opened in 1851. Elected to the Institute in 1852, he was commissioned to do one of the two major pediments for the Napoleon Courtyard, that of the Denon pavilion. He also tossed off the caryatids in the Sully pavilion.

François Jouffroy. Dijon, 1806–Laval, 1882.
Prix de Rome (1832), member of the Institute (1857), professor at the Academy of Fine Arts (1863), he worked on the great Parisian construction projects, doing the Harmony group on the façade of the Opera, the statues of the gare du Nord, the palais de Justice, etc., all while filling important salon orders. At the Louvre, he did the statues along the cornice of the Mollien Pavilion, and the large groups of the Grand Gates of Carrousel (1868).

Auguste Préault. Paris, 1809–Paris, 1879.
Préault is considered one of the greatest romantic sculptors, as his most tormented works attest, The Murders at the Museum of Chartres and the Ophelia at the musée d'Orsay. At the Louvre, he was first given the statues depicting the Arts along the cornice of the Library off the rue de Rivoli, then two enormous allegories of Peace and War in the corners at the rear of the Napoleon Courtyard (1857).

Pierre-Jules Cavelier. Paris, 1814–Paris, 1894.
His official career (Prix de Rome in 1842, professor at the Academy of Fine Arts, member of the Institute in 1865) was complemented by his work on the great construction projects of the imperial era and of the Third Republic. Creator of the statuary of the Longchamp Palace in Marseille, he worked on the decor of the church of Saint Augustine and on those of the gare du Nord. At the Louvre he also worked a lot: Pediment of the Petite Galerie on the garden (1850), cornice of the Turgot Pavilion, caryatids of the Richelieu Pavilion, reliefs on the clock of the Sully Pavilion, statue of Abelard—all for the Napoleon Courtyard (1855–1856). Then he completed the entire west face of the Pavilion of Flora (1864), and the large atlantes for the Mollien stairwell (1869).

Eugène Guillaume. Montbard, 1822–Rome, 1905.
Prix de Rome (1845), member of the Institute (1862), professor (1863), then director of the Academy of Fine Arts (1865), director of the Academy of France at Rome, before being elected to the French Academy (1899)... This varied activity didn't prevent Guillaume from working on a number of projects in Paris (Opera, église de la Trinité) and Marseilles. In 1854, he received his first large-scale order from the Louvre: the cornice of the Turgot Pavilion (due perhaps to the influence of his father-in-law, Hector Lefuel). He did the very elegant œils-de-bœuf in the Napoleon Courtyard (*Art and Beauty*), the large reliefs in the former stairwell of Flora (today the boardroom of the department of Graphic Arts), but was not able to finish the equestrian statue of Napoleon, which he had planned for the courtyard.

Albert Carrier-Belleuse. Anzy-le-Château, 1826–Sèvres, 1887.
Educated by his uncle François Arago, Carrier-Belleuse was not from an prematurely molded by any academy. Creating models for a porcelain manufacture, he capped his career at Sèvres manufacture—where he was director from 1876. Friend of Carpeaux, teacher of Rodin, he was eclectic, full of life, and enjoyed complete freedom of expression. The bacchic figures in plaster that he did for the two rotundas of the Great Gallery (1869) are full of verve and representative of his style.

Jean-Baptiste Carpeaux. Valenciennes, 1827–Courbevoie, 1875.
Painter and sculptor, Carpeaux is the most famous representative of statuary art under Napoleon III, whose protégé he was. *La Danse,* sensual et animated—done for the facade of the Opera (1865–1869)—and *Ugolino and His Sons,* dramatic and feverish, are works of a multitalented genius, sometimes light and subtle, sometimes serious in the manner of Michelangelo, sometimes an inspired portraitist. An independent and creative spirit, he did the obligatory rounds of the Beaux-Arts (Prix de Rome in 1856), but didn't submit to the authority of the Institute. At the Louvre, after doing a group for the roof of the Rohan Pavilion, *The Navy* (1854), he did the top part of the Pavilion of Flora (1864–1866): *Imperial France* and the haut-relief of *The Triumph of Flora.*

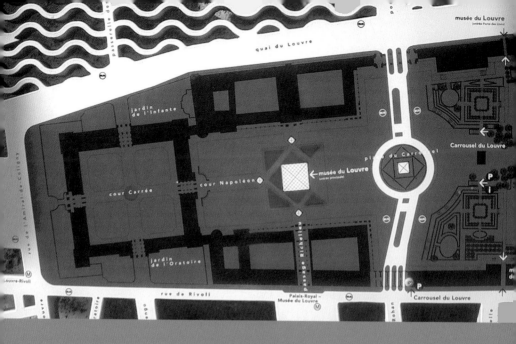

Informations

⇢ ACCESS

By way of the Pyramid (main entrance)
For individuals, from 9 a.m. to 10 p.m., except Tuesdays. Priority admission for the handicapped, those with children in strollers, and pregnant women.

By way of the Richelieu passage (between the place du Palais-Royal and the courtyard of the Pyramid)
From 9 a.m. to 6 p.m., except Tuesdays. This entrance is for groups, ticket holders, members (holders of "Amis du Louvre," or "Louvre jeunes" cards, auditorium attendees with tickets, and those holding passes.

By way of the Carrousel gallery (through 99, rue de Rivoli or through the Carrousel garden)
From 9 a.m. to 10 p.m., except Tuesdays. General admission, as well as for groups, ticket holders, members (holders of "Amis du Louvre," or "Louvre jeunes" cards), auditorium attendees with tickets, and those holding passes.

By way of the Porte des Lions (through the Carrousel garden or the quai François Mitterrand)
From 9am to 5:30pm, except Tuesdays and Fridays.

Transportation
Métro Palais-Royal/musée du Louvre (ligns 1 and 7); bus 21, 24, 27, 39, 48, 68, 69, 72, 81, 95 and Paris l'Open Tour; Batobus; underground parking accessible via Avenue du Général Lemonnier, every day from 7 a.m. to 11 p.m.. Tel.: (33) 01 42 44 16 32. Fax: (33) 01 42 44 16 33.

Tickets are on sale at the museum until 5:15 p.m. (9:15 p.m. Wed. & Fri.). Galleries begin closing at 5:30 p.m. (9:30 p.m. Wed. & Fri.).

Hall Napoléon
under the Pyramid is open from 9 a.m. to 10 p.m..

Louvre médiéval
open from 9 a.m. to 6 p.m. (9:45 p.m. Wed. & Fri.).

Temporary exhibitions
open from 9 a.m. to 6 p.m. (9:45 p.m. Wed. & Fri.).

CyberLouvre (the museum's multimedia space)
from 9 a.m. to 5:45 p.m..

⇢ CONTACTS

Information Desk
every day but Tuesday, from 9 a.m. to 6:45 p.m. (9:45 p.m. on Wednesdays and Fridays)
Tel.: (33) 01 40 20 53 17.

Services for the handicapped
Tel.: (33) 01 40 20 59 90. handicap@louvre.fr.

General telephone number
Tel.: (33) 01 40 20 50 50.

Internet
www.louvre.fr

Mailing Address
Musée du Louvre (Louvre Museum) 75058 Paris Cedex 01 France

⇢ OPENING HOURS

The museum is open every day but Tuesday and certain holidays from 9 a.m. to 6 p.m.. On Wednesday and Friday evenings until 9:45 p.m.. (These evening hours have been in effect since September 2004.)
Holiday closings during 2005: The museum will be closed for the following holidays during 2005: January 1 (New Year's Day), May 1 (Labor Day), December 25 (Christmas).

Permanent Collections
Open from 9 a.m. to 6 p.m. (until 9:45 p.m. Wed. & Fri.) Please note: certain galleries are closed on various days of the week.
Galleries closed for construction are posted on our website (www.louvre.fr).

⇢ ADMISSION FEES (2005)

Permanent collections and temporary exhibitions (except Napoleon Hall)
8,50 euros. This ticket is also valid on the same day to the collections and temporary exhibitions of the Eugène Delacroix museum.
Evenings: Permanent collections and temporary exhibitions (except Napoleon Hall): 6 euros from 6 to 9:45 p.m. on Wednesdays and Fridays.

Temporary exhibitions in Napoleon Hall
8,50 euros.

Twin ticket
13 euros. The twin ticket allows acces to the perma-

nent collections and all temporary exhibitions of the Louvre and the Eugène Delacroix museum.
Evenings: 11 euros from 6 to 9:45 p.m. on Wednesdays and Fridays.

Free admission to the Museum

Open free to everyone on the first Sunday of the month and on July 14.
Friday evenings to young people under 26 years of age: Entry to the museum is henceforth free to young people under 26 years of age every Friday evening from 6 until 9:45 p.m., with the exception of exhibitions in the Napoleon Hall.
Free admission to the Louvre and to the Eugène Delacroix museum is granted to those with valid identification to:
- those under 18 years of age;
- the unemployed and those receiving unemployment benefits (in effect for no more than 6 months);
- the handicapped and an escort;
- teachers of the humanities, of art history, of the plastic arts, the applied arts, currently working, upon presentation of identification that mentions the subject of instruction.
- sculptors belonging to the Maison des Artistes and to the AIAP (Association internationale des arts plastiques).

Advance purchase of tickets

Avoid waiting in line at the Pyramid or at ticket windows by buying your ticket in advance. Advance sale tickets are not available at the Louvre. The ticket is valid for any day of the year (except on Tuesdays, when the museum is closed, and on certain holidays). Valid only for the purchaser, it cannot be returned, exchanged or refunded.
Armed with your ticket you can gain quick access to the museum through the Richelieu passage (located between the place du Palais-Royal and the Napoleon Courtyard of the Pyramid from 9 a.m. to 6 p.m.) or through the Carrousel gallery (entrance at 99, rue de Rivoli or by the Carrousel garden). Go directly to the ticket collectors to enter the galleries.

Where to purchase in advance: Fnac, Carrefour, Continent, Leclerc, Auchan, Extrapole, Le Bon Marché, Printemps, Galeries Lafayette, BHV, Samaritaine, Virgin Mégastore, by phone (Fnac: (33) 0 892 684 694; Ticketnet: (33) 0 892 697 073), Transilien SNCF stations in Ile-de-France (forfait Transilien SNCF/musée du Louvre: roundtrip with train, metro, RER, and an entrance to all permanent collections), all major metro stations.

For 20 people or more (associations, corporations...)

Musée & Compagnie, 49, rue Étienne-Marcel, 75001 Paris, Tel.: (33) 01 40 13 49 13.

⋯⋗ MEMBERSHIP CARDS

Carte Musées et Monuments

La carte Musées et Monuments permits free access (without waiting) to the permanent collections of 60 museums and monuments, including the Louvre. It is sold under the Pyramid, in the other museums and monuments on the list, in major metro stations and at the Paris Tourism Office.
Information: (33) 01 44 61 96 60
Valid for 1 day: 18 euros; 3 days: 36 euros; 5 days: 54 euros.

Carte Louvre jeunes

Individual membership: 15 euros.
Valid for one year from the date of membership.
Telecharge membership application in PDF format (www.louvre.fr)
Group membershi : 11 euros For the applicant and members of his group. Valid until 30 September 2005, no matter the date of membership. The applicant must have 9 other candidates under 26 years of age. Request application at: 01 40 20 53 72
Telecharge membership application in PDF format. The applicant may be older than 26.
For information or to join:
-At the Louvre: At the membership desk in the Carrousel, passageway Grand Louvre.
Open Monday and Thursday, and the first Sunday of the month (except January 2, 2005) from 9 a.m. to 5:15 p.m., and on Wednesday and Friday from 9 a.m. to 9:15 p.m.. Closed on holidays. Tel.: (33) 01 40 20 51 04
- In writing: Fill out the application and send it with proof of age and a check payable to: M. l'agent comptable du musée du Louvre, at: Musée du Louvre Carte Louvre jeunes 75058 Paris Cedex 01
- By email: adhesion.louvrejeunes@louvre.fr
Holders of Louvre jeunes cards qualify for special admission to Friday evening events.
More information available on our website under Nocturnes du vendredi.

Carte Louvre professionnels

Membership: 30 euros. Valid for one year from the date of membership. The Louvre professionals card is for teachers, school and university librarians, anyone working in the education of young people or of people in the social or medical-social fields, pro-

fessional artists and artisans, art critics or members of the International Association of Art Critics, and art students over 26 years of age.

Membership:
- At the Louvre. Show proof of your status at the membership desk. You will be given your card at once.
- In writing. Telecharge membership form in PDF format (www.louvre.fr) and include payment of 30 euros (check only), payable to: M. l'agent comptable du musée du Louvre. Send your documents (application, check, identification certificate) to the following address: Carte Louvre professionnels Musée du Louvre 75058 Paris cedex 01. You will receive your Louvre professionals card within 15 days. No cards will be sent without the proper identification having been provided.

For information or to join:
- At the Louvre: At the membership desk located in the Carrousel, Grand Louvre passageway. Open every day but Tuesday, from 9 a.m. to 5:15 p.m., and until 9:15 p.m. on Wednesdays and Fridays. Closed on holidays and the first Sunday of the month.
Tel : (33) 01 40 20 51 04
- By email : louvreprofessionnels@louvre.fr

Carte Amis du Louvre
Information and membership under the Pyramid, every day but Tuesdays, Sundays and holidays, from 10 a.m. to 5:30 p.m.. Tel.: (33) 01 40 20 53 74. Rate of individual membership (for 12 months) from 50 euros to 650 euros. Preferential group rates from 40 euros. La Société des Amis du Louvre (www.amis-du-louvre.org) is an independent association whose mission is to enrich the collections of Louvre. Today it has nearly 80,000 members. Membership in the Amis du Louvre includes free access to the permanent collections and temporary exhibitions, substantial discounts to the Louvre Auditorium, and in the bookshop and restaurants of the museum, and to receive museum programs and the bulletin of the Amis du Louvre

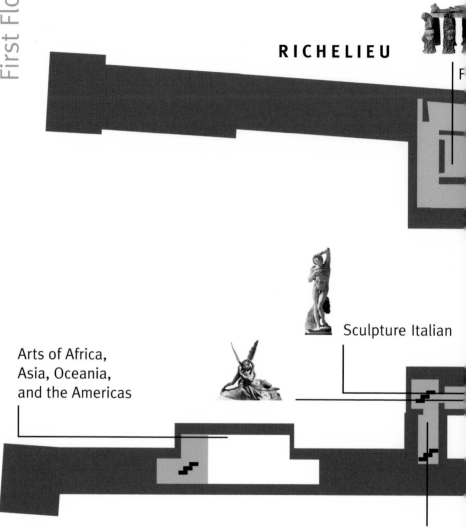

RICHELIEU

Sculpture Italian

Arts of Africa,
Asia, Oceania,
and the Americas

DENON

Northern
European
Sculpture

Oriental Antiquities

ture

SULLY

Greek
Antiquities

Egyptian
Antiquities

Etruscan
and Roman
Antiquities

Mezzanine

RICHELIEU F

Tempoary
Exhibitions

Italian and Spanish
Sculpture

Northern European
Sculpture

DENON

Romar
Egypt

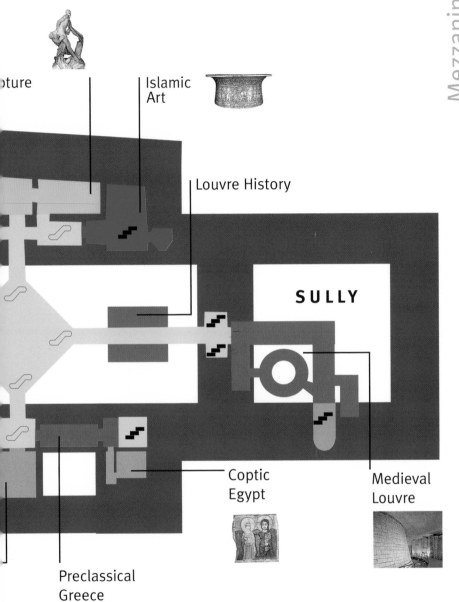

ıture

Islamic
Art

Louvre History

SULLY

Coptic
Egypt

Medieval
Louvre

Preclassical
Greece

RICHELIEU

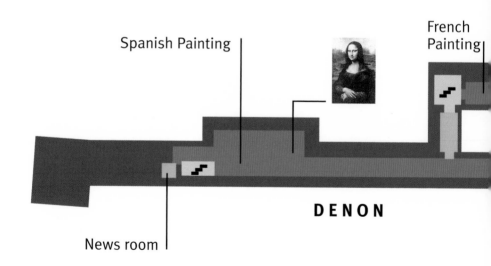

Spanish Painting

French
Painting

DENON

News room

Art pieces

La Chapelle
(temporary
exhibitions)

Egyptian
Antiquities

SULLY

Greek, Etruscan, and Roman
Antiquities

Painting and
Graphic Arts
Italian School

English and Venetian Painting

RICHELIEU Painting and Graphic Ar
Northern School

DENON

SULLY

Painting and Graphic Arts
French School

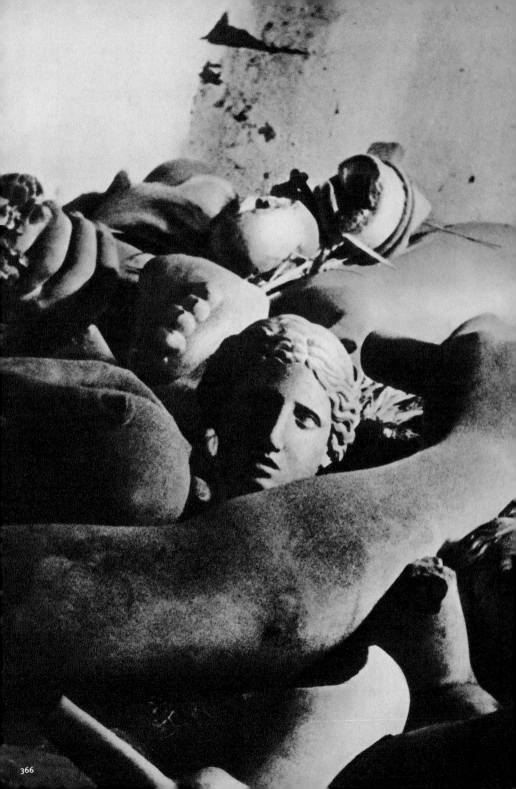

Index

Photo Credits

Acknowledgments

The authors would like to thank the team working for éditions Assouline, and especially Julie David and Nelly Riedel; their energy and help were fantastic.

The publisher would like to thank the Réunion des Musées Nationaux Agency, without whom the book would never have been made possible, especially Jan Pierrick, Raphaelle Cartier and Odile d'Harcour, and the photographers: Daniel Arnaudet, Martine Beck-Coppola, Michèle Bellot, Jean-Gilles Berizzi, P. Bernard, Gérard Blot, Bulloz, Chuzeville, Jérôme Galland, Béatrice Hatala, Christian Jean, Ch. Larrieu, Thierry Le Mage, Matthéus, Phillippe Miget, Hervé Lewandowski, André Martin, René-Gabriel Ojéda, Franck Raux, Caroline Rose, J. Scho, Jean Schormans, and Willi. The publisher would also like to thank: Fabienne Grévy (AKG), Mrs. Mayor ofPeyrolles-en-Provence, Mr. Lépine, Catherine Terk (Rue des Archives), Valérie Vincent Génod (Cbleu), Deide Von Shaewen, Serge Darmon (Christophe L.).